A CULTURAL HISTORY
OF COLOR

VOLUME 1

A Cultural History of Color
General Editors: Carole P. Biggam and Kirsten Wolf

Volume 1
A Cultural History of Color in Antiquity
Edited by David Wharton

Volume 2
A Cultural History of Color in the Medieval Age
Edited by Carole P. Biggam and Kirsten Wolf

Volume 3
A Cultural History of Color in the Renaissance
Edited by Amy Buono and Sven Dupré

Volume 4
A Cultural History of Color in the Age of Enlightenment
Edited by Carole P. Biggam and Kirsten Wolf

Volume 5
A Cultural History of Color in the Age of Industry
Edited by Alexandra Loske

Volume 6
A Cultural History of Color in the Modern Age
Edited by Anders Steinvall and Sarah Street

A CULTURAL HISTORY
OF COLOR

IN ANTIQUITY
VOLUME I

Edited by David Wharton

BLOOMSBURY ACADEMIC
LONDON • NEW YORK • OXFORD • NEW DELHI • SYDNEY

BLOOMSBURY ACADEMIC
Bloomsbury Publishing Plc
50 Bedford Square, London, WC1B 3DP, UK
1385 Broadway, New York, NY 10018, USA
29 Earlsfort Terrace, Dublin 2, Ireland

BLOOMSBURY, BLOOMSBURY ACADEMIC and the Diana logo are
trademarks of Bloomsbury Publishing Plc

First published in Great Britain 2021
Hardback edition reprinted 2023
Paperback edition published 2024

Series cover design by Raven Design
Cover image: Two Faces, House of the Golden Bracelet, Pompeii, fresco,
Roman 1st Century AD © Bridgeman Images

A catalogue record for this book is available from the British Library.

A catalog record for this book is available from the Library of Congress.

ISBN: Pack, HB: 978-1-4742-7373-2
 Pack, PB: 978-1-3504-6035-5
 Volume, HB: 978-1-4742-7327-5
 Volume, PB: 978-1-3504-5979-3

Typeset by Integra Software Services Pvt. Ltd.
Printed and bound in Great Britain

To find out more about our authors and books visit www.bloomsbury.com
and sign up for our newsletters.

For Laurette

CONTENTS

ILLUSTRATIONS

PLATES

FIGURES

SERIES PREFACE

A Cultural History of Color is a six-volume series examining the changing cultural understandings, interpretations, and utilizations of color throughout history. Each volume has the same structure and begins with a general overview of the major attitudes toward and uses of color in the historical period examined. The introduction is followed by contributions from experts, who investigate color under ten chapter headings that are identical in each of the volumes: philosophy and science; technology and trade; power and identity; religion and ritual; body and clothing; language and psychology; literature and the performing arts; art; architecture and interiors; and artifacts. Accordingly, the reader has the option of taking either a synchronic or a diachronic approach to the information provided. One volume can be read to gain a broad knowledge of color in a specific period or, alternatively, a theme or topic can be followed throughout history by reading the appropriate chapter in several volumes. The six volumes divide the history of color as follows:

Volume 1: A Cultural History of Color in Antiquity (*c.* 3000 BCE–500 CE)
Volume 2: A Cultural History of Color in the Medieval Age (500–1400)
Volume 3: A Cultural History of Color in the Renaissance (1400–1650)
Volume 4: A Cultural History of Color in the Age of Enlightenment (1650–1800)
Volume 5: A Cultural History of Color in the Age of Industry (1800–1920)
Volume 6: A Cultural History of Color in the Modern Age (1920–the present)

The general editors wish to dedicate the *Cultural History of Color* to the memory of their husbands who provided so much love and support: William Biggam (1944–2016) and Phillip Pulsiano (1955–2000).

General Editors, Carole P. Biggam and Kirsten Wolf

EDITOR'S ACKNOWLEDGMENTS

Thanks must go first to each of the authors who contributed their time and expertise to bring this volume into existence: Mark Abbe, Karen Bassi, Hilary Becker, Katerina Ierodiakonou, Katherine McDonald, Lloyd Llewellyn-Jones, Kelly Olson, Verity Platt, Ellen Swift, and Stephan Zink. I enjoyed working with all of them and learned a great deal from each. I also owe a debt of gratitude to the many other scholars whom I consulted on several matters.

Warm thanks are due to each of my colleagues in the Department of Classical Studies at the University of North Carolina at Greensboro, who have provided me with unfailing encouragement and friendship. Few scholars are lucky enough to have such a supportive department. The UNCG College of Arts and Sciences Office of Research also gave needed assistance at a crucial point.

Extraordinary thanks must go to the general editors of this series, who invited me to undertake this project. Carole Biggam and Kirsten Wolf supplied professional, patient, and painstaking help at every step of the way, especially in meeting the significant bibliographical challenges that this volume presented. Together with Carole Biggam, Tristan Mueller-Vollmer, a doctoral student in Scandinavian Studies at the University of Wisconsin–Madison, also provided indispensable assistance on the bibliography. Finally, Tristan Palmer of Bloomsbury Publishing supplied constant practical support and advice as well as aid in terms of identifying contributors.

Introduction

The word *Antiquity* in this book's title is large and loose in its reference, pointing to a web of peoples whose main nodes of connection, in the traditional view, are the civilizations of ancient Greece and Rome. Its timescale is equally large, especially if we include the Bronze Age (*c.* 3000–1200 BCE), which is touched on in some chapters of this volume. But even leaving that period aside, antiquity's span from the beginning of the Greek Dark Age (*c.* 1200–700 BCE), in which Greek epic poetry was born, to the end of the Roman imperial period (31 BCE–476 CE) is longer than all the eras covered in the other volumes in this series combined. Classical antiquity's geographic and cultural reach also includes Greece's and Rome's constant engagement and frequent conflicts with the peoples surrounding the Mediterranean basin and stretches far into Asia Minor, including the regions once consolidated in the Achaemenid Persian Empire, an area conquered by Alexander the Great and later by the Romans. The Roman Empire at its height also included North Africa, Egypt, the Levant, western Europe, much of northern Europe, and most of Britain.

Given antiquity's geographic, cultural, and temporal reach, I do not think the reader will be surprised to learn that this volume does not provide a comprehensive account of the roles of color in all these times and places. The meagerness of the surviving evidence is one obstacle. Much of the color of the ancient built environment, and nearly all of it on perishable items such as textiles or wood, has been destroyed by time and can only be reconstructed, often conjecturally, by painstaking technical methods that are new and constantly being refined. Surviving texts of Greek and Latin literature are more substantial, although few in comparison to what we know was once written down. But while many texts are rich in the language of color, they turn out to be very challenging to interpret when it comes to understanding exactly how to understand their color language. This is all to say that what this volume *does* provide is a guided

tour—a series of snapshots, if you will—of ancient uses of color in some of the more interesting and well-studied sites of a vast Mediterranean past.

THE DECOLORIZATION OF ANTIQUITY

Today, most people's dominant color impression of the ancient world is probably a monochrome light hue. The reasons are obvious: white or off-white is what people see if they are lucky enough to have visited ancient sites such as the Athenian Acropolis or the Roman Forum, and images of antiquity that appear in popular culture are dominated by archaeological remains of sculptures and buildings mostly made of light-colored bare marble or other stone. Theatrical revivals of ancient drama often show the actors, if they are masked, wearing white or off-white masks, and attempts at recreating ancient-looking costumes often use draped garments in white or in some other unpatterned color. Even serious students of classical antiquity may retain these monochrome impressions, because the archaeological remains they study show few or no traces of color, and the most commonly studied vase paintings that represent scenes from myth, theatre, or everyday life have a very limited color palette that allows only a few shades of red, black, and white. Modern textbooks of archaeology often skimp on the subject of color or are entirely silent (Brinkmann 2017: 13).

Yet we now know, and have known for some time, that these impressions are wrong. Vigorous and varied use of color was a pervasive feature of the ancient world's built environment, of its art and sculpture, and of the everyday life of rich and poor. How, then, did ancient color disappear? One obvious answer is "time." As colorful monuments and artworks fell into disuse, the perishable painted or gilt decorations on their exteriors and relief sculptures simply wore away. Many other buildings and sculptures were deliberately destroyed or suffered natural disasters, and their colored remains ended up underground, sometimes used as rubble in foundations for new building projects. Archaeologists who excavated them sometimes destroyed the remaining pigment traces in the process of cleaning the artifacts (see, for example, Jenkins 2001). The Italian cities of Pompeii and Herculaneum, which are among our most important archaeological resources for the study of color in antiquity, were buried under a layer of volcanic debris from the eruption of Mount Vesuvius in 79 CE. Painted surfaces elsewhere usually did not survive, and most colorful everyday artifacts, such as textiles and household items, quickly decayed. *Tempus edax rerum*—time, devourer of things (Ovid 1977–84: *Metamorphoses*, 15.234)—was especially hungry for color.

However, this does not entirely explain why we are inclined to think of antiquity as uncolored. We know that the living traditions of colored decoration of architecture and sculpture did not end with the fall of Rome, as the remains of Byzantine and medieval art, architecture, and decoration all attest (Collareta 2008: 62–77). Those traditions were strong well into the Renaissance. Before

the fifteenth century, if a sculpture remained undecorated, the cause was often lack of funds rather than a preference for bare marble (Brinkmann 2017: 13). But major sculptors of the Renaissance such as Da Vinci, Donatello, and Michelangelo began to turn away from the practice (Brinkmann 2010: 11–12; 2017: 13), and their influence, along with that of surviving ancient sculptures on display, most of which had lost their polychrome decorations either in antiquity or later, and the anti-polychromy views of influential art historians were very powerful in swaying European and American aesthetic tastes and presuppositions about art and architecture (Østergaard 2010: 79–84). Thus, the decolorization of antiquity has been both a physical and a cultural process. Some scholars have also noted a political component. Philippe Jockey has argued that the "myth of Greek whiteness" has roots reaching back to imperial Rome that are entwined with imperialist ideologies (Østergaard 2010: 84–6; Jockey 2015: 239–62). But whatever the reasons (too complex to explore here; see Brinkmann 2017: 19), our age has a distaste for colorful architectural decoration and painted sculptures (contemporary devotional sculpture in Catholic churches is an exception), and the polychromy of antiquity has not captured the popular imagination.

THE ARCHAEOLOGY OF COLOR

Ancient color is being recovered gradually. As Brinkmann (2017: 14) documents, systematic excavations in Pompeii and Herculaneum, begun in the middle of the eighteenth century, brought to light statues with obvious traces of color as well as exuberantly colorful wall paintings and mosaics. At about the same time, English and European architects, who had begun to systematically study the remains of ancient Greek architecture, could not help but notice scant but unmistakable evidence of color on the Parthenon and other Greek structures, and their findings began to make their way into some European architecture curricula. But acceptance of the idea of Greek polychromy took time. In the nineteenth century, excavations and research in the new academic fields of archaeology and art history brought more evidence to light, such as polychrome sculptures destroyed by the Persian invasion of 480 BCE and buried on the Athenian Acropolis (Brinkmann 2017: 14–15). Since that time, the debate among specialists in art history and archaeology—sometimes called "the polychromy debate"—shifted from arguments about whether or not ancient sculpture and architecture were colored to conflicting theories about the extent and nature of coloration. Were all surfaces decorated, or just some? And which colors and color schemes were preferred (Brinkmann 2017: 16–19)?

Researchers from many disciplines and institutions are now investigating these questions using increasingly sophisticated and innovative methods. Because their work is inherently interdisciplinary, requiring expertise in the

sciences, archaeology, and classics, much of the research is organized through collaborative consortia such as the Copenhagen Polychromy Network (Tracking Colour n.d.), the Ancient Polychromy Network (n.d.), the Technart Conference (Technart 2019), and the International Polychromy Round Table (9th International Round Table on Polychromy in Ancient Sculpture and Architecture n.d.), with international cooperation and sponsorship from universities and institutions in Europe and America, such as the Ny Carlsberg Glyptotek in Copenhagen, the University of Georgia, and the British Museum. Researchers use a variety of technologies and techniques to detect the remains of pigments and binding agents, including noninvasive methods such as ultraviolet fluorescence (UVF), infra-red reflectography (IRR), visible induced (infrared) luminescence (VIL), and X-ray fluorescence spectrometry (XRF). When conditions warrant, invasive methods may also include various modes of electron microscopy, Fourier transform infrared spectroscopy (FTIR), gas chromatography, mass spectrometry, and others (for an overview, see Brinkmann et al. 2017b: 87–97).

The results of this research are transforming our understanding and appreciation of ancient art and architecture. A single example will give a glimpse of what these methods can tell us. On the island of Aegina, about seventeen miles from Athens, stand the remains of a Doric temple to the mother goddess Aphaia built around 500 BCE. Significant portions of its pedimental sculpture have survived and are housed in the Glyptotek in Munich. The west pediment represents scenes from the Trojan War and includes a kneeling Trojan archer, possibly representing the Trojan prince Paris (Figure 0.1). In its current state of preservation, the figure is recognizable as non-Greek by his leggings, long sleeves, and Trojan cap with a neck guard, which are all evident in the form of the sculpture, even though no traces of paint remain on the figure. But as Vinzenz Brinkmann and Ulrike Koch-Brinkmann report,

> The ornamentation of the [archer's] clothing is [...] revealed by raking light and ultraviolet (UV) photography. Under raking light, the allover design on the left arm is faintly visible as a relief [...] a ghostly imprint resulting from the different resistances of each applied pigment to weather over time. The sleeve was covered with a diamond pattern, with every other row filled in with smaller diamonds [...] the UV reflectograph reveals that the archer's leggings feature a continuous zigzag pattern [...]. The individual zigzags with ends terminating in filled-in diamonds are visible in four or five different gradients of brightness. Much like a black-and-white photograph of a colored object, the reflectograph preserves the original colors in encoded form. Thus, we can postulate that the archer's leggings were painted in at least four colors (azurite, malachite, possibly cinnabar, and yellow ochre), if not five (brown ochre).
>
> (Brinkmann and Koch-Brinkmann 2017: 31)

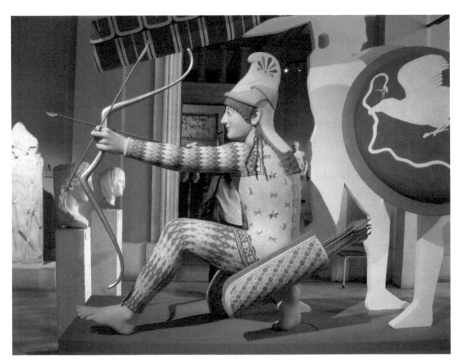

FIGURE 0.1 Modern reconstruction of the polychromy of a Trojan archer of the Temple of Aphaia, *c.* 500 BCE. On loan from the Glyptotek in Munich, for the Bunte Götter exhibition. Photograph by Giovanni Dall'Orto. Wikimedia Commons. https://commons.wikimedia.org/wiki/File:Istanbul_-_Museo_archeologico_-_Mostra_sul_colore_nell%27antichit%C3%A0_08_-_Foto_G._Dall%27Orto_28-5-2006.jpg.

The pigment scheme proposed here is based on surviving pigments found on comparable sculptures of Persians and other non-Greek figures elsewhere (Brinkmann and Koch-Brinkmann 2017: 31–2) and is therefore somewhat hypothetical, but there is no doubt that this figure and others on the Aphaia pediments were vividly colored and presented a striking visual experience. Even more, the patterns of this figure "give us a sense of the great fascination the Greeks of the early fifth century had for their Eastern neighbors" (33), because zigzag and diamond patterns were considered typical of Eastern (Persian or Trojan) and not of Greek dress.

The discovery of these colored patterns thus opens deeper questions for art historians about how to interpret the Greek reception and representation of Eastern clothing, customs, and mores at a time when Greeks and Eastern peoples were in cultural competition and open military conflict. What reactions might the colorful sleeves and leggings have been expected to produce in Greek viewers? Was it admiration of Eastern skill with patterned textiles, contempt for Eastern extravagant styles, or simple recognition of non-Greek

identity? How did these impressions relate to the ritual life of the temple? At the very least, we can say that the polychrome sculptures were intended to evoke livelier reactions than simply a detached contemplation of the beauty of sculptural form. Even more, these reconstructions give us clues about the colors and patterns of ancient textiles, whose remains in southern Europe are very fragmentary, although we must be careful not to assume that the colors on sculptures accurately represented the colors experienced on actual clothing (Harlow and Nosch 2014a: 7–9).

The Romans also incorporated color in their sculpture and architecture, influenced by Etruscan and Greek Hellenistic styles that were adapted as Rome's wealth and influence spread in and beyond the Italian Peninsula, and eventually grew into dominance of the Mediterranean. The use of different natural colors of marbles and other stones, both in sculpture and architecture, became increasingly popular as the Romans gained imperial control over many quarries around the Mediterranean (Østergaard 2019) to such an extent that its use, especially in domestic architecture, was considered extravagant even by elite Romans, such as Pliny the Elder (1962: 36.48–51). Stephan Zink (this volume) calls their desire for it a "veritable obsession" (see also Bradley 2006).

POLYCHROMY BEFORE GREECE AND ROME

Polychromy in art and architecture did not begin with the Greeks and Romans, who in this as in much else were deeply indebted to the traditions of Egypt and the Near East. Renée Dreyfus (2017: 53–65) tracks evidence of the artistic and architectural use of color at least as far as the Paleolithic era. The paintings found in caves at Lascaux, France, dating from 17,000 BCE used a black pigment, hausmannite, that may have been imported from as far as 150 miles away. Polychrome art appears possibly as early as the eighth millennium BCE in the Near East, and the Assyrians in the first millennium BCE used pigments, such as Egyptian blue, cinnabar, ochre, charcoal, and a variety of others (see Becker, this volume) as well as precious metals and ivory to enhance wall paintings, free-standing and relief sculpture, and floors, in what I.J. Winter has called a "royal rhetoric" displaying "the power of the king and of the state" (Winter 1981: 18; see also Dreyfus 2017: 57). The Persians as well, and especially the Achaemenid rulers of the fifth and fourth centuries BCE, used polychrome decoration extensively in architecture, reliefs, and monumental sculpture with an apparent preference for the use of blue in the depiction of hair and beards. Like the Assyrians, the Persians used polychrome decorations to project and exalt imperial power and wealth.

On the sculpted facades of the palaces of Pasargadae, Persepolis, and Susa, aside from paints and gilding, craftsmen made use of other materials such as gold, silver, and lapis lazuli to emphasize specific parts of a sculpture, such as hair,

beards, or ornamented jewelry (Nagel 2013: 598). And as one might expect, the Egyptians were also pioneers in polychromy. A surviving Egyptian polychrome terra-cotta head has been dated to 4000 BCE, and remains of limestone reliefs, statuary, funerary statuettes, sarcophagi, and painted tombs using black, red, yellow brown, blue, and green pigments through many centuries attest to their pervasive use of color (Dreyfus 2017: 63–5).

The use of color also emerges in early Bronze Age Cycladic and Minoan cultures, with red ochre and blue pigments turning up in burials, and evidence from painted Cycladic figurines suggesting the possibility of a practice of decorative skin tattooing, either permanent or temporary (Thimme 1977: 368, 543–4; Blakolmer 2004: 61). The "Kamares coloration style" is common in the middle Bronze Age, a style which Fritz Blakolmer (2004: 61) characterizes as "oligochromy," that is, using only a few colors, in this case white, black, and red. This scheme was used across a variety of domains, including wall paintings, sarcophagi, terra-cotta figurines, textiles, and ivory. The limitation to these few colors seems to have been a matter of choice, since other pigments were available, affordable, and occasionally used (Blakolmer 1999: 45–7; 2000: 229–31; 2004: 61). By the late Bronze Age, a free use of multiple colors is evident in architecture and art using color both for "realistic" representation as well as "strange and non-realistic" purposes (Blakolmer 2004: 62; see also Schäfer 1977: 15–18; Immerwahr 1990: 40–50). Late Bronze Age Mycenaean painters also had access to a wide variety of pigments (Perdikatsis 1998: 103–8; Dandreau 1999: 1–41; Muskett 2004: 68–73). All of this attests to vibrant and constantly changing cultures of color throughout the Mediterranean world, in which the Greeks and the Romans can be seen as rather late-arriving participants. But, as Mark Abbe's and Stephan Zink's chapters in this volume show, both the Greeks and the Romans developed these arts and the techniques of craftsmanship that supported them in distinct, beautiful, and sometimes astonishing ways.

Not all archaeology deals with monumental structures and public artworks, however, and we have troves of smaller colored artifacts that have only begun to be studied in systematic ways. As Ellen Swift documents in this volume, such items include glass, ceramic, or cameo vessels for drinking, amulets, pendants, game boards, dice, hairpins, brooches, seals, gems, rings, glass vessels, necklaces, and much more, in a multitude of colors. Making sense of the uses and meanings of the colors, however, is a daunting challenge. Nevertheless, such artifacts can provide glimpses into the color concepts of ordinary people, which perhaps differed from those whose ideas are represented in elite literature. They may also help reveal the color categories ancient people used for classifying and ordering items in the material world and the uses of color for imitation, sometimes to emulate the appearance of high-prestige objects, sometimes for magical, protective purposes.

ANCIENT COLORANTS

Much of this architectural and artistic decoration would have been impossible without the use of natural pigments, some of which were processed and applied in ways that we are still working to understand. The names of many pigments used in these contexts are known to us through literary sources such as the Greek philosopher Theophrastus in the fourth and third centuries BCE, the Roman architectural writer Vitruvius in the first century BCE, and the naturalist and encyclopedist Pliny the Elder in the first century CE, whose monumental *Natural History* is our richest, if not always most reliable, source for information about pigments in antiquity. But although we know the names of the pigments, their geographic sources (since Pliny usually provides this information), and even their methods of processing, we are still uncovering their chemical properties, and scientific inquiry is helping to give us more detailed knowledge than was possible before. For example, we know that one of the most popular pigments in antiquity was a substance called Egyptian blue, also called Vestorian blue after a Roman entrepreneur named Vestorius, who learned the secrets of its manufacture and made a business making and selling it. Vitruvius even provides a description of its manufacturing process (Vitruvius 1998: 7.11.1), but recent work in experimental archaeology has showed how its color and microstructure qualities were sensitive to variations in the local materials used in making it (Kakoulli 2009: 85; see Becker, this volume). We also know that some of the ochre on the wall paintings at Pompeii changed from yellow to red because of the heat of the volcanic eruption that destroyed the town. Chemical analysis is now helping us to distinguish the parts that were originally red and those that were changed to red by the disaster (Nicola et al. 2016: 560). Archaeological excavations of pigment workshops are also providing insight into the consumer and manufacturing economy of color production (see Becker, this volume).

We should add dyes to the discussion here as well, since much of the everyday experiences of human-made color for ordinary people in antiquity would have come from the colored and patterned textiles they wore. As Lloyd Llewellyn-Jones stresses in his chapter in this volume, the ancient Greeks and Romans loved to wear color at least as much as we do, and a delightful variety of dyes was available to consumers at all price points, ranging from inexpensive vegetable dyes to the most costly and desirable insect-based and shellfish-based luxury products (see Becker and Llewellyn-Jones, this volume). Here again, literary sources are helpful in understanding how the dye industry worked by recording the names of various kinds of dye workers and fabric cleaners, as well as recording many of the manufacturing processes. Further, archaeological finds of inscribed lead tags used in the textile trade to track orders of variously dyed products give us glimpses into the range of color choices available to

consumers in antiquity (see Becker, this volume). But experimental archaeology is providing some of the most exciting insights by reproducing ancient techniques for manufacturing the varieties of shellfish-based "purple" dyes that were perennially popular with the wealthy and powerful throughout antiquity (Koren 2005, 2013).[1]

The extremely high prices of some of these dyes and pigments naturally provided opportunities for the wealthy and powerful to use them to distinguish themselves through the purchase and display of expensive clothing and textiles, jewelry made of precious metals, and, especially in Rome, through interior paint applications of costly pigments as well as lavish application of colored marbles (Bradley 2006; see Zink, this volume). The wearing of purple garments became so strongly associated with the courtiers at the Persian court that they were popularly called "purple-wearers" (Reinhold 1970: 19). In the Rome of the later Republic and early empire, the use of purple shellfish dyes developed into a gradated visual code for use on the toga, the Romans' "official" civic dress, such that one's political power or military accomplishments had a visual analog in the amount and deployment of purple on that garment (Brøns et al. 2017: 55–63; Olson 2017: 44–54; Rothe 2020: 72–8; see Olson and Wharton, this volume). By the later empire, however, the wearing of all-purple garments, especially silks, was the normal regalia of the emperor, and the color became increasingly associated with him, even while purple-dyed garments were widely available for private use for those who could afford them (Reinhold 1970: 62–70).

ANCIENT COLOR LANGUAGE

The study of color language in classical literature begins with William Gladstone, the nineteenth-century British politician, a four-time prime minister, who, as a student at Oxford, secured first-class degrees in classics and mathematics. He wrote his multivolume *Studies on Homer and the Homeric Age* (1858) while serving in Parliament, and devoted a long section to Homer's use of color words and to speculations about ancient Greek color perceptions and concepts. Twenty years later, he updated his views in a long article published in *The Nineteenth Century*, which took into account newer studies of color carried out by Hugo Magnus (1877), and included fleeting reference to Darwin's new ideas on natural selection and the survival of the fittest. Although Gladstone's conclusions are sometimes discounted as obsolete or silly, his work is worth our attention here, partly because garbled versions of it continue to appear in popular culture, but more importantly, because he pioneered methods and gleaned insights into the nature of color language that are being used in current color linguistic research and philology, even if most modern scholars are unaware of his accomplishments (see Biggam 2012: 11–12; Sampson 2013).

The foundation of Gladstone's work was old-fashioned philology. He cataloged the referents of each color word in the *Iliad* and *Odyssey* and tried to work out their hue values. What he found confounded conventional English ideas (in his day and ours) about the usual or "natural" relation of language to color. He discovered that Homer used relatively few color words, and those that he did use frequently overlapped in their meanings. Words for white (*leukos*) and black (*melas*) strongly predominated but were used vaguely; other words that might be thought to denote hues appeared mostly to be focused on nuances of lightness or darkness, and the few words that actually referred to hues did so, to Gladstone's mind, indiscriminately. For example, the word *porphyreos*, often translated as "purple," is predicated of blood, a dark cloud, moving sea or river water, a ball used in a dance, garments, carpets, wool, and the rainbow. From these uses Gladstone inferred that, as a color word, *porphyreos* might denote red, purple, gray, or brown (Gladstone 1858: 461–2), but more probably just described things that are dark-hued. He found the same "vagueness" with nearly all other Homeric color words.

Gladstone compared Homer's color vocabulary to that of Modern English, and in particular to what he believed were the "natural," Newtonian, primary color terms (*red, orange, yellow, green, blue, indigo*, and *violet*), and concluded that Homer's odd usages could not be attributed simply to poetic license or to the poet's legendary blindness. Instead, he thought, the Greeks of the Homeric age were *unable* to distinguish hues as we do. But this was not because he thought the Greeks were "color blind" in the sense of our present-day usage of the term—that is, lacking certain physiological capacities for color sensation. About this possibility Gladstone said, "neither can we resort to the supposition of anything, that is to be properly called a defect in [Homer's] organization" (Gladstone 1858: 484), where "organization" for him means the development or coordination of the body in carrying out its functions (Sampson 2013: 10; *Oxford English Dictionary Online* 2019: s.v. 'organization'). Instead, he thought the "deficiency" was the result of cognitive, historical, and cultural factors affecting color cognition and perception.

Later research has shown that Gladstone was almost certainly wrong about the Homeric-age Greeks not being able to perceive subtle differences in hue (see further discussion below). But he was right about several things that modern research has confirmed and that are directly relevant to our modern understanding of ancient color language. First, he understood that color terms reflect cognitive color categories, and that the Greeks' color language was vague and confusing because their color concepts were different from ours. He wrote that they lacked "an ordered system of colors," and that Greek color terms "appear to exhibit a degree of indefiniteness, hardly reconcilable with the supposition that Homer possessed accurate *ideas of colour*" (Gladstone 1858: 465; my emphasis), and concluded that, "we must then seek for the basis of

Homer's system [of color] in something outside our own" (487). We no longer accuse the ancients of having disordered or deficient color categories, or say that if a culture's color ideas are different from ours that they are not "accurate," but it is true that Homer's color concepts are not ours, and this accounts for much of the difficulty that persists in understanding and translating his color terms.

Second, Gladstone grasped that color cognition and color language undergo historical development, an idea proposed by Hugo Magnus (1877), though we might object to Gladstone's phrasing. He said, "Painters know that there is an education of the eye for colour in the individual. The proposition, which I desire to suggest, is that this education subsists also for the race" (Gladstone 1877: 367). In this context, "race" meant for Gladstone any society or culture, not a biologically defined group (Sampson 2013: 10). Gladstone's use of the word *eye* here does not refer simply to the physical organ but to cognitive activities, which he describes in "The Color-Sense" as "the distinction between the elementary activity of one organ, and its higher exhibitions of function" (Gladstone 1877: 369). Of course, Gladstone is vague on precisely which "higher exhibitions of function" are involved, but the idea that a given language's color terms, along with the color categories that they name, undergo changes over time is one of the foundational ideas for the modern Universals and Evolution model (UE) of color terms (Kay et al. 2009: 1–12), whose consequences Katherine McDonald grapples with at length in her chapter in this volume. However, there is not a direct line of descent from Gladstone and Magnus's insight and the modern theory: Brent Berlin and Paul Kay, the originators of the UE hypothesis, admit they were unaware of Gladstone's work and that of other nineteenth-century color researchers responding to him, until *after* they had formed their own theory (Berlin and Kay 1969: 134–51).

Third, Gladstone observed that Greek color terms sometimes include in their denotation two or more color categories that we consider to be distinct. Of *chlōros*—often translated as "green" or "yellow" (see Irwin 1974: 31)—he says, it

> indicates rather the absence than the presence of definite colour [...]. If regarded as an epithet of colour, it involves at once an hopeless contradiction between the colour of honey on the one side, and greenness on the other. [...] Next to paleness, it serves chiefly for freshness, i.e. as opposed to what is stale or withered.
>
> (Gladstone 1858: 468)

The "contradiction" Gladstone found between *chlōros*'s yellow and green color references anticipates by almost a century another discovery of modern color research, namely, the existence of terms that denote "composite" color categories which include what English-speakers would consider to be more than one basic category (Kay et al. 2009: 6). For example, so-called "grue" terms

(which include both green and blue) are well established in the world's languages (Kay et al. 2009: 6). The yellow+green combination we find in Homer also turns up in a small number of the languages in the World Color Survey (see discussion in McDonald, this volume). More importantly, Gladstone's insight that *chlōros*'s denotation could include at once both hue and non-color qualities such as freshness anticipated Harold Conklin's (1955) similar observations about Hanunóo color categories, which were thought to be groundbreaking at the time (see also Biggam 2012: 6; Clarke 2004: 133–8).

Fourth, Gladstone saw that the Greek color lexicon was more strongly oriented to distinctions of lightness/brightness and darkness than it was toward hue: "Homer seems to have had [...] principally, a system in lieu of colour, founded upon light and upon darkness" (1858: 488); "the Homeric colours are really the modes and forms of light [...] and [...] darkness" (489; see also Sampson 2013: 4). Modern linguists agree; as the semanticist John Lyons has put it, for the Greeks, "luminosity was more salient than chromaticity" (1999: 65). Additionally, Gladstone noticed that Homer's Greek has few words that refer to what we would call "abstract" color, and that most color words got their color meaning by direct reference to colored materials. "[Homer's] words describing [colors] are figurative words, borrowed from natural objects [...] the more common use in Homer by far is to speak of rose-colour, wine-colour, fire-colour, bronze-colour and the like" (1877: 386; for a more recent treatment of the same problem, see Clarke 2004: 134–7).

Finally, Gladstone believed that the bond between language and thought was strong enough to affect the Greeks' *perceptions* of color distinctions. This view is in harmony with the "linguistic relativity principle" associated with twentieth-century anthropologists Edward Sapir and Benjamin Lee Whorf, although they were not the first to propose it, and Sapir at times distanced himself from it. Whorf described the principle this way:

> Users of markedly different grammars are pointed by the grammars toward different types of observations and different evaluations of externally similar acts of observation, and hence are not equivalent as observers but must arrive at a somewhat different view of the world.
>
> (Whorf 1956: 221)

If we substitute "color terms" for "grammars" in the above statement, the consequence would be that color terms strongly affect color observation. This view of language and perception was very influential in the twentieth century, and a Whorfian interpretation of Gladstone's color ideas still turns up with some frequency in the popular press, which has reported that, since Homer lacked a distinct term for what we call *blue*, the Ancient Greeks could not "see" blue, and that this is also true of modern cultures and languages that lack a blue term.[2] Experimental research on color language and color perception

has shown, however, that although color language does have minor effects on the speed of recognizing color distinctions, they affect primarily the right visual field and not the left (Regier and Kay 2009). This means that Greek (and Roman) color *perception* was not noticeably different from ours, even if their color-related *conceptions* were often very different from ours.[3]

It must be admitted that Gladstone saw all these features of Greek color language not as interesting characteristics of an ancient language but as *problems*. The Greek color lexicon's focus on brightness and darkness, its vague distinctions of hue, its dearth of abstract words, its frequent reliance on embodied colored materials, and the tendency of many of its words to communicate noncolor meanings—all appeared to be defects to a Victorian age that aspired to scientific precision in such matters. Many of these "defects" also turn up, to a lesser degree, in Latin (Bradley 2009a: 1–11, 189–206; 2013: 127–40) and are the cause of complaints by translators about carelessness or imprecision in the use of color language (see Edgeworth 1992: xiii). And yet it turns out that these "defects" of ancient color language were very well suited to the ancient Greeks' and Romans' needs.[4]

In the domain of religion, for example, the Greek and Latin color vocabulary's focus on luminance and brightness is often very convenient for expressing ancient ideas about the nature of the gods. When a Greek writer describes a goddess using the word *leukē*, or a Latin one with *candida*, these words communicate not just the white color but also shining and brilliance, an indispensable visual feature of divinities whose being is beyond human (see Platt, this volume). Materiality in color terms matters a great deal as well. For example, in the *Homeric Hymn to Demeter*, when the young goddess Persephone plucks a narcissus flower shortly before her abduction and forced marriage to Hades, the poet compares the flower to *krokos*, "saffron" (Homer 2003: *Hymn to Demeter*, line 428). The reference is not just to a yellow-orange color but to other material qualities of saffron, including texture, fragrance, and taste, as well as its connections to dyes made from the plant that were used for women's wedding clothing (see Platt's discussion, this volume; Grand-Clément 2011: 170–2, 390–2). It is the materiality of the color term that lets the poet symbolize Persephone's imminent change of status; an abstract term would drain the scene of its richness and ritual significance. And in the domain of religious cult, it was the use of colored materials such as ivory, gold, silver, bronze, glass, precious stones, gleaming marble, encaustic wax pigments, and richly dyed and patterned textiles to decorate the divine images and temples that gave to the gods the pleasing *poikilia* (multifariousness) that announced the presence of the deities in their sanctuaries (Platt, this volume; Grand-Clément 2012; 2015).

The light/bright versus dark opposition is apparent and pervasive throughout Greek and Latin literature as well. Karen Bassi finds that such words and

concepts function thematically in Greek epic and tragedy, where light (*phōs* or *phaos*) "serves as a powerful indicator of the distinction between life (light) and death (darkness)" (Bassi and Wharton, this volume), and argues that the chromatic indefiniteness of *porphyreos* can participate in the color symbolism of life and death in ways that are foreign to us. In at least one context *porphyreos* functions as a "dark" term (even though its hue value is not completely absent), and is used as an omen of death when predicated of blood that has been shed. But neither its color value nor its symbolic potential is fixed: it "oscillates between [lack of] luminosity (darkness) and chromaticity (redness)" (Bassi and Wharton, this volume) depending upon the needs of the context, and this is true of light and dark terms as well.

Porphyreos' Latin counterpart *purpureus* (similar in meaning, though not equivalent) is similarly vague in its color reference and equally complex in its literary implications. For example, in a passage of Vergil's *Aeneid,* where it describes the hero Aeneas' semi-divine appearance, I argue that it also connects him thematically with heroes of the *Iliad* and *Odyssey,* and that the color links him with the blushing of his future bride Lavinia (Bradley 2004: 117; 2009a: 150–2) and with the death of his abandoned lover Dido. *Purpureus* turns up again in Roman tragedy as an omen of death in Seneca's *Thyestes,* but light and dark are the stronger color themes that suffuse that tragedy, and I claim that Seneca adds a moral dimension to the light/dark contrast, where absence of light intimates not just death but moral degeneracy (Bassi and Wharton, this volume).

COLOR AND THE PHILOSOPHERS

Few modern researchers seeking to understand the nature and causes of color would turn to the ancient philosophers for such an account, because we know that the ancients lacked knowledge about matters that we consider fundamental for color science such as the nature of light, the physiology of the eye and the optic nerve, and so on. But the surviving ancient accounts were nevertheless serious attempts to explain color and color perception in terms of natural causes, and to ground these phenomena in coherent systems of physics and biology, just as modern color scientists do.

We can get a flavor of the ways that ancient philosophers approached the subject from the *De Coloribus* ("On Colours," Aristotle 1936), which comes to us as a part of the Aristotelian corpus. It certainly was not written by Aristotle, but it shows close connections to the Aristotelian tradition and may have been written by his pupil Theophrastus (Gottschalk 1964). It bears the marks of Aristotelian inquiry in its emphasis on empirical observations through which the author seeks the material causes of color and color appearances. According to the *De Coloribus*, the "simple" colors belong only to the basic elements, which

in several ancient traditions were thought to be earth, water, air, and fire. Air, water, and earth, when unadulterated, are white (*leukos*), whereas fire—and the light from it—are yellow (*xanthos*). For this author, light (*phōs*) is itself a color (*chrōma*); light is the color of fire. Black (*melas*) accompanies basic elements when they are undergoing a change in their nature, but the appearance of black is also caused by a lack of light, such as we see in shadows or when objects reflect little or no light. Other, non-"simple" colors arise through mixtures of these basic constituents (Aristotle 1936: 791a–b). That is, all colors result from the interaction of light with other material elements and the material elements themselves may be "dyed" through interactions with one another. The apparent colors of things vary according to the density, rarefaction, or mixture of the materials in question, and according to the effects of light reflecting off or shining through these materials. Thus the color of dark red wine is produced when deep black is mixed with the light of the sun; gray is a mixture of black and white; and violet arises when the rays of the sun mix with a material medium that is somewhat dark, such as the sea at sunrise or sunset (Aristotle 1936: 792b).

It is notable that the author is aware that the mixing of different colors of light does not produce the same colors as mixing pigments, and also at some points he distinguishes hue from brightness, anticipating some foundational concepts of modern color science. And although the author locates the causes of colors in various material substances, he clearly has a concept of "color" as an abstract quality that can be predicated of very different kinds of material objects, as do all the ancient philosophers. For example, purple can be attributed to water (at certain times of the day), to fabric, or to grapes, and his concept of "green" as the fundamental color of living plants is nevertheless explained as a combination of a yellow and a black element (Aristotle 1936: 797a). Much of the short text attempts an account of variation and changes of color in plants and animals, focusing on the roles of light, heat, and moisture; that is, it is not a study primarily about color per se, but about why colors appear the way they do and change their appearance in natural objects.

The *De Coloribus* raises ontological and epistemological questions that still haunt philosophical inquiries into color. It asserts that the "simple" colors are fundamental qualities of the elements, independent of our perceptions of them, such that white belongs to earth, black to elements undergoing change, and so forth. Philosopher Barry Maund (2019) calls this approach "color primitivist realism" and versions of it are held by several modern philosophers (Hacker 1987; Campbell 1994; McGinn 1996; Watkins 2005; Gert 2006). But the *De Coloribus*' contention that the apparent color of objects is affected by the light that shines through them or that is reflected off them complicates matters; an object's apparent color then may be different from its elemental color, since the color of light that shines off objects is affected by the color of the objects, and it is this light that reaches our eyes. The author does not distinguish an

object's elemental color from its apparent color, raising (but not answering) the question of which is the "real" color.

Similar questions are raised by the ancient philosophers discussed in Katerina Ierodiakonou's chapter in this volume. Most of them covered here—Empedocles, Democritus, Plato, Aristotle, Epicurus, and the Stoics—were color realists of one kind or another, but not naively so, and each of them attempted an explanation of color that is situated within more comprehensive systems of physics, physiology, and psychology. Thus Empedocles attributes his two basic colors (white and black) to fire and water respectively, and explains all other colors as mixtures of these; the Stoics also root colors' origins in the basic elements. Plato finds the cause of color in the geometry of pyramidal fire particles whose varying dimensions and proportions account for his basic colors white, black, red, and "bright" (*lampros*). Aristotle identifies black and white as the fundamental colors that produce the other colors according to varying ratios of their presence in objects; he believes the cause of an object's color is the degree of transparency (*diaphanes*) possessed by objects of vision.

The atomists Democritus and Epicurus both teach that color perception is attributable to shapes, sizes, and arrangements of atoms in the fine skeins or effluences of atoms (*eidōla*) that all objects constantly throw off, but they do not agree on the ontological and epistemological status of color. Democritus is a subjectivist and an eliminativist in that he does not believe that color is a real quality of objects in the world but rather is entirely a creation of our minds, and in this he is in agreement with many modern scientists. Epicurus, however, even though he shares Democritus' physics, believes that the *eidōla* preserve something real about the objects from which they come, and that colors are real properties both of the objects and their *eidōla*. One common feature of all these theories—the idea that a few "basic" colors combine in various ways to produce the many colors that we perceive—turns up as well in modern accounts of color cognition, such as the Hering primaries of Black, White, Red, Yellow, Green, and Blue (Hering 1964), which are foundational for the UE model (Kay et al 2009: 1–12). That is, as is often the case, the ancient philosophers were able to identify fundamental problems and outline plausible and coherent solutions, even without the apparatus of modern science.

CHAPTER ONE

Philosophy and Science

KATERINA IERODIAKONOU

It is not surprising that when philosophers try to understand the world we live in they take great interest in colors.[1] One question they raise is whether colors are part of reality or whether they are just part of the way things appear to us. The issue presented itself in the seventeenth century as the question of whether colors are primary or secondary qualities. But long before the debate in early modern philosophy, ancient philosophers discussed, sometimes in considerable detail, the ontological status of colors as well as epistemological issues arising in connection with the perception of colors. That is to say, almost from the beginning, ancient philosophers were interested in explaining what it is that makes things colored, what makes them have the particular colors they have, and how we come to see colors.

Indeed, many different theories about the nature of colors and the mechanism of color vision were introduced in antiquity. In this chapter I will examine some of these theories, especially those that were put forward from the period of early Greek philosophy to Hellenistic times. I begin with Empedocles and Democritus, who set forth the main traditions that were adopted, modified, or rejected by subsequent generations; then I examine how Plato and Aristotle developed, in their distinctive ways, the Empedoclean tradition; and finally, I follow the paths of both traditions in the works of the Epicureans and the Stoics. Needless to say, the available textual evidence for reconstructing the ancient theories of color is quite diverse, for not all of the relevant writings of

The research for this chapter was funded by Riksbankens Jubileumsfond, Sweden, as part of the program *Representation and Reality*, hosted by the University of Gothenburg (http://representationandreality.gu.se).

ancient philosophers are nowadays extant and many of their views are recorded by other authors who are not always reliable. It is therefore reasonable that the majority of ancient sources have received, over the years, numerous and often conflicting interpretations.

THE EMPEDOCLEAN AND DEMOCRITEAN TRADITIONS

Empedocles was the first ancient philosopher to refer to color as a phenomenon whose explanation forms a crucial part of a proper understanding of the world of experience. His reason for discussing colors can be traced to his preoccupation with the physical question of the constitution of things, as well as with the question of how humans are biologically equipped to function and survive in this world. He pursued these questions against the background of Parmenides' claim that reality is not the way we perceive it to be—that things, for instance, are not colored and do not change color. Against Parmenides, Empedocles argued that things are actually colored, and he tried to explain how we are able to perceive them as colored.

In the few surviving fragments from his poem "On Nature," it becomes clear that Empedocles based his cosmological system on four uncreated and indestructible basic elements—earth, water, air, and fire—which are united and separated during different stages of the cosmic cycle by two personified motive forces, Love and Strife. It is precisely in terms of these forces that Empedocles tried to explain the processes by which the things surrounding us, both animate and inanimate, have been created and have acquired their present forms and colors, as the result of the combination of some or all of the four elements in different proportions:

> And if, concerning these things, your conviction is in any way wanting,
> as to how from the blending of water and earth and aither and sun,
> there came to be the forms and colors of [all the] mortals,
> which now exist, fitted together by Aphrodite.
> (Diels and Kranz 1951: Empedokles B71; Empedocles 2001: 115)[2]

Given that all things are generated from the combination of some or all of the four elements, Empedocles claimed that their colors, too, depend on the combination of the colors of their constituent elements. This combination should be understood not as a complete mixture but as a side-by-side juxtaposition of the colors of the elements, in accordance with a mathematical ratio. The Empedoclean fragment about the mathematical ratio that explains how bones are generated is particularly illuminating, for it also explains why bones have the color they have, that is, why they are white:

And pleasant earth in her well-built channels
received two parts of gleaming Nestis out of the eight
and four of Hephaistos; and they become white bones
fitted together with the divine glues of harmony.
 (Diels and Kranz 1951: Empedokles B96; Empedocles 2001: 119)

In other words, bones are generated from the combination of four parts of fire, personified by the god Hephaistos, two of water, personified by the goddess Nestis or Persephone, and two of earth. Since fire is white, it is the excess of fire that gives bones their white color.

This is Empedocles' account of how things acquire their color: the elements are colored and one of them may exceed the others in quantity, thus accounting for the resulting color. To be more precise, only two of the Empedoclean elements are intrinsically colored: fire by nature is white (*leukon*), and water by nature is black (*melan*). There is no reliable ancient source that claims that Empedocles suggested two further colors for the other two elements, namely air and earth. It may well be that, when Empedocles undertook to construct his cosmological theory, he was also interested in explaining light and darkness, which play such a crucial role in the way things present themselves to us. He thus associated the color white with the brightness of the element fire and the color black with the darkness of the element water. Besides, it seems to have been a preoccupation of the time to understand how light falls on things and how the contrast between light and darkness is produced (Ierodiakonou 2005a).

But if Empedocles postulated only the colors of fire and water, how did he explain the production of all other colors from the mixture of just white and black? According to Empedocles, all colors are produced by the juxtaposition of very small white particles of fire and black particles of water. Although the white and black particles are not themselves apparent due to their minute size, something acquires a certain color as a result of the proportion of its white and black particles. That is to say, in Empedocles' view, the colors white and black should be regarded as two extremes in a continuum, like hot and cold. There are things that in absolute terms can be said to be white and black, namely the elements of fire and water, and everything else is characterized by colors that are understood as shades of white and black. For instance, Empedocles is reported to have said that eyes with more water than fire are black, whereas eyes with less water than fire are gray-blue (*glaukon*: Diels and Kranz 1951: Empedokles A91). Still, how could Empedocles have thought that the mere juxtaposition of white and black particles generates something with a color other than white, black, or gray? Empedocles seems to have taken his inspiration from the case of the different colors of the sea: the color of the sea, being by nature black, gradually changes depending on how much it is illuminated by the sun, that is,

on how much it is penetrated by fire; for at the surface it looks light blue and sometimes even white, whereas in the depths it looks dark blue or black.

Empedocles' theory of vision also confirms the interpretation that his list of basic colors includes only the colors white and black. Empedocles claimed that, in perceiving the world, human beings primarily see colors, which are effluences emitted from the things we see and which are commensurate with the pores of our eyes (Diels and Kranz 1951: Empedokles A86). We see the color white because an overwhelming proportion of particles of fire are emitted from something white and are commensurate with the pores of fire in our eyes; we see the color black because an overwhelming proportion of particles of water are emitted from something black and are commensurate with the pores of water in our eyes. The way we see other colors very much depends on the proportion of particles of fire and water emitted from the things we see (Sedley 1992).

Hence, the elements of fire and water play a crucial role, both in the fact that things have the colors they have and in the way human beings perceive the colors of things. That is to say, Empedocles put forward a color theory according to which the basic colors white and black are intrinsic qualities of things. As for the other colors, they seem to have a phenomenal character, but they are still considered as real and objective. This implies, however, that Empedocles defended two views that sound counterintuitive to us; namely, that the other two elements, air and earth, are colorless, and that all colors are produced by the combination of just white and black. Counterintuitive though these views may be, there certainly is a rationale behind them. We need to remember that Empedocles lived in a culture strongly inclined to think in terms of opposites, and in this case the opposites are white and black, or bright and dark.

On the other hand, Democritus initiated a radically different tradition of color theory. He advocated an antirealist position, according to which the basic constituents of things are colorless, and the colors of things are not real but only, as he famously put it, "by convention" (nomō). In fact, there are plenty of ancient texts preserving the famous Democritean dictum, "by convention sweet and by convention bitter, by convention hot, by convention cold, by convention color; but in reality atoms and void" (Diels and Kranz 1951: Demokritos B9). In other words, Democritus claimed that only atoms and the void exist. He also claimed that atoms are characterized only by their shape and size and have no other properties; therefore, atoms have no colors, and things are colorless. Needless to say, many conflicting interpretations have been suggested concerning Democritus' views on colors. Some contemporary scholars have recognized in him the first philosopher to treat colors as secondary qualities (Taylor 1999: 175–9), while others have argued that his stance has no affinity to the seventeenth-century distinction between primary and secondary qualities (Pasnau 2007). But what, exactly, does it mean that colors are "by convention"?

In his treatise *On the Senses* (sections 63–4), Aristotle's associate Theophrastus reports that, in Democritus' view, all sensible properties of things, apart from their shape and size, are by convention in the sense that they do not have a nature of their own but are mere "affections" (*pathē*), that is, phenomena that affect our senses and differ from one perceiver to another, depending, for instance, on their different states and ages. At the same time, Theophrastus points out, Democritus also claimed that perceivers do respond to changes in the shape, size, position, and arrangement of the atoms composing the thing from which the sensation originates. In the case of colors, it is the shape, size, and configuration of the atoms at the surface of a thing that affect our vision in such a way that we see the four basic colors—white, black, red (*eryrthron*), and greenish-yellow (*chlōron*)—from the mixture of which all other colors are produced:

> White is what is smooth. For whatever is not rough or shadowy or difficult to penetrate, anything like that is bright. [...] White consists of shapes of those kinds and black of the opposite, rough, uneven, and dissimilar, for they cast shadows and their pores are not straight or easily penetrable. [...] Red consists of the same sort of hot, only bigger; for the bigger the combinations of similar atoms are, the redder the thing is. [...] Greenish-yellow consists of a mixture of solid and void, the color varying according to their position and arrangement.
>
> <div align="center">(Theophrastus, On the Senses: 73–5; Taylor 1999: 115–16)</div>

So, Theophrastus accuses Democritus of contradicting himself. On the one hand, Democritus treats colors as mere affections of the sense of vision and, on the other, he seems to reduce his four basic colors to the shape, size, position, and arrangement of the atoms:

> But in general the greatest contradiction, which pervades the whole theory, is his both making them states of perception and at the same time distinguishing them by their shapes, and saying that the same thing appears bitter to some, sweet to others, and different to yet others. For it is impossible for the shape to be a state, or for the same thing to be spherical to some and differently shaped to others (yet perhaps that is how it has to be, if it is sweet to some and bitter to others), or for the shapes to change according to our dispositions. It is simply the case that shape is intrinsic, but sweet and sensible qualities in general are relative and dependent on other things, as he says.
>
> <div align="center">(Theophrastus, On the Senses: 69; Taylor 1999: 114)</div>

Is it possible to save Democritus from this charge? According to him, although the character and configuration of the atoms play some role in the affection of our senses, they do not seem to be the sole, or even the primary, causal element in our perception of colors. Rather, Democritus understood colors as something

we ourselves ascribe to things, on the basis of a characteristic visual experience produced in us by their atomic surface structure, that is, on the basis of the way we conventionally consider them. And it is in this sense that he claimed that colors exist by convention. We have a convention to call objects, which under normal circumstances produce a certain kind of visual experience in us, "white," or "black," or whatever, depending on the kind of visual experience we have, but in reality the things themselves do not have color.

It is thus reasonable to regard Democritus as an antirealist and an eliminatist. He claimed that in reality things are not colored, and he deprived colors entirely of their ontological status. The fact that he discussed how we see colors and defined them as affections of our senses does not mean that colors really exist. In locating colors within our perceptual experience, Democritus did not view them as part of the objective world. He defended a subjectivist theory in the sense that it is human beings who project color experiences to reality, though these color experiences should not be treated as completely arbitrary, since they are said to have physical correlates, namely, atoms of a certain character and configuration. Still, Democritus was not a reductionist; he did not reduce colors to properties of atoms, or properties of groups of atoms, or facts about our visual perception. For if we take Democritus' antirealism seriously, it implies that in reality there are only atoms and void, and nothing else (Ganson 1999; Lee 2005: 181–216; Mourelatos 2005).

But there are, undeniably, experiences of colors, and if the world itself has in reality no color, Democritus owes us an explanation of how we could be so wrong. This is, I think, what Democritus aimed at when he presented his elaborate theory of vision. He is reported to have maintained that what we actually perceive are very fine effluences of atoms, the so-called *eidōla*, which are constantly emitted from the surface of things and affect our sense organs. The details of Democritus' theory have puzzled contemporary scholars, who have tried to resolve certain discrepancies in the ancient sources and present them as a unified theory (Baldes 1975; Burkert 1977; Rudolph 2011). There is at least no dispute about the fact that the *eidōla* involved in our visual perception are, according to Democritus, colorless. This is perfectly consistent with Democritus' view that both the atoms as well as the things of our ordinary experience are colorless, including the *eidōla* they emit.

Furthermore, Democritus' theory of the nature and perception of colors constitutes the principal motivation behind his list of basic colors and provides us with an adequate explanation as to why he added the colors red and greenish-yellow to the Empedoclean white and black. In fact, Democritus was probably the first ancient philosopher to introduce a list of four basic colors, given that Theophrastus (*On the Senses*: 79) criticizes him for not having justified the addition of the two further colors. Empedocles, as mentioned before,

considered as basic colors only the white of fire and the black of water, because it is on the basis of these that light and darkness can be adequately explained. For Democritus, on the other hand, since it is human beings who project their color experiences onto reality, it is the experience of human beings that should be taken into consideration in the postulation of basic colors. Thus, it is as if Democritus realized, maybe for the first time in ancient philosophy, that the colors white and black do not generate anything but gray, and it is necessary to add other colors to the list of basic colors in order to account for the production of the different hues we perceive.

Besides, by the time Democritus presented his color theory, both ancient painters and medical doctors, each group for its own reasons, had shown a particular interest in a list of four basic colors that included, in both cases, the colors white, black, red, and yellow. Ancient doctors postulated the four humors of the human body, namely phlegm, black bile, blood, and yellow bile, which were considered to be intrinsically characterized by these basic colors. And there is also enough evidence, both archeological and textual, that at a certain time in the classical period, it was fashionable among ancient painters to use just these four basic colors (Ierodiakonou 2005a). Therefore, it seems that, both for reasons in connection with his own account of the nature and perception of colors, as well as for reasons in connection with the cultural context of his time, Democritus proposed a list of four basic colors that extended Empedocles' list of the colors white and black.

DEVELOPMENTS IN THE EMPEDOCLEAN TRADITION

Plato followed Democritus in postulating a list of four basic colors but disagreed with him profoundly with regard to their ontological status. To understand Plato's conception of color and show its dependence on, but also its divergence from, the Empedoclean tradition, we need to study his systematic account of color and color vision in his dialogue *Timaeus* (Plato 2000: 67c4–68d7), starting with its definition of color: "Color is a flame which flows forth from bodies of all sorts, having its parts commensurate with the visual body so as to produce perception" (*Timaeus*, 67c6–7; with some changes in the translation). In fact, this definition corresponds to the definition of color that Plato himself attributed to Empedocles in another dialogue, the *Meno*, according to which colors are effluences that are emitted from the things we see and are commensurate with the pores of our eyes (Plato 1976: 76d4–5).

Nevertheless, there are crucial differences between Empedocles' and Plato's conceptions of color. Although, according to Empedocles, it is only from the things we see that effluences are emitted, Plato claimed that there is also a stream of fire emanating from our eyes, which coalesces with daylight in such a way as to form together a single homogeneous body that extends from our eyes

to the things we see (Plato 2000: 45b2–d3). It thus constitutes, as it were, an extension of our eyes, and helps us to actively focus on, and to be, as it were, in touch with, the things we see. Vision results, because the effluences from the things we see cause changes in this visual body, which are then transmitted to our eyes and from there to our soul. But this happens only when the effluences from the things we see are commensurate, not with the pores of our eyes, as in Empedocles' theory, but with the visual body extending from our eyes to the things we see.

A yet further difference between Empedocles' and Plato's accounts of color is that the two philosophers take a different view as to what makes up these effluences. Empedocles claimed that two of the four elements are involved in visual perception, namely, fire and water. But according to Plato, the effluences responsible for the colors of the things we see are all said to be fire particles, as are daylight and the visual stream emitted from our eyes. More specifically, he distinguished varieties of fire, which differ due to the sizes of the triangles that constitute them. In the *Timaeus*, Plato adopted the four Empedoclean elements but also claimed that these elements consist of particles in the shape of regular solids (Plato 2000: 55d6–57d6). All particles of fire are tetrahedra, that is, pyramids; all particles of air are octahedra; all particles of water icosahedra; and all particles of earth cubes. Hence, the fire particles that make up the visual body and the fire particles that are emitted from the things we see can be of different kinds, because the triangles that constitute their pyramids, and thus the pyramids themselves, are of a different size.

Indeed, colors depend, according to Plato, on the size of the fire particles emitted from the things we see (Brisson 1999; Ierodiakonou 2005b). Something is white when the fire particles it emits are smaller than those of the visual body; being smaller, they divide the visual body. Something is black when the fire particles it emits are larger than those of the visual body; being larger, they compress the visual body. But Plato's list of basic colors does not include, like Empedocles', only white and black; rather, he added two further basic colors, namely the bright (*lampron*) or brilliant (*stilbon*), and the red. Something is bright when the fire particles that it emits are much smaller than those emitted from something white. Accordingly, they have a more penetrating motion that makes them not only divide the fire particles of the visual body right up to our eyes but even force their way into the passages of our visual organs. The tears that come out from our eyes are then mixed together in different proportions with the fire particles emitted from the things we see, and this results in the dazzling effect due to which we see all kinds of colors. Something similar, though not the same, happens in the case of the color red. Something is red when the fire particles that it emits are bigger than those emitted from something bright, but smaller than those emitted from something white. Because of their size, they have a speed such as to reach the moisture of our eyes and blend with it, and it

is their blending with particles of water, through which they shine, that causes us to see the color red.

There are puzzling details in Plato's account of the colors bright and red. For instance, the inclusion of the bright among the basic colors immediately captures our attention, given that brightness denotes for us a certain quality of colors and not another hue. Still, it is reasonable to suggest that Plato added the colors bright and red to Empedocles' list of basic colors, because he realized, perhaps following Democritus, that white and black do not generate anything but gray. He thus added the color red to the list in order to account for the production of the different hues we perceive and added bright in order to account for the generation of the different shades of the different hues. Hence, Plato presented in the *Timaeus* a list of nine mixed colors that are produced, according to him, by blending the colors white, black, bright, and red; reddish-yellow (*xanthon*), for instance, is produced by blending white, bright, and red, while purple (*alourgon*) is generated by blending white, black, and red (Struycken 2003).

However, if Plato recognized the necessity for postulating four basic colors, just like Democritus, did he also agree with him concerning the ontological status of colors? Perhaps this is what we would think, reading the following passage from Plato's *Theaetetus*:

> According to this theory [that there is nothing which is, in itself, one thing], black or white or any other color will turn out to have come into being through the impact of the eye upon the appropriate motion; and what we naturally call a particular color is neither that which impinges nor that which is impinged upon, but something which has come into being between the two, and which is private to the individual percipient. Or would you be prepared to insist that every color appears to a dog, or to any other animal, the same as it appears to you?
>
> (Plato 1990: 153e5–154a4)

This passage suggests that colors are nothing but the private objects of the perceivers' experiences. It describes a doctrine according to which there are no stable things or perceivers, since they are all motions; when we say that we see something white, for instance, this should be understood as actually meaning that one motion, the perceiver, affects another motion, the thing we see, so as to generate two further motions, namely the sight of white and the color white. Hence, colors exist only as long as particular perceivers interact with particular things. But this doctrine is attributed by Plato to Protagoras and should not be taken to be Plato's own. Besides, later in the same dialogue, Plato considered sensible features as properties of things that are independent of any perceiver, even though they are accessed through their effects on the sense organs; this is the view which he further elaborated in the *Timaeus*.

Therefore, according to Plato, something has a certain color insofar as it emits fire particles of a certain kind, and it does so independently of whether it is perceived or not. What is true, though, is that we normally identify the color of a thing by the distinctive way we perceive it. Yet it is not the distinctive character of the visual experience that makes a color the color that it is, but rather that it is an effluence of a certain kind. Plato's colors are thus perfectly real and objective, just like Empedocles' colors. Nevertheless, a moment's reflection shows that Plato's conception of color is also, in certain respects, similar to Democritus'. Democritus claimed that atoms have no color and that things have no color either; what things have is a surface structure characterized by the shape, size, and configuration of their atoms, and this makes us perceive them as having the colors we attribute to them. For Plato, too, individual fire particles have no color, and things have no colored surface either; things emit fire particles, and this makes us perceive them as having certain colors. So, what is the difference between Plato and Democritus? Democritus understood color as something we ourselves ascribe to things on the basis of a characteristic visual experience produced in us by their atomic surface structure, and hence colors for him do not exist in reality. Plato, by contrast, in defining colors as effluences of a certain kind, considered them as something objectively real, as a property something has independently of any perceiver.

Aristotle was in full agreement with Plato in this regard but put forward a different account of the nature and perception of colors. In fact, there are two accounts of the nature of color in Aristotle's treatises: in his treatise *On the Soul* (*De anima*), Aristotle described color as what "is capable of setting in motion that which is actually transparent" (Aristotle 1831–70: 418a31–b1), while in his treatise *On Sense Perception* (*De sensu*), he characterized color as "the limit of the transparent in a determinately bounded body" (439b11–12). Evidently, there are differences between these two accounts; what they have in common, however, is that in both cases Aristotle referred to the notion of the "transparent" (*diaphanes*). So, in order to understand Aristotle's conception of color, the obvious question to start with is what precisely he means by this term. In the treatise *On the Soul*, we find the following definition:

> By transparent I mean that which is visible, not strictly speaking in its own right but due to the colour of something else. Of this sort are air, water, and many solids.
>
> (Aristotle 2016: 418b4–7)

On the other hand, in the treatise *On Sense Perception*, we find something different:

> But what we call transparent is not something peculiar to air, or water, or any other of the bodies usually called transparent, but is a common nature

and power, capable of no separate existence of its own, but residing in these, and subsisting likewise in all other bodies to a greater or lesser degree.

(Aristotle 1984: 1:439a21–5)

There is no inconsistency between these two accounts. According to Aristotle's commentator Alexander of Aphrodisias (1901: *In De sensu*, 45.11–16), Aristotle used the term *diaphanes* in a wide sense that applies to all things but also in a narrow sense that applies to the medium of vision, namely, air or water. In the first case, all things are transparent in the sense that all things admit light, that is, they all become visible by partaking of color. In the second case, those things are transparent that admit light to such a degree that they let the color of something else be seen through them; that is, they become visible by making the color of something else manifest through them. To put it briefly, transparency is understood in terms of the notion of visibility; the degree to which something becomes visible depends on the degree to which it is transparent, and vice versa. So, although it may sound to us counterintuitive to claim that the more transparent something is, the more visible it is, because we think that the more transparent a curtain is, for example, the less visible it is in itself, it makes perfect sense in the Aristotelian context. For the more transparent a curtain is, the more it has power to make the color of something else more manifest through it and in this sense it becomes more visible. It seems, therefore, that Aristotle stressed the role of transparency because he believed, first, that vision requires the transparent medium, and second, that light and color are of a similar nature, a nature responsible for making things visible (Ierodiakonou 2018).

Having thus established that things are colored due to the fact that they are transparent, we need to clarify the nature of the transparent and how exactly it determines the generation of the different colors. Aristotle claimed that all things are colored because they are transparent to a greater or lesser degree. In fact, there are several passages in Aristotle's works which suggest, for instance, that something is white because it is transparent to a great degree and black because it is not at all transparent. That is to say, the color black is regarded as the privation of the color white (Aristotle 1831–70: *On Sense Perception*, 439b14–18; 442a25–6). What about all the other colors? How is the degree to which something is transparent responsible for the particular color it has? Aristotle did not give a clear answer to this question, but in his treatise *On the Generation of Animals* (Aristotle 1831–70: 779b28–33) he explained the black or blue color of some animals' eyes on the basis of how much water they consist of; more water makes the eyes less transparent, and therefore black, less water makes them more transparent, and therefore blue. And there are more passages in the same treatise (735b33–7; 784b13–15; 786a12–21), which indicate that fire and air make something white, whereas water and earth make something

black. It thus seems reasonable to infer that, for Aristotle, the color of things depends on the proportion of the different elements they consist of, which directly determines their degree of transparency.

It is, again, Alexander of Aphrodisias (1901: *In De sensu*, 45.26–46.6) who explains the Aristotelian view about the production of the different colors on the basis of the degree of transparency. That is to say, something is white, or has a color adjacent to white, for instance yellow, when it has more fire and air than water and earth; something is black, or has a color adjacent to black, for instance blue, when it has more water and earth than fire and air. Although it seems to us absurd to claim that it is because of the presence of fire and air that something is transparent to a great degree, and therefore has a color adjacent to white, or that it is because of the presence of water and earth that something is transparent to a small degree, and therefore has a color adjacent to black, this makes sense in the context of the Aristotelian color theory. For the four elements should not be identified with the fire, air, water, and earth of our everyday experience and, most importantly, Aristotle's and Alexander's notion of transparency should not be considered as the same as our modern notion. Therefore, when Aristotle defended Empedocles' view that all colors are produced by the mixture of just white and black (Aristotle 1831–70: *On Sense Perception*, 439b18–440b25), what he had in mind was that colors depend on the proportion of elements in things, and thus on their degree of transparency. Indeed, he further elaborated his theory of the production of mixed colors by associating each particular color with a certain mathematical ratio; the more attractive colors are those that arise from simple ratios, while the less attractive do not (Sorabji 1972; Fine 1996).

It is important to note, however, that the Aristotelian doctrine concerning the production of colors does not imply that the elements themselves are colored. On the contrary, Aristotle distanced himself in this respect from Empedocles' theory and moved away from Plato's doctrine that colors are streams of fire particles. But, having postulated that the four elements are not themselves colored, Aristotle is left with the task of explaining the ontological basis of colors. This is, I think, what he aimed at when he introduced the notion of the transparent, which he regarded as "the common nature and power" that is inherent in all things to a greater or lesser degree. Most importantly, Aristotle thought of this power or disposition of things to affect perceivers as perfectly real and objective, for he stressed that colors depend not on the way we perceive them but on the degree of their transparency, which depends, in turn, on the proportion of the different elements composing them. In other words, Aristotle regarded colors as objective features of the world that cause us to perceive them rather than as properties of our own experiences. Hence, although Aristotle's color theory differed considerably from Empedocles' and Plato's, they all shared the realist thesis that colors are properties that things

actually have independently of any perceiver. Indeed, Aristotle made absolutely clear that color is the cause of vision, but it is no part of his account of the nature of color that it be visible. That is, he strongly believed that there is no vision without colors, although there can be colors that are not perceived (Broadie 1993; Everson 1997; Johansen 1997; Broackes 1999; Kalderon 2015; Caston 2018).

But how, according to Aristotle, do we perceive colors? This issue has drawn much attention in the Aristotelian scholarship, and two main interpretations have been suggested. One, the literalist interpretation, claims that, in Aristotle's view, something from the colored object actually moves and starts a material process affecting the transparent medium (Sorabji 1992, 2001). The other, the spiritualist interpretation, claims that the color only appears through the transparent medium, which thus becomes in a way colored without undergoing a real alteration (Burnyeat 1992, 1995). This is a highly controversial issue (Caston 2005; Lorenz 2007), and it is also interesting to study how the ancient commentators dealt with it; for instance, Alexander of Aphrodisias defended a spiritualist position and stressed that the transparency of the medium takes on color without being really affected (Sorabji 1991; Tuominen 2014). But even before late antiquity, it seems that Aristotle's color theory was modified significantly by his immediate successors, who did not explain colors by referring to the degree of transparency but by attributing them directly to the four elements themselves (Ganson 2004). What is more intriguing, though, is that in the Hellenistic period right after Aristotle, the debate between the Empedoclean and the Democritean traditions of color theory was rekindled and took a novel turn.

THE DEBATE BETWEEN THE
TWO TRADITIONS REKINDLED

It is in Epicurus, of course, that we find an adherent of Democritus' atomist doctrine. For Epicurus, too, posited atoms and the void as the most fundamental principles and agreed with Democritus that atoms are colorless. But did he also follow him in claiming that colors exist only by convention? Plutarch explicitly says that Epicurus deviated from Democritus on this subject, claiming that colors are real:

> So Democritus should be charged, not with drawing conclusions which agree with his principles, but with choosing principles from which those conclusions follow. For he ought not to have posited changeless primary substances, but having posited them he should have seen that all qualities disappear. But it is altogether shameless to see the absurdity and then deny it. So Epicurus is being altogether shameless when he says that he

posits the same principles, but does not say that color is by convention, and sweet and bitter and the other qualities.

(Plutarch, "Against Colotes", in *Moralia*: 1111A–B; Taylor 1999: 152–3)

Is Plutarch's criticism fair? To what extent did Epicurus actually revise Democritus' views and, if he actually did, what were the reasons that led him to do so? According to our textual evidence, Epicurus did not claim that only atoms and the void exist; he claimed that the objects of our everyday experience exist, too. In addition, the properties belonging to these objects, permanent or transient, also exist. They do not have the independent existence that objects have, but they do exist and are not mere constructions of our mind (Sextus Empiricus, *Against the Mathematicians*: 10.219–27; Long and Sedley 1987: LS 7C). Thus, when we say that an object has a particular color, Epicurus insisted that we say something about the object itself (Sedley 1988; Furley 1993; O'Keefe 1997; Castagnoli 2013; Ierodiakonou 2015).

But what is it exactly, according to Epicurus, that we actually perceive when we perceive an object having a particular color? In order to explain perception, Epicurus followed Democritus in claiming that very fine effluences of atom (the *eidōla*) are constantly emitted from the surface of objects and affect our sense organs. Note here that, under normal conditions, the *eidōla* preserve the character and configuration of the atoms as found at the surface of objects. So, when we say that we see the color of an object, Epicurus took this to mean that we must be referring to the character and configuration of the atoms transmitted by the *eidōla*. He also believed that, under normal conditions, these very fine delineations provide us with the desired information about the color of objects (Lucretius, *On the Nature of Things*: 2.730–833; Long and Sedley 1987: LS 12E). As a result, Epicurus believed, contrary to Democritus, that the *eidōla* are colored as much as the objects themselves.

The fact that sometimes people at different moments, or for that matter different people, perceive the same object as having different colors should not surprise us. This can be explained, in Epicurus' view, by the fact that, although the *eidōla* emitted from the surface of an object preserve the character and configuration of its atoms, the *eidōla* that actually affect a perceiver do not always preserve this character and configuration. Sometimes they change due to external factors; for instance, when the perceiver sees an object from a distance, the configuration of the atoms may have been affected by the journey over this distance. Sometimes they change due to the physical constitution of the perceiver's eyes; for instance, the perceiver may suffer from jaundice, or the perceiver's eyes may be of a kind that does not allow certain sizes of atoms to enter them.

So Epicurus claimed that colors exist and should be regarded as transient properties of objects due to the objects' particular dispositions to produce

appearances in virtue of their atomic surface structure and the conditions under which they are perceived. Something is red, for instance, if it emits effluences of such a nature that it appears red to a perceiver under normal conditions. Of course, if it is dark or the perceiver is ill, the object may not appear red, but it is red nonetheless, for it still has the disposition to produce such an appearance under normal conditions. In other words, the Epicurean theory ascribes to colors the ontological status of real properties of objects, for the fact that colors are perceiver-dependent does not make them thereby mere constructions of our mind. At the same time, the fact that colors depend, as dispositions, on the character and configuration of the atoms at the surface of objects does not mean that Epicurus is a reductionist, for colors depend on the atomic surface structure of objects, but they are irreducibly different from it. In other words, Epicurus was not a slavish adherent of the Democritean color theory; on the contrary, he deviated considerably from Democritus' antirealist doctrine. In fact, he introduced such a radical modification in the atomist tradition because his ontology made space not only for atoms and void, but also for objects and all their sensible properties, permanent or transient.

The next obvious question to ask, then, concerns the motivation behind the significant disparity between the color theories of Democritus and Epicurus. According to Democritus, what we perceive is not what really exists, and this implies that we never come to know the things in themselves. He maintained that an object has a sensible property if and only if it appears so to a perceiver, and thus one appearance is no truer than another. Epicurus, on the other hand, was an empiricist, and it was crucially important for him to defend the veridicality of our appearances. He did not want to say, for example, that something is red just because it appears so to someone; rather, he insisted that the objects we perceive have the color we perceive them to have. Epicurus advocated a different color theory from the Democritean one, I believe, in order to solve epistemological problems from which, at least according to him, Democritus' version of atomism suffered.

Indeed, from Epicurus onwards, there seems to have been an important shift regarding the way philosophers dealt with the issues concerning colors. Although early Greek philosophers, as well as Plato and Aristotle, were mainly interested in grasping the physiology of perception as a biological function that gives us the ability to be aware of and distinguish things around us, Epicurus explicitly raised the epistemological question of whether the colors we perceive are those that actually characterize reality. And the subsequent controversies between the Stoics and the skeptics confirm that this was an issue that deeply concerned them as well.

Unfortunately, though, we know very little about the Stoic views on the nature and perception of colors. It is only in doxographic sources that we find an account of color attributed to the founder of Stoa, Zeno of Citium, who is

said to have defined colors as "the primary characteristics [*schēmatismoi*] of matter" (Aëtius: 1.15.6; Diels 1879: 313, 19–20). By defining colors in this way, Zeno most probably referred to the fact that matter as such does not have any quality or form, and it is colors that constitute the first characteristics matter receives, or are at least among its first characteristics. More precisely, matter, according to the Stoics, is unqualified and without form, whereas the four elements, fire, air, earth, and water, are endowed with form. In fact, the four elements are said to be primarily characterized not only by whether they are hot or cold, but also by their color; fire, for instance, is hot and bright, while air is cold and dark (Diogenes Laertius: 7.134; Long and Sedley 1987: LS 44B).

The Stoic doctrine that the four elements should be associated with certain colors belongs to the Empedoclean tradition, as does the doctrine that the color of something depends on the mixture of its elements. The point on which the Stoics' originality lies is their claim that colors are corporeal, since they are qualities; all qualities are, according to them, corporeal. They are corporeal because incorporeals cannot affect anything, since it is only a body that can affect another body, and colors do affect our sense organs. Moreover, they are corporeal because incorporeals cannot be in anything, since being in something requires contact, and colors are in things. In particular, the Stoics claimed that colors are "breaths" (*pneumata*), which sustain the bodies and give them their particular characteristics. Therefore, colors, according to the Stoics, are intrinsic qualities of objects that are either essential, as in the case of the four elements, or accidental, as in the case of the ordinary objects we perceive. An object has the color it has because of the mixture of its constituent elements. As to the elements themselves, they have the colors they have in virtue of the breaths permeating them (Hahm 1978; Ierodiakonou 2015).

But what did the Stoics have to say about the way we perceive objects and their colors? Most of our sources suggest that, according to the Stoics, we see when the air between our eyes and an object is pricked by the *pneuma* emitted from the eyes, and is thus stretched into the shape of a cone with its base contiguous with the object. As soon as the cone of stretched air undergoes a change of state induced by the state of the object, for example the particular color it has, this state is communicated to the eyes, and the state of the eyes is registered by the rational part of the soul. Hence, vision was explained by the Stoics in parallel with touch; it involves a continuous substance between our eyes and the things we see, a visual body that is often compared with a walking stick:

> Seeing takes place when the light between the visual faculty and the object is stretched into the shape of a cone, as Chrysippus says in the second book of his *Physics* and Apollodorus, too. The air adjacent to the pupil forms the tip of the cone with its base next to the visual object. What is seen is reported by means of the stretched air, as by a walking-stick.
>
> (Diogenes Laertius: 7.157; Long and Sedley 1987: LS 53N)

There are, of course, problems in grasping this Stoic doctrine in all its details. But it is clear that, although the Stoics seem to have taken into consideration the central tenet of geometrical optics after Euclid, according to which multiple rays diverge from the eyes in a cone-shaped array, they followed closely Plato's theory of vision. For instance, the Stoic theory reminds us both of Plato's visual body, formed by the sunlight and the fire particles emitted from our eyes, as well as of his description of the changes occuring in it when we see something white or something black. That is to say, Plato had talked about the division and compression of the visual body, and similarly the Stoics claimed that something bright or white diffuses our sense of vision while something dark or black confuses it:

> Since fire is simultaneously hot and bright, the nature opposite to fire must be both cold and dark; for as dark is the opposite of bright, so is cold of hot, and as dark confuses sight, so cold has the same effect on touch. But heat diffuses the sense of the person touching, just as brightness does that of the person seeing. Therefore what is primarily dark in its nature is also primarily cold.
> (Plutarch, *On the Principle of Cold*: 948D–E; Long and Sedley 1987: LS 47T)

CONCLUSION

Although the story of the ancient theories of color does not end in Hellensitic times, I hope to have shown that their diversity is significant and intriguing. Most ancient philosophers, following the Empedoclean tradition, explained the colors of things on the basis of their constituent elements and put forward a realist position, by defending the view that the objects of our experience have the colors they have independently of whether or not there are sentient beings to perceive them. But there was also the atomist tradition, according to which colors are not real but constructions of our mind, or they are dispositions of objects that produce appearances in virtue of their atomic surface structure. My aim was not to single out the best of these theories. Rather, I wanted to make clear that the ancient philosophers' views on the nature of color and the mechanism of visual perception were not at all arbitrary; they clearly reflected their ontological and psychological theories, and they were perfectly consistent with them. Hence, before we quickly discard the ancient theories of color as hotchpotch, it is important to study them carefully and to try to uncover the assumptions underlying them. In this way, there is a better chance to get a firmer grasp of how the ancients thought about colors, even if their accounts do not exactly fit our modern categories.

Technology and Trade

HILARY BECKER

A certain Apollonios wanted a garment of a particular color in Roman Egypt in the second century CE. His sister, Aline, a dyer, encouraged him to send a sample of that color to her so that she could match it. Similarly, a painter in Roman Egypt had started to paint a portrait on a wooden panel.[1] The preliminary draft of this painting survives, where an outline of the portrait of a woman had been sketched. Written instructions specified what colors (for example, "purple" and "green necklace") should be painted in which areas on the panel. In both cases, before the textile or painting had been created, an artist was thinking about what color might be appropriate. Just what colors did Aline and the panel artist have to choose from in antiquity? And how were these colors (whether pigments or dyes) gathered or produced? What choices did artists, patrons, and everyday buyers have in terms of color and price?

The Greeks and Romans used a great number of pigments and dyes that gave color to textiles, faces (cosmetics), statues, walls, and the like. This chapter surveys the trade in ancient pigments and dyes, first looking at how they were produced (or mined) and then examining the evidence for how these colors were sold and priced. It will set dyes and pigments in parallel, moving from manufacture to product specialization and then to the market, where prices and color choices will be explored.

MATERIALS: DYES

It is first useful to define dyes in relation to pigments. Most pigments were naturally occurring minerals; however, a few, such as white lead and Egyptian

blue, were manufactured. The materials used as pigments do not overlap much with those used to make ancient dyes because most pigments would not stand up to multiple washings. Dyes are soluble in water and largely drawn from vegetable and mineral sources, and dyes can be made into pigments (known as *lakes*) if they are dyed onto a substrate such as clay.

Archaeological and textual sources show that there was a great variety of dyes produced from vegetable, animal, and mineral sources. A variety of yellow vegetable dyes existed, including weld or dyer's rocket (*Reseda luteola*), dyer's broom (*Genista tinctoria*), saffron (*Crocus sativus*), tanner's sumac (*Rhus coriaria*), the Mediterranean hackberry (*Celtis australis*), and the pomegranate (*Punica granatum*) (Juan-Tresserras 2000: 247; Cardon 2007: 168–77, 179–80, 302–7, 431–3, 481–4; Martelli 2014: 122–4). Blue could be obtained from dyer's woad (*Isatis tinctoria*) (Cardon 2007: 367–79). While indigo (*Indigofera tinctoria*) was rarely used as a pigment, evidence for its use as a dye by the Greeks and Romans has not been found; however, indigo may have been used as a dye by the ancient Egyptians (Pliny the Elder 1952: 35.27; Cardon 2007: 363; Borgard et al. 2014: 200). For vegetable reds and purples, lichen (*Roccella tinctoria*), madder (*Rubia tinctorium* or *Rubia peregrina*), safflower (*Carthamus tinctorius*), henna (*Lawsonia inermis*), or whortleberry (*Vaccinium myrtillus*) could be used (Cardon 2007: 54–9, 83–5, 107–23, 243–5, 495–503). Pliny mentions that the whortleberry was employed as a dye in Gaul to dye the clothes of slaves, while Vitruvius states that this material made an exquisite purple (*purpuram elegantem*) for painting when mixed with milk (Pliny the Elder 1968: 16.31; Vitruvius 1998: s. 7.14.2).

Dark colors could be produced using walnut shells (Pliny the Elder 1968: 15.87 and 16.9; Cardon 2007: 74–9). A scale insect, the *kermes vermilio*, produced a rich scarlet dye (Cardon 2007: 611–19). Perhaps the best-known ancient dye is the purple derived from various species of murex molluscs. Colors thus produced can range through shades of purple, but also include pink, blue, and reddish brown. Murex purple is attested as early as the late Bronze Age (in a Linear B text, on a fresco, on an amphora fragment, as a raw pigment, and in murex shells at Aegean sites), and it continued to be used as a premium pigment and dye until the fall of Constantinople (Karali and Megaloudi 2008: 183; Koren 2005; Sotiropoulou and Karapanagiotis 2006; Cardon 2007: 553–82).

MATERIALS: PIGMENTS

The majority of pigments used by the Greeks and Romans are naturally occurring minerals, including red ochre (hematite) and yellow ochre (goethite), green earth (the minerals glauconite or celadonite), cinnabar (*minium*, mercury sulfide), and different types of white (especially forms of calcium carbonate). Some other pigments, which were processed or manufactured include Egyptian

blue, red lead (*minium secondarium*), and white lead (*cerussa*). Dyes made from murex purple or madder could also be used to make pigments. Pigments such as malachite, azurite, indigo, lazurite (the pigment form of *lapis lazuli*), and a few others were used very rarely on Roman wall paintings that were produced using the true fresco method, where pigments were applied to wet lime, due to chemical incompatibilities (see Becker forthcoming-a: ch. 1).

Pliny the Elder is an important source for information on ancient pigments. His *Natural History* frequently lists different varieties of pigments, such as three different types of Sinopian red ochre, noting that it can come from many different places (for example, from Pontus, Egypt, Lemnos, Cappadoccia, and so forth (Pliny the Elder 1952: 35.13)). Pliny's list is not exhaustive, however. For example, both red and yellow ochre could be found in many different places in Italy but the only Italian ochre Pliny mentions is a yellow ochre that is found twenty miles from Rome (33.56).

MANUFACTURE: PIGMENTS

The pigments that were sourced from mines had to be cleaned of impurities. Pigments such as ochres, green earths, and calcium carbonates are among those that were likely purified, while the very rare lazurite had to be significantly processed to remove materials such as pyrite and calcite from the lapis lazuli stone. A good deal of production went into the processing of the premium red pigment cinnabar (mercury sulfide). One source of cinnabar in the Roman imperial period was the Almadén mines (at ancient Sisapo in Spain), which were owned and operated by the Roman state. Cinnabar mined there was shipped under seal to be purified only at the state workshop on the Quirinal Hill in Rome (Vitruvius 1998: 7.9.4). Workers in this workshop wore bladder masks to protect them from this toxic pigment.

Other pigments underwent chemical and physical transformations in the manufacturing process. For example, the earliest manufactured pigment was made by burning (calcining) yellow ochre, which turns it red (Pliny the Elder 1952: 35.15). It should be noted that, due to the high temperatures that occurred at Pompeii and Herculaneum during the volcanic eruption of 79 CE, some frescoes painted with yellow ochre had their color naturally transformed by this heat into red ochre (Nicola et al. 2016: 560). Recent investigations at Pompeii and Herculaneum have found that differences in the chemical composition or the crystalline structure of the ochre can help scientists to differentiate between red ochre that was originally red, and yellow ochre that was scorched red by the heat of the eruption (Marcaida et al. 2017; Rainer et al. 2017: 199–202). While this was a process that occurred in nature, the Greeks and Romans created calcine yellow ochres to expand their color choices.

Pliny the Elder classifies the black pigments with which he was familiar as artificial colors. Lamp black is made from setting materials such as oil, resin, pitch, or even coal on fire and collecting the soot (Eastaugh et al. 2008: 90–1). Other black pigments also involve roasting or burning materials to obtain the color, using, for example, wine-lees (wine black), or bone or ivory (bone black). There were natural blacks as well, such as a brine found in sulfur pits (Pliny the Elder 1952: 35.25). In addition, Romans could occasionally use the minerals found in their own areas; in the realm of black pigments, these could include pyrolusite (manganese oxide) or magnetite (Kakoulli 1997: 136, 139; Nicola et al. 2016: 560).

An example of a manufactured pigment from antiquity is white lead (*psimythion* in Greek or *cerussa* in Latin). Theophrastus explains that it is produced by placing lead in a closed jar, where it is exposed to vinegar fumes for ten days (Theophrastus 1956: 56–7; Katsaros and Bassiakos 2002). The substance scraped off the lead is decanted and becomes white lead. A burial from the fourth century BCE in the Kerameikos district of Athens contained about a dozen lead pellets inside a vessel (Katsaros et al. 2010: 71). Actors used this pigment to paint their faces (or bodies) white.

An important manufactured pigment in the Roman era was Egyptian blue, which was first developed during the third millennium BCE. This pigment was used in the Minoan and Mycenaean periods, and later in classical Greece and Rome. The manufacture of Egyptian blue was brought to Italy in the mid-first century BCE when the Roman entrepreneur Vestorius used the Egyptian recipe to manufacture the pigment in Puteoli, Italy. Vitruvius described the method of manufacturing this blue:

> Sand is ground with flower of natron so finely that it becomes almost like flour. Copper, broken by coarse files until it is like sawdust, is sprinkled with this sand until it clings together. Then it is formed into balls by rolling it between the hands and bound together to dry. Once dry, the balls are put into a ceramic pitcher, and the pitchers are put into a kiln. In this way the copper and the sand, boiling with the energy of the fire, bond together, and exchanging their sweat between them they leave off their original properties; with their natures merged they produce a blue color.
>
> (Vitruvius 1998: 7.11.1; translation by H. Becker)

While Vitruvius' instructions are not specific, the copper used to make Egyptian blue can come from copper, bronze, malachite, or azurite, and the sand needed for its production required silica and lime. Conveniently, Vestorius' workshop in Puteoli was near to the River Volturnus, which has a quartz-rich sand (Kakoulli 2009: 83; Lazzarini and Verità 2015: 579). Importantly, changing the source of the copper or sand changes the color, composition, and microstructure of the final product (Kakoulli 2009: 85).

Several workshops for the production of blue have been located in the Bay of Naples region containing remains such as fragments of ceramic crucibles that are incrusted with a glassy blue residue from production (Lazzarini and Verità 2015). Although Egyptian blue was the most widely used blue pigment in the Roman Empire, the technology for its manufacture was nearly forgotten after the early fourth century CE, but it continued to be used sporadically in different places in the medieval period and beyond, indicating that the ancient recipe was still circulating (Lazzarini 1982; Gaetani et al. 2004). Thus, the technological expertise behind this ancient blue somehow had a long, if episodic, survival as an occasional alternative to lazurite and azurite.

MANUFACTURE: DYES

A variety of tradesmen worked with dyes, and archaeological evidence allows us to reconstruct many stages of their work as well as their interaction with customers, although consumers certainly could have dyed the wool themselves or purchased dyed wool to weave at home (Burnham and Wacher 1990: 48). Roman dyers were known as *tinctores* and *infectores*, while *offectores* brought new color to old garments, as they re-dyed clothes and textiles (Festus 1913: 99; Moeller 1976: 14; Kolendo 1986: 38; Larsson Lovén 1998: 74; Borgard and Puybaret 2004: 52). And if someone needed color lightened on a finished textile, yet another category of artisan would have been involved, as fullers (*fullones*) could whiten or brighten clothing (Flohr 2013b: 59–62; see also Llewellyn-Jones, this volume).

Wool was usually dyed before it was carded, combed, or woven, as it absorbs dye more readily at that stage (Moeller 1976: 13; Radman-Livaja 2013a: 98). There were also dye workshops that have archaeologically distinct and recognizable features. At Pompeii, seven dye shops have been identified, of which six have been excavated (Flohr 2007: 132n27; 2013a: 60–1). These dye shops can be recognized because they have small furnaces that heat large lead cauldrons built in above them. The cauldrons would have been used to soak the wool with mordants (materials such as alum, urine, or potash) to help make the fiber more dye-ready (Wilson 2004: 156). Once the wool was ready to be dyed, it would have been dipped in warm dye heated in smaller basins. In a funerary relief from Roman Gaul, dyers stir the dye and wool with sticks (Espérandieu 1913: no. 4125; Moeller 1976).

Phillippe Borgard believes that shops used for the initial dyeing of carded wool (*officinae infectoriae*) may have been distinct in their size and equipment from shops in which used textiles were re-dyed (*officina offectoriae*), although it should be noted that the names for these workshops are not attested in antiquity (Moeller 1976: 14; Brun et al. 2002: 478; Borgard et al. 2003: 19; Borgard and Puybaret 2004: 52–7; Wilson 2004: 156; Flohr 2013a: 61). Those workshops

used by the *infectores* appear to have a clearer hierarchy in terms of their equipment for both stages of production. The workshops of the *offectores* are not as well organized and have smaller cauldrons. There is epigraphic support for Borgard's reading of these shops, for the excavation of a shop at Pompeii with equipment that he associates with *infectores* yielded an electoral inscription mentioning them, while, similarly, a shop with equipment associated with *offectores* also bore an appropriate electoral inscription (Building IX.7.2 has CIL 4.7812; Building X.3.2 has CIL 4.864). Both types of shops varied in their scale, but in general such workshops tended to have three to nine cauldrons (Flohr 2013a: 62).

Archaeologists have conducted experiments at the dye workshop at Building V.1.4 at Pompeii, where they used knotweed (*Persicaria tinctoria*) to make a blue dye, employing one of the ancient cauldrons, which they restored with a modern lead tank (Borgard et al. 2014). They used a process much like that which the Romans would have used, heating the dye at a low temperature so that it could be fermented. This reconstruction allowed researchers to understand how long it would take to make such a fermented dye (monitoring it carefully for the level of alkali), how to maintain a constant heat, and how this process would have produced a noxious smell.

Pliny the Elder's instructions for dyeing purple were carried out by Zvi Koren, who used an all-natural dyeing process to make murex, or royal, purple (Pliny the Elder 1983: 9.61–2; Koren 2005). Several variables influence the shade of color derived, including the temperature and the choice of snails, but *hexaplex trunculus* snails are always present (Koren 2013). Other variables that could impact color include the mordant used and whether a garment is dyed early in the dye process (when the dye is most colorful) (Marzano 2013: 147; Meiers 2013: 51–3, plate 9). Pliny the Elder also stated that color could be impacted by where the dye was made and the season (Pliny the Elder 1952: 9.62). Another variable is how many snails are used, so that the more snails are added, the more brilliant the color produced. However, Koren observed that three snails were enough to color one gram of wool a light purple. When discussing making a purple pigment from the murex purple dye, Pliny states that silversmith's chalk (*creta argentaria*) dyed with the woollen cloth at the beginning of the purple dye batch will have a deeper color than that added toward the end, when the dye has become more dilute. It makes sense that dyed textiles would similarly be able to acquire a darker color at first and a more dilute color toward the end of the batch. In addition, experimental archaeology has confirmed Pliny's description that the first wool dyed would have a more brilliant color than the last wool that was dyed in the same solution (Pliny the Elder 1952: 35.26). To dye one kilogram of wool a deep purple, 10,000 murex snails would be needed, which has implications for the price of this dye (Koren 2005: 146; Cardon 2007: 559–62).

Thus epigraphy, archaeology, and experimental archaeology provide information about the Roman dye industry. An additional layer can be added that gives insight into how a dye workshop might keep track of different dye requests. Lead tags, which can be found in towns of the first two centuries CE in the western provinces of the Roman Empire, provide insight into work inside the textile dyeing industry. Approximately 1,200 lead tags have survived, for example, from the town of Siscia (in the Roman province of Pannonia), most of which served to facilitate textile transactions (Radman-Livaja 2018). Some tags labeled the price of a finished product, but these tags were also used if an individual wanted a garment cleaned, fulled, dyed, or re-dyed, as the customer's name would often be inscribed on the tag, along with the name of the color, the garment, and the cost of the service. Such tags would have been useful for the workers but also served like a modern dry-cleaning tag, so that customers could track down their garments once they were ready. The colors *purpura* (purple) and *morinum* (dark mulberry) were found on several tags from Noricum (Gostenčnik 2013: 76). *Louteus* (Vulgar Latin for *luteus* "saffron-colored") and the verb *coc[ili]are* or possibly *coc[cin]are* (verb forms that are otherwise unattested), probably signifying to dye something scarlet or purple, were also found on tags from this area. Tags from Feltre (Italy) present a range of other colors such as *caeru[leus]* (blue), *[h]aema[tinus]* (blood red), and *topas[us]* or *topasi[us]*, an otherwise unattested color term probably denotes blue-green after the gem that Pliny the Elder and later Christian authors refer to as *topazion*, *topazum*, or *topazium* (Buchi and Buonopane 2005: 44; Radman-Livaja 2013a: 93–4).

Aline from Roman Egypt, mentioned at the beginning of this chapter, asked her brother to specify the color he wanted for a garment. In a passage from Macrobius, even the Emperor Augustus is critical of a shade of a purple textile presented by a merchant (Macrobius 2011: 2.4.14).[2] The color, it seemed, was too dull for Augustus, as he preferred a brighter shade of purple, which would speak to his being well dressed (*cultum*). Like Aline's brother's request, the incident with Augustus shows that consumers hoped to have a choice as to the shade they bought. Similarly, these tags, with the name of the clients, provide evidence for bespoke textiles, dyed to order (Radman-Livaja 2013a: 96–8).

Two valuable sources for understanding how artisans had control over the colors around them can be found in the Stockholm and Leyden Papyri (late third to early fourth century CE) (Caley 1926, 1927). These documents from Roman Egypt are instructional manuals with 265 recipes, which tell their users how to purify metals, how to make fake gem stones, and how to make various colors of dyes.[3] For all such recipes, one envisions an ancient artisan mixing various substances in order to get the desired consistency and color. These instructions make clear that a range of varied ingredients would be needed in order to manufacture materials of varied colors. To fake an emerald, for

example, one method is to mix copper, verdigris, and honey (Caley 1927: 985, no. 34). Seventy-nine recipes give tips for the varied steps of dyeing textiles (including mordanting) and using different materials in order to produce the desired color. For example, one recipe describes a base dyeing solution using bruised henna (? *krimnos*), water, and alum mixed together to make a scarlet dye, but sulfur and water could be added to make it leek green, or natron and water to make it quince yellow (Halleux 1981: *P. Holm.* 89; Martelli 2014: 123; 125–6).

PRODUCT SPECIALIZATION: MATERIALS AND PRODUCTION

Pigments and dyes were drawn from all over the Roman Empire (and beyond), but some of the most basic varieties could be found locally. Madder could be found in many places in the Roman Empire, but the most praised (*laudatissima*) was found in Italy, and the best of all was found in the suburbs surrounding Rome (Pliny the Elder 1950: 19.17; Dioscorides 2005: 3.143.1; Moeller 1976: 76). Thus, a color such as this would have little need to travel very far. Saffron was cultivated in southern Italy, Sicily, Cilicia, Crete, Gallia Narbonensis (in southeastern France), and Greece (Benda-Weber 2014: 131). The best saffron within the Roman Empire came from Cilicia, in southeastern Turkey, but saffron was also imported from Arabia (Pliny the Elder 1969: 21.17; Strabo 1866–77: 14.5.5; Dioscorides 2005: 1.26; Huntingford 1980: s. 24). The varied local specialties were often tied to flourishing textile markets that specialized in particular types of dyes, such as Hierapolis in southwestern Turkey, which had a reputation for its madder-dyed clothing that rivaled the color made from the kermes insect or murex purple (Strabo 1866–77: 13.14; Benda-Weber 2013: 180).

Among the purple dyes and pigments, as mentioned, different locations were associated with the color's production and use, each with perceived differences in quality and color. Pliny reports that the best purple dye for making a purple pigment came from Puteoli (Pozzuoli, Italy) while the worst came from Canosa (Apulia, Italy) (Pliny the Elder 1952: 35.26; see Becker forthcoming-b). Such location-specific specialization is also apparent in Diocletian's *Edict* on prices, which mentions twice-dyed true wool from Miletos (Diocletian 2016: 24.6–7; Benda-Weber 2013: 175; see Table 2.1). Of course, we know of many more purple workshops beyond these, thanks to archaeological evidence and inscriptions, but these examples are sufficient to show the different supply options (Kalaitzaki et al. 2017).

Just as with dyes, specific regions and places specialized in particular pigments. Even though red ochre was widely available in Italy, Pliny detailed a variety of red ochres from varied areas that had different shades, properties,

and prices (for example, African ochre retailed for eight *asses*; Pliny the Elder 1952: 35.13). Scientific analyses, using techniques such as X-ray fluorescence and Fourier-transform infrared spectroscopy, can sometimes enable us to trace the chemical fingerprint of a pigment on a painted object back to its original mine. Such work is vital for understanding the trade and economy of these materials. For example, the analysis of cinnabar from Herod's Palace at Jericho revealed that that pigment was sourced from the Tarna mines in north central Spain (Edwards et al. 1999: 536).

COMMERCE: THE MARKET

Dyed garments reached their next stage when they went to market, where they would be sold by *vestiarii*, the clothing merchants (Flohr 2013a). Two clothing merchants appear to be visible in a painted depiction of the economic life of the Forum of Pompeii, painted on the *praedia* (estate house) of Julia Felix (Building II.2,2l; Flohr 2013a: 67, fig. 9). On this fresco, two men, who are either *vestiarii* standing outside their shop or itinerant salesmen, display two different colored textiles that two customers are appraising. Purple sellers, the *purpurarii*, were specialists who dyed and sold purple-dyed clothing (Hughes 2007; but see Marzano 2013: 156).[4] The tombstone of one purple seller, Gaius Pupius Amicus, is decorated with small flasks that probably held the purple-dye stuff (Larsson Lovén 1998: 75). No other specialized dyers, beyond purple sellers, are securely attested.

The Latin term for pigment shops has not survived, but pigment sellers were known as *pigmentarii*. A large quantity of pigments were found in a shop located in the Area Sacra di S. Omobono, perched atop the podium of the twin temples of Fortuna and Mater Matuta, and dating from the third to the early fourth centuries CE (Beeston and Becker 2013). This area is most likely the only surviving pigment shop in ancient Rome, but it is also possible that this space was used as a workshop. Identification of this space is complicated because no furniture survived here. Evidence from the surrounding commercial space at S. Omobono reveals that there was a metal workshop nearby. Shards of pottery were found among the pigments at S. Omobono. However, evidence from shops, workshops, and painting sites at Pompeii reveal that pigments could be stored in a variety of vessels, often in small open containers. In Pliny's account, pigments are sold by weight, so the Roman shop likely had scales. Whether the shop at S. Omobono also sold brushes, lime, or other materials that painters might have needed can only be hypothesized.

The pigments found at S. Omobono offer an opportunity to see the range of pigment colors available to artists. This shop had a wide variety of ochres ranging in hue from maroon to red, orange, and yellow; it also offered green earth, calcium carbonate, a pink pigment, and a variety of Egyptian blues, some

still in the small manufactured balls just as Vitruvius described, whereas others had been ground up and incorporated with calcium carbonate, likely Pliny's *lomentum*. It is not yet clear, however, precisely which ochres were present at the shop at S. Omobono. Was there an African ochre or a Sinopian ochre? Knowing exactly what types of ochres were for sale would help us understand the distance that these wares traveled to be sold in this shop. As stated before, it is possible that further scientific studies of pigments sampled at mines might help to clarify their provenance. But what can be said is that a range of different ochres were for sale in one place, and that patrons and artists had choice (at least in urban contexts). In addition, Roman artists regularly mixed pigments, expanding their color range, and also frequently used an undercoat in one color (black, red, yellow) over which another color could be painted.

PRICES

Pliny's *Natural History*, papyri, epigraphic sources recording daily life and commerce, and the *Edict* on prices of Diocletian (301 CE) all provide insight into the prices of the range of pigments and dyes in the Roman imperial period, from the most expensive colors to their cheaper alternatives. For many Romans, the cost of color in textiles would be included in the price of the garment. The most thorough survey of prices for dyed garments is found in the *Edict* of Diocletian (Diocletian 2016). In several examples, the base product is a pound of wool, and the dye used to color the garment determines the cost, such that wool dyed with murex purple dye has varied prices, all of which are substantially higher than the dyes made from kermes or lichen (see Table 2.1). Rejuvenating the colors on used textiles had costs, too. A lead tag from Štrbinci, Croatia (the Roman province of Pannonia Inferior), gives the fee for dyeing a hooded cloak with ochre (*si*[*licea*]) as two denarii and two asses (Radman-Livaja 2013b: 166–9). Thus, such tags make it possible to see the market price of adding color.

Similar choice and variety appear in other sources as well. Two price lists from Oxyrhynchus, Egypt, specify colors of different qualities: a scarlet of the first grade and another of the second grade.[5] Interestingly, in a papyrus list (Coles 1987: *P.Oxy.* LIV 3765, lines 19–20), first-grade scarlet costs eight talents per pound, while the same weight of the second variety costs only two (*c.* 326 CE; Martelli 2014: 124). But on another price list (Coles 1980: *P. Harr.* 73, lines 41–2), a pound of first-grade scarlet sold for ten talents, while the second grade at the same weight was five talents (*c.* 329–31 CE; Coles 1980). These papyri are dated only a few years apart, showing us not only the range of quality choices available and their relative price differences, but also that prices for similar products could vary significantly even over short periods of time.[6]

As stated previously, the great number of shellfish needed to produce murex dye contributed to its high cost. In the first century BCE, Publius Lentulus Spinther

was met with censure for spending at least 1,000 denarii for the double-dipped purple on his *toga praetexta* (Pliny the Elder 1983: 9.63; Sebesta 1994: 69). Apparently, Pliny disapproved of such expense, as he complained that in his own day such double-dyed purple was very common.

It is possible that insect dyes were also valued highly, as a cheaper alternative to purple, since so many insects were needed to make these dyes, too (Cardon 2007: 551, 609–19). We do not know the price of kermes dye from Pliny the Elder, but later, in the *Edict* of Diocletian, its price is relatively high, especially in comparison with a vegetable-based dye (see Table 2.1).

In addition, kermes dye was collected as a tax in Spain and was reserved for the *paludamenta* or cloaks of generals—all factors that seem to show it was highly valued (Pliny the Elder 1968: 16.12; 1969: 22.3). Pliny did not state a price for madder dye, but he did note that its producers made a good profit from it (Pliny the Elder 1950: 19.17). Henna was five denarii per pound (Pliny the Elder 1968: 12.51).

Both Pliny the Elder and Diocletian's *Edict* on prices provide prices of pigments in Roman times. From these, it is clear that some pigments, such as cinnabar, true murex purple, and Egyptian blue, could be expensive. Other pigments, such as the ochres, were more moderately priced, due to the fact these minerals were widely abundant in nature. Even so, prices for some pigments vary. The later *Edict* of Diocletian records two grades of cinnabar and of Egyptian blue (or here, "Vestorian blue") (see Table 2.2).

Pliny's text reveals price gradients for pigments in the first century CE as well (see Becker forthcoming-b). The reasons for the price variation can vary but include pigment provenance, physical characteristics (such as coverage or tone), and particle size. For example, the best red ochre retailed for two denarii a pound in Pliny's day and could be collected in many locations.[7] For a quarter of the price, one could purchase a chickpea-colored ochre from Africa. To get

Table 2.1 The Prices of Wools Dyed with Purple in the *Edict* of Diocletian.

Dyed Materials	Price per pound (denarii)
24.4. Wool dyed with Tyrian purple (*oxytyriae*)	16,000
24.6. Wool dyed twice with the best Milesian purple	12,000
24.8. Wool dyed with (?) Kermes from Nicaea (?)	1,500
24.9–12. Wool dyed with four different qualities of lichen purple	600, 500, 400, or 300

Source: Diocletian 1974: s. 24; 2016.

Table 2.2 Prices of Pigments in the *Edict* of Diocletian.

Pigment	Price per pound (denarii)
34.73. Indigo (?)	750
34.74. Cinnabar, first grade	500
34.75. Cinnabar, second grade	300
34.78. *Sandyx* (mixed white lead and red ochre)	40
34.83. Egyptian blue (called "Vestorian"), first class	150
34.84. Egyptian blue (called "Vestorian"), second class	80
34.107. Ochre	100

Source: Crawford and Reynolds 1979: s. 34.

an idea of the real cost to buyers, consider that a loaf of bread could sell for one to two asses in the first and second centuries CE (sixteen asses = one denarius) (CIL 4.5380 (Pompeii); CIL 9.2689 (Asernia, second century CE)).

When Egyptian blue appears on frescoes, its use expresses wealth, because it was one of the more expensive pigments available. This is likely due to its production costs and more especially to its copper content. Egyptian blue could be purchased for eight, ten, or eleven denarii per pound. A low-grade Egyptian blue, known as *tritum*, that was ground up and very diffuse in color (Pliny the Elder 1952: 33.57), retailed for only five asses. One of the most expensive pigments was cinnabar. It is the only pigment for which a price was set in Pliny's time, and it sold for seventy sesterces (or 17.5 denarii or 280 asses). The Roman state's involvement in the economy of pigments reveals an interest in protecting elites and their purchasing of luxury items.

The *Edict* of Diocletian also provides prices for some pigments. And while the economy and the value of the Roman currency changed substantially from the late first to early fourth centuries CE, the relative values of pigments remained constant. While not all pigments are listed in the *Edict*, the pigments that appear provide choices in quality as well as price (see Table 2.2). Indigo was one of the more expensive pigments in Pliny's time (twenty denarii) and if this price has been read correctly in the *Edict*, then it continued to be expensive later, since indigo could not be sold for more than 750 denarii (Pliny the Elder 1952: 33.57; see Table 2.2). Cinnabar also continued to be a pigment and particular shade (red-orange) that expressed wealth. There are two grades of cinnabar in the *Edict* that have price ceilings set at 300 and 500 denarii. Lower

grades of pigments also appear in the *Edict*, such as sandyx, which has a price ceiling of forty denarii, although it was only 2.5 asses in the first century CE (Pliny the Elder 1952: 35.20; see Table 2.2).

SHOPPING CHOICES: LESS EXPENSIVE ALTERNATIVES

In the Roman era, consumers were aware of the different costs for various colors (whether dyes or pigments). One Egyptian woman looking for purple could not find the desired quality, but only "cheap" purple (*sapra*) (Wilcken 1936: *P. Brem.* 59, line 8; early second century CE; Martelli 2014: 120). One of the many reasons for murex purple's price stability was its color constancy and durability. When Alexander the Great conquered Susa in Persia, he discovered five thousand talents in weight of purple textiles that had been looted from Greece, and that had retained their color for more than 150 years (Gage 1993: 21; Plutarch 1919: *Alexander*, 36.2). Murex purple was remarkably more lightfast than vegetable dyes (*sed culpant ablui usu* "but they complain [that vegetable dyes] are washed out from use," Pliny the Elder 1969: 22.3; Bradley 2009a: 202). Pliny, who is concerned with the high price (and wasteful spending) demanded for murex purple, encourages women to consider alternative purples. He asks, using a rare joking tone, why individuals would fish for murex shells in the deep sea, where they could be eaten by sea monsters, when one could have instead harvested vegetable dyes, just as farmers cull crops. Thus, Pliny mocks the dangerous extent to which people's passion for purple might take them, and suggests an alternative, backed by the quintessential idea of the Roman farmer. By "substituting cheaper things" (*subiciendo viliora*), he hopes to restrain luxury and conspicuous consumption. As Mark Bradley has reasoned, "this was not so much approval of imitation dyes as a deliberate and calculated dismissal of the inherent value of high-status dress *colores*" (2009a: 202). And indeed, there were a variety of ways that people went about finding cheaper colors.

For dyes, the aforementioned Stockholm and Leyden papyri offer ways to make less costly dyes. Some of the ingredients used to produce red and purple colors in these recipes include bloodstone, gall-nut, laurel berries, amaranth blossoms, grapes, madder, kermes, and archil (Caley 1927: nos. 97–100, 107, 110, 117).[8] Textiles from Roman Egypt (first to third centuries CE) included some dyed with Tyrian purple, as well as purple made from a combination of this purple and insect dyes (including the kermes insect and *porphyrophora* insects, the latter found in Egypt) (Cardon 2010: 4–5). Similarly, the Stockholm papyrus advises dyeing madder on top of a blue-dyed textile (Caley 1927: 999, no. 153; Benda-Weber 2013: 179–80). A fabric sample (late first century CE) from the Bourse, Marseille, exemplifies this technique, in which dyer's woad was combined with madder to make a purple color (Juan-Tresserras 2000: 247). Phrygian textile fragments from Tumulus III at Gordion (Turkey) from the late

eighth to early seventh century BCE show an attempt to imitate purple, as madder and indigo were woven together at angles (warp/weft) (Benda-Weber 2013: 179). Similarly, among pigments, not only could madder or other substances be used to make a pink or purple pigment, painters also mixed Egyptian blue and red ochre to produce a purple color (Clementi et al. 2011: 1819). These cheaper solutions were clearly widespread over space and time, and such alternatives were deemed acceptable, so long as they were not sold as if they were murex purple or some other similarly expensive pigment or dye (see the chapter on the fraud and adulteration of pigments in Becker forthcoming-a). There were certainly choices to be made in the realm of pigments, as well as dyes.

CONCLUSION

The colors of the Greco-Roman world were something to manipulate so that dyes and pigments could be used to bring color to lily-flowers, perfumes, or even birds—the colors of their world were many and flexible (Pliny the Elder 1969: 21.13; 1968: 13.2; 1983: 10.34). The Greeks and Romans were well aware of the properties of color and could regularly alter it to make different colored pigments and dyes. They could produce expensive and cheaper dyes, in a range of shades, and even made-to-order colors to match the customer's specifications. Pigments were mined and manufactured all over the Mediterranean and beyond, providing Romans with a range of choices in color.

Power and Identity

KELLY OLSON AND DAVID WHARTON

COLOR, POWER, AND IDENTITY IN ANCIENT GREECE

Generally, in Greece we do not find the same degree of explicit visualization of color to indicate power as we do in, for example, ancient Rome. But even though Greek methods of utilizing color were simpler and carried fewer overt signs of rank and status than Roman usage, this does not mean that the use of color in Greek antiquity was less significant.[1] Greek color carried "an equal range of meanings, but … these were less formalized, or unified, as we would indeed expect from this diverse culture" (Cleland et al. 2007: 181). Our eyes have been instructed by red- and black-figured pottery, and by neoclassical statuary, but there is extensive evidence that there was a "range of colors and hues," especially in Greek clothing (Lee 2015: 93).

Color is not straightforward. Greek ways of looking at color have caused much scholarly ink to be spilled over the years, including spirited debate as to whether the Greeks were color-blind (they were not).[2] Michael Clarke raises several important issues about ancient perceptions of color. For instance, we in the modern era organize our color vocabulary on the basis of "the full spectral range of strong bold colors" because color is presented to us "overwhelmingly at bright saturated values on flat static surfaces" (Clarke 2004: 132).[3] But in the ancient world, such bold vivid color would only be experienced occasionally, "such as the plumage of birds or a few rare and expensive fabric dyes" (132).[4] Other scholars have raised equally important questions about the role color played in Greek society: how did the Greeks experience or evaluate color, for instance? How do we account for the fact that there are many ancient color

terms that are exceptionally difficult to translate? Why are there several basic colors that appear to have no equivalent in antiquity (Lyons 1999; Bradley 2013: 128; McDonald, this volume)?

Finally, it seems the ancients employed a highly sophisticated color system: "rather than hue, the ancients were sensitive primarily to such things as luminosity, saturation and texture, or even less obvious variables such as smell, agitation and liquidity" (Bradley 2013: 127). Ancient color prototypes were often at "the meeting point of several cognitive domains," for example, color, light, movement, texture, mental states, and so forth (131). Homer's "wine-dark sea" is the best example of an ancient color problem.[5] But if we consider that the descriptor *oinops* invoked not only wine's color but also its effects and dangers (frenzied, Dionysiac, deep, intense, treacherous) this makes more sense (Bradley 2013: 133).

COLOR IN CLOTHING

We find mention of colored garments in Homer on both men and women: saffron, purple, or black. Some were patterned or multicolored, all of which added value to the garment and marked the wearer out as one of high status.[6] Women's veils in Homer were also often brightly colored or patterned (Llewellyn-Jones 2003: 128). In the classical period, the prevailing colors of the tunics and cloaks of Greek men were white, gray, or brown, colors natural to the textile from which the garment was woven, and there seems to have been little in the way of ornamentation. But there were exceptions to this general rule: at some point in the fifth century BCE, upper-class men wore the long Ionian *chiton*, golden grasshopper pins in flowing hair, as well as purple or decorated cloaks (Thucydides 1919: 1.6.3–5; FGH II.200).[7]

One colorful foreign garment that gained popularity after the defeat of the Persians in 480 BCE was the *ependytes* or *chitoniskos cheiridotos*, a luxurious over-*chiton*. Assumed by men and women as a fashion item in the second quarter of the fifth century, it was short, made of wool or linen, and patterned and colorful, in shades of black, red, violet, blue, or green (Miller 1989, 1997: 176). Both vases and inscriptions record a variety of decorative borders (the pattern types appear to be purely Hellenic) (Miller 1997: 158–9, 160–1, 169, 176, 177–9). The *kandys* was a long-sleeved coat but properly draped over the shoulders with the billowing sleeves left empty; five were dedicated at Brauron, Attica (IG II² 1523.27–9 = IG² 1524.202–4; see Miller 2006 and 2006/2007: 130).[8] One was multicolored and described as *amorgine* (silk?); one was linen with "colorful inweaving predominantly in green" (Miller 2006/2007: 118); one was designated simply as *poilikos* (multicolored). Some *chitoniskoi* (little-sleeved tunics) are described as multicolored in temple inventories, dyed purple and other colors (Miller 1997: 179; Cleland 2005: 91–3). In addition, colored designs would have been woven

or embroidered into garments, and we have examples of decorative gold foil attachments, which would have been attached to clothing (Lee 2015: 95).[9]

These were luxury garments, but power and identity were also made known somewhat ironically through the *lack* of color: Athenian men's "democratic" dress, for instance, was an undyed tunic and himation (an outer garment) in the natural colors of wool: beige, white, or off-white.[10] Some men may have assumed these to provide a sharp contrast to the colorful garments of eastern "tyrants."

PURPLE

There was only one color in Greek antiquity that truly indicated power, and that color was purple (*porphyreos*).[11] That purple was an important color is testified to by literary, artistic, and archaeological evidence from all over Greece and Magna Graecia.[12] Interestingly, "purple" for the Greeks represented a wide range of hues, not just our modern mauve/violet (Grand-Clément 2016: 124); scholars hold that ancient purple was in fact closer to our own color red than to blue.[13] There were different dyes and terminology for purple: *halourgos*, *porphyreos*, *hyakinthos*, *orphninos* (Brøns 2017: 109–11). Sea-purple was the most expensive, so called because it was extracted at great expense from the bodies of mollusks. Many factors influenced the final color of the dye, including the type of mollusk used: *murex trunculus* produced a bluish tint, for instance, while *murex brandaris* a more reddish tone.[14]

As Adeline Grand-Clément and others have noted, one of the attractions of sea-purple was that it was "a bearer of light" (Gage 1993: 25; Grand-Clément 2016: 125). Menander described a cloth of interwoven purple and white threads, which shimmered according to the fall of illumination (in Kock 1880–8: 667 K2). *Porphyrein* means to "heave, surge, or ripple" (often of the sea), "which may perhaps be accounted for by the many color-changes in the dyeing process but which is also of course the condition required for the perception of luster itself" (Gage 1993: 25; Homer 1995: *Odyssey*, 2.428; 1999: *Illiad*, 16.391; Clarke 2004: 133): the Greeks associated color words with bundles of other qualities and the overall "flux of sensory experience" (Clarke 2004: 133). The dye was one of the few color-fast pigments in antiquity as well, which must have added to its value.

PURPLE IN GREEK LITERATURE

A symbol of status and wealth, Reinhold claims it was Alexander's use of the color that gave it "world-wide currency as a status symbol" (Reinhold 1970: 28).[15] But textiles dyed with purple signified power and affluence even in Homeric times (see Stulz 1990: 96–120; Brøns 2017: 114; Homer 1995: *Odyssey*, 4.125–35).

Lyric poets of the Archaic age also mention the color as being status-laden and connected with gods and heroes (Campbell 1991: *Simonides*, fragment 576; Campbell 1992: *Bacchylides*, *Epin.* 11.49, *Dithyr.* 17.112, *Dithyr.* 18.52; Pindar 2012b: *Pythian Odes*, 4.114).[16] The color continued to be popular throughout the fifth century: Greeks then anxious to show their status wore purple cloaks and embroidered tunics (Athenaeus 1951: 12.512b–c), and the color appears on a rug in Aeschylus' *Agamemnon* (Aeschylus 2008a: 910, 946, 957). The appearance of Alcibiades in a purple cloak in the theatre caused "great astonishment" (Athenaeus 1951: 12.543c; Reinhold 1970: 25). By the end of the century, philosophers and Sophists had also begun to dress in luxurious purple dress (Aelian 1997: 12.32; Apuleius 2017: *Florida*, 9.18).[17] The painter Parrhasius also assumed this garment: Athenaeus says of him that he was thought to have dressed luxuriously "in a way offensive to good taste and beyond his status as a painter" (Athenaeus 1951: 12.534c, 543f; 15.687b). Women wore the color too: at the end of Aeschylus' *Eumenides* the women of Athens wear purple-dyed garments in celebration (Aeschylus 2008a: 1028 and see Plutarch 1959: *On the Love of Wealth* 527F, 528B).

Purple garments were also listed in the temple inventories (lists of what were perceived as important objects) from all over Greece, dating from the fifth century BCE to the second century CE (Brøns 2017: 111). Purple garments were dedicated at the Parthenon, at Brauron, a temple of Demeter and Kore at Tanagra, Delos, the Heraion at Samos, Thebes, and the sanctuary of Artemis Khitônê at Miletos.

GOLD

Sea-purple possessed shine, vividness, iridescence, permanence, and resistance, as did gold (Grand-Clément 2011: 116–17; 2016: 125).[18] "For these reasons, purple dyed fabric was considered by the Greeks as the equivalent of golden artefacts in the realm of textiles" (Grand-Clément 2016: 125). I would state in addition that gold ornament and purple dye were associated in ancient sources because of their expense: they were the two most costly substances known to the Greeks at that time.

RED

Poenicus was a shellfish dye but distinguished from purple by being a bright vermilion.[19] Like sea-purple, the color was expensive and colorfast. Lycurgus reportedly had male citizens wear a *stolê phoinikis*, a red garment, into battle (Xenophon 1925: *Constitution*, 11.3),[20] but other soldiers wore them as well: one Athenian officer is splendid in a bright-red tunic produced with Sardian dye (Aristophanes 1998b: *Peace*, 1172–6; for different grades of red dye, see

Blum 1998: 32–4). By Xenophon's time, red tunics were worn by hoplites (citizen-soldiers) across Greece (Xenophon 1925: *Agesilaus*, 2.7; 1998: 1.2.17; Wees 2017: 218). In addition, shoes called "Lakonian" were exported to or made in Athens and worn there: the shoes were red, "a color associated with manliness and superiority" (Aristophanes 1998b: *Wasps*, 1158; Sekunda 2009; Wees 2017: 217).

GREEK WOMEN'S COLORS

In ancient Greece, yellow was specifically a feminine color, associated with brides and *hetairai* (courtesans or prostitutes). *Krokos* is the word for crocus flower but was used also as a color term to denote garments dyed with saffron. It was the hue of the gods: the Dawn, the Muses, and Dionysus all wear this color (Ronchaud 1886: 76; Llewellyn-Jones 2003: 224 with references), but is overwhelmingly associated with women and female goddesses.[21] Usually translated as "yellow" or "saffron-colored," Lloyd Llewellyn-Jones makes the point that what *we* would classify as being in the yellow family of hues, the ancients were happy to see as *red* (2003: 225–7).[22] (Andriani Koutsakou notes that crocus stamens are red but produce a yellow dye [2013: 57 and n57].) The dye was expensive (Llewellyn-Jones 2003: 224), so this meant not only the initial dye-bath but also that the maintenance of this color could be costly: Isabella Benda-Weber notes saffron-dyed clothes unless dyed with a mordant or re-dyed periodically with saffron, will fade from a brilliant to a soft creamy yellow (Benda-Weber 2014: 132). Scholars have postulated a connection between the color yellow and femininity, because saffron was thought to be efficacious in curing among other things gynecological complaints (Sebesta 1997: 540n33; Grand-Clément 2011: 170–2; Koutsakou 2013: 58n65; Benda-Weber 2014: 131–2, 138);[23] when men wore the color they tended to be ridiculed (Aristophanes 2000: *Women*, 253, 1044; 2002: *Assemblywomen*, 328–32).

COLOR, POWER, AND IDENTITY IN ANCIENT ROME

When we think about the role of color in Roman political and social life, we should keep in mind that the colors associated with Roman power were essentially rooted in a set of colored (or uncolored) material objects and colorants. Abstract color concepts and terms were not used in Roman political discourse in the way that, for example, terms for red and blue can be used today to describe the political leanings of different populations or political groups. Thus, while it is common to say that purple was enormously important in Roman political life, this is in some sense true but also misleading. It was not the mere fact that a political symbol had a certain hue that was essential to its meaning; what mattered much more were the particular colorants and materials

that composed the symbol. The use of substitute dyes or materials to achieve the same hues would not confer high status, and such counterfeits were avoided by the powerful (Bradley 2009a: 201–2).

UNDYED AND DYED TOGAS

In Roman civic life, through much of its history, one of the most important political symbols was the toga, and the colorant normally used on the toga was *purpura*, which we shall discuss shortly. The toga was of course the garment most characteristic of Roman civic identity in the late Republic (509–31 BCE) and empire (31 BCE–476 CE) (Rothe 2020: 42), although it evolved from an everyday garment in the Republic to a largely ceremonial one in the empire and eventually fell out of use entirely in the fifth century CE (Stone 1994: 13–38). It was a large semicircle or semi-ellipse of woollen cloth from white sheep, draped and folded in elaborate ways that changed over time (Stone 1994: 13–38; Olson 2017: 21–43), and was usually worn over a tunic (Rothe 2020: 21–3). The *toga pura,* also known as the *toga virilis,*[24] which was worn by most adult Roman male citizens, was an undyed, undecorated garment, probably off-white or grayish in color (Stone 1994: 15).

Nuances of color on the *toga pura,* however, could signify status or wealth. Its degree of whiteness showed wealth, since wealthier citizens were able to afford togas made of higher-quality wool and to have them cleaned more frequently than their less-well-off peers (Rothe 2020: 91–6; Llewellyn-Jones, this volume). Toga coloration could also denote temporary social or political status. The *toga candida*, artificially whitened to a brilliant white color, was worn by candidates for political office, and the *toga pulla,* darker in color, was worn in specific circumstances to denote mourning or other somber circumstances.[25]

Higher political, military, and religious status was signified by the regulated use of *purpura* on the toga. *Purpura* in Latin does not mean "purple" as an abstract color term, although it is often translated that way. It is a name for a murex shellfish, but more often refers to the dye derived from this creature, and by metonymy, to textiles colored with the dye; the word only rarely refers to an abstract color category (André 1949: 90–102; Glare 1982: under *purpura*), and it shares many of the noncolor connotations of *porphyreos* discussed above. As already noted, shellfish dye was extremely expensive and normally available only to the very wealthy, and the colors that murex dye could produce were much more various than our word *purple* suggests (Bradley 2009a: 98). The Romans were well aware that it had been widely used for centuries throughout the Mediterranean world as a status symbol for aristocrats and monarchs (Reinhold 1970: 5–36).

Pliny the Elder believed that *purpura* was a significant political colorant even at the beginning of the Roman state and that it was associated with the early

kings of Rome. He says, "I see that *purpura* was always used in Rome," and attributes a *purpura*-dyed robe (*trabea*) to Rome's legendary founder Romulus and a *purpura*-bordered toga and striped tunic to Tullus Hostilius, the third king of Rome (Pliny the Elder 1983: 9.63).[26]

But Dionysius of Halicarnassus attributes an anti-*purpura* sentiment to Lucius Junius Brutus, the man the Romans believed was responsible for overthrowing the Etruscan kings and founding the Roman Republic. In Dionysius' retelling, Brutus specifically linked *purpura* to the arrogance and tyranny of monarchy, and recommended eliminating its use and that of most other insignia of monarchy "unless it be upon certain festal occasions and in triumphal processions, when the rulers will assume them in honour of the gods" (Dionysius of Halicarnassus 1939: 4.73–4).[27] Of course, there is no way of knowing whether Brutus ever said any such thing, but Dionysius conveniently attributes to him what became the customary attitude toward the use of *purpura* in civic life in the Roman Republic, where the desire to use it as a symbol of status and power was in constant tension with the urge to restrain and control it.

In any case, the undyed state of the *toga pura* was politically significant, especially since most wealthy Roman men who could afford *purpura* were prohibited by custom and law from wearing it on their civic costume. The *toga pura* was thus a visual symbol of the Romans' Republican ideology and opposition to monarchy in Rome. This symbolism was not lost on non-Romans, as we see in an observation in the First Book of Maccabees:

> Those whom [the Romans] wish to help and to make kings, they make kings; and those whom they wish, they depose; and they were greatly exalted. Yet with all this, none of them put on a diadem or wore purple as a display of grandeur. But they made for themselves a senate chamber, and every day three hundred and twenty men took counsel, deliberating on all that concerned the people and their well-being.
>
> (1 Macc. 8:13–15; New American Bible, Revised edition)

However, not all togas were undyed. Just as the Roman Republic had divided up the power of the ancient kings among a few high offices, so also it parceled out the use of *purpura* among those few men who held them. The *toga praetexta*, which had a narrow *purpura*-dyed border, was worn by magistrates who held high offices at Rome (consuls, praetors, and curule aediles) as well as members of the highest priestly colleges. Over time this privilege was expanded to those holding such offices in the colonies and in towns that possessed the right of Roman citizenship, and those who had previously held those offices were sometimes allowed to wear the *praetexta* on special occasions (Olson 2017: 44; Rothe 2020: 73–4).[28]

The tunic that was typically worn beneath the toga (whether dyed or undyed) also used *purpura* to signify social class. Members of the equestrian class, the

second-highest social class, were allowed to wear a narrow stripe of *purpura*, the *angustus clavus*, that descended downward from each shoulder on the tunic. Members of the highest class, the senatorial class, wore broader stripes (*latus clavus*) (Stone 1994: 15, 40n17).[29]

During the Roman Republic, the right to wear the *toga purpurea*, entirely dyed with *purpura*, was permitted to an even smaller number, perhaps as the ceremonial and funeral dress of censors (Polybius 2011: 6.53.7) and possibly to consuls on other specific occasions (Gabelmann 1977: 329). But when Julius Caesar wore this garment in public as the Republic was collapsing, the symbolic link to his ambition for monarchical power was clear (Cicero 2009: 2.85; Meister 2017: 91; Rothe 2020: 75), and in the imperial period, only the emperor was permitted to wear it. In the later empire, the highest qualities of shellfish dye, along with silken garments, became increasingly associated with the emperor (Reinhold 1970: 49–73).

At the top of the status pyramid during the Roman Republic was the privilege of wearing the *toga picta*, entirely dyed with *purpura* and decorated with patterns in golden wire. It was permitted at first only to men to whom the Roman Senate had granted the privilege of an official triumph, the elaborate military victory procession of the Romans. The victorious general, the *triumphator*, wore this garment along with associated triumphal regalia that perhaps were kept in the Temple of Jupiter Optimus Maximus, linking him symbolically with Jove himself. The political and military conditions placed on granting this honor were strict: the *triumphator* must have won a lawful, sanctioned war in which he had killed at least 5,000 people, and for which he had been granted full *imperium* (legal authority to wage war) by the Senate (Gellius 1927: 5.6.21–2; Valerius Maximus 2000: 2.8.1).[30] Such authority was normally reserved for those few men who held one of the highest political ranks: *consul*, *praetor*, or *dictator* (Livy 2017: 31.20).

The typical *triumphator* was allowed to wear the *toga picta* only during the triumph itself, although after his death it could be displayed in his funeral procession (Meister 2017: 86). In the first century BCE, however, these norms too began to break down, along with the constitutional arrangements of the Republic, as ambitious men such as Caesar and Pompey accumulated greater personal power and wanted to wear the *toga picta* in other contexts as a sign of their status. Thus Pompey was granted permission to wear the *toga picta* at Roman games (91).

Purpura was not the only significant color feature of Roman triumphs: the *triumphator* had a golden crown held above his head by a slave standing with him in the golden triumphal chariot (Pliny the Elder 1969: 23.4). There is also evidence that, in the early Republic, the *triumphator* colored his body and perhaps his face with *minium* (today called cinnabar), a very expensive, bright red pigment normally used in painting and decoration (Pliny the Elder

1952: 33.111; Meister 2017: 86).[31] Presumably the *triumphator* would not be wearing a tunic underneath his toga so as to expose some part of his pigmented body, although it is uncertain whether the significance of the pigment was to connect the *triumphator* to the gods, particularly to Jove, or to the ancient kings (Bonfante Warren 1970). In later periods, pigmentation on the body was abandoned and the *triumphator* wore the *tunica palmata*, a tunic decorated with palm or floral embroidery (Livy 1926: 10.7; Olson 2017: 49–50). Although it is tempting to think of the Roman triumph as composed of fixed and invariable features, it developed and changed over time,[32] and individual *triumphators* could vary elements to enhance their self-presentation. One example of this involving color was the general Camillus' unprecedented use of four white horses to draw the triumphal chariot; it was not well received by the Roman people, who considered it a "wanton extravagance" (Plutarch 1914b: *Camillus*, 7).

While on military campaign, Roman leaders after the early Republic generally did not wear the toga, but they did use an expensive pigment to show high status on their *paludamenta* (military cloaks), which were colored with a very expensive insect-based dye called *coccum* (Pliny the Elder 1969: 22.3).[33] In the later empire, the *paludamentum* was dyed with *purpura* and became a symbol of imperial power (Reinhold 1970: 59). Eventually *purpura*-dyed garments, particularly those made with the highest-status varieties of dye, were increasingly associated with the emperor as his "special insignia," as was the use of porphyry, a purple-colored stone. In the late empire, the use of these dyes with silken garments was preferred and sometimes regulated for imperial use, although most varieties of shellfish dye remained available on the open market for private use (59–73).

COLOR VARIATION, BRANDS, AND STATUS

As previously noted, the *purpura* shellfish and its relatives could be processed to produce a wide range of hues. These ranged across what we would call pink, red, purple, blue, violet, and even darker shades, depending upon which varieties of shellfish were harvested, their origin and habitats, the ways they were processed, and the techniques used in applying them to different materials (Pliny the Elder 1983: 9.62–5; Bessone 1998; Vitruvius 1998: 7.13; Cardon 2007: 554–75; Olson 2017: 109–11; Becker, this volume).

The fact that the Romans used the word *purpura* and other related shellfish terms such as *conchylium* and *ostrum* in a similarly broad way should not be taken to imply that the Romans could not make fine color distinctions or that they lacked a sophisticated color vocabulary. Quite the opposite: their obsession with expensive products manufactured with these dyes led them to coin or borrow a suite of terms to describe an astonishing variety of dye

products with descriptors such as *amethystinus, heliotropium, hyacinthinus, hysginum, ianthinus, puniceus, purpura dibapha Tyria, purpura Tarentina, purpura violacea,* and *Tyrianthinus* (Sebesta 1994: 71). Although these terms referred to narrower color ranges than the broader term *purpura*, it would be a mistake to think that they were simply fine-grained, abstract color terms in the way that words such as *mauve* and *fuchsia* are for us. Many of the Latin terms communicated not just color but the specific dye materials, provenance, and sophisticated craftsmanship associated with each of them. That is, they named dye products, not just colors, and in this way, they functioned more like modern brand names than abstract color terms. The Romans needed these names not just to distinguish hues but to know which products conferred higher status.

Pliny the Elder gives some insight into the social dynamics of dye-color distinctions in a remark he records of Cornelius Nepos (110–25 BCE):

> When I was a young man, he said, violet [*violacea*] *purpura* was popular, a pound of which sold for a hundred *denarii*, and not long after, red Tarentine [*rubra Tarentina*] came into vogue. After this came double-dipped Tyrian [*dibapha Tyria*], which could not be bought for a thousand *denarii* a pound. P. Lentulus Spinther, the curule aedile, was criticized for first wearing this on his *toga praetexta*, but who today does not fit out his dining room with this *purpura*?
>
> (Pliny the Elder 1983: 9.63; translation by D. Wharton)

Nepos' observation shows that it was not enough just to wear *purpura*; one must have just the right kind of *purpura* as fashions changed, and one must have the most expensive kind. In the late Republic there is evidence that such variations in shade could also be used to signal one's political leanings (Bradley 2009a: 197–8). By the early empire, *dibapha Tyria* and *amethystina purpura* had such high status value that the emperor Nero banned them (presumably to reserve them for himself) and shut down the shops that sold them; when he caught sight of a woman wearing such a garment at one of his own public poetry recitals, he ordered her to be dragged out of the venue and had her garment and all her property confiscated (Suetonius 1997: *Nero*, 32:3–4).

Pliny did not understand or approve the high prices paid for various shellfish dyes that were not used on civic dress, whose colors he does not particularly like:

> The official rods and axes of Rome clear a path for *purpura*, and it also marks the honorable state of boyhood; it distinguishes senators from equestrians, it is called in to appease the gods; it brightens every garment, and in triumphs it is blended with gold. Therefore, the madness for *purpura* may be excused; but what is the cause of the prices paid for *conchylia*, whose dye stinks, and whose color is a gloomy gray-blue like an angry sea?
>
> (Pliny the Elder 1983: 9.60; translation by D. Wharton)

Conchylia here refers to a shellfish dye product made with a different process than *purpura*'s and that produced less saturated hues (9.138). Pliny later refers to the rising price dynamic for various prestige dye products as a competitive game (*iuvat ludere impendio*) of which he disapproves (9.65). We can understand what was happening, however, in terms of Thorstein Veblen's notion of "conspicuous consumption," in which the consumer gains status simply by buying very expensive products, even if those products are not inherently beautiful (Veblen [1899] 2017: 64, 97).[34] Despite Nero's temporary interdiction of some varieties of *purpura*, the expensive dyes described here, and many others, were normally available to consumers, and they were used freely on non-togate garments of all kinds by both men and women.

ROMAN WOMEN'S COLORS

Clothing and adornment were particularly important for Roman women; since they were excluded from the direct exercise of political power, dress was a principal way to display social standing (Olson 2008: 96–112).The yellow range of the color space seems to have been reserved for Roman women (as it was for Greeks); women's wedding veils were yellow-red (*luteus*), and saffron-colored (*croceus*) garments characterize women in Latin poetry (Pliny 1969: 21.46; Goldman 2013: 57–62); men who wore garments in this range could be considered effeminate, including men who wore *galbinus*, a bright yellow-green (Martial 1993: 1.96; Juvenal 2004: 2.93; Olson 2008: 13; Goldman 2013: 60–1). Both Ovid and Plautus provide lists of the names of many of colors used on women's clothing (Ovid 1979: *Art of Love*, 3:169–92; Plautus 2011: *Epidicus*, 230–5). But apart from white, black, and gray, which women avoided, "the greater part of the rainbow was left to women" (Olson 2008: 13–14), and they showed their status and social class not through the use of any particular color but by using color effectively as a part of their overall self-presentation.

COLOR AND DINING CULTURE

Nepos' remark above locates another site of social competition: the dining room (*triclinium*). In Roman dining culture, much political business was transacted, and status-jockeying was accomplished through extravagant expenditures on food, wine, architectural decoration, and dyed textile furnishings such as tapestries and dining-couch fabrics.[35] Here again color embodied in expensive colored objects plays an essential role. But whereas the color palette on official male garments was limited, the colors of the dining room were wildly varied.

The Roman poet Lucan gives us an over-the-top, fictional description of Cleopatra's dining area as prepared for a visit by Julius Caesar

(Lucan 1928: 10.104–35). He describes thick gold covering the ceiling beams; solid marble, agate columns; onyx and porphyry inlays on the floor; ebony doors; and decorations of ivory, tortoise, emeralds, and jasper. Dining-couch textiles are also prominent, some made with fabric long-soaked and multiply dipped in Tyrian *purpura*, some embroidered with gold thread (*auro plumata*), and still others dyed with *coccum* that produced a fiery (*ignea*) red color. Here the power and wealth on display are that of a foreign queen who became a hated enemy of Rome, and Lucan's description is openly critical of its excesses. And yet he admits that these excesses eventually migrated to the Roman world (109–110), and we know all these colorful materials were available to Roman consumers in the early empire, since all are cataloged in Pliny the Elder's *Natural History*, and archaeology confirms extravagant colored materials in Roman houses.

COLOR AND CHARIOT RACING

The world of chariot racing was one sphere of Roman life where colors helped form social identity across all social classes. It was the most popular and enduring spectator sport in Rome (Bell 2014: 559–60), dating back at least to Rome's founding, and continuing unabated into the Byzantine period. By the early empire, there were four well-established professional teams (*factiones*), each with its own color, that were avidly followed by their fans, who included "young and old, male and female, rich and poor, native and foreign," even boys and girls, as well as emperors (567).

The team colors were *albus* (white), *russeus* (red), *prasinus* (green), and *venetus* (blue), but the color names are puzzling. Apart from *albus*, which is the basic Latin term for white, the names are rare elsewhere in Latin literature and are not the ordinary Latin terms for red, green, and blue. Goldman argues that these are the "brightest out of their color group," but the evidence for this is not conclusive (Goldman 2013: 89).[36] The color names seem to have functioned like some modern college sports team names, for example, the Harvard Crimson or the Stanford Cardinal. The emperor Domitian tried to add two more teams with *auratus* (golden) and *purpureus* (purple) uniforms, but was unsuccessful (Suetonius 1997: *Domitian* 7.1; Goldman 2013: 85).

Fans' dedication to their teams could be extreme. Pliny the Elder records that a devotee of Felix, a charioteer for the *russeus* team, committed suicide by throwing himself on Felix's funeral pyre. Backers of the other teams, unwilling to grant such glory to an opposing team, claimed that the man had merely fainted because of the overpowering smell (Pliny the Elder 1942: 7.53.16). The emperor Nero was a fan of the *prasinus* team from his boyhood and loved the sport so much that he learned to race and competed in the Circus Maximus and at the Olympic games (Suetonius 1997: *Nero*, 22)—shamefully in the eyes of many, since most professional charioteers were slaves, freedmen, or foreigners

(Bell 2014: 563). Caligula was so devoted to the *prasinus* faction that he would dine in the team stables (Suetonius 1998: *Caligula*, 55.2). Fans apparently liked to wear their team's colors, just as modern fans do (Martial 1993: 7.4), and for many ordinary people, their team's performance was the most important thing in their life: "the height of all their hopes is the Circus Maximus" (Ammianus Marcellinus 1939: 28.4.9). Many curse tablets (*defixiones*) record fans' prayers calling down death, destruction, or demons on opposing teams, and fan violence at the games was not unknown (Bell 2014: 568).

Not everyone approved of the sport. Snobs, such as Pliny the Younger, thought devotion to racing was childish and claimed (implausibly) that if the charioteers changed the color of their uniform (*pannum*) mid-race, fan loyalty would follow the color, not the chariot team (Pliny the Younger 1969: *Epistle*, 9.6). The early church father Tertullian (*c.* 155–*c.* 240 CE) objected to the sport not so much as evil in itself but because he thought the team colors were linked to pagan deities: *russeus* to Mars, *albus* to the Zephyrs, *prasinus* to Mother Earth and spring, and *venetus* to Sky and Sea (Rendall 1931: *De spectaculis*, 9). Given that the sport's popularity and team colors persisted centuries into the Christian era (Cameron 1976), he does not seem to have persuaded many.

CHAPTER FOUR

Religion and Ritual

VERITY PLATT

What color are the gods? How does color shape religious experience? Historians of ancient religion have not traditionally paid much attention to these questions; nevertheless, I was compelled to address them when choosing cover designs for a book on divine epiphany (Platt 2011).[1] The image I had chosen— of the dramatic arrival of the goddess Selene on a Roman sarcophagus—was predictably monochrome, any traces of pigment having long since vanished from the marble. As so often, antiquity was destined to appear in shades of black and white (Manfrini 2009; Stager 2016: 97–8). When the press's first design arrived on my desktop, however, the cover's accent color was the deep orangey-red so familiar to us from Greek vases. For me, this earthbound tone was not the color of epiphany! After consideration, I requested an ethereal lilac—a shade that evoked the shimmering violet of the rainbow (Bradley 2011: 48–50); the divine *porphyreos* "purple" that featured in so many sacred garments (Grand-Clément 2011: 116–21; 2016); or the rich drapery that frames the body of Persephone in one of antiquity's most striking scenes of epiphany, from a painted Macedonian tomb (Brecoulaki 2006b; see Figure 4.1). My more allusive approach to imagining ancient color conflicted with one that drew more directly upon antiquity's material relics (in the press's case, vases of Attic clay). Conveying my idea to the designers, moreover, required its reduction to a Pantone number—a branded, standardized system of hues based on specific combinations of pigments designed for modern-day printing (Eiseman and Recker 2011).

The challenges I encountered in accessing and reproducing the chromatic qualities of ancient visionary experiences illustrate how difficult it is for

FIGURE 4.1 Abduction of Persephone, from the Tomb of Persephone, Vergina, *c.* 340 BCE. Painted fresco. Wikimedia Commons. https://commons.wikimedia.org/ wiki/File:Painting_vergina.jpg. Public domain.

scholars of Greco-Roman culture to recover the religious "chromatosphere." Like other fields within classical studies, we struggle both to recuperate the colors of material environments (so often faded or lost) and to reconcile obscure ancient color terms with post-Newtonian concepts of hue. But we must also accommodate the complex subjectivity of the religious imagination, in which culturally specific notions of color intersect with ritual practices that are seldom clearly documented and with spiritual beliefs that are seldom overtly expressed (Grand-Clément 2017). The challenge of seeing color as *others* see it (that is, the subjectivity of perception) is exacerbated by the methodological challenge

of understanding the internal belief systems of societies that are no longer accessible to us (the subjectivity of faith). In the sphere of religion, problems of knowledge and meaning raised by color are thus magnified.

These challenges, however, should not inhibit us. The pre-Socratic philosopher Empedocles emphasized how vital color was to ritual practice in antiquity, comparing the generation of species from the elements to painters who "adorn votive offerings" (*anathēmata poikillōsin*) when they "seize pigments of many colors (*polychroa pharmaka*) in their hands, mixing in harmony more of some and less of others, [and] produce from them forms resembling all things" (Kirk et al. 1983: 292–3, Empedocles B23; Stager 2016: 97–8). As we shall see, color is a crucial mediating device between human worshippers and the gods. The bright paints that adorned votive statues such as Archaic *korai* constructed them as *agalmata* (delightful objects designed to please the divine), while valuable pigments such as gold and metallic foils were regarded as offerings in themselves. Colors were a fundamental feature of ritual performances such as processions and sacrifices, carefully coding features such as the costumes of specific personnel or even the coats of sacrificial animals (Ekroth 2014: 334–5). Numerous sanctuary regulations demonstrate how the dress of celebrants could be highly controlled, often stipulating white clothing alongside an absence of bright dyes, cosmetics, or gold jewelry (so reserving polychrome effects for the gods and their offerings); in mystery cults, the coding of dress color could mark important distinctions between levels of initiation; in other cases, it identified cultic personnel or those in mourning (Mills 1984).

A sixth-century BCE painted panel from Pitsa, near Sicyon, Greece, provides a rare piece of visual evidence for the ways in which colored objects could play salient roles within acts of religious performance and communication (see Figure 4.2). Dedicated to the Nymphs, it marks differences in skin tone between male and female worshippers, while highlighting in white gesso the light color of the sheep being brought to sacrifice (appropriate for deities of the upper realm), the pale olive green of fresh myrtle wreaths and branches, and the dark red hematite, intense Egyptian blue, and (for the women) patterned white trims of ceremonial dress (Brecoulaki 2014). Whether or not these colors corresponded to actual clothing worn by celebrants, their preservation in the form of a painted panel transforms ephemeral ritual into a more permanent record of worship, adorning the sanctuary with a highly variegated *poikilia* "multifariousness, elaboration"—the same aesthetic with which Empedocles describes the painting of polychrome offerings (Grand-Clément 2012, 2015). Moreover, to the right of the panel, we see on the blue-edged altar the (now faded) signs of a burning flame and, below it, red streaks indicating the blood of animal victims—traces of previous sacrifices (Gaifman 2008). As the leader of the procession tips her wine-jug toward the altar in a performance of libation, these streaks draw attention to the role of material substances that mediate

FIGURE 4.2 The Pitsa Tablet, *c.* 520–500 BCE. Painted wooden tablet. National Archaeological Museum, Athens. Photograph by DEA / G. DAGLI ORTI / De Agostini via Getty Images.

between the realms of the human and divine, highlighting the aesthetic and symbolic role played by color in ancient religious practice.

In what follows, I explore the relationship between color, religion, and aesthetics across two cultural domains. First, I explore the role of color in literary texts that attempt to convey divine appearance, focusing on the use of color terms in the *Homeric Hymns*. The language of color in Homeric Greek has played a paradigmatic role in modern attempts to define and comprehend ancient ways of seeing (Gladstone 1858: 457–99; Irwin 1974; Sassi 1994; Carastro 2009). The Homeric gods highlight crucial differences between Greek and post-Newtonian formulations of color; at the same time, the importance assigned to light and saturation (as opposed to hue) in these texts does not just illustrate a contrast between the ancient and the modern, but arises from the supernatural character of the gods themselves. Second, I return to archaeological evidence, examining the relationship between colors and materials in Greco-Roman visual culture. As Vinzenz Brinkmann's Gods in Color project has highlighted, ancient statues did not vaunt the cold white marble of the neoclassical imagination but were richly painted and patterned (Brinkmann and Wünsche 2007). The materiality of color raises an intriguing set of questions

when applied to the religious sphere: how did the the physicality of colored stones, pigments, metals, and fabric dyes relate to supernatural beings whose very nature defied the limits of matter? Here, any contextualizing account of color and the sacred must wrestle with the complex ontology of both the gods and their physical representations.

WHAT COLOR ARE THE GODS?

quo mea se molli candida diva pede
intulit et trito fulgentem in limine plantam
innixa arguta constituit solea.

(There my gleaming-white goddess came with soft step
and paused, her shining foot on the worn threshold,
her sandal sounding as it stepped down.)

(Catullus 68, lines 70–2)[2]

In these verses, the first-century BCE Roman poet Catullus pictures his lover arriving for a secret rendezvous, pausing on the threshold in a vision of dazzling beauty. Evoking the epiphanies of the *Homeric Hymns*, she is framed within the doorway as a *diva*—a "goddess."[3] But how should we translate the term that is used to describe her—*candida*? In its most general sense, *candidus* conveys the notion of whiteness: it is used to describe the fair skin or blonde hair of desirable women (especially brides), and is also applied to snow and ivory; by extension, it can signify that which is beautiful or lovely (Baran 1983; Clarke 2003: 52–66). *Candidus* does not just convey a sense of white as a color but that which is bright, gleaming, or shining: it is fundamentally tied to the effects of *light*. When applied to skin, *candidus* suggests a smooth, glossy sheen associated with youth and femininity. But it also conveys a luminosity that transcends mortal bodies altogether, associated with the brightness of the sun (Catullus 8.3, 8.8) or the white wool spun by the Fates (Catullus 64.318), each of whom wears a shining "white garment" (*vestis candida*, Catullus 64.307–8). In religious cult, white is generally regarded as a celebratory and purifying color, associated with objects of good omen, clothing worn at festivals, and animals sacrificed to the Olympian gods (Grand-Clément 2011: 368–96; 2016: 129–30): Catullus compares the date of his tryst to those days in the religious calendar marked by a "whiter stone" (*lapide candidiore*, Catullus 68.148).

The miraculous appearance of Catullus' *candida diva* contrasts dramatically with the "black storm" (*in nigro* [...] *turbine*, Catullus 68.63) of grief and longing in which the poet has been engulfed prior to her arrival. The predominant effect conveyed is a sudden, intense radiance, reinforced by the "shining sole of her foot" (*fulgentem* [...] *plantam*, Catullus 68.71), a quality that is often applied to

the feet of Homeric heroes (Homer 1999: 2.44, 10.22). This visual impression of brightness operates synesthetically: the gleam of her skin conveys a textural quality that resonates with her "soft foot" (*molli* [...] *pede*, Catullus 68.70), yet this delicacy also describes the sound and weight of her tread. Likewise, the threshold on which she pauses is described as "worn down" (*tritus*, Catullus 68.71) by the feet of those who have gone before and, by extension, polished smooth. The sense of radiance is reinforced by Catullus' description of his lover's sandal as *arguta*—a term derived from *arguo*, "to make clear," which conveys not only brightness but also sounds that are piercing or penetrating and thus sharp-sounding (Catullus 68.72). Its use here is impossible to translate, conveying the bright tap or high-pitched squeak of footwear, the gleam of a finely wrought sandal, and the quick-moving or twinkling motion of its wearer (Fordyce 1961: 352; Lewis and Short 1879: s.v. "argutus"). In sum, any *visual* sense of color in terms of hue or luminosity in this scene is inseparable from the haptic, sonic, and kinetic effects of the whole.

With economy and intensity, Catullus conveys the nexus of cultural tropes in which any attempt to apprehend divine color in antiquity is enmeshed. On the one hand, he emphasizes the degree to which perception or imagination of the gods is bound up with anthropomorphism: the poet's vision of his mortal lover as a *candida diva* is inseparable from Greco-Roman conceptualizations of the goddess Aphrodite/Venus in particular, in which the whiteness of the idealized female body merges with the radiance of divine form. Like the Aphrodite of Greek myth, the poet's lover holds out the possibility of erotic fulfillment: in poetry, as in statuary, the goddess's beautiful, pale-skinned body is made visible and almost tangible for those who desire (and worship) her (Platt 2011: 180–211). Likewise, mortal women and Olympian goddesses are repeatedly described as "white-armed" (*leukōlenos*) in the Homeric poems (Irwin 1974: 112–13, 182). On the other hand, Catullus' vision of a shining goddess almost denies her corporeality altogether: she is experienced as an almost blinding luminescence, in which any sense of hue is overwhelmed by the brilliance of pure light. At the very moment when the poet's *diva* should be most tangibly and visibly present, she virtually disappears, and her elusive nature gives form to the feelings of loss and uncertainty that characterize the poem as a whole (Clarke 2003: 53).

The semantic overlap between the whiteness of body and brilliance of light encapsulated by the phrase *candida diva* captures a fundamental feature of divinity in the Greco-Roman epiphanic tradition: the gods may have forms that are apprehensible by the human senses, yet the material qualities of such forms are by their very nature impossible to pin down (Platt 2011, 2016a; Petridou 2015). This tension has important implications for our exploration of divine color, for it parallels one of the most fraught debates in chromatic theory: the question of whether color is an objective, intrinsic property of

matter, or whether it is a subjective quality dependent upon conditions and/or individual sensations. As Adeline Grand-Clément observes (and as we ourselves experience), colors were not "perceived as abstract categories" by the ancients, but as "visual qualities of objects and substances" (Grand-Clément 2016: 123; see also Bradley 2011: 128–32; Sassi 2015); at the same time, as Maria Sassi argues, several ancient theories of color posited it as existing "between body and light" (Sassi 2009), whether the quality of that light be determined by the elements that constituted bodies themselves, as for Empedocles, or by its interaction with the viewer's visual ray, as for Plato (see Ierodiakonou, this volume). In possessing bodies that can both resemble and transcend the objects of human perception (Vernant 1991), the gods, too, exist "between body and light"—that is, between material property and immaterial being. Likewise, their appearances to mortals raise difficult questions about the subjectivity of perception, for they are seldom seen in the same way by multiple individuals. Catullus deploys both these enigmas to literary effect, as his *candida diva* (whom he repeatedly refers to as *lux mea*, "my light") shimmers between mortal mistress, divine vision, and lovelorn fantasy (Catullus 68.132, 160).

Catullus' "black" (*niger*) storm and "shining-white" (*candida*) goddess are the first color terms to appear in a text characterized by a highly controlled palette. Later, the intensely saturated yellow of the Roman bridal veil, the *flammeum*, will dramatically expand the text's tonal range (and its emotional ironies), as Cupid flits around the poet's lover in his "saffron tunic" (*crocina* [...] *tunica*, Catullus 68.134).[4] The stark contrasts of black and white, darkness and light, which define the chromatic, emotional, and symbolic architecture of the piece also draw upon a literary tradition that goes back to the Homeric poems. They are especially prominent in the *Homeric Hymn to Demeter*, dated *c*. 600 BCE, which relates Demeter's desperate search for her daughter, Persephone, following her abduction by Hades.[5] Here, contrasts between the upper and lower worlds, the fertility of nature and sterility of death, feminine and masculine, nurture and violence, love and grief, are mapped onto a play of light and darkness. As deities, such as Hecate "of the glossy veil" (*liparokrēdemnos*, line 25), the "shining" Helios (*aglaos*, line 26), and "gold-winged" Iris (*chrysopteron*, line 314) aid the recovery of Persephone from the "misty darkness" of Hades (*zophon ēeroenta*, line 80), any sense of color is again conveyed primarily in terms of luminosity rather than hue.

This emphasis on contrast echoes aspects of Homeric epic, which led nineteenth-century scholars to posit that the Greeks suffered from some kind of cognitive deficiency in their perception of color (Gladstone 1858: 457–99; Schultz 1904; see Bradley 2011: 14–16). Certainly, early Greek theories of color place a firm emphasis on black and white, but Empedocles and others interpret these as *basic* colors rather than an absence or *negation* of color. Like the four elements, black and white form primary units that combine to

form other tones (Diels and Kranz 1951: Empedokles B21, B23, B71, B96).[6] In a hymn that maps contrasts of gender, emotion, and social role onto cosmic antitheses associated with life, death, and the seasons, it makes sense that the poem's chromatic landscape should be expressed in binary terms (Irwin 1974: 111–203). This need not suggest an undeveloped sense of color, however, for the hymn is tinted by chromatic complexities that guide us through the narrative, orienting our relationship both to the divinities that appear within it and to the ritual backdrop that shaped its production and reception.[7]

Within the *Hymn*'s spectrum of color, we experience a dramatic contrast between the "dark robe" (*kyaneos peplos*) of the grief-stricken Demeter as she roams the earth in disguise as an old crone (lines 42, 182–3, 319, 360, 374, 442, 374) and the "radiance" that shines from her body when she reveals her true divinity to mortals (lines 189, 278). At the *Hymn*'s climactic moment of epiphany at Eleusis (site of her future cult), the blazing effect of Demeter's manifestation is reinforced by her "flaxen hair" (*xanthai komai*, line 279). Like the Latin *flavus*, *xanthos* is often translated as "yellow," "golden," or "blond," and is associated with the rippling, glistening, many-stranded texture of both hair and corn.[8] Demeter's epiphany thus introduces a more saturated sense of color into the *Hymn*'s palette, simultaneously implying the play of light and the texture of matter; like Catullus' *candida diva*, *xanthos* captures the anthropomorphic paradox that is so fundamental to the operations of Greco-Roman divinity, in that it characterizes both the physical properties of body and a luminosity that transcends the corporeal. In Demeter's case, "corn-light hairs" also embody the substance in which her authority as goddess of agriculture resides, triangulating the god–body relationship with the plant matter that defines her power.

The *Hymn*'s revelation of *xanthē Dēmētēr* (line 302) provides a close contrast with both the "dark-colored" (*kyaneos*) robe she wears in mourning and "dark-haired Hades" himself (*kyanochaita*, line 347).[9] Like *xanthos*, *kyaneos* resists translation in terms of hue: it conveys a rich blue-black associated with deeply colored, glossy materials such as lapis lazuli, dark-blue enamel, or sea-water, and is applied to supernatural phenomena ranging from the monstrous Scylla's cave to Zeus's mighty eyebrows (Homer 1995: 12.75; 1999: 1.528; see Irwin 1974: 79–110; Grand-Clément 2011: 121–8, 373–4). The epithet "dark (blue)-haired" (*kyanochaita*) is frequently applied to Poseidon (Homer 1999: 13.563), while *kyaneos* also describes the hair and eyes of Dionysus (West 2003: 7.5, 15). In both cases, it brings together a sense of the deity's physical domain (the blue depths of the sea or the purplish-blue sheen of grapes and wine) with an impression of texture and luminosity that highlights striking features of a divine body.[10] In the *Hymn to Demeter*, *kyaneos* does not map straightforwardly onto contrasts between the Olympian and the chthonian (the upper and lower worlds), but characterizes both Demeter's robe and Hades' hair; indeed,

Demeter herself was worshipped at Phigaleia in Arcadia as Demeter *Melaina*, "Black," perhaps because of her chthonic associations.[11] For both Demeter and Hades, *kyaneos* resonates with notions of loss and the netherworld, yet it also conveys a divine intensity that marks a sense of force and presence—one that is apprehensible even when deities are in disguise.

Both *kyaneos* and *xanthos* are paradigmatic of the challenges posed by early Greek color terms insofar as they convey aspects of value, luster, texture, depth, and intensity over those of hue. In their semantic complexity and synesthetic range, they act as "pivots" or reference points for clusters of qualities, effects, and associations that activate several cognitive domains (Clarke 2004; Bradley 2011: 16–17). In particular, they define aspects of the gods' appearance that operate at the outer edges of their bodies: like Zeus's epithet "black with clouds" (*kelainephei*, lines 91, 316, 396), features of divinity that attract color terms tend to be those such as hair and clothing that frame, cover, or conceal divine form rather than constitute its essence. As such, they occupy an indeterminate category, hovering at the edge of tangible matter. When divine attributes are defined in terms of color, they are frequently "golden" (*chryseos*), such as Demeter "of the golden sword" (line 4), the "golden chariot" of Hades (line 19), or "gold-winged" Iris (line 314). The term *chryseos* is frequently applied to divine attributes or body parts in the Homeric poems—to eyes, hair, arms, jewels, garments, and weapons (Grand-Clément 2016: 123–4); in the Homeric epics, Aphrodite is repeatedly described as *chryseē*, "golden" (Homer 1995: 8.337, 17.37; 1999: 3.54, 5.427). *Chryseos*, of course, is inextricably identified with *chrysos*, the material of gold itself; but it also conveys a sense of radiance, value, purity, power, and desirability that is constitutive of divinity. Gold, too, is an ambiguous substance, being both bound to matter and transcendent of it (Lapatin 2015a: 19–33; Zorach and Phillips 2016).

The role of color in poetic accounts of divine body is thus complex: color may be inherent within specific substances, from corn-blonde locks and golden attributes to dark-toned hair and garments, yet these substances constitute surfaces and appendages rather than bodies themselves. Manon Brouillet (2016) has observed how the properties of specific materials (and their capacity to be perceived by the human senses) are used to define the material assemblages through which the Homeric gods enact their power. These establish a "zone of contact" between gods and mortals, marked by physical properties such as radiance, richness, sonority, and splendor, which shape human experiences of divine body. The relative rarity of color terms in Homeric Greek means that when they *are* used, they saturate the senses with a brilliance and intensity that underlines the potency of divine presence, despite the limited range of hues that they convey. As a property of the outer surface of body, color (*chrōma*) is derived from the Greek term *chrōs*, which is applied to both skin and flesh—the body's visible (and vulnerable) outer coverings (Carastro 2009). In the case

of the gods, the *chrōmata* of hair, clothing, and attributes construct a kind of corporeality defined by its radiance and intensity—a set of gleaming and reflective surfaces that project divinity and construct a sense of interiority, while revealing little about the substance of divine body itself.

So far, we have focused on the application of specific color terms to deities in the *Hymn to Demeter*. In their controlled palette, these might seem to reinforce earlier assumptions about the Greeks' limited chromatic range, whether due to constraints of cognition or language (Kay et al. 2009). Yet if we look beyond terminology to the role played by colored objects in the hymnic narrative, we see a very different picture. In particular, our attention is drawn to the salient colors of items that the gods *touch*, which form a point of contact between divine bodies and the world of the mortal reader/worshiper. In this sense, the hymn is framed by two prominent objects that determine Persephone's descent into Hades and the terms of her return to Demeter (Suter 2002): the narcissus flower "that Earth put forth as a snare for the maiden with eyes like buds" (lines 8–9, 428) and the pomegranate seeds that Persephone confesses to having eaten in the Underworld (lines 372, 412).

The narcissus blooms in a meadow of flowers whose names suggest a panoply of colors—"roses and saffron and lovely violets, iris and hyacinth" (lines 6–7); significantly, the Greek term *anthos* "flower, blossom," is also used to refer to dyes and to bright colors in general. Amidst this polychrome landscape, the narcissus is described as a *sebas*, an object of "reverential awe," which "shines wondrously" for humans and gods alike (line 10). While this initial description emphasizes the flower's radiance, assimilating it to the luminosity of the divine, it is later described as being "like saffron" (*krokon*, line 428). Commentators have identified it as the *Narcissus tazetta*, with its creamy white petals and deep orangey-yellow center, clusters of which grow in low-lying parts of Greece from autumn to early spring (Richardson 1974: 144), though the specific varietals and colors of flowers in Greek texts can be difficult to determine (Grand-Clément 2011: 103–4).[12]

Like color terms, references to flowers and fruit stimulate several cognitive domains simultaneously, generating a sense of hue, saturation, texture, fragrance, and taste, as well as specific symbolic associations. In particular, the saffron crocus (*Crocus sativus*) with its famously red-gold filaments is associated with the initiation of young women into marriage (Grand-Clément 2011: 170–2, 390–2)—an association that is later echoed in Catullus' description of Cupid "in his saffron tunic" (Catullus 68.134). In lending its color to the *narkissos* flower plucked by Persephone, saffron functions as a dramatic "shifter" within the text, symbolizing and prompting the change of status that the maiden will undergo upon becoming Hades' bride. Likewise, the deep red-purple of the pomegranate seed reinforces Persephone's new status as wife: the irruption of its intense coloration into the narrative toward the hymn's close emphasizes

that, given her daughter's loss of virginity, Demeter's quest will be denied any straightforward resolution.

Between the chromatic potency of the narcissus and the pomegranate stands the red wine (*oinon erythron*, line 208) that Demeter explicitly rejects during her stay in Eleusis, in favor of the *kykeon* (a mixture of water, barley, and herbs).[13] In turning away from a red liquid and aligning herself with the paler fluid that was customarily imbibed during the Eleusinian Mysteries, Demeter establishes and consecrates the fundamental rituals of her cult, while rejecting a shade associated with blood, death, and the loss of virginity (Wunderlich 1925). In contrast to the red-toned signs of rupture that mark her daughter's transition to the spheres of marriage and Hades, Demeter's drink aligns her with the "white grain" (*kri leukon*, lines 309, 452) that is sown in vain by mankind upon the barren earth, awaiting its transformation into the "long ears of corn" that will grow once spring returns (line 454). Here at the hymn's close, the verb *komaō*, "to let grow," echoes the "corn-light hair" (*xanthai komai*) that had characterized Demeter's epiphany at Eleusis, uniting the goddess and the agrarian sphere over which she presides in celebration of a return to cosmic order.

The *Hymn to Demeter* paints a carefully controlled world of light and shade in which more saturated colors emerge at key moments in the poetic narrative. The dominant tones of darkness (*kyaneos*), light (*xanthos, chryseos, leukos*), and red (*erythros*) establish a strong, stark palette akin to that found in the Homeric epics, commonly referred to as the "Homeric triad" (Rowe 1972). Alternatively, we might emphasize the *Hymn*'s contrast between rich, golden-yellow tones (Demeter's "corn-light hair," the saffron and narcissus, the golden attributes of the gods) and the deep red-purple of wine and pomegranate. Added to those of black and white, these comprise the four pigments that would later be associated with the "Four Color Painters" of the fifth and fourth centuries BCE (Gage 1999: 29–32). Just as Greek philosophers sought to define color in terms of four "basic" elements, so the *Hymn to Demeter* establishes a concentrated "chromatosphere" that actually serves to define the entire cosmos. It would be wrong to cast this palette as primitive; just as epic uses of color are far more diverse and self-aware than earlier scholarship permitted, so the tonal play of the *Homeric Hymns* is markedly nuanced. In particular, color can be understood according to a relationship of figure and ground, in which a general contrast between darkness and light is punctuated by highly saturated images, often related to salient features or objects charged with symbolic meaning (Jones and McGregor 2002: 11–12). These moments of intense coloration orient the hymn's audience to nodes of communication between mortals and deities. They mark confluences of being and matter where the gods make their bodies visible as sensible phenomena, products of nature that instantiate divine presence and authority within the mortal sphere, and objects that facilitate ritual

participation. There is, in effect, a particular *theology* to the use of color in the Homeric poems, a chromatic framework within which the gods' identities and their relationships with mortals might be defined and celebrated.

MATERIALIZING DIVINE COLOR

Literary accounts of the gods face a double challenge: they must convey the visual experience of color by means of language, with all its limitations, while wrestling with the elusive nature of divine bodies and their complicated relationship to the material stuff of mortal experience. When it comes to instantiating the gods in image form, the relationship between color, divinity, and matter takes center stage.[14] Making the gods present for their worshippers by means of physical objects raises questions about representation, materials, and human skill. What should the gods look like? What should their images be made of? How far can physical media and human artistry capture divine form?

Color intersects with these questions in diverse ways. On the one hand, colors are understood as inherent properties of matter, inseparable from qualities such as value, texture, density, and luminosity; color thus plays a crucial role in the selection of materials for sacred images, whether they be precious metals, ivory, glass, or colored stones, including gleaming white marble. It is no accident that gold and ivory—the prime components of chryselephantine cult statues such as Pheidias' Olympian Zeus and Athena Parthenos—emulate the effects of color and light that are associated with divine epiphany in the Homeric poems (Lapatin 2001: 61–95; see Figure 4.3). The golden glow and white gleam of such statues do not merely project a visual impression; their sanctity is intrinsic to the rare, valuable materials from which they are formed. On the other hand, color can be understood as a visual effect that is applied to surfaces—whether through gilding (*chrysōsis*), the application of pigments (*ganōsis*),[15] or the dressing of statues in dyed, woven, or embroidered fabrics (*kosmēsis*).[16] In contrast to the Athena Parthenos, for example, the ancient olive-wood image of Athena Polias, displayed in the Erechtheion, Athens, was ritually dressed in a *peplos* (women's full-length garment), which Euripides describes as saffron-colored (*krokeos*), embroidered "with threads of flowered hue" (*anthrokrokoisi pinais*, Euripides 2005: *Hecuba*, line 468); elsewhere it is described as *huakinthinos*, "hyacinth-colored."[17] Here, color is still bound to matter, but that matter is primarily understood as a coating or clothing for other materials.

The double function of *chrōma*, "color," in Greek parallels the term from which it is derived, *chrōs*, "skin, flesh": both can constitute the substance from which a body is made and the outer envelope of that body (Carastro 2009; Stager 2016). The duality of color—as both inherent to matter and comprising its visible outer surface—further complicates its relationship to artistic representation. Color can be understood as an intrinsic property or effect that emerges naturally

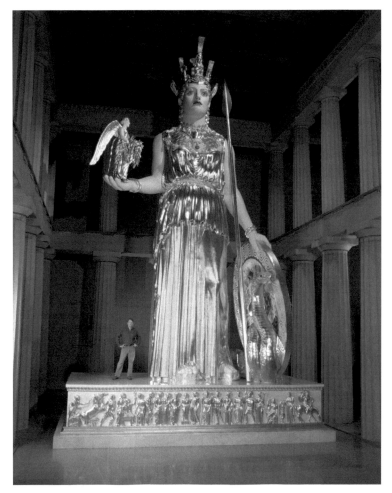

FIGURE 4.3 Alan LeQuire, Reconstruction of Pheidias' Athena Parthenos, 1990. Parthenon, Nashville. Photograph by Dean Dixon. Wikimedia Commons. https://commons.wikimedia.org/wiki/File:Athena_at_Parthenon_in_Nashville,_TN,_US.jpg.

from the substance of which it is part, or it can be extracted, processed, and applied in order to imitate something else, such as flesh, eye-color, or patterned fabric. It is thus part of the toolbox of imitation, even disguising the materiality of the objects it coats (Bradley 2009b). In this light, it is interesting to observe how many sacred images in antiquity were acrolithic (composite statues made of many parts). This technique allowed for the creation of commanding, over life-size sculptures such as those of Pheidias, but also for the use of different materials, the colors and properties of which could represent diverse features including eyeballs, hair, flesh, or drapery. In acrolithic sculpture, color and matter worked together to generate the effect of a variegated but unified whole,

often enhanced by painted or gilded details and metal accessories (Ridgway 1990). Together, they created *poikilia*—that pleasing "multifariousness" noted above, which was fundamental to the reciprocal *charis* (grace) through which the gods were honored and made present for their worshippers. Nothing could be further from the notion of bleached-white marble gods that Western culture has inherited from neoclassicism, an aesthetic that repeatedly celebrates form rather than matter (Platt 2016b).

To explore how these ideas might apply to specific ancient artifacts, let us examine a column-krater from southern Italy, dated 360–50 BCE (see Figure 4.4).[18] The scene is dominated by a statue of Heracles positioned on

FIGURE 4.4 Column-krater from Apulia, 360–50 BCE. The Metropolitan Museum of Art, Rogers Fund, 1950. Accession number 50.11.4.

a high base, observed by his father Zeus (on the upper left) and Nike, goddess of victory (on the upper right), while to the center right, a "living" version of Heracles observes his own statue in wonder. Meanwhile, a craftsman applies paint to the statue's lion skin, using a brush and pigment from a small pot, while to the left, his assistant heats rods over a brazier. We see here a rare depiction of the process of *ganōsis*, in which wax pigments were applied to statues by means of encaustic painting. The vase itself is made of terra-cotta and painted in the red-figure technique: it thus offers a world that may be *imagined* as polychrome but that is primarily depicted in monochrome. Against this stark binary of black and red, further pigments are applied in a clay slip, marking out the bright white of Heracles' statue and the orangey-yellow of the brazier, which may be intended to convey bronze as well as the heat of the coals.

How are we to interpret Heracles' whiteness here? Is it meant to suggest the gleaming skin of a deity, casting Heracles as a *candidus divus*? Although the skin of heroes is occasionally described as white in the Homeric poems, masculine figures (whether human or divine) are traditionally painted red in Greek and South Italian vase-painting, and white slip is reserved for females. Moreover, the figure of the "living" Heracles, to the right, is in monochrome, save for the white teeth of his lion-skin cloak. A more convincing explanation is that the white slip is intended to look like gleaming, white marble.[19] The application of an additional color draws our attention to the material from which sacred images are often carved. Within the imagined polychromy of the scene, however, the painted details applied to the statue through the process of *ganōsis* are rendered in red-figure. The *absence* of additional pigment on the surface of the krater paradoxically indicates the *presence* of different colors upon the painted surface of the statue, which create the dappled (*poikilios*) effect of the lion's skin and mane. We are invited to imagine how, as the painter completes his work and paints Heracles' entire body, the statue will slip back into the red-figure world that comprises the rest of the scene. The linear realm of red-figure is presented to us as the "real" polychrome sphere of the gods, who observe the statue's transformation from colored matter into a naturalistically rendered deity. Color facilitates the object's transition from mere object to mimetic image: it makes the gods visible to themselves. In this sense, *ganōsis* is understood not as a simple process of surface application, but as a conjuring of liveliness that animates and activates the image. Grand-Clément compares this process to an act of sanctification or even consecration; the regular repainting and regilding of sacred statues parallels ritual acts of washing and adorning them in religious festivals (Grand-Clément 2011: 275–6).

The Heracles krater raises vital questions about the painting of marble statues in antiquity. In depicting the deified hero observing his own image, it suggests there is a critical gap between a representation and its living model, which the application of color has the potential to overcome. Tellingly, Heracles' attributes

receive this treatment first, with the coloration of his lion-skin cloak and bow bridging the gap between deity and human viewer by means of mediatory objects as in the *Homeric Hymn* discussed above. But how naturalistic might the painted marble have been, once completed? Would it have entered fully into the polychrome world of its environment? Or would it have retained an element of its blinding whiteness, marking it out as something *different* from the mortal bodies of Heracles' worshippers?

As far as we can tell from literary sources, the period in which this krater was produced (the mid-fourth century BCE) marked an important shift in the tinting of marble statues. During the Archaic period, the colors preferred for statuary in religious sanctuaries seem to have favored a bright, saturated hyper-realism, as suggested by pigment traces recovered by Vinzenz Brinkmann and reproduced on plaster casts (see Figure 4.5), as well as the Pitsa panel discussed

FIGURE 4.5 Painted plaster cast of the *c.* 530 BCE "Peplos Kore" as Artemis, based on pigments determined through analysis. By Vinzenz Brinkmann. Glyptotek, Munich. Photograph by Giovani dall'Orto. Wikimedia Commons. https://commons. wikimedia.org/wiki/File:Istanbul_-_Museo_archeologico_-_Mostra_sul_colore_ nell%27antichit%C3%A0_01_-_Foto_G._Dall%27Orto_28-5-2006.jpg.

above.[20] By the late classical period, sculptors seem to have preferred a more delicate, lifelike look, as famously preserved on Praxiteles' *Aphrodite of Knidos* (known as the Knidia), dated *c.* 350 BCE and known to us through several Roman copies.[21]

Pliny the Elder tells us that Praxiteles and his colorist, Nicias, were especially celebrated for perfecting the art of painting with wax (Pliny the Elder 1952: 35.39, 35.40.133); the extraordinary sense of corporeal presence and epiphanic intensity projected by the Knidia was achieved through a combination of eroticized form and naturalistic pigmentation, in which the process of *ganōsis* played a crucial role in fashioning the statue's sanctity and desirability. Nevertheless, the application of pigments to marble did not conceal or efface the qualities of the stone altogether (Bradley 2009b); sources tell us that the Knidia was made of Parian marble, celebrated in antiquity for its dazzling whiteness (Pseudo-Lucian, see Lucian 1967b: *Amores*, 13). Whether or not Praxiteles used this marble in particular, the desire to emphasize its color and origin reinforces the statue's materiality, suggesting a unity of substance, appearance, and effect. As with Catullus' *candida diva*, the Knidia's gleaming whiteness makes her stand out as highly desirable in anthropomorphic terms, yet simultaneously more than human; the properties of radiance, beauty, and permanence associated with marble are aligned with the nature and identity of the deity herself. It makes sense, then, that the scene of *ganōsis* we see upon the Heracles krater seeks to have it both ways, for the scene simultaneously celebrates the mimetic potential of the painted surface while emphasizing the material luminosity of its marble substrate. Both elements of the statue are sources of wonder (*thauma*), as the "living" Heracles expresses astonishment both at his transformation into a material object and at the power of such objects to make the gods visible.

CONCLUSION

She's like a rainbow,
Coming colors in the air
Oh, everywhere
She comes in colors.
(*She's a Rainbow*, The Rolling Stones, 1967)

The question of the Knidian Aphrodite's color, or that of marble versus painted flesh, illustrates the ever-shifting relationship between divine color and materiality in the Greco-Roman cultural imagination. In *Zeus the Tragic Actor*, a second century CE text by the Greek satirist Lucian, Aphrodite's color even generates a theological crisis (Branham 1989: 167–77). Called to an assembly by Zeus, who is concerned that the gods are no longer honored by mortals, each deity is seated "according to his material and workmanship, those of gold in the

front row, then next to them those of silver, then all those of ivory, then those of bronze or stone" (7). This prioritization of matter (*hylē*) is challenged by Aphrodite (10): for while Hermes claims she is made "of white stone [...] turned into Aphrodite and put into the care of the Knidians," she herself claims a place in the front row, for "Homer says [...] that I am 'golden Aphrodite'." Here, "white marble" (*leukos lithos*) is rivaled by the goddess's "golden" Homeric epithet (*chryseos*). The authority of her most famous material image is explicitly challenged by the language of epic poetry: the visual skill of Praxiteles is pitted against the verbal skill of Homer, and the aesthetic value of classical naturalism is trumped by Archaic grandeur.

Color here emerges as a powerful tool with which to question the authority of religious and cultural tradition, as well as the constructed nature of both language and visual representation. It points to the inherent multiplicity of Greek polytheism, in which the color, form, attributes, and significance of each deity could vary dramatically according to cult practice, geographical location, or literary genre. We might note that the poet Anacreon describes Aphrodite as "purple" (Anacreon 1988: 54–5, fragment 357) and that in Athens, the statue of Aphrodite *Pandemos* was dressed in purple clothing (Mansfield 1985: 448), while at Paphos on Cyprus she was worshipped in the form of the black "Aphrodite stone"—supposedly a meteorite that had fallen from heaven (Maier 1979: 228). At Athens, valuable murex dye produced by shellfish (and thus from the sea from which she was born) suggests a value, brightness, and iridescence that is repeatedly associated with the realm of the divine (Grand-Clément 2016); conversely, the black aniconism of Aphrodite's stone on Cyprus suggests an otherworldly origin that defies all mortal comprehension. Whether white, golden, purple, or black, the colors of Aphrodite mark an intense and exciting zone of contact wherein her divinity might be imagined and apprehended by her human worshippers. This is indeed a goddess who "comes in colors." Yet like the ever-elusive rainbow, the colors of the gods are marked by a particular epistemological ambiguity: they offer a phenomenon by which divinity might be made visible within the sensible world, yet maintain an indeterminacy that is critical to any conception of the supernatural.

CHAPTER FIVE

Body and Clothing

LLOYD LLEWELLYN-JONES

What colors did the Greeks and Romans choose to wear in their clothes? This seems to be a simple enough question, but do not ask for or expect a clear answer. Over the many years I have worked on the theme of dress in antiquity, I have developed a suspicion that trying to answer this question with a knowledge of modern color semantics is unworkable, and any attempt to determine the exact criteria by which the clothing of antiquity was regarded as "colorful" is a next to hopeless exercise (see André 1949; Osborne 1968; Maxwell-Stuart 1981; Eco 1985: 157–75). I can say, though, that the Greeks and Romans did not *only* wear colorless (that is to say, white) garments; let us firmly and decisively put that misconception to bed once and for all. Centuries' worth of artistic misrepresentations of classical dress have led us to this, the most rooted, of historical inaccuracies. (For recent discussions of color in ancient dress, see Sebesta 1994; Cleland 2004b; Cleland and Stears 2004; Lee 2015: 93–5; Olson 2017: 106.)

Greek and Roman clothing flashed and zinged with color and pattern, and dress could be as garish as the painted sculptures and reliefs that are now the focus of much-needed scholarly attention (thanks mainly to the Tracking Color Project at the Ny Carlsberg Glyptotek in Copenhagen; Brinkmann et al. 2017a). Of course, we must be careful not to transpose the rather limited color palettes that were used by artists to paint the marble sculptures onto the delicate textiles of the Greeks and Romans. But there may well have been some correlation between the colors chosen to paint marble statues and the colors employed in textile construction, if only of a symbolic nature (Skovmøller 2014). At the very least we can now confirm that the world of Greece and Rome was vibrantly colorful, and that dress added considerably to that visual richness.

THE "WRITTEN GARMENT"

In his important study of dress and fashion, Roland Barthes commented,

> At first sight, human clothing is a very promising subject to research or reflect upon: it is a complete phenomenon, the study of which requires at any one time a history, an economy, an ethnology, a technology and maybe even, as we will see in a moment, a type of linguistics. But above all, as an object of appearance.
>
> (Barthes 2005: 20)

Barthes noted that in contemporary fashion magazines there is always an image accompanied by text; there is always, therefore, image-clothing, accompanied by the written-garment. Both of these phenomena exist in relation to what Barthes calls "real clothing"—that is to say, the physical, worn garments themselves, which are (or can be) divorced from both image and text. "Real clothing" must be known not by sight, because its visual image does not reveal all its intricacies, but must be known through the mechanical process of its production: the seams, the pleats, and the fastenings as they are manufactured. Image-clothing is manifest through iconic structures and the written-garment is manifest in verbal structures.

Barthes makes the verbal structures of the written-garment the focus of his seminal study, and although he does not deny that real clothing also works within a "sign system," in the end Barthes felt that:

> language conveys a choice and imposes it, it requires the perception of this dress to stop here (i.e., neither before nor beyond), it arrests the level of reading at its fabric, at its belt, at the accessory which adorns it. [...] The image freezes an endless number of possibilities, words determine a single certainty.
>
> (Barthes 2005: 13)

Now, given the almost total lack of complete, "real" garments that have survived from classical antiquity, and the difficulties we have (as we have noted) in distinguishing the real from the imaginary in representations of dress depicted in ancient art, then inevitably we are forced to look at the texts themselves to access the lost world of ancient textiles and color. (On the archaeology of dress items, see Barber 1991; Carroll and Wild 2012; Harlow and Nosch 2014b. On the artistic distortion of dress and the body, see especially Llewellyn-Jones 2002.) The surviving fragmentary records of the treasury at the sanctuary of Artemis Brauronia on the Athenian Acropolis give a remarkable and unexpected glimpse into the colorful world of ancient dress (Linders 1972; Cleland 2005; Brøns 2017; Gaspa et al. 2017). This fifth-century BCE list of clothing dedications offered to the goddess by pious

worshippers (mainly women) gives us both a catalog of clothing terminology and an indication of the colors encountered in the dress of the Athenians. Here are some typical extracts:

> a purple *chitoniskos* [short tunic], patterned all over [...]; a *chitoniskos*, patterned, purple, in a [presentation] case [...] Pheidulla [dedicated] a woman's white *himation* [mantle] [...]; Mneso [gives] a frog-colored garment [...]; Nausis [dedicated] a woman's himation with a wide purple wavy border all round [...]; Glukera, Xanthippos' wife, [dedicated] a *chitoniskos* with a border of washed-out purple [...] a child's *chitoniskion*, shorn-smooth [...] it has a crimson parabolic stripe [...] a light-colored summer dress [...] a *chitoniskos* with a purple wavy border [...] blue-gray robe [...] broom yellow garment [...] a quince-colored *chitoniskos* [...]; Hedule [dedicated] a child's saffron *chitoniskos* [...] a frog-colored garment with an encircling wrap, patterned all over [...] a white head-veil having ribbons [...] a fine veil [...] having gold-plated spangles along the ribbons [...] an embroidered luxurious wrap [...] *himation* with purple in the middle [...] a [...] yellow *chitonion* with a purple border [...]; Teleso [dedicated] a frog-colored garment.
>
> (Cleland 2005: 30–5)

The difficulties posed by this text are many, and our imperfect understanding of ancient clothing terminologies and color terms is made starkly real when we attempt to translate the Greek original. We are as much hostages to the vagaries of language as was Barthes, but more so, it transpires, since we do not have either image-clothing or real-clothing to help us, and we must therefore be completely reliant upon decoding the "written-garments" of the ancient past.

The Brauron catalog describes ninety of its 158 listed garments by color; thirty-three of the descriptions focus on a base hue, usually purple, white, saffron, and "frog-colored"—the last-named perhaps a range of green-browns. Less common are garments describing more delicate or transitory colors: *glaukeion* (blue-gray), *thapasion* (broom-yellow), and *melinon* (quince-colored). The text also mentions colored decoration applied to the garments—simple borders, complex borders, and colored areas. In fact, seventy-two of the 158 garments are described through reference to such applied decorations.

This "vestimentary code," as Liza Cleland classifies it in her important study of the Brauron clothing catalogs, "cannot exist without language, [but] language cannot accurately convey information [...] about clothing" (Cleland 2005: 12). It is clear that in the Brauron inscriptions we are dealing with written-clothing and, as Cleland comments,

> the overall implication is that all the colors which are explicitly marked in these descriptions were remarkable, either in themselves, or in terms of the

garment of which they form part [...] The idea also applies to decoration—
although the presence of decoration is frequently asserted, its color is only
marked if that color was purple.

(80–1)

What constituted an Athenian conception of "purple" is, of course, fluid. The
Barthian construct read into the Brauron catalog can, and perhaps should, be
applied to the study of all ancient texts, which create a language of dress that
is crafted through words. As imperfect as this endeavor might be, it is, with
the exception of a few faded archaeological textile scraps, our only remaining
access to the color-world of ancient clothing.

COLORS AND DYE-STUFFS

Let me begin with a general overview of the color palette of ancient clothing.
Most clothing for everyday use, and certainly the ordinary dress of the poor,
which was made from wool or hemp, was of dull or indeterminate color,
displaying either the natural colors of textile fibers or of low-quality, non-
fast, plant dyes, which provided little depth of hue or color saturation (Zisis
1955). The everyday dress of antiquity was, for the most part, a series of muted
browns and washed-out pastel-shades. Clothing regulations and mourning
conventions imply that most Greeks possessed at least one white or notably
light garment, probably of linen, which is easy to bleach but difficult to dye,
and one black, or notably dark garment of easy-to-dye wool, but beyond that,
the "fancy" clothing of ordinary people was probably distinguished by woven
patterns (especially striped borders) rather than by hue (Mills 1984; Ogden
2002; Lee 2015: 214–24; Brøns 2017: 324–64; on patterned borders, see
especially Spantidaki 2014 and Harlizius-Klück and Fanfani 2016).

The Romans, though, clearly valued brightly colored clothing, and even
among the poor, plain tunics and cloaks were decorated with contrasting stripes
or borders and worn with belts of various colors and shades (Bradley 2009a:
128–211). For the Romans, colors were not all universally appropriate: dark
colors (*pullus*) were strictly for mourning, while bright white (*candidus*) was
used by politicians canvassing; ordinary soldiers probably wore off-white tunics
and yellow-brown cloaks, but higher ranks may have worn red, while the scarlet
paludamentum, or military cloak, was for generals only; patricians wore a
special sort of dark pinkish-red shoe (*mulleus calceus*). However, certain colors,
such as purple and scarlet, were especially highly prized by the Romans and
were worn regularly by those who could afford them. Although literary sources
record a wide range of hues and shades for both male and female garments, the
exact colors referred to in texts are not always clear. The popularity of color is
nevertheless confirmed by representations of clothed figures in Etruscan tomb

FIGURE 5.1 Panel painting of a woman in a blue mantle; Egypt, *c.* 54–68 CE.
The Metropolitan Museum of Art. Accession number 2013.438.

paintings, Roman wall paintings and mosaics, and—importantly—the Egyptian
mummy portraits from the Fayum, which perhaps give the most accurate
reflection of clothing from any place or period in antiquity (Walker and
Bierbrier 1997; Roberts 2008). But on the whole, it is important to remember
that the colors used in artworks may have been chosen because they were easily
available in that artistic medium rather than for faithfully recording actual use
(see Figures 5.1 and 5.2).

In the literary sources, color in ancient clothing is often described in very
general terms by using words denoting pattern or brightness, without hue. For
instance, we find *anthēropoikilos* "decorated with flowers" (see Figure 5.3),

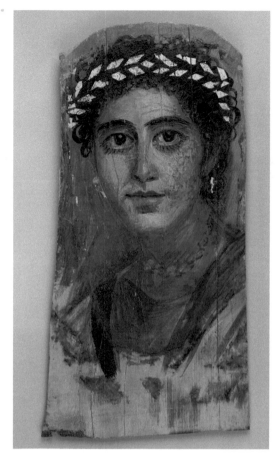

FIGURE 5.2 Portrait of a young woman in red; Egypt, *c.* 90–120 CE.
The Metropolitan Museum of Art. Accession number 09.181.6.

anthinos "brightly colored, flower decorated," *baptos* "dyed," *poikilos* "colored, well-worked," and *lampros* "bright." Furthermore—and frustratingly for scholars of ancient dress—many garments were described purely by their color, without reference to their form or to the manner of their wearing, for example, *batrachis* "frog-green garment," *flammeum* "yellow-red garment," *halourgēma* "purple garment," and *krokōtos* "saffron colored." However, other garments, such as the Greek *baukides*, which were elaborate saffron-dyed shoes or boots, *ependytēs*, a tunic-like garment of purple wool or linen, and the *himation nymphikon*, a saffron-dyed mantle, were persistently associated with a particular color (for the garments themselves, see Lee 2015). In Rome, Latin terminology could highlight both color and garment type. Indeed, symbolically colored garments are generally described using both the color and the garment-type

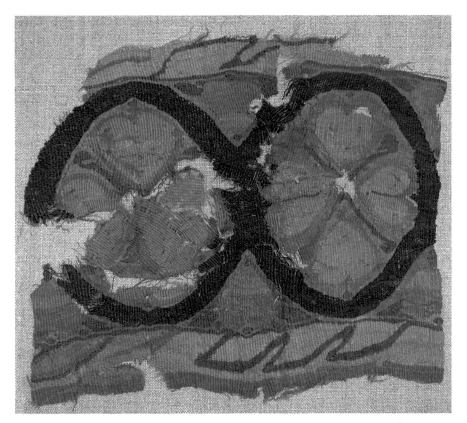

FIGURE 5.3 Fragment of a band with a floral motif in subtle shades of red and pink with green details. Linen and wool, *c.* 500 CE. The Metropolitan Museum of Art. Gift of Nanette B. Kelekian, in honor of Nobuko Kajitani, 2002. Accession number 2002.239.1.

terms (Sebesta 1994), such as the *luteum soccum* (a yellow bridal slipper), the *toga pulla* (a dark toga worn in mourning), the *toga pura* (an unadorned toga in the natural, off-white, brownish color of wool), the *toga purpurea* (a toga of purple-dyed wool, worn in triumphs and associated with emperors), or the *tunica pulla* (an undyed or unbleached tunic, somewhat cheap and therefore regarded as inappropriate for Roman governors).

DYEING AND GARMENT CARE

Throughout classical antiquity, a wide variety of textile colors were available from a range of natural dyes, although this scope of color—especially many more bright colors—increased greatly during the Hellenistic and Roman periods due to the expansion of trade and the development of dyeing as a specialist, large-scale enterprise. Roman *tinctores*, for instance, had their own guilds in

major towns (Forbes 1955, 1956, 1966; see also Becker, this volume). These developments meant that an expanded range of dyestuffs could be maximized by complex processes requiring relatively rare mordants (inorganic oxides that fix dyes in textiles). It is in this period that we first have written technical records of dyeing practices, particularly the papyri of Hellenistic Egypt. These indicate that dyeing was already a highly developed, well-established enterprise, which makes it clear that the earliest emergence of written evidence should not be confused with any radical technical change. Earlier archaeological and literary evidence for dyeing is minimized because, in the "cottage industries" of home textile manufacture, its equipment and processes probably overlapped considerably with cooking and other domestic tasks, although evidence exists for early large-scale dyeing operations at Bronze Age Mycenae and in early Corinth (Leggett 1944).

Remarkably, the fundamental processes of natural dyeing have remained relatively unchanged from prehistory to the present. Certain plants and a very few shellfish and insects contain chemically active color compounds, which, once extracted, are induced to combine with natural fibers, producing relatively stable colors. Sometimes this is simply by infusion of the dye and the textile in hot water, as for saffron, but at the other end of the scale, shellfish purple dyes require an immensely complex, still imperfectly understood, process to render them water-soluble and to bond them with fibers to obtain particular colors. Most plant dyes, however, fall between these extremes, with many requiring an additional chemical, or mordant, for a stable color. A relatively small number of plant sources give fairly fast and distinctive colors on most fiber types using simple processes and common mordants. These include woad (*isatin, glastum*) for blue; madder (*erythros, rubia*) for red; and weld (*ochra, luteus*) for yellow— the dyes most commonly referenced in the classical texts. However, these are a tiny fraction of potential sources from which dyes might be extracted, although most of the others give relatively non-fast, dull colors in the yellow-green-brown range. Accordingly, it must be recognized that fast, bright colors were prized in ancient clothing because of the cost involved in creating them. Well-dyed garments were a mark of conspicuous consumption. Nevertheless, non-fastness could be overcome by re-dyeing garments, or overdyeing them to a darker color, although these practices would in turn have increased the value of colored decoration, reliant on fast color. Of course, high-quality dyes would only be applied to the best fabrics, but neither the physical colors of cloth nor the lexical terms used to describe them were as fixed as they are now. For instance, *melas* (black) referred to any dark color, and ancient "purple" terms extended from "cold" blues to "hot" reds. Compounds and derivatives of *krokos* (saffron) referred only to saffron-dyed clothing and tended to denote red and (perhaps) a deep orange, but did not denote yellow (see Llewellyn-Jones 2003: 224–5).

Maintaining colors and color-intensity in ancient garments was difficult. We wash most of our clothes to remove dirt; in antiquity this was sometimes done too and, indeed, washing scenes are a *topos* in classical literature, often emphasizing and romanticizing the work of young women. Such scenes occur around rivers, as other water supplies were often limited. Of course, there was always a danger the dyes would fade or simply run out of the garments when washed. Thus much attention had to be given to caring for dyed fabrics, which were always stored folded in the dark, dry, environment of a chest (Lee 2015: 30), and to preserving or renewing their desired appearance. Brushing and bleaching a garment in the air and sun might ultimately restore its appeal; white and light-colored garments in particular required such treatments to restore the purity of their color. White garments with colored decorated borders or sections must have been the most difficult to maintain, since washing, bleaching, and fulling to keep the white pure would have degraded the colors of many dyes used in creating patterned decoration.

The ancient craft of fulling—the process that involved the cleansing of cloth (particularly wool) to eliminate oils, dirt, and other impurities—was therefore very important to garment maintenance. Cloth was placed in a large tub or trough filled with urine, and the fullers used their feet to pound the textiles. The urine was a source of ammonium salts, which assisted in cleansing and whitening the cloth, although fuller's earth (a soft clay) was introduced to the process in late antiquity. Fulling could also thicken cloth by matting the fibers together to give it strength and increase waterproofing. In the case of wool this process could ultimately produce felt. Finally, clean fresh water washed away the urine or soil and removed the stench of the fulling process. Fulling formed the last stage of textile manufacture, in which white fabrics were bleached, and various other effects such as raising or polishing the nap of the textile were achieved. Garments could also be fulled throughout their life to restore their appearance.

For colored garments, fading induced by cleaning or age could be remedied by overdyeing, either with the same or a darker shade, although this too would have revealed age through an increasingly dark, dull color. Sources for dyeing with saffron emphasize this aspect of maintenance. Saffron was a special case, because a good (if temporary) color could be achieved simply by immersing the garment in a hot solution of the sweet-smelling spice. Other dyes required more complex, less pleasant processes, many of which could nevertheless be carried out at home, while better, brighter colors were achieved by sending the garment to a professional. Again, this emphasizes the luxury of colored (as opposed to textured) patterns.

In short, newly colored garments would have been visually distinctive, and the processes of maintenance would probably not have restored all their desirable qualities (Cleland 2005: 87–95). Individuals with only a few

garments would necessarily find that their garments received and showed heavy use, and that the colors of the clothing were washed out, while the wealthy could rotate garments to preserve their fresh appearance and vivid hues. It is worth emphasizing, though, to those of us living in a society in which so many have access to multiple garments and everyday cleaning facilities, that ancient clothing was rarely cheap, and that owning and maintaining most garments, however modest, represented a considerable investment of time or resources.

COLORED GARMENTS AND CULTURAL CONCEPTS

Beyond the practical application of dyes to textiles, it is clear that the many color terms in the Greek and Latin lexicons indicate the complexity of color as a subject and as a concept. Exact shades of color were impossible to maintain in the dyeing process and, as a consequence, the Greeks' and Romans' color concepts were broader and vaguer than ours. This may explain why the range of overtly symbolic colors was relatively small. Here I want to look in a little more detail at the meanings encoded in garments colored red, purple, white, and black in Greek and Roman society.

Red

White, black, and red appear to be the basic color triad in most cultures, ancient and modern, and in general, Greece and Rome are no exception to this rule. Both cultures seem to have seen red as the most "colorful" of all colors and regarded it as a paradigmatic dye-color. However, much of the symbolism attached to pure red in many cultures (for blood, sexuality, and so forth) seems in Greece and Rome to have been delegated to specific shades, especially the red-purples and yellow-red produced by saffron, which were classified through words such as *baphos*, *porphyreos*, *purpureus*, *croceus*, *flammeum*, and derivatives of *krokos*. Red was associated with military and ritual violence and clothing, for example, in Aeschylus' *Eumenides* (Aeschylus 2008a: line 1028). Outside of this, though, red garments were valued for their visibility; bright shades, such as those produced by dyeing with kermes insects, are emphasized over the red hue itself, perhaps explaining the very wide range of terms used for this color in clothing.

In ancient Greece, red was the color of clothing worn by those who stood outside society or who underwent a transition from one state of being to another (Vidal-Naquet 1980). Red woven cloths are attested covering corpses at funerals, and in the artworks (on white ground *lēkythoi*, that is, oil-flasks) red mantles are worn by Thanatos (Death) and Hypnos (Sleep), by the god Hermes in his role as the "Leader of Souls," and by Charon, the ferryman of the River Styx. Red was also a color particularly associated with the mantles

worn by Athenian *ephebes* (male adolescents) as they progressed from youth
to adulthood (Maxwell-Stuart 1981). Moreover, the offering of red fillets to
beautiful boys, who wore them wrapped around their arms and thighs at the
euandria (a right-of-passage event cum male beauty contest), confirmed that the
youths were in a transitory period of life as well as being at an age when they
were most sexually desirable. As a color that alluded to social transition, red
was particularly appropriate for the all-covering veils worn by Greek brides (La
Follette 1994; Llewellyn-Jones 2003: 223–7) (see Figure 5.4).

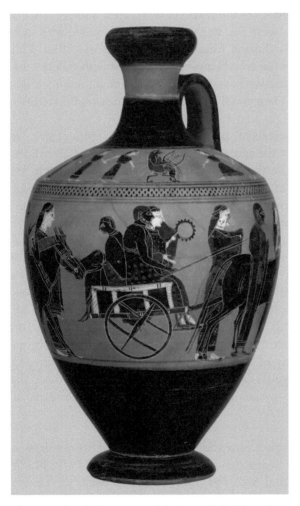

FIGURE 5.4 Bride in a red veil. Terra-cotta *lekythos* (oil flask) attributed to the Amasis
Painter; Athens, *c.* 540 BCE. The Metropolitan Museum of Art. Accession number
56.11.1.

For the Greeks, red textiles had a shining quality; this is a constant point of reference in ancient descriptions of red, which is repeatedly noted for its brilliance and luster (Philostratus 2005: Book II.24; Gage 1993: 29–33). Red took on the luminosity of starlight, for, according to Aristotle, stars are shiny because they reflect light and make things brilliant. Thus, in Apollonius Rhodius' *Argonautica* (2008: Book 1.721–4), Jason is given a splendid red mantle by Athene, which gives off an irresistible brilliance like the light of a star, and in the *Iliad* (Homer 1999: Book 6.288) Hecuba offers Athene a robe so beautiful that "it shone like a star" (see further, Aristotle 2016: 418b; 1984: *Sense and Sensibilia*, 1:439a 18; Shapiro 1980). The stellar imagery contained in these descriptions of red textiles may connect it to the series of vase paintings in which brides wear wedding veils that are decorated with star-motifs or small hatched crosses (Boston Museum of Fine Arts: 03.802). While it is possible that the decoration could consist of woven or embroidered designs, it is more probable that the stars symbolically represent shining or brightly colored red cloth and might be a visual interpretation of the common term *liparokrēdemnos*, "shining veil."

Red was perceived as a highly charged erotic color, especially when compounded by the epithet *liparos*, "shining." Thus, Bacchylides' *Ode* 17 dwells on the sexual awakening of Theseus when he meets with Amphitrite and is given the gifts of a red robe and wreath of roses, and his *Ode* 13 tells of the red veils of the Muses (*phoinikokrademnois te Mousias*), which is an apt portrait for divinities so clearly related to the notion of beauty. More notable, however, is his description, in *Ode* 11, of "Leto of the red veil" (*phoinikokrademno Latous*), an altogether appropriate connection to Leto's desirability. The mother of Apollo and Artemis naturally takes on the attributes of divinity and nobility for which red-dyed clothing is appropriate, but Leto is also a sexual being; after all, she arouses the passions of Zeus and loses her virginity to him, and spills her blood giving birth to the divine twins, although her amorous adventures do not end there. Leto is pursued and almost raped by the giant Tityus, and the iconography of this attempted violation repeatedly involves Leto's act of veiling. Bacchylides' allusion to "red-veiled Leto" is especially apposite to a goddess whose mythology is so closely connected with sexual allure.

Purple

Purple was the color par excellence of Greek and Roman dress, and its symbolic meanings have been extensively studied (Reinhold 1970; Bradley 2009a: 189–211; Enegren and Meo 2017; on the murex itself, see Lewis and Llewellyn-Jones 2018: 22, 647, 666, 683–6). However, its centrality in ancient life did not really focus on "purple" as we understand the term, since the shellfish dyes to which many ancient purple terms referred (for example, Greek *porphyreos*, Latin *purpura*) produced a range of hues, from what we would call deep

crimson red, through purple, to violet, or even "Prussian" blue. The symbolism of ancient purple was very much associated with its origins, and since shellfish dyes were prized not only for their distinctive color qualities, but also because they were difficult to obtain and apply and were fast and long lasting, true sea-purple was regarded as the ultimate class statement.

The process of murex dyeing was lost in late antiquity, probably due to the shift from outdoor to indoor ritual and status activities in the Byzantine period, and was only rediscovered in the nineteenth century. Since then, scholars have debated exactly what colors are possible, from which shellfish, and using what process (Ziderman 1987: 25–33; 2004: 40–5). Each process requires removing the tiny dye sacs of hundreds or thousands of individual shellfish, and these must then be chemically reduced to form a water-soluble compound that can be applied as a dye. It is essentially a form of fermentation, probably using a variety of processes in antiquity. Depending upon the species and origin of the shellfish, these produced variations in the finished color, and recent experiments have also suggested that purple dye application is light-sensitive: the color becomes blue if exposed to light during the formation of the dye bond (Ziderman 2004).

This reduction makes mordanting unnecessary and promotes a very fast dye-bond, not subsequently degraded by exposure to light or washing. Meanwhile, the colors produced by the murex are visually bright, rich, and complex, contrasting favorably with the generally relatively dull and frequently fading colors of plant dyes (Pliny the Elder 1983: 9.61.130–62.135; for cheaper plant dyes, see Pliny the Elder 1968: 16.31.77 and 1969: 22.3.3; for the range of colors in the "purple" category, see 1969: 21.22.45–6). The value of purple dyes, therefore, was not only aesthetic or economic, but also practical: they remained both a status symbol and, because of their origin, an important item of trade throughout the Greek and Roman worlds (see Becker, this volume). Purple hues could also, however, be made in other ways. Double-dyeing with woad and madder was a cost-effective way of producing a comparatively convincing "knock-off" purple, and reference to a washed-out (*ekplytos*) purple garment recorded in the Brauron clothing catalog indicates that this process was more common than we might otherwise imagine.

Purple in Greek culture denoted both status and blood, as well as passion, through its association with Aphrodite. It is a heroic color and was much used in tragedy (see Bassi and Wharton, this volume). In Aeschylus' *Agamemnon* (Aeschylus 2008a: lines 905–78), for instance, a famous scene focuses on purple-dyed textiles: Agamemnon's vengeful wife, Clytemnestra, encourages him to commit an act of fatal *hybris* by walking on the purple-dyed textiles of their household wealth (Armstrong and Hanson 1986). Color, luxury, and value are all signifiers in this scene, but textiles are also to be understood as Clytemnestra's domain and the products of her labor (Bakola 2016). In this and their vibrant color, symbolic of blood, they recall the blood shed in the sacrifice of their

daughter, Iphigeneia, who was killed at the outset of the Trojan War. From these "bloody" textiles, Clytemnestra creates a path of blood-purple textiles along which her husband strides to his doom. The scene foreshadows Agamemnon's death, trapped in a patterned garment woven by his wife along with her plans for revenge, then dyed with his blood. While the *hybris* of Agamemnon may come from an over-proud material act (his joy at the "red carpet treatment"), there is also implicit in the scene a more personal motivation—Agamemnon is offered one final chance at humility (to assuage Clytemnestra's desire for revenge), but he does not feel shame about the death of his daughter, nor about bringing the captive Trojan princess Cassandra into his house as a concubine. But he continues to walk the bloody path, and so his life comes to its violent end. These textiles (as in the stories of Iphigeneia, of Ion, and the myth of Tereus and Procne) speak of kinship, home, duty, and betrayal; the textiles are the words that Greek tragic women are not given to say.

In Rome, purple was formally associated with status display. It was worn by kings in the earliest times (the *toga purpurea* being an early symbol of kingship), by generals at their triumphs (*toga picta*), and by imperial military commanders, favorites of emperors. *Clavi* (stripes) on tunics were purple, their width designating senatorial or equestrian status, and so was the border of the *toga praetexta*, which was worn by high-ranking magistrates. Pliny the Elder (1983: 9.60.127) notes that purple "marks the honourable estate of boyhood; it distinguishes the senate from the knighthood; it is called in to secure the favour of the gods; and it adds radiance to every garment, while in a triumphal robe it is blended with gold."

The most expensive double-dyed (*dibapha*) Tyrian purple was first used for the *toga praetexta* in 63 BCE, and in the Roman Empire the richest purple dyes were fashion items for those who could afford them despite their nasty, "fishy" smell:

> even the mad lust for the purple may be excused; but what is the cause of the prices paid for purple-shells, which have an unhealthy odour when used for dye and a gloomy tinge in their radiance resembling an angry sea?
>
> (Pliny the Elder 1983: 9.60.127)[1]

Cost and status implications resulted in the establishment of occasional laws attempting to control and restrict use, and both Caligula and Nero tried to limit or discourage the wearing of purple in public in order to avoid being outshone by others; further attempts were made in the fourth century CE (Plutarch 1914a: *Romulus*, 25; Suetonius 1997: *Nero*, 32.3; 1998: *Caligula*, 35.1; *Codex of Justinian* 2016: 4.40.1; *Theodosian Code* 1952: 10.20; Bradley 2009a: 198).

The long-standing Roman association between purple and the concept of *luxuria* was, in itself, the product of a much earlier use of the color as a status-indicator among Persian and Hellenistic kings. One of the finest and

rarest surviving textile fragments from antiquity is a panel of purple murex-dyed cloth interwoven with pure gold thread. Dating from the fourth century BCE, it was found wrapped around the cremated bones of a young woman in Tomb II at Vergina in Macedonia (Grand-Clément 2016). Without doubt, this was a garment used by Macedonian royalty, and even in its current state, with the purple dye now turned black, it is an object of remarkable beauty. This weaving technique is attested in Roman inscriptions commemorating specialist *aurinetices*, "weavers of golden garments," and Diocletian's edict notes that their wares were set at 1,000 denarii, making them the most expensive garments on the market.

White

In Greek and Latin, words such as *albus, candidus*, and *leukos* referred to all light colors, not just "pure" white. White was certainly a common—but not the standard—color for garments in classical antiquity, and it was particularly thought to be a good symbol of ritual purity, being appropriate for wedding guests, festival goers, officials, and priests. Since most textile fibers are naturally off-white, pure whiteness in clothing was achieved only by bleaching and fulling, and was probably at least as difficult to obtain and maintain as any dyed color. In ancient dress, white was valued for its bright contrast both to the generally dull shades of most clothing and to the rare, vivid colors of visibility and status in dress. Its status is reflected in clothing regulations, clothing in tragedy, and the Roman emphasis on white as symbolic of the virtues required of priests (*albogalerus*), candidates for office (*candidatus*), and citizen men (*toga candida, toga pura, toga virilis*).

Bonnie MacLachlan (1993) has shown how the ancient concept of *charis*, "grace, beauty, charm," was endorsed by visual codes and notes that sparkling beauty was erotically attractive to the ancient Greek eye (see Wagner-Hasel 2002; Platt, this volume). Thus the oiling and perfuming of the skin, the wearing of glistening jewelry, and the donning of shining white garments all denote and demarcate *charis*, a concept that works in tandem with the Greeks' irresistible love of light. Hera's veil is described as being so dazzlingly white that it shines like the sun: "Lovely among the goddesses, she veiled her head downward with a sweet fresh veil; it was as white as the sun [*leukon d'hēn hēlios hōs*]" (Homer 1999: 14.184). The word *leukos* "white" is used by Homer on at least sixty occasions, where it is usually imbued with positive qualities that often include connotations of light. When Hera and Zeus make love on the summit of Mount Ida, they do so discreetly veiled within a dazzling cloud that reflects the sun's rays and glistens with drops of dew that gleam as brightly as Hera's shining white veil.

Whiteness of skin was also an aspect of desirable femininity (Thomas 2002; Eaverly 2013: 83–155). The fertile qualities of the Homeric Hera were defined

through her epithets such as "white-armed Hera" or "the goddess of the white arms," and Penelope is lauded as having skin "whiter than sawn ivory" (Homer 1995: 18.196; 1999: 1.55, 595). In Athenian tragedy the whiteness of female flesh is commented on with some regularity. Princess Glauke, for instance, is notable for the beauty of her white face and neck, but also for "her all-white foot" (Euripides 1994: *Medea*, 1163–6; see Bassi and Wharton, this volume, on the colors of women's masks in Greek and Roman drama). The glorification of whiteness in poetry, performance, and philosophy must have had its influence on actual women. Women in Athens were customarily veiled and, to some extent, they were segregated from the outdoor world of men, spending much time indoors (Llewellyn-Jones 2003). This was perhaps the aspiration, although in reality, poorer women needed to work in agriculture or other forms of labor, with the result that their skin could become darkened by the sun.

The word *cosmetic* derives from the Greek *kosmos*, meaning order, arrangement, or display. The ordered display of beauty and its enhancement were very important to Greek and Roman women, and archaeological finds and artistic and literary sources all point to a proliferation of products designed to beautify the face and hair. The Greek admiration of light skin, signifying upper-class status, could be enhanced with a light use of cosmetics. Xenophon's Isomachus criticizes his young wife for applying too much white powder and rouge (Xenophon 2013: *Oeconomicus*, 10.2), although the orator Lysias (1930: 1.14) relates that wives, leaving their husbands to visit lovers, painted themselves with cosmetics. In fact Greek women had access to many substances to improve their appearance and allure. Honey was used as a moisturizer and olive oil was employed to protect the skin and make it shine. Oil could be infused with scents for perfume, or mixed with ground charcoal for eye shadow, while ocher or *phykos* were used for rouge or mixed with beeswax and olive oil for the lips. The face was often whitened with lead carbonate (*psimythion*), despite its toxicity.

Similarly, Roman women used *cerussa*, another white lead pigment, to lighten the face, although lanolin or bear fat also served as bases for white pigment. Soot was also mixed for black eyeliner, red ocher for cheeks and lips, wine dregs were used as lip-color, and saffron was ground and applied as eyeshadow. The ideal of Roman beauty was therefore a white face, red lips, and dark brows and lashes. As in Greece, a white face symbolized the upper-class life of leisure, indicating that a woman was not bound to labor outside in the sun, but could remain indoors. Ovid, in *The Art of Beauty*, lampoons the lengths to which Roman women went to appear beautiful. He includes recipes for cosmetics and cleansing mixtures, and it is interesting to note that women in the ancient world continued to use ingredients that were known to have toxic side effects (Stewart 2007).

Black

Although black was an important color for the Greeks and Romans, there was nothing simple about its associations. Greek *melas* included all dark shades, not simply "pure" black; the Latin word *pullus* had the same connotations, although Latin has other main black terms such as *ater* and *niger* (see McDonald, this volume), while Greek describes glossy black colors by *porphyreos*, or *melas* with *lampros* or another brightness term (Maxwell-Stuart 1970; Stratiki 2004). Dark colors would have been achieved relatively easily, and in the course of use, with repeated dyeing, garments would tend toward darkness anyway. In the epigraphic sources, black colors are explicitly opposed to the ritual purity of white dress, echoing the deliberate dirtying of clothing as an aspect of grief.

In antiquity black had close ties with death: chthonic deities were offered sacrifices of black rams, heifers, goats, and puppies; in epic poems, dying warriors bled black blood and were enclosed by black mists, and grief and sorrow were visualized as black, as were the dangerous waves that swelled up from the bowels of the mysterious sea (see Bassi and Wharton, this volume). According to the famous myth of the return of Theseus to Athens, it was a black sail hoisted on the mast that made Aegeus throw himself into the Aegean, thinking that it heralded his son's death. Black was part of the ritual costume of death and little children dressed in black robes to serve at the shrine of Hera at Corinth to appease a vengeful demon who killed infants and expectant mothers and to mourn for the deaths of Medea's children (see Diodorus Siculus 1939: 4.61.4, 4.61.6–7; Pausanias 1965–9: 1.22.5, 2.3.11; Plutarch 1914a: *Theseus*, 22.1; Strabo 1866–77: 8.7.4).

In the ancient world, the initial outpouring of grief was often accompanied by some symbolic gesture associated with dress. Greek women threw off their veils and sometimes tore them in two, while the laceration of the cheeks and tearing of the hair often followed as a conspicuous display of grief. Conversely, men tended to veil themselves with their robes, covering their heads and faces in a silent demonstration. Both were symbolic inversions of gender norms. It is difficult to know if a prescribed, protracted period of mourning followed all deaths, but ancient peoples, particularly mourning women (see Figure 5.5), certainly wore black, dark blue, or gray in order to display grief. In Rome, black, dark, or dirty clothes were associated with mourning (*atratus*, *sordidatus*), and men traditionally wore the *toga pulla* (Sebesta 1994). Such clothes could also be worn in the face of other disasters or misfortunes, often to show the wearers' lack of care about their appearance. Black garments appear in a variety of everyday contexts in Roman literature; the *lacerna* (a cloak worn over the toga), for instance, was commonly black or white, and *calcei senatorii* (senators' shoes) were black too (see Cicero 1948–53: *Against Verres*, 2.4.24; Juvenal 2004: 10.245; Stratiki 2004).

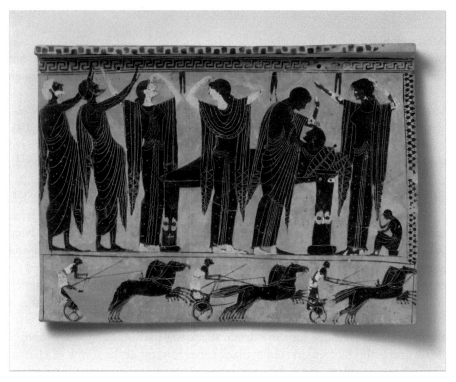

FIGURE 5.5 Terra-cotta funerary plaque; Athens, *c.* 520–510 BCE. Funerary scene with figures in mourning. The Metropolitan Museum of Art. Accession number 54.11.5.

Cicero suggests that the *toga pulla* was only worn at the funeral, not the funerary feast, when other colors might be worn (Cicero 1984: *In Vatinium* 12.30–13.32). Roman women were expected to observe visible mourning for a longer period, and they, too, wore dull or dark colors, though Herodian implies that white might also be worn by women in mourning (Herodian 1969–70: 4.2.3). The *ricinium* in particular was associated with female mourning, and in the year following her bereavement, a widow would make her status known by covering her head with this dark garment instead of the colorful *palla*. Originally a generic term for a square mantle, the *ricinium*, was worn thrown back or doubled. It is mentioned in the "Twelve Tables" (laws concerning Roman citizenship, displayed in the Forum, dating to *c.* 450 BCE) in connection with funerals, and in later Roman times it seems to have become de rigueur for women in the "second stage" of mourning. It had a purple border and seems to have been the same dark color as the *toga pulla* (Nonius 1903: 869; Festus 1913: 274–5 M; Varro 1951: 5.132–3).

Limitation of extravagant mourning is part of sumptuary legislation in most periods, and classical antiquity was no exception. Occasional Greek requirements

for white or gray mourning dress perhaps curtailed pure black dress as more symbolically obvious—and conspicuously consumptive—than dark, dirtied clothing (since deep blacks were probably relatively rare and once dyed black a garment was unalterable, unlike one that was simply dirtied). Black was also the color of mourning in mythology: chthonic deities and personifications such as Night are characteristically black-clad (*melanophoros*), and black clothing was especially common in hero cults. In the Homeric *Hymn to Demeter* (West 2003: lines 181–3, 319, 360, 374, 442), black veils and black clothes are central to the goddess Demeter's characterization, as we trace her progress from her introduction as the "fair-tressed awesome goddess" to the moment of her darkest despair, when she learns of her daughter's abduction and rips the *krēdemnon*-veil off her head, replacing it with a black *kalumma*-veil. The dark clothes of the goddess are fundamental to the story and convey Demeter's grief: "She, grieved in her heart, walked with her head veiled [*kekkalummenē*]. And the dark *peplos* swirled around the feet of the goddess" (West 2003: lines 181–2).

Athenian tragedy also attests to the use of black clothing as an indication of mourning. On his arrival home in Argos, for example, Orestes witnesses a party of female libation-bearers approaching the grave of his murdered father conspicuously veiled in black robes (Aeschylus 2008a: *Libation Bearers*, 2–8), while in Thebes, Queen Jocasta intentionally wears a black *pharos*-veil instead of a white one as a sign of mourning. As she says to her long-lost son Polyneikes, "I cut my white hair short and let it fall loose, weeping tears for you, my son. I never wear a white veil (*pharos*) now; instead I put on this old disarrayed rag, murky as night" (Euripides 2002: *Phoenician Women*, 322–6).

We can suppose that tragic characters reflect the real-life social situation, and that the wearing of black garments was commonplace for mourning. The use of black garb at a time of emotional upheaval is noteworthy given the ancient idea that the color black was brilliantly intense. Black was meant to draw the eye of the spectator. Black in antiquity is not to be regarded as an absence of color (as black often is in modern Western fashion-tradition), for it has an existence and a function specific to itself and it is even seen, like white, as a vivid intensifier of other colors, as in a pseudo-Aristotle text (Aristotle 1936: *On Colours*, 795b).

CONCLUSION

A painting found in a villa at Boscoreale, Naples, shows a plump young Roman woman clothed in a voluminous purple gown and buttercup-yellow-white *stola* (see Figure 5.6). Her pale skin is adorned with a golden bracelet and earrings, and a headband with a central medallion of gold sets off her dark, well-coiffured, hair. Behind the seated kithara-playing woman stands a small girl wearing a sleeveless purple chiton. She, too, is adorned with a gold headband, bracelet,

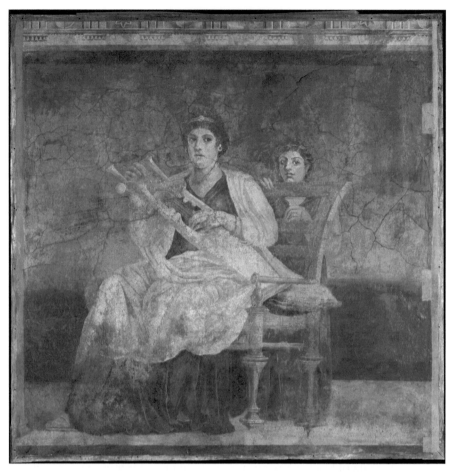

FIGURE 5.6 Wall painting from Room H of the Villa of P. Fannius Synistor at Boscoreale, *c.* 50–40 BCE. The Metropolitan Museum of Art. Accession number 03.14.5.

and loop earrings. It has been suggested that the pair may represent a Hellenistic queen or princess and her daughter or younger sister. The gilded kithara and richly adorned, throne-like chair, the carefully rendered gold jewelry and headbands, and the richly colored garments certainly give the impression of the appearance of royal personages. But whatever the exact subject, this painting may help us to better understand the significance and ubiquity of color in the dress of the Greeks and the Romans.

In classical antiquity colors were not only decorative means of sartorial embellishment but also conveyors of meaning. Colors expressed cultural values and social status; they indicated moments in the life cycle and projected aspirations and codes of "being." Greeks and Romans clearly possessed a

developed sense of color appreciation and were able to see colors as abstracts and playful cultural constructs. How else might we explain, say, Odysseus' "hyacinthine" hair?

> But when he had washed his whole body and anointed himself with oil, and had put on him the raiment which the unwedded maid had given him, then Athena, the daughter of Zeus, made him taller to look upon and mightier, and from his head she made his locks like the hyacinth.
>
> (Homer 1995: 6.231)

Of course, this description might be linked to the shape of the petals of the hyacinth, suggesting Odysseus' hair is curly (as is mentioned in Homer 1995: 16.175) or, more probably, to the color of the flower—violet—as a (diluted) way of linking Odysseus to the *kyaneos*-haired (blue-haired) gods of Olympus (see Platt, this volume). It is possible that in the description of hair (including eyebrows and eyelashes) as *kyaneos*, Homer is indebted to an ancient Egyptian tradition of imagining the hair of gods as pure lapis-lazuli. Classical conceptions of color differed to those we hold common today, and they often had the aim of harmonizing colors and materials in such a way as to make them seem as one. The use of color in textiles reflects this ambition.

Furthermore, the abstraction of the idea of color often led to the use of analogies with nature. No Greek would think of calling a garment merely green, but would compare it with the world around him and describe it as "frog-green," or "olive-green," or "apple-green." A certain kind of Roman clothing was known by the rarely used term *vestes calthulae* (after a yellow wild-flower), and competitors in the games were distinguished by their *vestes prasinae*, "leek-colored" cloaks. A famous passage in Ovid's *Art of Love* advises women on the colors they should choose for their clothing, in order to attract men:

> O wool that blush with Tyrian dye. When so many cheaper colors walk abroad, what madness to carry whole incomes on one's body! Lo! there is the color of the sky, when the sky is cloudless, and warm Auster brings no rainy showers; lo, here is one like thee, who once art said to have rescued Phrixus and Helle from Ino's wiles; this color imitates water, and from water has its name: in this raiment I could think the Nymphs were clad. That color counterfeits saffron: in saffron robe is the dewy goddess veiled, when she yokes her light-bringing steeds; this has the hue of Paphian myrtle, that, of purple amethysts, these of white roses and of Thracian cranes; nor, Amaryllis, are thy chestnuts lacking, nor yet almonds; and wax has given to fleeces its own name. As many as are the flowers that the new-born earth produces, when the vine in warm spring urges forth its buds, and sluggish winter is fled, so many dyes and more does the wool drink up; choose those that are sure to please, for not every one of them suits every woman. Snow-white skins

like dark gray colors, dark gray became Briseis; even when she was carried off was her robe dark gray. Those dark of hue like white; in white didst thou please, Cepheis: for thee thus clad was Seriphos oppressed.

<div align="right">(Ovid 1979: Art of Love, 170–80)</div>

The pure blue of the cloudless sky, the natural color of wool, the yellow of saffron, the green of the Paphian myrtle, the darker green of the oak, the gray of the crane, the amethyst, the almond-tree, and the cherry—these are the colors of antiquity. So, while we can dispel the myth of classical whiteness and look to restore to the dress of the Greeks and Romans all the colors they enjoyed, we need to concede that we are defeated by the imperfect way in which we understand ancient color theory and the processes of wearing and even seeing color. Passing through the ancient dye spectrum from yellow to red, scarlet through indigo to purple and blue, from blue through sea-green to yellow, and from yellow of all shades to pure white, we can imagine the fashionable world was one of color, but the challenges of recreating the living world of color and dress out of the texts through which we must predominantly work remains daunting. And so I reiterate my opening statement: do not, just do not ask for or expect a clear answer to the question: "what colors did the Greeks and Romans wear?"

CHAPTER SIX

Language and Psychology

KATHERINE MCDONALD

INTRODUCTION

The color terminologies of ancient languages, and the attempts of nineteenth-century classicists to understand them, were a catalyst for color linguistics. Ironically, however, Ancient Greek and Latin still resist fitting neatly into any established theory of color categorization. This chapter explores the history of the study of ancient color linguistics and outlines our current understanding of the color categories of Homeric and classical Greek and classical Latin, all of which present different problems for modern scholarship in color cognition and perception.

In the terminology of modern color linguistics, the word *color* is the visual impression caused by light entering the eye. It is characterized by several perceptual elements: *hue,* also called *chroma* or *chromatic color,* which is determined by the dominant wavelengths of light; *lightness,* which refers to closeness to white or black, also sometimes called *tone; saturation,* which is vividness or intensity, often understood as the amount of gray that is perceived to be present; and *brightness,* which is the amount of light reaching the eye, either because the object is well-lit, is reflective, or is itself a light source (Biggam 2012: 3–5).[1]

Most English color words denote hue and lightness. Thus, for example, the words *red* and *green* name hues, while *pink* names a combination of hue and lightness. Other modern European languages' color systems, which also mainly refer to hues, have a slightly different selection of words. Some have no word for the concept PINK, for example, and some, such as Russian, have separate terms

for the concepts LIGHT BLUE and DARK BLUE. In general, European languages can indicate lightness with additional modifiers where no single word exists for a concept, such as the modified terms *dark green* or *light blue*. Modern English has few, if any, single-word terms to indicate saturation, instead using modifiers such as *washed-out blue*, *vivid purple*, and *bright red*. (*Brightness* is used differently in common parlance from its use as a technical term in linguistics.) Color terms can also suggest properties such as sheen or glossiness, usually indicated with modifying words such as *shiny* or *matte*, but many English speakers would also consider *silver* a different color from *gray* (Wharton 2016: 180).

English speakers, then, tend to consider hue as the main element of color, with other qualities being secondary. However, it is possible to imagine a color system where lightness, for example, was the main quality named in the most common color terms and hue was secondary. In this thought-experiment, we might imagine such a system having two color terms, the equivalents of English *dark* and *light*, and it being possible to further distinguish color by saying *blue-dark* and *green-dark*. And color systems can, in theory, be even more different from our own than this, as Biggam explains:

> A society may be concerned, for example, with the general appearance of an entity, involving a mixture of visible features in which hue cannot be separated from one or more other aspects such as shininess, roughness, darkness, wetness and more, in varying combinations. Even more surprising to the English speaker and others is that the so-called "color terms" of a language may include non-visible elements which cannot be excised from the overall meaning of the word or phrase.
>
> (Biggam 2012: 2)

When we talk about the linguistics of color in other languages, it is therefore necessary to put aside our own culturally determined conception of what "color" is. This is particularly important for understanding cultures in which speakers' experience of color may have been very different from ours, such as those societies—including in the ancient world—where natural colorings predominate and where modern, highly saturated dyes are unknown.

However, despite the many possibilities for how languages could theoretically categorize and name colors, some researchers believe that there are universal patterns for how color terms function. The most famous hypothesis is Berlin and Kay's theory of "basic color terms" and their acquisition (Berlin and Kay 1969), later developed into the universals and evolution (UE) model. Although it has been criticized over the years, this is still the most influential theory of how colors are categorized and named in human languages, and the theory has been updated several times to respond to new research, most recently to reflect the findings of the World Color Survey (Kay et al. 2009).

Berlin and Kay's research and that of the World Color Survey is based on eliciting color names from native speakers using an array of Munsell color chips of different hues and lightness, plus a range of achromatic chips (black, various shades of gray, and white). Their model suggests that all languages have between two and eleven basic color terms (henceforth BCTs), which name the basic color categories.

According to the UE model, color terms need to meet certain criteria before they can be considered "basic." Berlin and Kay suggested that a BCT should be "monolexemic," by which they meant that a color term's meaning should not be predictable from its parts. In many languages, it would normally consist of a single morpheme (that is, a single discrete meaningful element). This means that a word such as *greenish*, which is made up of two morphemes, *green* and *ish*, cannot be a BCT (although there are a few languages whose word-formation rules demand exceptions to this criterion). In addition, a BCT cannot be a hyponym of another color word—that is, its whole meaning cannot be contained within the semantic field of another word. *Scarlet* and *crimson*, for example, can both be said to fall fully within the semantic field covered by *red* in English, and therefore cannot be BCTs. In the UE model, a BCT cannot be contextually restricted to particular types of referents, as *blond* is traditionally restricted to human hair. BCTs must also be salient—that is, they must quickly come to speakers' minds when color terms are considered, and they should appear in the vocabulary of every native speaker of the language. They must have a reasonable degree of consensus (stability across different informants) and consistency (stability across multiple occasions of use), though in practice, speakers are not always in complete agreement with each other about the boundaries of color categories. Furthermore, potential BCTs should not be recent loan words from another language (though Berlin and Kay are vague on what constitutes "recent") and they should not also name a similarly colored object, such as *turquoise* or *burgundy* or *rose*, unless it can be demonstrated that the color term is completely abstracted from its original referent (Biggam 2012: 23–34).

Berlin and Kay's model also sets out the order in which these BCTs appear in a language and it dictates that languages should move from having fewer to more BCTs. In its original form, Berlin and Kay's model stated that languages start with two BCTs, corresponding to the categories LIGHT and DARK (Stage I), then they add a basic color category (BCC) for RED (Stage II), then a BCC for either YELLOW or GREEN (Stage III), followed by a BCC for the remaining category, that is, either GREEN or YELLOW (Stage IV), then BLUE (Stage V), then BROWN (Stage VI), then PURPLE, PINK, ORANGE, and GRAY in any order (Stage VII). This evolutionary model has been altered over the years. The most notable alterations are, firstly, that Stage I languages actually seem to have one term for the concept LIGHT/RED/YELLOW and one for DARK/GREEN/BLUE, so that the initial conceptual opposition

is now understood to be not LIGHT versus DARK but WARM versus COOL (Rosch 1972). Secondly, more possibilities have been added at Stage III, to reflect the fact that some languages introduce a BCC for grue (that is, a term for the concept GREEN+BLUE) rather than for GREEN alone—we will return to the problems of this stage later. Thirdly, the later BCCs are now considered to be "wild cards," which can emerge out of sequence (Kay et al. 2009: 7–8).

The model has received wide support and has also been supported and refined by further cognitive models, such as fuzzy set theory, which provides a way in which items can be *partial* members of a category (Kay and McDaniel 1978); vantage theory, which seeks to describe the cognitive processes behind color categorization (MacLaury 1997; Maffi 2007: viii); and to some extent, the emergence hypothesis, which offers an alternative route that some languages seem to take through Stages I and II (Kay et al. 2009: 41).[2] Research by Rosch and others has suggested that there might be universal foci for color categories, and that the boundaries between categories are where languages most differ from each other (Rosch 1972, 1973; Mervis et al. 1975). This strand of research has favored the hypothesis that there are universal patterns in color terms rather than all languages naming colors arbitrarily.

However, there has been considerable criticism of the Berlin and Kay and UE models, in ways that are highly relevant to the study of ancient languages. It is possible that the methodology of these studies—which use stable, high-saturation color chips to test participants—unfairly privileges a modern, Western notion of color based on hue, and that this has fundamentally affected the results of these studies (Lucy and Shweder 1979; Lucy 1992: 179–85; Saunders and van Brakel 1997: 176–8; Wierzbicka 2005, 2008). Some scholars have contended that shifting, complex, or desaturated color names can be considered BCTs in some languages but would never be elicited from speakers using this methodology (Bornstein 2007: 18). Saunders has been very critical of researchers "cleaning" the data from the World Color Survey to fit into the UE model, including favoring the answers of subjects whose responses fit the model (Saunders 2000: 91–2). Scholars have also criticized the use of English as the meta-language of color research—that is, the language used to describe other languages (Wierzbicka 2008: 218–20). Other researchers have found Rosch's experiments, which compared English-speaking undergraduates and speakers from non-Western populations, methodologically unsound (Lucy and Shweder 1979) and her results impossible to replicate across other speech communities (Roberson, Davies, and Davidoff 2000). As a result, linguistic relativism has, to some extent, reasserted itself over universalism, although scholars have taken various positions on this problem. Wierzbicka, for example, argues that there are language universals but that color is not one of them (Wierzbicka 2008: 222–3).

Berlin and Kay's criteria for BCTs can also cause problems. The rejection of terms such as *sea-colored* may give a misleading impression of some languages,

particularly those in which the vast majority of color terms make reference to objects (Clarke 2004: 132). It can also be difficult to know when an object-based color name has become a BCT, as they clearly can over time. For example, Berlin and Kay accept English *orange*—which has become abstracted from its original referent—as a BCT, but their criterion presupposes that color can always be conceptually separated from objects that naturally occur in that color, even though this may not be true in all societies. Arguably, it is important to study color terms in their usual context, in reference to objects that are commonly described using that color term—for example, by pointing to different objects in a speaker's environment—and not in an abstracted form such as Munsell chips (Biggam 2012: 88).

It has also proved difficult to find evidence for linguistic relativism that is accepted by adherents of the Berlin and Kay model. There are very few contemporary societies sufficiently isolated to be unaware of modern saturated dyes, and many informants used in Berlin and Kay's studies had at least some awareness of a modern European language (in the research on which their original 1969 model was based, all the participants were living in California). The ancient world therefore provides a rich testing ground for understanding color through the lens of a society with completely different experiences of the world, without super-saturated dyes and with more direct reference to the natural world. As we will see, Latin and Greek can provide some challenges to the Berlin and Kay and UE models.

ANCIENT GREEK FROM HOMER TO ARISTOTLE

The linguistics of color in Homeric Greek has been a source of scholarly debate for over a hundred years. William Gladstone, the former British Prime Minister, was among the first to write at length about these color categories. He noted that color terms in the Homeric poems are not particularly plentiful and (if using the standard English translations) are used in ways that seem to us completely counterintuitive. Most famously, the sea is often *oinops*, "wine-looking" (usually translated as "wine-dark" or "wine-colored"), and this is also a term applied to oxen. *Porphyreos*, usually translated as "purple," is used to describe blood, the surging sea, the rainbow, and a blushing face. *Chlōros*, translated as "green," "yellow-green," or "pale," is used of items as different in hue as vegetation and blood.

"The starting-point," Gladstone wrote, "is an absolute blindness to color in the primitive man" (1877: 325); he also writes that "the organ of color and its impressions were but partially developed among the Greeks in the heroic age" (1858: 488). It is a matter of debate whether Gladstone thought that Greeks of Homeric times were color blind. This is the most common way of representing his argument in work on this subject, both within Gladstone's lifetime and more

recently (Allen 1879; Cunningham 1886; Schöntag and Schäfer-Prieß 2007: 108; Deutscher 2010: 37; for a summary of the history of this field, see Biggam 2012: 11–18). However, it is also possible to read his argument in a different way, as has been argued by Sampson (2013). Gladstone says, for example, that "Homer seems to have had [...] principally, a system in lieu of color, founded upon light and upon darkness" (1858: 488). Twenty years later, reflecting on his earlier work and its impact, he writes:

> My meaning was substantially this: that he operated, in the main, upon a quantitative scale, with white and black, or light and dark, for its opposite extremities, instead of the qualitative scale opened by the diversities of color [...] I find that the more we treat, as a general rule, what are apparently his words of color as quantitative expressions of light or its opposite, the nearer do we come to the establishment of harmony and coherence in his terminology.
>
> (Gladstone 1877: 323)

It is possible to read Gladstone as arguing not that the Archaic Greeks were biologically color blind, but that their linguistic and cognitive categories distinguished brightness or lightness rather than hue, something that current scholarship agrees with in many respects (Biggam 2012: 12). His focus on the "education" or "training" required to distinguish and name colors also suggests that he was discussing cognitive categories rather than physical ability (Sampson 2013: 9–10).

From the point of view of modern linguistics, Gladstone's terminology is inexact, and this is why it is possible to read his argument in multiple ways. He uses *color* to mean both "color" and "hue," *blindness* to mean "lack of perception" and "lack of cognitive or linguistic distinction," and *organ* to mean both "organ" in the modern biological sense and "mental faculty." Already in the nineteenth century, Gladstone's article is characterized as arguing that the human eye was physically less able to perceive color in Archaic Greek times (Cunningham 1886), and his work received interest from scientists working on color blindness as well as classicists. Whatever his original argument, the debate raised by Gladstone prefigured many of the debates about the linguistics of color in the twentieth century (Schöntag and Schäfer-Prieß 2007).

How, then, do we explain the color categories found in Homeric Greek? The most common Homeric Greek color terms are fairly straightforward: *melas* (black/dark), *leukos* (white/light), *erythros* (red, red-brown), and *xanthos* (yellow, yellow-orange, yellow-brown). *Erythros* does not always match up to a modern European idea of red—it can be applied to copper (Homer 1999: 9.865) as well as wine (for example, Homer 1995: 5.165, 9.163) and blood (Homer 1999: 10.484, 21.21). But it is easy enough to see this as an extended semantic range for the red hue term to denote some of the ground covered in English by *brown* or *red-brown*. *Xanthos* is used mainly of gold and blond or red-blond

hair and seems also to cover some lighter browns, such as the brown of cooked meat or fish in Aristophanes' comedies—Edgeworth suggests this inclusion of brown was a semantic expansion that took place after Homer, but *xanthos* may also cover light brown hair in an earlier period (Edgeworth 1983: 33). These four terms make sense in a hue-based color system, and one might say that Homeric Greek has a Berlin and Kay Stage III color system, with YELLOW as the first additional BCC.

However, there are many other color terms present in Homer and in later Greek texts, which seem not to conform to a hue-based color system. Some of these terms would not meet the criteria for basicness in Berlin and Kay's system, such as those that make explicit reference to objects or materials. Other terms do seem to meet the main BCT criteria, but name conceptual categories that violate the evolutionary developments outlined in the UE model.

The most problematic term is perhaps *chlōros*, which is common and widespread enough to be considered a BCT. The hues referred to by *chlōros* seem to span yellow and green, including very pale and very vivid examples of both. In the Archaic and classical periods, this term is used to refer to vegetation, honey, sand, egg-yolk, the part of the rainbow at the opposite end to purple, wine, blood, nail beds, tears, roses, limbs, steel, and also to scared or fainting people (Clarke 2004: 134).[3] It is also used in a noncolor sense to mean "fresh," for example, when used of fish or cheese (for example, Lysias 1930: 23.6; Aristophanes 2002: *Frogs*, 559). One of the most famous uses of this word is in the work of the Archaic poet Sappho, who says, "I am more *chlōros* than grass" (Sappho and Alcaeus 1982: Sappho fragment 31), prompting many hundreds of years of scholarly discussion about whether this refers to pallor, sweatiness, fear, or something else—depending on whether the imagined comparison is to the wetness of grass, the color of live grass, the color of dried grass, and so on—and how the simile should be translated into other languages.

The apparent semantic range of *chlōros* is a problem for fitting Ancient Greek into the standard UE model. According to this model, which initially splits the basic color categories into WARM and COOL, there is not normally a term naming the category GREEN+YELLOW before Stage IV, though there can be terms for GRUE (for the concept GREEN+BLUE) and even terms for YELLOW+GREEN+BLUE at Stage III (see Kay et al. 2009: 30, fig. 1). Ancient Greek is not the only language that shows evidence of a GREEN+YELLOW term. World Color Survey data suggest that there are BCTs naming a GREEN+YELLOW category in a small but significant number of the world's languages. Berlin and Kay admit that this is a problem that requires more research, but it may be resolved if these languages, including Ancient Greek, are considered to follow a rare evolutionary pattern of "non-partition" or "emergence" (Kay et al. 1997: 30, 32–3; 2009: 30, 38–9, 41n46; see also MacLaury 1997: 22–3, 40–1, 47–9, for examples).

Some scholarship has also suggested that *chlōros* is a good example of a color term that is not only, or even primarily, about hue. It may include wetness or freshness, or some idea of texture. In the Hippocratic corpus, the oldest texts of which are from the classical period, *chlōros* is "yellow-green" or (of plants) "fresh and alive" (Clarke 2004: 137). Clarke therefore characterizes this term as primarily referring to "the green fecund vitality of moist growing things" (134) rather than to a hue, with other meanings deriving from this central meaning through the addition or deletion of features.

This kind of relationship between BCTs and terms for growth and freshness is attested in several modern languages; it is a reported feature of the Hanunóo language, spoken in the Philippines (Conklin 1955, 1986), a situation described by Lyons as remarkably similar to that in Ancient Greek (Lyons 1999: 38n2). Some scholars have urged against trying to separate the hue-meanings and the non-hue-meanings of these terms, because abstracting the hue-meaning is often not intuitive to speakers of these languages.

> Common confusions arise when it is unclear whether a word is about color appearance or aspects of growth. For example in Lokono (Arawak) there is *imoroto* unripe, immature, green, pale yellow, *koreto* ripe, mature, red, orange, deep yellow, and *bunaroto* overripe, overdone, brown, buff, tan, purple. Attempts to conclude that either color is metaphorically extended to growth or vice versa, fail.
>
> (Saunders and van Brakel 1997: 178)

If similar words in Hanunóo and Lokono are indeed BCTs, but terms from which hue cannot be fully abstracted, this gives us a completely different perspective on what a "basic" color term might look like in the ancient world. However, we also need to keep in mind that the semantic range of *chlōros* also changed considerably over time. By the classical period, it is clear that *chlōros* could be completely abstracted, at least by some speakers, and was used in philosophical texts as the name of one of the four main colors (Lyons 1999: 60).

The term *glaukos* is usually translated as "green," "gray," "blue-green," "blue," or "light blue," or in the case of human or divine eyes, as "flashing," particularly in the Homeric poems. This color sometimes has negative connotations, particularly for eyes, where it is considered an unattractive color. *Glaukos* appears to name a basic color category that occurs in a small number of current world languages. This color category usually covers gray and various low-saturation shades, such as beige, brown, and lavender, and it varies more in hue than most BCTs; though not all languages develop this concept, it is demonstrably named by a BCT in the languages that have it (MacLaury 1999: 18–19). As Kay and colleagues describe it: "[A] category of desaturated, non-vivid, or 'bad' color. Usually this category contains gray and a diverse collection of hues that never attain high saturation [...] with no chip attaining a high level of consensus" (Kay et al. 1997: 32). In

their research, they concede that the methods of the World Color Survey, which uses high-saturation color chips for eliciting color words from participants, are not appropriate for fully understanding this color category, and it has not yet been reconciled with the UE model.

Over time, the semantic field of *glaukos*, like that of *chlōros,* changed, and this term seems to have become more associated with a specific hue. The timing of this semantic change is difficult to pin down, not least because later authors frequently alluded to Homeric usage in their work. Plato is explicit that *glaukos* is the combination of *kyanos*, "dark blue," and *leukos*, "white" (Plato 2000: 68c). However, *glaukos* was still not simply "light blue" during this period—it was used in classical Greek for olive leaves, vines, and grapes as well as blue or gray eyes (Deacy and Villing 2004: 85). The hue of *glaukos* is gray-green-blue, perhaps something like grue, but it still seems to retain a reference to sheen even in classical times. Without native speaker testimony, however, it is difficult to reach firm conclusions.

Some of the other common color terms found in Homer would not necessarily be considered "basic" in the UE model, because they refer to objects or materials. However, it is very difficult to determine when or if these terms became abstracted enough from their original referents to be considered BCTs.

For example, the term *kyaneos* appears to be an emerging Ancient Greek BCT for blue. In Homer, *kyanos* is a dark blue enamel or lapis lazuli used as decoration found on objects such as the breastplate of Agamemnon and the foot of a decorative table. But the derived adjective *kyaneos* is used to mean "dark blue" or just "dark." It refers to the mourning garments of the nymph Thetis, armies as they move, sand just uncovered by water, a mare, and a ship's prow. In reference to hair it seems to mean simply "dark": it is used of the eyebrows of Zeus and Hera, and the hair of Hector, Odysseus, and Poseidon. In the classical period, *kyaneos* looks in some contexts like a BCT naming BLUE. However, in philosophical discussions, *halourgos*, otherwise usually translated as "purple," appears to have been the more salient term for BLUE (Lyons 1999: 63).

The two color terms *porphyreos* and *phoinix* might be best taken as hyponyms of the BCT *erythros*. The term *porphyreos* is usually translated as "purple" and is derived from the word for a murex sea-snail and the dye that it produced. Of clothes and blankets, *porphyreos* probably refers to the color produced by that dye, which included colors that in English would be described as *dark red* and *dark blue* as well as *purple*. But *porphyreos* already shows signs in Homer of not being limited to a specific dye. It is used of the sea when stormy or surging, blood when gushing from a wound, the rainbow, and blushing faces. It is also used more metaphorically to describe death or human minds when confused or apprehensive. Clarke describes its meaning as something like "heaving, rippling movement and dark hues" (Clarke 2004: 136) and suggests that it is a term indicating darkness and motion. *Phoinix* (and its derivatives,

including *phoinikeos*) also referred originally to a reddish dye used as a material for dyeing ivory, and it is used in a simile as a comparison to Menelaos' blood (Homer 1999: 4.141). It is also used in Homer for the color of horses, blood, a serpent, the skin of a lion, jackals, and cloaks. But, despite their original link to specific dyes, it is possible to argue that in classical Greek, and outside of poetic contexts, there are examples where *phoinikeos* and even *porphyreos* can be used as a basic term for the category RED. For example, Aristotle names *phoinikeos* as one of the four main colors (Lyons 1999: 59).

To finish on the famous *oinops*, or "wine-dark": is this a color term at all? It is used most usually as a stock epithet of the sea but is also used twice of oxen (Homer 1999: 13.703; 1995: 13.32). Clarke has suggested that it covers attributes including a dark reddish color, but more prominently darkness, opaqueness, or a shiny or reflective quality (Clarke 2004: 136). This word is limited to a few poetic contexts and is an unlikely candidate to be a BCT. We do not know exactly what semantic field it covered.

Ultimately, our sources do not permit us to definitively name all the BCTs for any period of Greek.[4] Criteria such as salience and consensus are impossible to establish from written sources, and without the opportunity to question the judgments of native speakers we will never be able to fully understand the borders between one color category and the next. However, as Gladstone observed over 150 years ago, the Ancient Greek color terms are fundamentally different from our own. Even though his observations kick-started the study of the linguistics and psychology of color, Greek color terms remain resolutely difficult to explain using current theoretical models.

LATIN AND ROMANCE

There are currently two main approaches to describing the color categories of Latin. Bradley (2004, 2009a) has argued that the Romans did not, on the whole, use abstract color terms. He suggests that Latin color terms were closely tied to specific materials or objects, and that the use of these color terms to describe objects other than their normal referents was usually deliberately poetic (see also Baran 1983). For example, he argues that *rubor* is not "red" but "blush" and that any use of this word is an implicit comparison to a human face flushing (Bradley 2004). The word *viridis* therefore means not "green" but "verdant" and is a reference to foliage (compare Lyons 1999: 166). *Caeruleus* is not the abstract color category BLUE but always refers to the sea; *flavus* is not "yellow" but refers to blond hair. This idea of color terms that are contextually restricted (that is, it can be used to describe only a limited range of items) is familiar to English speakers from hair-color terms such as *blonde* and *brunette*.[5]

Recent challenges to this view have come from Wharton, who demonstrates, using Pliny the Elder's *Natural History*, that many of the words discussed by

Bradley (2004, 2009a) were used as abstract color terms applicable to a wide range of contexts. A third of Pliny's uses of *viridis*, for example, refer to non-botanical items, such as gems, where only the color can be meant (Wharton 2016: 185). Even though *viridis* can also imply qualities such as moistness, growth, and verdancy, it need not do so in every instance; in the same way, the English word *green* can mean "non-polluting" or "new" alongside the color concept GREEN, but it does not imply these additional meanings every time it is used (189). Wharton agrees with Bradley (2009a) on *flavus* meaning "blond" (Pliny's usual terms for "yellow" are *fulvus* and *luteus*, though *luteus* refers to a wider range of hues than English *yellow*) but emphasizes that the restricted semantic range of *flavus* does not imply that Latin had few abstract color categories.

Wharton's work on Pliny the Elder also demonstrates that BLACK/DARK and WHITE/LIGHT are by far the most common color categories in Latin prose dealing with everyday subjects. There is, however, no single term for either of these categories. Pliny uses two roughly synonymous terms for the concept WHITE/LIGHT: *candidus* (382 times) and *albus* (285 times) (Wharton 2016: 192). The term *niger* for BLACK/DARK—which covers a wider range than English *black* and includes colors which English-speakers would describe as dark versions of other hues—is used 450 times; and *ater* for BLACK/DARK (with negative connotations) is used 20 times (192). It is difficult to know how representative Pliny's usage is of speakers of the first century CE, and it is certainly necessary to keep in mind how Latin changed over time. For example, other evidence suggests that *ater* was the unmarked term for the category BLACK/DARK in early Latin, and that it was slowly replaced by *niger*, which became the BCT in later Latin and in the Romance languages (Kristol 1980: 138). Pliny therefore lived in a transitional period between two competing BCTs. Whether or not Pliny's usage is completely typical, Wharton provides evidence that the Roman concept of color privileged the light/dark contrast.

There is, nevertheless, a large range of Latin color terms that are derived from the names of objects and materials, as emphasized by Bradley (2009a). The most common of these is *purpura* and the derived adjective *purpureus*, usually translated as "purple" but applicable to a range of hues from red to blue, which could be produced by *purpura* dye (André 1949: 96–7). Other color words derived from materials or objects include *aureus* (gold), *croceus* (saffron-yellow), *lacteus* (milky, milk-white), *melleus* (honey-colored), *roseus* (rosy), *sanguineus* (blood-red), *violaceus* (violet), and many others. It is difficult to know to what extent these words always evoked the object they were named after, and the connotations of these color terms may have been different for different speakers. As a comparison, in English *orange* means both a fruit and a color; the color term is derived from the fruit name, but not all speakers are aware of this, and despite its transparent etymology *orange* is now considered a basic color term in English.

We might guess that *purpura*, which also referred to the dye and the shellfish used to make the dye, retained its material reference in the minds of speakers over a long period (Wharton 2016: 192). However, there is some evidence that it was abstracted, not just as a hue-based term but to denote brightness generally (André 1949: 97), for example, when used of swans (Horace 2004: *Odes*, 4.1.10) and salt (Valerius Flaccus 1936: 3.422). Because of these uses, it is listed in some dictionaries as having the secondary meaning: "bright." However, Edgeworth has shown that most of these examples can be explained in various other ways: as metonymies (for example, Valerius calls salt *purpureus* as a reference to the color of the sea, not the salt itself), as allusions to literary Greek uses of *porphyreos*, or simply as striking and memorable imagery, such as the *purpureus* light of the underworld (Virgil 1999: *Aeneid*, 6.640–1), which may indeed be purple rather than bright (Edgeworth 1979). If this analysis is correct, then this suggests that *purpureus* may be mainly a hue-based term, albeit with a semantic range wider than English *purple*. But without more extensive data from native speakers, it is difficult to make judgments about how "basic" a term such as *purpureus* was for Latin speakers, and how far its semantic range was stretched in poetic usage.

Luteus is another Latin term that has caused some debate, and that has sometimes been argued to be a BCT (Lyons 1999: 67). Like *purpureus*, it also originally refers to a dye, made from a plant called *lutum*. This dye could produce a range of different hues, from mid-red to light red (that is, pink) to yellow; in English, the yellowish dye produced from the same plant is traditionally known as "Dutch pink." *Luteus* is used to describe clothing— particularly the distinctive veil worn by a Roman bride—and other textiles such as awnings. But it is also used more abstractly to describe substances such as sulfur (Ovid 1977–84: 15.351) and egg yolk (Pliny the Elder 1963: 30.14.49; 1969: 21.80.87, 23.7.63–4). Edgeworth uses various examples to show that although modern translators consistently favor the translation *yellow* or *saffron* (and, in French, *jaune*), there are situations where *pink* or *red* would clearly be more appropriate (Edgeworth 1985). For example, in Catullus (1988: 61, line 188), the bride's *luteus* face is more likely to be pink than yellow, but this could also be a metonymy for the veil rather than a reference to hue. He also points out that Aulus Gellius is unambiguous that *luteus* should be considered a subset of *rufus*, "red" (Gellius 1968: 2.26.8). There are plenty of situations, such as descriptions of clothing, where any of these hues could be meant. This raises interesting questions about whether the Roman bridal veil really was yellow or could have been a range of hues produced by the same dye. Like *purpureus*, it is not clear that Latin speakers had completely abstracted the color from the dyestuff. If *luteus* was a BCT, it probably covers the category YELLOW+LIGHT RED.

The color system of Latin is also characterized by considerable borrowing from other languages. For example, the Proto-Indo-European root *h_1rewd^h-

results in at least three cognate words in classical Latin: *rubor*, *rutilus*, and *rufus*; the slightly rarer *russ(e)us* is probably also linked to this root. *Rubor* (also *rubere*, "to be red, to blush") is the native Latin term that was inherited directly from Proto-Indo-European, while based on its phonology, *rufus* must be an early borrowing from a neighboring Sabellic language of Italy.[6] These words are all words for the concept RED, but they are not interchangeable. *Rubor* is used as "red" but also as the "blush" color of red cheeks (Bradley 2004, 2009a). *Rutilus* was used for red-orange or red-gold. *Rufus* was not only "red" but also "red-headed," hence the common nickname *Rufus*, which became a widely used Roman cognomen. However, both *rubor* and *rufus* are described by Roman authors as umbrella terms for red, and there are contexts where it seems that these terms are used as synonyms. Having two (or more) cognate synonyms is hard to reconcile with a model that states that only one of these terms should be a BCT. Responding to Lyons (1999), Kay points out that synonymy is possible under his model, particularly when one term is in the process of replacing the other (Kay 1999: 82), but it is not clear that either of these Latin terms was in the process of replacing the other in ancient times.

In poetic texts, the Latin color system also shows considerable borrowing from Greek with words such as *purpureus* and *glaucus* turning up in poetry, particularly in authors who make frequent allusions to Greek literature. Some Roman authors (perhaps protesting too much in order to emphasize their own skill and learning) liked to emphasize the poverty of the Latin language and the need to borrow extensively from Greek. Aulus Gellius' *Attic Nights* (1968: 2.26), written in the second century CE, includes a debate about color terminology between two characters, Favorinus and Fronto (see also Goldman 2013: 10–15, though her explanation of the text is too reliant on English color categories). Favorinus complains that the color vocabulary of Greek is richer than that of Latin and, in particular, that Latin *viridis* and *rufus* cover huge semantic fields; Fronto agrees to some extent, but contends that not only does Latin in fact have many different terms for different shades of red, but also that it has filled in gaps by the judicious borrowing of Greek terms such as *poeniceus* and *glaucus*. He points out that poets engage in the borrowing of color terms, and highlights that Virgil was more likely to use a familiar Greek term than an unusual Latin one.[7] This passage shows that there was an awareness of the borrowing of color terms in these learned circles, and that it was seen as a particular feature of Latin poetic language.

The Berlin and Kay basicness criteria encourage us to discount recent loan words as possible BCTs, though it gives no specific time frame for what should be considered "recent." In Latin, it seems that *rufus* had been borrowed so long ago that it was no longer considered a loan, but Greek terms were often less well integrated into everyday language and more often recognized as borrowings, as shown by the Aulus Gellius passage. Unlike the poetic origins

of the Greek loans, the Sabellic borrowings are much more likely to have been incorporated into Latin during the long period of trade with speakers of Sabellic languages during the early Republic and earlier. The borrowed words relate to hair colors or possibly the colors of fur, leathers, or other goods that might be traded. We cannot be sure at what point words such as *rufus* were integrated into Latin fully enough to be considered BCTs. But however we understand these terms to have fitted into the Latin system of BCTs, they are an important piece of evidence for the sustained, close contact between ordinary Romans and speakers of the other languages of Italy during a period of history that we otherwise know little about.

Another way in which we might try to judge whether color terms are "basic" is their appearance in names (Wescott 1970: 354). Long-established BCTs are more likely to be incorporated into the names of people and places, just as family names incorporating *white*, *black*, *red*, and *green* are common in English (used themselves as names and also in compounds, for example, Whitehead, Blackman, and so forth), while more recent BCTs such as *purple* are much less common, and non-BCTs, for instance *turquoise*, rarely if ever appear in family names. The Roman naming system has more opportunities for the use of colors than the Greek naming system, and we find color terms in both the inherited family names (*gentilicia*) and in the *cognomina*, which were originally personal nicknames but became part of the inherited family name in many cases. The family names Helvius and Fulvius (approximately "Goldson"); Albius and Albinus (approximately "Whiteson"); and Viridius (approximately "Greenson"), among others, all refer to colors, while Niger, Rufus, Candidus, and Albus all appear as common *cognomina*, probably originally as nicknames referencing hair color or complexion. This gives all these terms a reasonable, although not watertight, case for being considered BCTs.

Like Greek, Latin gives us an opportunity to take a diachronic view of color—that is, looking at change over time rather than evidence from a single period. The semantic changes that affect the BCTs of Latin as it developed into the Romance languages (French, Spanish, Italian, and so forth) are debated, but seem to provide some evidence of how the semantics of color terms might change over many centuries. For example, we have already mentioned that classical Latin was in transition between the BCT *ater* and the BCT *niger*, which replaced it. Similarly, *flavus* and *fulvus* were eventually replaced in Romance with *galbinus* (in classical Latin, "greenish-yellow"), *croceus* (in classical Latin, "saffron-colored"), and *amarus* (in classical Latin, "bitter, sour"), this last probably as a semantic extension from the taste of under-ripe fruit to its color (Kristol 1980: 138). In late Latin and the Romance languages, the BCT *ruber* was also replaced by *rubeus* and/or *russ(e)us* (Kristol 1978: 148–54).

One controversial term is *caeruleus*, which Kristol has argued was a BCT in classical Latin but disappeared in late Latin (Kristol 1980). Although it is

derived from the word for sky, "as false popular etymologies show, Romans of the historical period were no longer aware of its object derivation" (Kristol 1980: 138). In his analysis, *caeruleus* originally named the concept PALE BLUE, but then expanded its semantic field to include blue, black, and blue-green under the influence of Greek before falling out of use. No cognate word is found in Italian, which instead has *blu* and *azzurro*, of which the latter is usually considered the BCT. However, these words did not replace *caeruleus* immediately in the way that *russ(e)us* replaced *ruber* for RED. Instead, it seems that the Romance languages lost all trace of a BCT for the category BLUE, and only later continued along the UE evolutionary model. Many southern Italian dialects of the twentieth century used *verde* for GRUE (a usage found in thirteen dialects in Kristol's study) or seemed to lack a term that incorporated this part of the spectrum at all (four dialects). Kristol shares fieldwork notes for this question including, "knows no color for the sky" and "great embarrassment," though he recognizes that these notes are open to interpretation (Kristol 1980: 142–3).

If Kristol's diachronic analysis is correct, this is a key example of the loss not just of a BCT but of a BCC. Berlin and Kay suggested in their original formulation of the evolutionary sequence that this regression could be possible but highly unlikely. They wrote:

> For a language to gain or to lose color terms it must do so in the order specified [...]. Although it is logically as possible for languages to lose basic color terms as to gain them over time, this appears rarely, if ever, to actually happen. [...] We have so far found no indication of the loss of a basic color term.
>
> (Berlin and Kay 1969: 14–15)

However, Latin and its Romance daughters give us over two thousand years of written sources and may allow us to understand diachronic change in color terms better than the evidence from the recent World Color Survey.

CONCLUSION

It has been demonstrated several times in this chapter that ancient color terms and color categories have provided a challenge to the UE model. Kay has responded to this scholarship and has periodically criticized attempts to identify BCTs in ancient languages because of the nature of the sources, which tend to be poetic, philosophical, or technical, and the differences of methodology that are necessary for dealing with historical sources (Kay 1999).

His description of the nature of the sources is accurate. If we look beyond literary sources, there are few types of writing in ancient languages that use color terms. The papyri of Hellenistic and Roman Egypt may provide examples in wills, letters, and other documents, but to my knowledge the color terminology in these texts has not yet been investigated in detail. In most

of the rest of the ancient world, where papyrus did not survive, we rely on inscriptions, particularly gravestones and dedications to the gods, for our data on "ordinary" language. Even though these texts do not represent the full range of the population, they provide some evidence for the language used by scribes, soldiers, craftsmen, merchants, freedmen, and other nonelite sectors of society. The only color term that occurs commonly on Latin inscriptions is *viridis*, "green," though it is not used as a color term in this context. Instead, it appears in phrases such as *viridis iuventa* and *viridis aetas,* meaning something like "in full flower of youth" on the gravestones of those who died young. We might also note the relatively frequent occupation term *purpurarius*, "purple seller," where *purpura* refers to the dye rather than the color.

If the requirement for understanding the color terms and color categories of ancient languages is that we have extensive sources produced by ordinary native speakers, then our evidence fails to meet this bar. In several places, this chapter has dealt explicitly with poetic language, but even when the focus has been on scientific and philosophical writers, we are dealing with the language of a small, wealthy, predominantly male subset of the speech community, and only a small number of individuals of this class. However, this chapter has shown how much one may understand of the language and psychology of color in the ancient world, even when the sources are limited to literary and historical documents.

Despite the apparent limitations of the sources, Greek and Latin provide fascinating testing grounds for linguistic theory. In both languages, the chronological and geographic spread of our sources provides very different, and in some ways more extensive, evidence than modern research such as the World Color Survey. Several Greek BCTs simply do not fit into prevailing understandings of color, including the hypothesis developed by Berlin and Kay, and in Latin, the use of borrowings and words derived from materials stretches the definition of basic color terms. Ancient languages provided the first inspiration for the linguistic study of color but still resist explanation. As they have done since the nineteenth century, linguists are still seeking to understand how Homer saw color.

Literature and the Performing Arts

KAREN BASSI AND DAVID WHARTON

Scholarship on color in classical studies is dominated by terminological and broadly cultural approaches, from William E. Gladstone's *Studies on Homer and the Homeric Age* (1858) to Eleanor Irwin's *Colour Terms in Greek Poetry* (1974) to Mark Bradley's recent *Colour and Meaning in Ancient Rome* (2009a).[1] Art historical and archaeological studies of color in ancient material culture (vases and statuary) tend toward empirical analyses. What John Gage calls "a history of color" (Gage 1999: 7) has fluctuated between these approaches to the use of color in Greek and Roman sources. This chapter looks at the use of color in two important literary and performance genres in ancient Greece and Rome: epic and drama. While recognizing the significant formal differences between these two genres, we pay tribute to Homeric epic as a principal source of dramatic plots, characters, and language in the Greek and Roman traditions. We also note that the meanings of Greek and Latin color concepts do not map neatly onto English color vocabulary (nor onto each other's), and that many Greek and Latin color concepts include features that we would not today consider to be "color," strictly construed.[2] In what follows, we use a broad notion of "color" that includes luminosity and absence of light as well as the range of hues recognized in the industrialized West, including white and black.[3] We focus (though not exclusively) on the language of light versus dark, luminosity versus absence of light, and hues in the red range, an approach warranted by the frequent use of such expressions in both classical and modern languages

(Corbett and Davies 1995; Hays et al. 1972). We show that these expressions are flexible and acquire new meanings as they are adapted to changing social, cultural, ethical, and performance contexts.

This chapter is organized in two sections. In the first, we discuss what can be known about the use of color in actual tragic performances, that is, in terms of staging, masks, and costumes. The emphasis here is on the social and political implications of color. In the second part, we provide close readings of selected passages from epic and tragedy that illustrate the ways in which luminosity and hue are key to interpreting these genres.

COLOR ON THE GREEK AND ROMAN STAGE

Neoclassical ideals imagined the ancient cities of Athens and Rome sheathed in pristine white marble (see Prater 2002: 23–36; Brinkmann 2008; Bradley 2009b). However, research has shown that their temples, funerary monuments, and statues were awash in color, even in "strong primary colors" (Brinkmann 2008: 18–39; Holloway 2008: 348; Brinkmann and Wünsche 2007). It is against this vibrant backdrop that epic and tragedy were performed. The ancient experience of these performances was decisively influenced moreover by the fact that they were routinely performed in daylight (Platnauer 1921: 162).

In his account of developments in tragic performance in the *Poetics*, Aristotle reports that Sophocles introduced the use of *skēnographia* (Aristotle 1999: 1449a19), a term that may refer to painted panels as part of ancient staging (see Webster 1956: 13–16; Scullion 1994: 108–28; Davidson 2005: 203; Finglass in Sophocles 2011: 13–20). Unfortunately, there is no clear evidence for such painted scenes in fifth-century Athens, including the colors that may have been used in their production. Centuries later, in Rome, colorful awnings helped define the theatrical space. The Roman poet Lucretius (first century BCE) describes the scene:

> And often we see yellow, red, and rust-colored awnings, stretched over poles and beams, scatter their colors as they wave and flutter. There they stain the cavern of the seats, the stage, and the Roman men and women, and make them flow with colors. And the more the theatre is enclosed by these awnings, the more everything inside is suffused with charm by the daylight filtered through.
>
> (Lucretius 1992: 4.75–83; translation by D. Wharton)

Color here creates a festive atmosphere for theatrical performances, which were nearly always performed during public religious holidays that included other entertainments.

When stone theaters became the norm for the Romans, they continued the Greek tradition of scene painting (Pollux 1900–1937:

4.128–32; Moore 2012: 17), and the theatrical backdrops became much more elaborate. Pliny the Elder describes an egregious example in the early first century CE:

> [Marcus Scaurus' theatre] had a three-story stage with 360 columns [...]. The lowest storey of the stage was marble, the middle glass [...] and the highest was made of gilded planks. [...] There were 3,000 bronze statues [...]. The rest of the furnishings, with gold-embroidered fabrics, paintings, and other material, were so valuable that when what was left had been carried to his villa in Tusculum for use in everyday pleasures and the villa was burned by angry slaves, the loss was 30,000,000 sesterces.
>
> (Pliny the Elder 1962: 36.114–15; translation by D. Wharton)

On structures like these, the colors of the marbles, glass, and artworks proclaimed the wealth and power of the owners;[4] their direct relevance (if any) to dramatic action on stage is not clear.

The actors in most kinds of Greek and Roman drama wore stylized masks that covered the entire head (Webster 1995: 2). No actual ancient masks survive, since they were made of perishable materials, but archaeological remains in the form of terra-cotta representations of masks or dramatic figurines, vase paintings, wall paintings, and mosaics all provide evidence of the colors used on masks (for a catalog of surviving artifacts, see Webster 1967, 1978, 1995).

As the "most important [...] of all vase-paintings having to do with the performance of Athenian drama" (Griffith 2010: 47), the Pronomos Vase is our best guide to what tragic masks may have looked like in the fifth century BCE. With reference to the vase, David Wiles notes that the masks were white in color and characterized by a "lack of expression" with no indication of "character or feeling" (Wiles 1991: 30; see also Aristotle 1987: 203–6; Wiles 1991: 148; compare Irwin 1974: 111–34; Marshall 1999). This effect is enhanced by the fact that the masks had empty holes to indicate the character's mouth and eyes. Other applications of white can help contextualize the alleged whiteness of the Greek tragic mask. The most relevant of these is the white-ground *lekythos*, a common type of vase found almost exclusively in funerary contexts. Julia Valeva (2015: 182), cites John Howard Oakley as saying that "the connection of the color white to death is explicitly illustrated by the application of a white ground on funerary *lekythoi* from Classical Athens" (Oakley 2004: 11). Valeva does not speculate about the source of this connection, but suggests that the bodies of the heroized dead on Italian vases are painted white in order to indicate that they are "shadows of the once living" (Valeva 2015: 182). If, as Wiles states, "Masks brought into the theatre dead people from the heroic age *as if* they were alive," they also made the "as if" quality of this effect explicit (Wiles 1991: 247; emphasis in the original). Given the array of characteristics described above, tragic masks clearly looked more like the faces of dead mortals

(or dead heroes) than living ones. The effect of Greek masked drama is thus achieved in the contrast between the lifeless and inanimate (white?) mask and the myriad emotional states that tragic characters express in language and, if less certainly known, in movement.

The most detailed written source for the ancient mask comes to us from the *Onomasticon* of Julius Pollux, a Greek-speaking scholar and rhetorician of the second century CE. The *Onomasticon*, Pollux's only surviving work, is a quirky thesaurus that contains a description of stage painting and equipment, costumes, and masks for tragedies, comedies, and satyr plays (Pollux 1900–1937: 4.99–154). Pollux's descriptions are not representative of the whole history of Greco-Roman theatre, since mask styles underwent significant developments from their beginnings in early Greek theatre to the more stylized forms of the Hellenistic and Roman stage (Wyles 2011: 41). (See Figure 7.1 for a second-century mosaic artist's depiction of Roman comic and tragic masks.) Nor do we know the precise sources of Pollux's descriptions. However, he might have

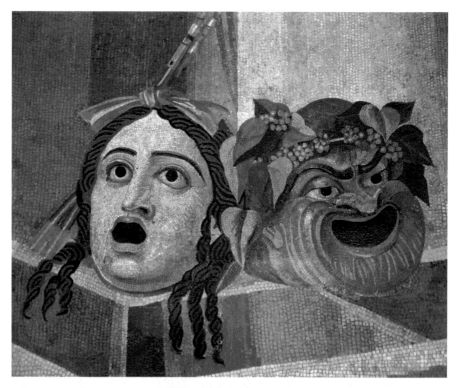

FIGURE 7.1 Roman mosaic depicting theatrical masks of tragedy and comedy (Thermae Decianae), second century CE. Capitoline Museum, Rome. Wikimedia Commons. https://commons.wikimedia.org/wiki/File:Mosaic_depicting_theatrical_masks_of_Tragedy_and_Comedy_(Thermae_Decianae).jpg. Public domain.

had firsthand knowledge of actual theatrical masks (Poe 1996: 311–12), and his descriptions provide insight into how color functioned in the theatrical context in the second century CE, and probably for the Hellenistic and Roman stage as well (Webster 1967: 13).

Pollux uses about twenty different color terms to describe nuances in complexion and hair color on dramatic masks, which were deployed in conjunction with mask shape, facial expression, hairstyles, beard length and texture, and adornment, to create an array of seventy-six masks. The masks used gradations of skin and hair color to communicate distinctions in age, sex, health, social status, and occupation, but there is not a one-to-one correspondence between color and any such status. White or various shades of pale/sallow skin appear on masks for the old, the sick, the wounded, the Delicate Youth, who seems to have been "brought up in the shade" (Pollux 1900–1937: 4.147), and most women. Darker shades are often applied to mature men's complexions, as well as to the comic Old Freedwoman. Reddish/ruddy complexions appear on vigorous young men, messengers, and the comic Mature Prostitute. Very white hair denotes the very old; gray and "sprinkled gray" the merely aged; younger characters' hair color ranges from black/dark to various shades of blonde. Almost all comic slaves' masks have bright red hair, and prostitutes' masks could be distinguished by various colored adornments such as hair ribbons, gold woven into the hair, or a multicolored headdress (*mitra*) or scarf.

Some of these color distinctions are based on familiar or everyday experience; for example, white/gray hair for old people, pale complexions for those who are ill or wounded, and ruddy complexions for those who are physically vigorous. But others are connected to social conventions. The dark/light divide between men's and women's complexions depends on the division of labor in the ancient world, where free women were mostly restricted to indoor activity; this would also explain the darker skin of the Old Freedwoman, who would have worked outdoors when she was a slave. The colored adornments of prostitutes' masks may be connected to conventions of adornment of actual prostitutes, and the Mature Prostitute's reddish complexion perhaps refers to the application of rouge. The red hair of slaves communicated barbarism or foreign origin to Greek audiences (Wrenhaven 2011: 101), and the Romans maintained the convention.

Beyond these signifiers of age, sex, health, occupation, and class, scholars do not agree on how much each mask's combination of visual elements communicated deeper information about characters' dispositions. Some have argued that, especially in Greek New Comedy, these combinations of complexion, hair color and texture, and facial features "enabled an experienced member of the audience to predict the total personality of a character on his first entrance" (Arnott 1979: xxxiii; see also Bernabò Brea 1981: 13), and that particular feature/color combinations were widely associated with specific

dispositions such as salaciousness, spitefulness, courage, cowardice, and the like. The relationship between physiognomy and masks is complex, however, and the reliability of physiognomic "science" was controversial even in the ancient world (Wiles 1991: 85–8; Bradley 2009a: 135–7). J.P. Poe (1996) argues persuasively that the feature and color combinations described in Pollux's mask catalog for the most part do not align with established physiognomic types, and that many masks provide contradictory signals. Both Wiles (1991: 68–99) and Petrides (2014: 156–73) believe that the masks' physiognomic ambiguity offered opportunities for nuanced character portrayals and subtle or surprising dramatic effects. Color played a crucial role in all this.

Our knowledge of how colors were used in costumes is as limited as that for masks, although we can say with certainty that the modern image of white draped garments is entirely wrong (see Llewellyn-Jones, this volume). The archaeological record provides plentiful evidence of exuberant use of color and patterns, though costume styles changed considerably through the centuries (Wyles 2011: 5–6; Dunbabin 2016). Pollux also reports on the costume conventions of the second century CE. Because costume styles changed over time, his observations are not fully corroborated by the archaeological record (Webster 1978: 4), but at least they give us a glimpse of how colored garments could be associated with character types. Here are a few examples:

> The *syrtos* of a woman in distress is black, the throwover blue gray or yellowish […]. [In comedy] young men wear a *phoinikis* ("scarlet") or dark purple *himation* […]. Young men use a purple dress, while parasites wear black or gray […]. Pimps take pleasure in a dyed (i.e., brightly colored) *chiton* and a flowery wrap […]. Some women have a *parapechy* and a *symmetria*, which is a *chiton* down to the feet, purple-dyed all round.
> (Pollux 1900–1937: 4.115–20; translation from Csapo and Slater 1995: 395–6)

According to Pollux, the Greek and Roman stage presented a symphony of colors that enabled ancient playwrights and producers to communicate, and ancient audiences to interpret, nuances of a given character's age, sex, social status, and dispositions.[5]

LIGHT AND DEATH IN GREEK AND EPIC TRAGEDY

Beginning with the Homeric poems, human life in the Greek literary tradition is equated with the presence of light (*phōs* or *phaos*). To be alive is "to see the light of the sun" (for example, Homer 1999: *Iliad*, 18.61); to be dead is "to leave the light of the sun" (for example, Hesiod 2018: *Works and Days*, 155). At the other end of the spectrum, death is equated with what is unseen, invisible, or covered up as expressed in the periphrasis "the end of death covered [him]" (Homer 1999: *Iliad*, 5:553; Sophocles 2011: *Ajax*, 608 and 635; Plato 1932:

Gorgias, 493b). In distinguishing life from death in terms of the presence or absence of light, these expressions align the limits of mortal life with Greek conceptions of color, as summarized by John Lyons:

There are many well-studied passages in works by Plato, Aristotle and others that strongly support the view that it was more natural to the Greeks [in the Archaic and classical periods] than it is to us to think of the basic color terms (whatever they are and however many) as being arrangeable on a scale between *melas* and *leukos* at the end points. These two words [...] are generally translated into English either as *black* and *white*, or *dark* and *light* (or *bright*) according to context.

(Lyons 1999: 58)[6]

If, as Lyons concludes, "luminosity was more salient than chromaticity" (65) for the ancient Greeks (see also McDonald, this volume), then luminosity serves as a powerful indicator of the distinction between life (light) and death (darkness).[7] In what follows, it is demonstrated how Greek epic and tragedy mine this distinction in a selective examination of three Greek terms: light (*phōs*), black/dark (*melas*), and red/dark (*porphyreos*).

The Homeric poems are the earliest source of death (*thanatos*) as "black," or *melas*.[8] This usage conforms to the association of death with the absence of light, as noted above. Variations can be rhetorical or lexical. The former includes the description of Erymas' death at the hands of Idomeneus, where the blackness of death is attributed to a cloud by hypallage or transferred epithet: "A black cloud of death (*thanatou melan nephos*) covered him completely" (Homer 1999: *Iliad*, 16.350; compare Homer 1995: *Odyssey*, 4.180). The latter includes a larger set of examples in which *kēr*, regularly translated as "doom" or "violent death," is described as black (*kēra melainan*, Homer 1999: *Iliad*, 2.859).[9] If we agree with color theorists that color terms—including those that denote light and dark—can be either figural or concrete (that is, inhering in objects), the colors ascribed to states of life and death constitute a singular class.

The interplay between light/life and darkness/death is exemplified in a pivotal scene in the *Iliad*. Following the death of Patroclus, this scene focuses on the intense struggle over his corpse led by the mighty warrior Ajax:

Ajax went among all [the Greeks], urging them on in every way.
He commanded that no one fall back from the corpse
and that none of the Achaeans fight in the front lines apart from the rest,
but stand close to the corpse and fight hand to hand.
Thus the mighty Ajax charged them and the earth [*chthōn*] grew wet
with dark [red?] blood [*haimati porphyreōi*] as the corpses of the Trojans,
their powerful allies, and the Danaans fell in heaps.
For these did not fight without shedding blood [*anaimōti*]

But fewer of them by far perished. For they always had in mind
to ward off utter destruction from each other in the melee.
So they fought like fire, nor could you say
with certainty that the sun and the moon even existed.
For they were covered by the haze of the battle [*ēeri ... machēs*]
all the best fighters who stood around the slain son of Menoetius.
(Homer 1999: 17.356–69; translation by Murray, with some modifications)

In this scene, the "haze of battle" produces doubt about the very existence
(*emmenai*) of the sun and the moon, that is, about the existence of light on the
earth. This doubt occurs only here in the epics where it emphasizes the interplay
of light and darkness in the context of uncertainty about whether characters
will live or die. As such, it may be the earliest expression of what Carl von
Clausewitz famously called the "fog of war" (*Nebel des Krieges*, in Clausewitz
1976: 101). At the center of this atmospheric half-light are a human corpse and
the battle over its possession. The corpse is the physical and irreversible proof
that humans are mortal. But it is Achilles' ignorance of Patroclus' death and
the question of when or if Achilles will return to the fighting that motivates the
action at this critical moment in the narrative.

The quality of light—from nonexistent to hazy to bright—is the ground
against which the description of the earth as "wet with dark [red?] blood" comes
into focus (Homer 1999: *Iliad*, 17.360–1). *Porphyreos* "dark" or "red" has a
wide semantic range in the epics. In addition to blood, it is predicated of textiles,
the waves of the sea, clouds, and death. Gladstone comments that *porphyreos*
presents "a startling amount of obvious discrepancy" (Gladstone 1858: 461;
compare Platnauer 1921: 159). More helpfully, Michael Clarke explains the
wide semantic range of many Greek color terms as the effect of "an undivided
continuum in which colour is inseparably bound up with other channels of sensory
perception and cultural knowledge" (Clarke 2004: 133). He also demonstrates
that the principal variables are light, shade, and movement. In Lyons's terms,
porphyreos oscillates between luminosity (darkness) and chromaticity (redness).

Porphyreos is predicated of blood (*haima*) in this single and notable example
in the epics. More commonly, blood is described as *melas* or *kelainos*, both of
which are translated as "black" or "dark." Andreas Fountoulakis claims that black
blood is "a symbol of imminent death" (Fountoulakis 2004: 113). We have seen,
too, that black (*melas*) is a common attribute of death (*thanatos*). Black is also
commonly predicated of the earth, or *gaia,* as in our passage (for example, Homer
1999: *Iliad*, 20.494; 1995: *Odyssey*, 11.365), and is triangulated with blood and
earth in two repeated verses in the *Iliad*: "Black blood [*melan haima*] flowed
out, and drenched the earth [*gaian*]" (Homer 1999: *Iliad*, 13.655 and 21.119)
and "The black earth [*gaia melaina*] flowed with blood" (15.715 and 20.494).
In these verses, *melas* (black) is again a transferable epithet that emphasizes the

correlation between luminosity (or the absence of light) and death, expressed here in black blood that flows out of the human body and into the black earth.[10]

Rudolf Bultman has shown that the tragic poets adopted the Homeric associations of life with light and death with darkness (Bultman 1948: 4–10). In Sophocles' *Electra* (410 BCE), Electra addresses Orestes as "dearest light" (*philtaton phōs*, Sophocles 1997: 1224) in a scene in which she comes to realize that her brother is not dead, as falsely reported. Here the presence or absence of light again signifies uncertainty about whether a character is living or dead. Bultman notes that this signification is so strong that Sophocles can make it the source of a paradoxical statement by Ajax in the play of his name produced in 442 BCE:

> Darkness [*skotos*], my light [*phaos*]
> Oh Erebos, the most bright, at least to me.
> Take me, take me as your inhabitant,
> Take me.
>
> (Sophocles 2011: 394–7)

Ajax's assertion that darkness is (his) light mirrors the central paradox of the play: the unheroic death by suicide of one of the greatest warriors of Greek legend. This is the hero who, as we have seen, stands in the front line of defense over the corpse of Patroclus in the *Iliad*. Sophocles' play introduces a long-standing conundrum in the history of classical scholarship about whether the hero's suicide took place onstage (in the light of day) or offstage.[11] The questions surrounding Ajax's death are explicitly and repeatedly figured in terms of the presence or absence of daylight.

At the beginning of his so-called "deception speech," Ajax posits the unpredictability of life as a relationship between the passing of time and the presence or absence of light: "Long and uncountable time brings forth all things that are invisible, and hides all things that have been brought to light" (*phanenta*, Sophocles 2011: 646–7). This gnomic passage exemplifies the complex relationship in the play between luminosity (daylight), the material conditions of tragic performance (staging techniques), and the dividing line between life and death. This relationship is then extended in Ajax's suicide speech in which he calls upon death (*thanatos*) and then upon the light of day (*phengos*):

> O Death, Death, come now and visit me!
> And yet I shall meet and speak with you there [in the underworld?] too.
> And I call upon you, o present blaze of the bright day,
> And the Sun, the charioteer,
> for the very last time and never again later.
> O daylight [*phengos*]!
>
> (Sophocles 2011: 854–9; translation by Finglass, with some modifications)

Some scholars believe these lines are interpolations and subject them to withering criticism (see Finglass in Sophocles 2011). But in paradoxically equating death with daylight ("O death," "O daylight!"), Ajax's apostrophes recall Calchas' prophecy that Ajax will die if he leaves his tent (which he has done). For Ajax, the suicide, the presence of daylight—rather than darkness—means death.

Upon discovering Ajax's corpse, Tecmessa tells the chorus that it "must not be seen" and that she will cover it entirely "since no one who loved him could bear to look at him as he spurts blackened blood [*melanthen haima*] towards the nostrils and out of the bloody wound as a consequence of his self-inflicted slaughter" (Sophocles 2011: 915–19, translation by Finglass; compare line 376). Scholars have questioned the authenticity of these lines based upon their perceived un-Sophoclean goriness (see Sophocles 2011). And yet at the very end of the play, Ajax's brother Teucer similarly observes that the hero's "still warm channels are spurting up his black life force" (*melan menos*, Sophocles 2011: *Ajax*, 1411–13). This description is no less graphic than Tecmessa's; both use the same verb meaning "to spurt" (*phusaō*). If we accept the authenticity of both passages, "black/darkness" is once again a transferred epithet whose effect is to equate "blood" and "life force," where the loss of the former is the physical manifestation of the loss of the latter at death. The question raised is whether these descriptions of Ajax's bloody corpse conform to what the ancient audience saw, that is, whether the "blood" on the dummy corpse was painted black. If so, it provides vivid and visible testimony for the dominance of black/darkness as an attribute of both blood and death.

The emphasis on daylight and darkness in the *Ajax* exemplifies how luminosity trumps chromaticity in the ancient Greek conception of the line that separates life from death. Weighed against the relative absence of color terms in the play, this emphasis brings us back to the tragic mask. Ajax's corpse remains on stage for the entire second half of the play during which characters argue over whether or not it is to be buried. Scott Scullion suggests that, following Tecmessa's covering of the corpse, it may have remained covered throughout the play so as to "avoid the problem of having a very gory false corpse in full view for over 400 lines" (Scullion 1994: 125–6). But like the "un-Sophoclean" problem mentioned above, the source of Scullion's "problem" is not obvious. Soon after Teucer arrives on the scene, he gives the instruction to "Come, uncover him, so that I may see the whole evil thing" (Sophocles 2011: 1003). He then comments: "O face [*omma*] hard to look upon, full of bitter daring. What pains you have sown for me in your death" (1004–5). Finglass (Sophocles 2011) assumes that the whole body is uncovered at this point. But Teucer's attention immediately turns to Ajax's face (*omma*), or rather to the mask that represents his face. Whether or not the shroud has been completely removed, in other words, the dead face stands for the entire corpse both by

apostrophe and by synecdoche. C.W. Marshall remarks that, "The normal way of representing death on the tragic stage did not involve new masks [...]. The mask that had formerly been animated by the actor now appears a lifeless shell" (Marshall 1999: 193). As we have seen, this transition from animated actor to lifeless corpse dominates the dramatic trajectory of Sophocles' *Ajax*. As the most visible sign of this transition, however, the tragic mask does not suddenly become a "lifeless shell." Rather, as suggested above, its death-like quality is present even when "animated." Ajax's mask, whether figuratively or literally stained with black blood, epitomizes tragedy's adaptation of the epic interplay of light/life and dark/death to a fully mimetic form. In animating the characters of myth and legend, moreover, tragedy paradoxically confirms that humans are "beings that live for a day" (*ephemeroi*, for example, Pindar 2012b: *Pythian*, 8.95; Aeschylus 2008b: *Prometheus Bound*, 255) in the process of denying it. The source of this paradoxical effect is the light of a single day as the source of a complex interplay between luminosity, tragic mimesis (imitation), and eschatology.

THE ETHICS OF COLOR IN ROMAN EPIC AND TRAGEDY

Turning now to Latin genres, we analyze several passages in Virgil's *Aeneid* and Seneca's *Thyestes* that illustrate how Roman writers borrowed from and expanded on Greek conventions of color usage. It is not possible to cover here the literary color language of Latin in all its variety. Rather, in our analysis of Virgil, we employ Edgeworth's categories of color use in an examination of two key scenes of the *Aeneid*. In particular, we trace how Virgil uses color as a linking device, both externally, as a means of allusion, and internally, as a way to focus attention on connections between distant sections of his narrative, while at the same time highlighting Roman social and cultural norms. Our discussion of Seneca will attend to his use of light, dark, and color to explore Stoic ethical and cosmological ideas.

Virgil's use of color is well exemplified in a passage describing the hero Aeneas when he first appears to the Carthaginian queen Dido, with whom he will have a disastrous love affair. At their first meeting, Aeneas' mother Venus, who abets the affair, beautifies him:

> Aeneas shone forth [*refulsit*] in clear light [*clara luce*], his face and shoulders like a god. For his mother herself had breathed beautiful hair on her son, and the purple light [*lumen purpureum*] of youth, and a delightful grace to his eyes, just as artists' hands add beauty to ivory [*ebur*], or when silver [*argentum*] or Parian marble [*Parius lapis*] is decorated with yellow gold [*fulvo auro*].
>
> (Virgil 1999: *Aeneid*, 1.588–93; translation by D. Wharton)

What are the colors' functions here? The bright light (*clara luce*) in which Aeneas appears comports neatly with the association between light and life discussed above, especially because in this context those present explicitly wondered whether he was still alive (Virgil 1999: *Aeneid*, 1.546–7), and he has just appeared out of a dark mist (*obscuro ... aere*: *Aeneid*, 1.411), which like the dust cloud in the battle for Patroclus' body, is a visual analog to his potential death.[12] His shining appearance (*refulsit, lumen*) also marks him for ancients as quasi-divine (see Platt, this volume). Red hue, here referred to with the term *purpureus*,[13] when applied to people, is frequently associated with youth and vigor (André 1949: 261). In the simile, Virgil mostly avoids abstract color terms, as is typical of Latin poetry,[14] preferring words whose meanings include hue as well as other qualities. Ivory, gold, silver, and Parian marble encode smooth texture, sheen, costliness, and desirability, as well as hue,[15] and Virgil invites us through his use of these terms to contemplate all these qualities' relevance to Aeneas in his relationship with Dido and to Venus.

Borrowing Edgeworth's categories of color use (1992: 1–2), we can say that gold and silver here are "allusive" in that they evoke Homeric similes that enrich the narrative context. In the *Odyssey*, Athena beautifies Odysseus for the Phaeacian princess Nausicaa, who has come to the beach to wash her clothes because she wishes to attract a suitor:

> Then Athena, daughter of Zeus, made him taller and stouter, and made his hair flow down his head like hyacinth flowers. And just as a man overlays silver [*arguros*] with gold [*chrysos*], a cunning workman whom Hephaestus and Pallas Athena have taught every kind of craft, and he produces graceful works, so the goddess shed grace on his head and shoulders.
>
> (Homer 1995: 6.229–35; translation by D. Wharton)

The same simile appears nearly verbatim elsewhere in the *Odyssey* (Homer 1995: 23.156–62), when Odysseus is revealed to his wife Penelope after his twenty-year absence. Aeneas' appearance to Dido is thus compared with Odysseus' appearance to the marriageable Nausicaa, as well as to his own wife Penelope—both scenes full of erotic possibility, which is thereby infused into the Virgilian context. But Virgil expands on the Homeric model to include ivory, which in combination with the reference to Aeneas' *purpureus* complexion, suggests a different simile from the *Iliad*, when a Trojan archer strikes Menelaus' thigh with an arrow, breaking a truce, and instigating the epic's first major battle:

> Just as a woman dyes ivory [*elephas*] with red [*phoinikis*] dye, a Carian or Maeonian woman, stains a horse's cheek piece, and it is stored in an inner room and riders want to have it, but it is the prized possession of a king, his team's adornment and the glory of their driver, just so, Menelaus, your leg, shin, and shapely ankle were stained with blood.
>
> (Homer 1999: 4.141–7; translation by D. Wharton)

All Plates are color versions of black and white Figures distributed throughout this volume's chapters. The numeration is the same for Plates and Figures.

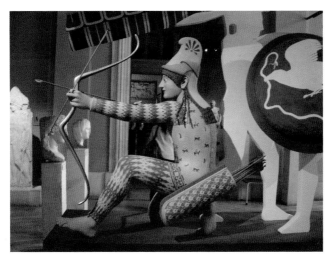

PLATE 0.1 Modern reconstruction of the polychromy of a Trojan archer of the Temple of Aphaia, *c.* 500 BCE. On loan from the Glyptotek in Munich, for the Bunte Götter exhibition. Photograph by Giovanni Dall'Orto. Wikimedia Commons. https://commons.wikimedia.org/wiki/File:Istanbul_-_Museo_archeologico_-_Mostra_sul_colore_nell%27antichit%C3%A0_08_-_Foto_G._Dall%27Orto_28-5-2006.jpg.

PLATE 4.1 Abduction of Persephone, from the Tomb of Persephone, Vergina, *c.* 340 BCE. Painted fresco. Wikimedia Commons. https://commons.wikimedia.org/wiki/File:Painting_vergina.jpg. Public domain.

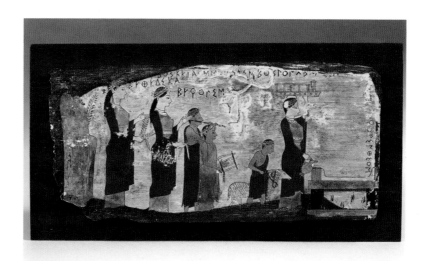

PLATE 4.2 The Pitsa Tablet, *c.* 520–500 BCE. Painted wooden tablet. National Archaeological Museum, Athens. Photograph by DEA / G. DAGLI ORTI / De Agostini via Getty Images.

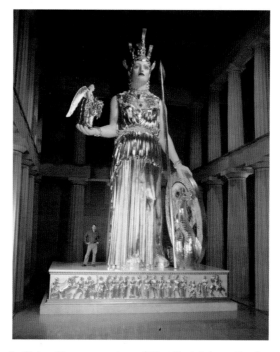

PLATE 4.3 Alan LeQuire, Reconstruction of Pheidias' Athena Parthenos, 1990. Parthenon, Nashville. Photograph by Dean Dixon. Wikimedia Commons. https://commons.wikimedia.org/wiki/File:Athena_at_Parthenon_in_Nashville,_TN,_US.jpg.

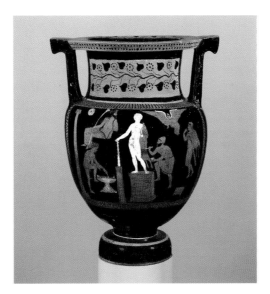

PLATE 4.4 Column-krater from Apulia, 360–50 BCE. The Metropolitan Museum of Art, Rogers Fund, 1950. Accession number 50.11.4.

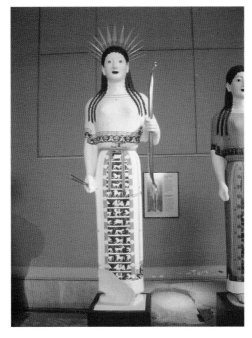

PLATE 4.5 Painted plaster cast of the *c.* 530 BCE "Peplos Kore" as Artemis, based on pigments determined through analysis. By Vinzenz Brinkmann. Glyptotek, Munich. Photograph by Giovani dall'Orto. Wikimedia Commons. https://commons. wikimedia.org/wiki/File:Istanbul_-_Museo_archeologico_-_Mostra_sul_colore_ nell%27antichit%C3%A0_01_-_Foto_G._Dall%27Orto_28-5-2006.jpg.

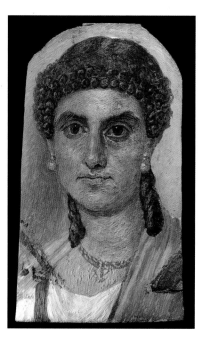

PLATE 5.1 Panel painting of a woman in a blue mantle; Egypt, *c.* 54–68 CE. The Metropolitan Museum of Art. Accession number 2013.438.

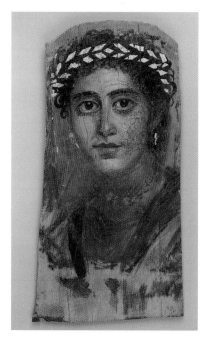

PLATE 5.2 Portrait of a young woman in red; Egypt, *c.* 90–120 CE. The Metropolitan Museum of Art. Accession number 09.181.6.

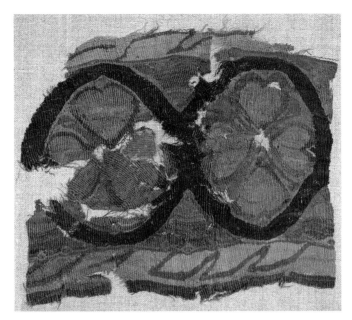

PLATE 5.3 Fragment of a band with a floral motif in subtle shades of red and pink with green details. Linen and wool, *c.* 500 CE. The Metropolitan Museum of Art. Gift of Nanette B. Kelekian, in honor of Nobuko Kajitani, 2002. Accession number 2002.239.1.

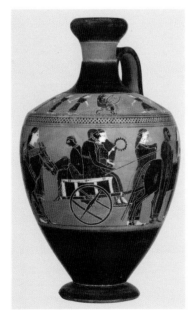

PLATE 5.4 Bride in a red veil. Terra-cotta *lekythos* (oil flask) attributed to the Amasis Painter; Athens, *c.* 540 BCE. The Metropolitan Museum of Art. Accession number 56.11.1.

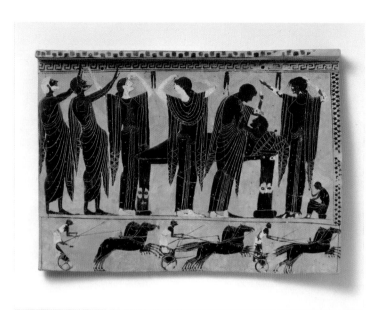

PLATE 5.5 Terra-cotta funerary plaque; Athens, *c.* 520–510 BCE. Funerary scene with figures in mourning. The Metropolitan Museum of Art. Accession number 54.11.5.

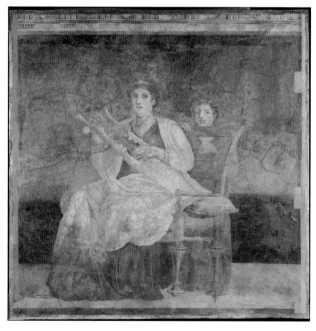

PLATE 5.6 Wall painting from Room H of the Villa of P. Fannius Synistor at Boscoreale, *c.* 50–40 BCE. The Metropolitan Museum of Art. Accession number 03.14.5.

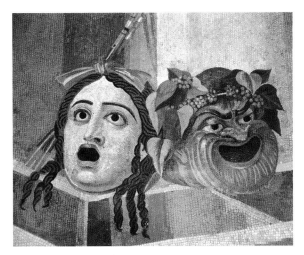

PLATE 7.1 Roman mosaic depicting theatrical masks of tragedy and comedy (Thermae Decianae), second century CE. Capitoline Museum, Rome. Wikimedia Commons. https://commons.wikimedia.org/wiki/File:Mosaic_depicting_theatrical_masks_of_ Tragedy_and_Comedy_(Thermae_Decianae).jpg. Public domain.

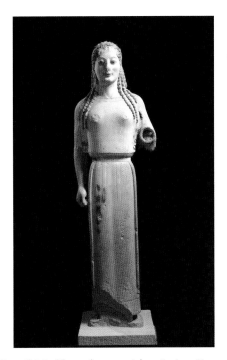

PLATE 8.1 "Peplos Kore." Marble sculpture with painting. From the Athenian Acropolis, c. 530 BCE. Athens, Acropolis Museum. Photograph by Leemage/Corbis via Getty Images.

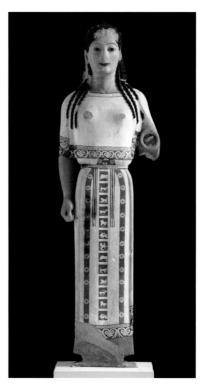

PLATE 8.2 Digital projected polychrome reconstruction of the "Peplos Kore," Acropolis Museum. Photograph: © Acropolis Museum, 2012. Polychrome reconstruction: Hara Sfiri.

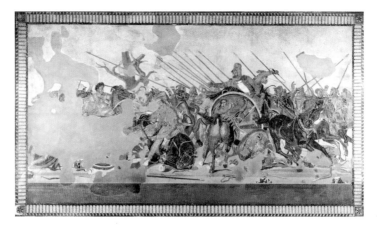

PLATE 8.3 "Alexander Mosaic," late second century BCE. Monumental mosaic after a painting of the early third century BCE. From the House of the Faun, Pompeii. Naples, National Archaeological Museum. Photograph by David Lees/Corbis/VCG via Getty Images.

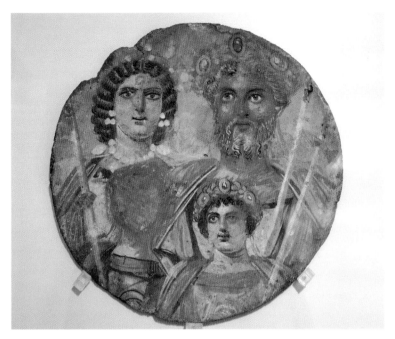

PLATE 8.4 Painted wooden panel with family portrait of Septimius Severus, Julia Doman, Caracalla, and Geta (erased). From Egypt, *c*. 199–211 CE. Berlin, Altes Museum, Antikensammlung. Photograph by Carole Raddato. Wikimedia Commons. https://commons.wikimedia.org/wiki/File:Carole_Raddato_(13543792233).jpg. Public domain.

PLATE 9.1 Aegina, late Archaic Temple of Aphaia, *c*. 500 BCE. Digital reconstruction of the color scheme. © Hansgeorg Bankel, visualization by Valentina Hinz and Stephan Franz, with annotations by Stephan Zink.

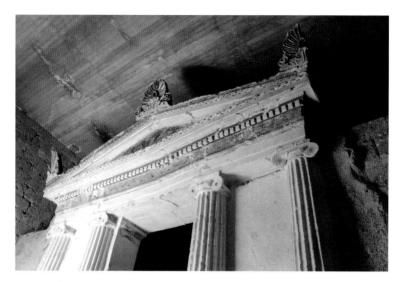

PLATE 9.2 Lefkadia, Tomb of the Palmettes (third century BCE). Photograph by Vassiliki Feidopoulou. Wikimedia Commons. https://commons.wikimedia.org/w/index. php?curid=73161388.

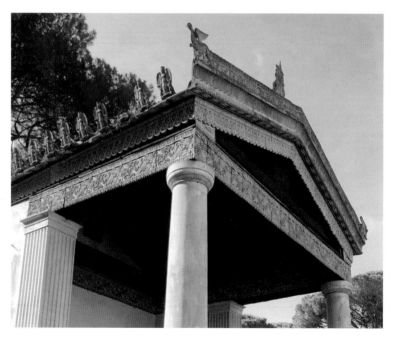

PLATE 9.3 Etrusco-Italic temple from Alatri (third century BCE). Detail of 1:1 reconstruction (carried out in 1890) in the courtyard of the Museo Nazionale Etrusco di Villa Giulia in Rome. © Jens Pflug.

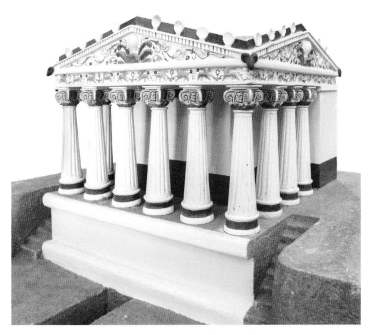

PLATE 9.4 Sovana, Tomba Ildebranda, first half of third century BCE. Reconstruction model with polychromy in the Archaeological Museum of Savona. © M. Hofmann modified by Stephan Zink.

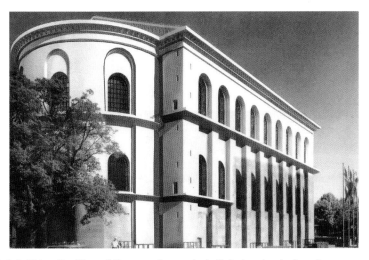

PLATE 9.5 Trier, Basilica of Constantine or Aula Palatina (early fourth century CE). Color reconstruction and, in the lower register, current state of preservation. © Klaus-Peter Goethert and H&S Virtuelle Welten GmbH, with additions from Nicole Riedl and Friederike Funke.

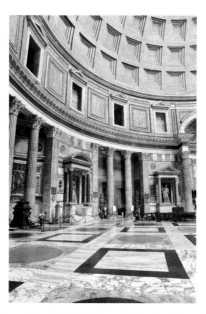

PLATE 9.6 Rome, Pantheon (*c.* 120 CE). View of the interior, which preserves much of the original decoration in various colored marbles. © Stephan Zink.

PLATE 9.7 Athens, wall decoration in the Structural (or Masonry) Style, late second to early first century CE. Wirth 1931. Public domain.

PLATE 9.8 Rome, Palatine Hill, detail of an *opus sectile* floor in "quadricromia Neroniana," probably from the Aula of Nero's Domus Aurea. © Dörte Blume.

PLATE 9.9 Ostia, Aula from the building outside of Porta Marina (*c*. 393/394 CE). Detail of wall incrustation in colored marble imitating brickwork and *opus sectile* wall facing. © Brent Nongbri.

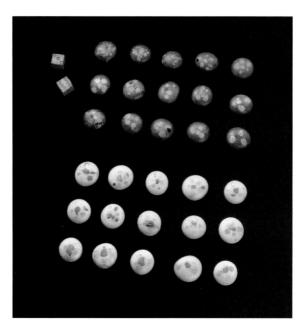

PLATE 10.1 Provincial Roman gaming counter set from Lullingstone Roman Villa. Artist: J. Bailey. Detail of gaming counters and dice excavated from the Mausoleum at Lullingstone Roman Villa, Eynsford, Kent, 1991. Photograph by English Heritage/ Heritage Images/Getty Images, via Getty Images.

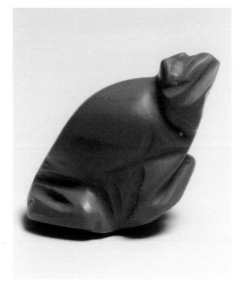

PLATE 10.2 Egyptian late period/Hellenistic jasper frog amulet. The Metropolitan Museum of Art, The Cesnola collection. Accession number 74.51.4448.

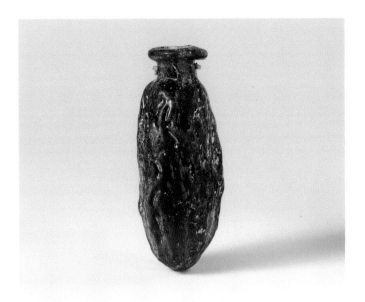

PLATE 10.3 Roman glass date bottle. The Metropolitan Museum of Art, Edward Moore collection, bequest of Edward Moore, 1891. Accession number 91.1.1295.

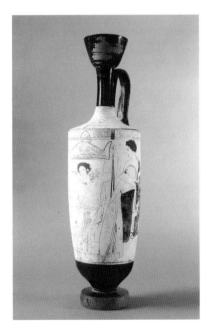

PLATE 10.4 Greek *lethykos* colored white, showing a funeral scene. Ethnikó Arheologikó Moussío (National Archaeological Museum), Athens. Photograph by DeAgostini/Getty Images, via Getty Images.

PLATE 10.5 Fragment of an early Bronze Age monochrome necklace in jet. The British Museum, accession number 1870,1126.1. © The Trustees of The British Museum.

PLATE 10.6 Mesopotamian jewelry set with carnelian and lapis lazuli from Ur. Photograph by DEA / A. DE GREGORIO/De Agostini, via Getty Images.

This simile's connection with violence, warfare, red color, and blood is relevant to Aeneas and Dido's meeting. Their affair will result in Dido's suicide with a sword foaming with her blood that spatters her hands (*ensemque cruore / spumantem sparsasque manus,* Virgil 1999: *Aeneid* 4.664–5), and in enmity and warfare between Carthage and Rome (4.621–9).

The red-on-white motif is also "associative" in Edgeworth's terminology in that it links the Dido-Aeneas passage to a later dramatic scene in the *Aeneid*. In book 12, Virgil describes the face of Lavinia, princess of Latium, as she hears her mother, her father, and the Rutulian prince Turnus argue about whether Aeneas or Turnus shall carry her off as a bride-prize after battle:

> Lavinia received her mother's words with tears, her flaming [*flagrantis*] cheeks flushed, and a great blush [*plurimus rubor*] sent fire [*ignem*] racing through her burning face. Just as if someone stained [*violaverit*] Indian ivory [*ebur*] with blood-hued purple dye [*sanguineo ostro*], or as white lilies [*lilia alba*] glow red [*rubere*] when mixed with many roses [*multa rosa*], just so did the maiden show colors [*colores*] on her face. Love agitates Turnus, and he fixes his gaze on the maiden; he burns for arms all the more.
>
> (Virgil 2000: *Aeneid*, 12.64–71; translation by D. Wharton)

The meaning of Lavinia's blush is much debated, but it can surely be interpreted as a sign of her sense of *pudor,* "modesty" (especially sexual modesty), about having her marriage openly discussed in the presence of a potential bridegroom (Bradley 2004: 117–21; 2009a: 150–60; Cairns 2005: 195–213). And the red-on-white similes refer to a combination of colors of women's skin that was a widespread trope of young women's beauty.[16] Jacqueline Clarke (2003: 189–90) notes the connection of red-purple color with the loss of virginity and the breaking of the hymen in Catullus' wedding poem 61 (Catullus 1988), a connection that Virgil makes even more explicit here with the phrase *sanguineo ostro,* "blood-hued purple dye," and his use of the verb *violaverit,* which can refer to the act of sexual intercourse with a virgin. The *rubor* of Lavinia's face is thus linked not only with having her marriage openly discussed but also with the blood associated with the marital sexual act, implicitly the subject of her parents' and Turnus' conversation.[17]

Though Lavinia never speaks in the *Aeneid,* the colors attributed to her communicate ingrained ideals of Roman culture: the high value placed on women's beauty and on their *pudor,* and the centrality of the virginal marriage bed in creating and populating the future Roman Empire, beginning with her subsequent marriage to Aeneas and the birth of their son Silvius, who will become a king in Latium. The color-thematic linking of this episode with the earlier encounter between Aeneas and Dido also encourages readers to consider the contrasts between the two women. Dido is an anti-Lavinia: by her own admission she abandons *pudor* in pursuing Aeneas and breaks a vow

of faithfulness to her late husband (Virgil 1999: *Aeneid*, 4.20–30); her sexual relationship with Aeneas not only produces no marriage and no offspring, but also ends in her death and in hatred between Carthage and Rome. The similarity of color themes across the two scenes, then, has the paradoxical power of highlighting deep moral and social antitheses.

Seneca the Younger (4 BCE–65 CE), statesman, Stoic philosopher, and tragic playwright, uses color strategies in his tragedies that are quite different from Virgil's. Although his color vocabulary spans the visible spectrum, its distribution is distinctively skewed; more than 90 percent of his color-related expressions fall into one of three categories.[18] One is characterized by luminosity, in the sense of emitting or reflecting light, and includes words for fire (*ignis*), flame (*flamma, flagrare, flammeus*), lightning or flashing (*fulmen, fulgere, micare*), and bright whiteness (*candidus, niveus*); the second is characterized by the absence of light, including words for night or shadow (*nox, nocteus, tenebra, umbra*) and for black or dark (*ater, niger, piceus, obscurus, caecus*); the third relates to blood (*sanguis, sanguineus, cruor, cruentus*).

A passage from his *Thyestes* (Seneca the Younger 2018: lines 641–884) typifies his technique. In it, the Messenger describes how Atreus murders, dismembers, and cooks his brother Thyestes' boys in an inner grove of his palace. The palace itself shines (*fulget*), but in the dark grove (*obscura silva*) grow black (*nigra*) ilex trees; beneath their shade (*umbra*) is a gloomy (*tristis*) spring in a black swamp (*nigra palus*). In the dark night (*nox caeca*), the wood flickers with flame (*micat flamma*) and the tree trunks burn without fire (*ardent sine igne*). Even in daytime the grove has its own night (*nox propria*). Atreus binds the boys with a purple (*purpurea*) sacrificial headband; he sings the prayers as a meteor leaves a black trail (*ater limes*) in the sky. Wine poured into the flames is changed to blood (*libata in ignes vina mutato fluunt / cruenta Baccho*) and a sacrificed boy's blood extinguishes the altar fire (*cadit ille et aras sanguine extinguens suo*). The fire burns unwillingly (*ignis … invitus ardet*) and turns into pitch-black smoke (*piceus fumus*), which hides the household gods in its ugly cloud (*nubes deformis*). Thyestes' later unknowing consumption of his sons is only briefly described, but during the meal, the sun reverses its course, and night (*nox*) covers the foul deed with strange shadows (*novae tenebrae*).[19] The Chorus then embarks on a lengthy description of a cosmos in which the heavenly bodies leave the sky and do not return, leaving all in darkness.

The contrast between luminosity and darkness in this passage, although drawing upon the associations seen above in Greek epic and tragedy, communicates more than the life-death binary. The shining of Atreus' palace certainly cannot be interpreted as life-bearing, but is more likely a description of its luxurious decoration and hence its decadence.[20] The creepy flickerings in the woods serve principally to highlight the grove's darkness and horror. Natural light from the heavens, however, is conspicuous by its absence. Seneca

and his audience no doubt associated such light with life, and that is one reason why it is excluded. The darkness of the grove presages and surrounds the killing of Thyestes' boys and is an emblem of the other murders—of Pelops, Iphigenia, Agamemnon, Cassandra, Aegeus, and Clytaemnestra—of the House of Atreus. And the splashes of red color in the scene carry none of the positive associations that we saw in the *Aeneid*, where they were oriented toward youth and fecundity. Here, the purple headbands on the boys intimate their deaths, prefiguring their blood, which will extinguish the sacrificial flames.

But Seneca is less concerned with mortality per se than he is with the moral depravity that leads not just to death but to twisted acts of revenge against kin, including the ritual sacrifice of children and cannibalism. For Seneca the Stoic, such deformity of soul may be worse than death (see Seneca the Younger 1917: *Letter* 4; 1928: *On Anger*, 1.1–2), and his use of light and darkness is tinged with Stoic ideas.[21] One of these is the notion of *sympatheia*, which holds that the entire cosmos is a unified organism, all parts of which are intimately connected (Sambursky 1959: 9, 41). In *Thyestes*, the darkness of the grove is not just a sign of the depravity of the House of Atreus; it appears to be the result of it, and Atreus' unbridled anger has the power to keep out daylight, to turn a meteor trail black, to transform fire into a pitchy cloud, and to turn wine into gore. It is not just the murder of the boys, but the culminating horror of Thyestes eating them, that drives the sun from the sky.

The Chorus's subsequent lengthy song, wondering whether all the heavenly bodies will now depart in repugnance at the deed, has led some scholars to believe that Seneca here intends a reference to another Stoic doctrine, that of the world's cataclysmic destruction (Volk 2006: 186–7). Seneca's treatment of Stoic ideas here is of course dramatic rather than philosophical, but he has effectively, if hyperbolically, conscripted and adapted established uses of light, dark, and red into the service of an ethical and cosmological worldview with a distinctly Stoic tint.

CONCLUSION

We have provided here, in lieu of a survey of the uses of color in Greek and Roman literature and performance—an impossible task in this short space—a few core samples of ways that ancient literary artists exploited references to light, dark, and hue to enhance the emotional, social, moral, and intellectual effects of their works.

CHAPTER EIGHT

Art

MARK B. ABBE

Art in the ancient Mediterranean was defined by a wide range of colorful paintings and multiple polychrome materials. Although the importance of color on Egyptian and (to a lesser extent) Near Eastern art has long been manifest and accepted, the vivid, nuanced, and often lifelike colors and sumptuous materials of Greek and Roman art continue to astonish our common inherited notions of a "classical" art as allegedly defined by pure marble-white sculpture, and a subdued earth-toned palette of painting as predominately evident in painted pottery.

In the first two decades of the twenty-first century, the importance of color in Greek and Roman art and visual culture has rapidly emerged in both archaeological study and historical interpretation.[1] New forms of examination conducted at the microscopic level, technical imaging, and scientific analysis now regularly reveal and characterize previously hidden remains of color and allow us to see beneath the surfaces of artworks to intimately glimpse the ancient processes of painting, gilding, and other forms of coloration. Significant evidence of color continues to be discovered both in objects in old museum collections and on new archaeological finds. Many challenges remain, most often due to the fragmentary and deteriorated condition of many forms of ancient coloration. We currently have only a limited understanding of the diverse range of binding media artfully employed in painting, the many ways in which bronze sculpture was patinated, and of the varnishes, waxes, and other protective coatings that were central to the final visual appearances of much polychromy. An acute challenge in current research is thus how to bridge the often microscopic scale and deteriorated condition of the evidence to postulate

accurately the original appearance produced by such coloration in antiquity at the visual (macro) scale.

Color remains something of a missing visual language in our histories of classical art. At present, there is no general synthetic history of color in Greek and Roman art or visual culture. The emerging picture from recent research is one of increasing diversity of color that significantly expands our traditional art historical narratives (while reframing some of their familiar assumptions). We should not seek to impose a single or fundamentally unified history for color across antiquity. The richness and variety of coloration in different forms of ancient art is better understood as displaying multiple highly flexible and fluid languages of color that were often materially informed and contextually employed across a wide range of different historical and cultural environments. In an individual work, many of the specific aesthetic, economic, and cultural meanings of color were defined by the immediate context of its display and in turn framed the work's cultural reception.

This essay, arranged chronologically and necessarily selective, aims to highlight key and broad chromatic shifts in the arts of painting and sculpture during classical antiquity. It also seeks to highlight how the history of these two art forms—frequently privileged in ancient Greek and Roman notions of visual culture—were often intimately interrelated, despite being often separated (if not viewed as conflicting) in histories of ancient art since the sixteenth century.

EARLY GREECE, *c.* 800–480 BCE

The history of color in Greek art after the collapse of artistic crafts in the late Bronze Age between the eleventh and eighth centuries BCE remains largely a realm of speculation given our limited evidence. The shiny "metallic" black glazes and contrasting matte lighter fabric colors of geometric pottery have been compared to the "chromatic" descriptions of metalwork and other artistic media in Homer, which emphasize contrasts of light and dark and reflective surfaces rather than hue. An orderly sequential expansion of color in Greek art from mono-, bi-, tri-, and tetra-chromy in the eighth and seventh centuries BCE is often imagined because of Pliny's highly unreliable history of the development of early Greek painting (Pliny the Elder 1952: 35.15–16). Archaeology tells a different and more complex story involving the rapid expansion of color in art around the middle of the seventh century both in and around the Corinthia (Hurwit 2014; Walter-Karydi 2018). Various terra-cotta media—vase painting, sculpture, and architecture—display an increased palette of earthen tones of white/cream/light gray, blacks/dark grays, and a rich variety of reds from light to brown to purple (Winter 2002), as evident from the large mythological painted figural panels from Thermon (Koch 1996). More suggestive of the period's full palette are fragmentary examples of painted stucco panels from the Temple

of Poseidon at Isthmia that display a variety of purple, brown, light blue, red, orange, and yellow. Interestingly, more circumscribed palettes of color have recently been discovered on temple mural frescoes at Kallapodi (Niemeier et al. 2012) and a monumental funerary painting executed in tempera from Chilomodi (Korka 2013).

The fragmentary votive wooden panel paintings (*pinakes*) from Pitsa, near Sikyon, from the second half of the sixth century BCE preserve unique evidence for the use and techniques of color in early Greek painting (Brecoulaki et al. 2017; Plantzos 2018: 87–9, 94). The best-preserved painting, depicting a scene of sacrifice (see Figure 4.2), is executed on a white gypsum plaster preparation with a palette of bright blue, reds, orange-reds, yellows, and a range of blacks. The painting displays outlines of exceptional linear refinement, strong contrasting juxtapositions of color, and a visual interest in patterned details. The sacrifants' skin tones are traditionally gendered—pale white skin (the prepared ground) for the women with flesh areas outlined by bright red, and added red brown for men with the otherwise default black outline. The relatively restricted palette in this early painting is expanded in the later panels from Pitsa that display a wider range of color, including rare and brilliant, precious luxury pigments.

Abundant, readily visible color remains on a large number of the marble and limestone sculpture (free-standing, relief, and architectural) from Greece dating to the seventh and sixth centuries BCE, including, most conspicuously, the large caches of sculptures from the Athenian Acropolis first discovered and studied in the late nineteenth century. Modern reexamination has revealed an expanded range of patterned and figural details once defined through painting (Brinkmann 2003); the key importance of bronze additions in these mixed-media works, including inset eyes in bright precious material, is increasingly recognized (Schäfer 2013). As the remains of color are inevitably fragmentary and often chemically deteriorated, many aspects of the coloration of such sculptures remain unclear. Recent hypothetical color reconstructions, such as those of the so-called "Peplos Kore," *c.* 530 BCE, display significant chromatic and pattern variety (see Figures 8.1 and 8.2 and compare the coloration of Figures 0.1 and 4.5) and have spurred considerable debate about the nature and extent of skin color, the significance and interpretation of decorative details, and aspects of the surface finish, and thus the original appearance and aesthetic impact of such statues (Koch-Brinkmann et al. 2014: 126–9, 136–7; Katsaros and Vasiliadis 2019: 708–9; see also Schmaltz 2018). At a minimum, such interpretive reconstructions—on this and other sculptures—highlight important ambiguities and modern aesthetic assumptions about these complex and nuanced artworks. In truth, the scientific characterization of the pigments and painting techniques on early Greek sculpture is just beginning, and future research using ever increasingly detailed methods of examination promises to incrementally reveal important aspects about even

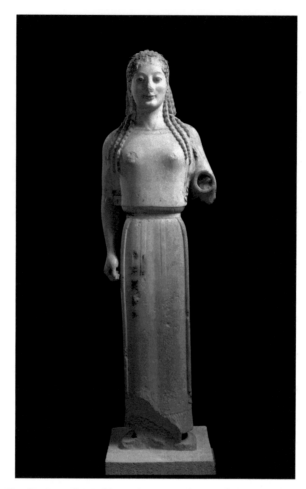

FIGURE 8.1 "Peplos Kore." Marble sculpture with painting. From the Athenian Acropolis, *c.* 530 BCE. Athens, Acropolis Museum. Photograph by Leemage/Corbis via Getty Images.

the most well-studied artworks (for example, the Phrasikleia kore: Schmaltz 2016; Kantarelou et al. 2016).

The use of color in Greek painting from the seventh to the late sixth century BCE appears to have been fundamentally graphic in nature: compositions were defined by outlines and filled in with solid, unmodulated strong colors without gradations of hue and shade to create bold juxtapositions of hue against a neutral color background. Like the compositional and sculptural schema of this "archaic" period, this use of color is closely akin and no doubt partially inspired by contemporary practices in Egypt and the Near East. It drew upon a fundamentally conservative schema of consistent beauty that paired a delight

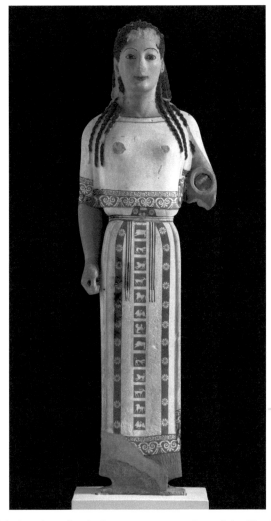

FIGURE 8.2 Digital projected polychrome reconstruction of the "Peplos Kore,"
Acropolis Museum. Photograph: © Acropolis Museum, 2012. Polychrome
reconstruction: Hara Sfiri.

in precise, controlled linear definition and detail paired with bold contrasts of
bright color to define elements in highly variegated patterns and assemblages
(or *poikileia*) (Grand-Clément 2015).

By the end of the seventh century BCE, white marble had already been chosen
(over limestone and other stones) as a privileged and widely traded medium
for sculpture within the Greek world. The reasons for this appear to have been
primarily visual rather than practical or material: the freshly worked pure white
stone appeared infused with light, if not seemingly generating it, and offered

a unique sparkling (*marmaros*) brightness that was central to Greek aesthetics and visually conspicuous in the ancient experience. Archaic marble sculptors' carving and finishing techniques deliberately enhanced marble's surface luminosity, which was then defined and adorned by detailed, highly contrasting polychromatic painting. This and other later eye-catching marriages between color and light lay at the heart of the long marble sculptural tradition in the classical world.

The broader cultural interest in visual brilliance and radiance is manifest in sumptuous large-scale sculpture in other media: bronze, silver, and pieced statues of gold and ivory as exceptional survivals from Delphi powerfully demonstrate (Amandry 1991; Lapatin 2015b: plates 10, 60, 152). These materials would emerge as central to the aesthetics of the classical period.

EARLY AND HIGH CLASSICAL GREECE, *c.* 480–430 BCE

The period from the end of the sixth to the mid-fifth century BCE was a time of revolutionary change in thinking about color, materials, and visual experience, as in almost every realm of Greek culture. In the visual arts, Archaic precedents often gave way to a new, more austere, and subdued palette of color and a reduction of ornamentation through the mid-fifth century; this new chromatic range functioned at many levels—social, political, and philosophical. In the culturally defining conflicts with Persia, such coloration became an important visual signifier of collective Hellene identity and moderation defined in opposition to what was now viewed as the extravagant use of too much color by the non-Greek *barbaroi*. In art, the previously more symbolic figural image, a sign (*sema*), became a likeness (*eikon*) with visually arresting direct modes of representation that powerfully demonstrated a new kind of (culturally contingent) observed reality in images that seemingly belonged to the immediate world of the viewer in observable time. Monumental panel painting emerged as a leading form of public civic art in works such as the complex multi-figural mythological and historical paintings by Polygnotos that adorned the *Stoa Poikile* (Painted Stoa) in Athens. These displayed new forms of spatial depth, pictorial illusionism, and compositional openness. Our physical evidence for the coloration of Greek painting in this critical period is extremely limited and often indirect. The only extant monumental paintings from the fifth century BCE are the unique frescoes of the Tomb of the Diver at Poseidonia (Italy) on the fringe of the Greek world dating from *c.* 480 BCE. The degree to which their use of color reflects broader chromatic trends remains much debated (Oddo 2018; Plantzos 2018: 120–3; Pontrandolfo and Rouveret 1992: 13–21). Some white ground ceramics from Athens are generally thought to bring us closer, such as the large panel-like painting on a kylix krater attributed to the Phiale Painter (*c.* 440 BCE). Depicting Hermes bringing Dionysos to Papposilenus and the nymphs of Nysa, it displays a

restricted palette—red purples, oranges, and browns, and a bright "second" white against a yellowish background—with interesting dilutions of black to suggest variations and shadows on rocky landscape elements (Mertens 2006: 233–4).

The extant marble sculpture from the early and middle of the fifth century preserves little coloration. The austere use of simple patterns is faintly discernible on the hemmed garments of the pedimental sculptures from the Temple of Zeus at Olympia from *c.* 460 BCE (Brinkmann 2003). Recently important remains of painting have been discovered on the elaborately sculpted drapery of the pedimental figures of the Parthenon dating to *c.* 437–2 BCE.[2] These sculptures exhibit a wider range of ornamentation and color, including the use of black shadow painting within drapery folds to heighten the three-dimensional aspects of garments and complex figural friezes on textiles that were legible to ancient viewers. These discoveries underscore how numerous compositional and stylistic aspects of the Parthenon's sculptures appear to have been influenced by painting; ancient sources report that Phideas began his career as a painter and collaborated closely with his relative, the celebrated painter Panainos (Harrison 1996: 18).

The colors and material aesthetics of fifth-century sculpture, however, were predominantly defined in more lustrous and sumptuous materials than painted marble, namely, new kinds of bronze and chryselephantine (gold and ivory) statues. The corroded matte and green-to-black appearances of Greek bronze sculptures today are, of course, fundamentally alien to their originally highly polished and gleaming surfaces that blazed dazzling reflected light. To contemporaries, the magnificent brilliance of these figural images was the stuff of Pindarian glory and renown (*kleos*), and bronze quickly became established as a prized material for honorific sculpture by the early fifth century, a position it widely retained in civic honors for the rest of antiquity.

The range of metallic polychromy on classical (and later Hellenistic) Greek bronzes was exceptionally wide and has few post-antique parallels in large-scale statuary. Color was principally achieved by three methods: (1) extensive manipulation of the metallic alloys; (2) patination, which offered a veritable rainbow of color (blacks, brown, purples, reds, oranges, pinks, yellows, and whites); and (3) inlaid materials, including stone and glass eyes, copper lips and nipples, silver teeth and finger nails, as well as multicolored textiles and attributes (Formigli 2013; Descamps-Lequime 2015; Giumlia-Mair 2018). The highest quality and best-preserved survivals from this period, such as the Delphi charioteer from *c.* 470 BCE and the Riace bronzes from *c.* 440 BCE, display a focused, once-radiant surface realism paired with fine anatomical detail.

For the images of the gods, a revolutionary class of resplendent colossal chryselephantine temple image was created by Pheidias, the most celebrated artist of the ancient world, who expanded an earlier tradition to a new majestic scale (Lapatin 2001). Works such as the Athena Parthenos (see Plate 4.3),

dedicated in 438 BCE, and the more famous Olympian Zeus captured for ancient viewers something of the majesty and sumptuous splendor of the gods at their full Olympian scale in an awe-inspiring epiphany that came to define the classical vision of the divine in material form. Not bichromatic, these colossi were richly polychromatic displays. The Olympian Zeus reportedly included painting or subtle tinting on the ivory flesh, inlaid colored glass on the golden garments, gold-backed glass, and ebony. Finds both from Pheidias' workshop at Olympia and further afield give us some sense of the materiality of these lost works (for example, Lapatin 2015b: 16, plates 55, 153, 162, 165). The Pheidian model would continue in other chryselephantine and pseudo-chryselephantine marble acrolithic (not entirely of stone) statues for the rest of antiquity, for example, the seated acrolithic marble colossus of the Roman emperor Constantine as Jupiter *deus praesens* (the present god) in the Basilica of Maxentius, Rome, from *c.* 315 CE (Presicce 2012).

LATE CLASSICAL AND HELLENISTIC GREECE, *c.* 430–31 BCE

Colors and their interactions with light emerged as an important focus of Greek culture in the late fifth and fourth centuries BCE, significantly spurred by new forms of pictorial illusionism and representation (*mimesis*) and new ways of perceiving and viewing the world. Painting, the premiere and defining art form of Greek visual culture in this period, displayed a growing mastery and manipulation of color over time and came to function at many levels in Greek culture. Ancient sources attribute the revolutionary developments of moving beyond outline painting to Apollodoros, who appears to have systemized earlier shading/shade painting (*skiagraphia*) and explored illusions of depth, light, and shadow. Subsequent *trompe l'oeil* effects, for instance those of the famously competitive painters Zeuxis and Parhassios, spurred contemporaries, such as Plato, to (re)examine the nature of perception and reality, as well as the roles of art, producing a tradition of art criticism.

Subsequent fourth-century painters developed highly individual styles of color and explored the use of different pigments and painting binding media in pictorial representation. Apelles, the most esteemed of Greek painters, was famously alone favored by Alexander the Great for his own painted royal portrait and masterfully used a restricted palette of pigments for powerfully subdued tonal renderings of graceful naturalism. Sculptors both collaborated with and took direct inspiration from painting, such as Lysippos, who famously sought to depict men "as they appeared," exploring light, shadow, and surface in three dimensions (Pliny the Elder 1952: 34.61). In the Hellenistic period, this tradition of painting and artistic color came to play a broad role in both public urban life and private domestic decoration. The achievements of

fourth-century painters became legendary and a focus of art criticism. Painting, increasingly decorative in subject matter and function, became a traditional form of Greek high culture with extensive royal patronage and large public painting galleries (*pinacothekai*) defining metropolitan life in the third and second centuries BCE.

No wooden panel paintings survive from the late classical and Hellenistic world, save for one fragment from the early fourth century BCE depicting a seated goddess from Saqqara, Egypt (Rondot 2013: 37). Our understanding of Greek painting continues to be fundamentally transformed (often dramatically) by ongoing archaeological research in Macedonia, where a corpus of large-scale paintings of outstanding quality on the facades and interiors of royal and elite funerary monuments have been revealed since the late 1970s.[3] In the fifth century BCE, elite Macedonians became active patrons of Greek painters (including Zeuxis) from the Greek city states to the south. A later body of monumental tomb painting in Macedonia, from the mid-fourth to second century BCE, offers invaluable evidence for the kinds of sophisticated painting created on wooden panels that was adapted for tomb contexts.

The use of color in these paintings is visually astonishing, technically sophisticated, and stylistically diverse. In the "Tomb of Persephone" at Aigai from the mid-fourth century BCE, the use of regular outline in closed forms is abandoned for an unprecedented quick, expressive, and open free-style on dry plaster. In the well-known figural frieze, a limited and subdued palette of red and yellow hues is strikingly contrasted with the bright pinks of the goddess's splayed and unfolding garment (see Plate 4.1) to highlight her violent divine abduction (Andronikos 1994; Brecoulaki 2006b). An altogether different kind of complex, highly deliberate, and meticulously nuanced use of color is evident on the remarkable monumental (5.6 meters long) royal hunting frieze on the architectural facade of the "Tomb of Philip"/Tomb II at Aigai from *c.* 330–310 BCE (Franks 2012; Brecoulaki 2015: 226–30). It displays a pastiche of three hunting narratives—probably transferred from cartoons of a monumental panel painting—with a new sophisticated emphasis on light, shadow, and form in painting. Within a wooded landscape with a hazy blue atmospheric perspective of reduced clarity and low color saturation, a royal suite of dramatically posed active hunters, attendants, and their wild game in the foreground are rendered through a masterful use of hatching, color shading, and tonal variation presenting the figures' ample volumes in a wide, luxurious palette. Light—seemingly the emerging sunlight of dawn—in one corner of the complex composition casts shadows rendered though multi-tonal shading with the warm pink and green shading on the figures achieving a nuanced effect of tonal and chromatic equilibrium overall. Such painting presented the world of visual chromatic experience in new exploratory and enhanced ways. In contrast, a veritable extravaganza of bold and subtle color transitions

is manifest in the antechamber of the "Tomb of the Palmettes" at Mieza from around 300 BCE, where a polychromatic rainbow of supersized palmettes and water lilies on a pale-blue background seemingly allude to a dreamlike fantasy of sacred fertility in the Underworld (Rhomiopoulou and Schmidt-Dounas with Brecoulaki 2010).

Close evidence for contemporary wood panel painting is the similarly scaled painting on the back of the luxurious marble throne of the "Tomb of Euridice" at Aigai, from the third-quarter of the fourth century BCE (Brecoulaki 2006b; Kottaridi 2006). A divine epiphany is represented: Hades and Persephone standing in formal ceremonial postures face frontally, driving a team (*quadriga*) of white and brown horses against a pale-blue background. They wear sumptuous detailed purple and pink garments and hold scepters adorned with gold leaf. A masterfully skilled hand, fluent in materials and subtle optical effects, is evident in many aspects of this linear and chromatically nuanced painting, including the tone variations on the horses and gods' flesh areas with added highlights, the palette of rare precious pigments and unusual colorants, and the use of topical varnish that enhanced the coloration. An altogether different approach to color is evident in the monumental "Alexander Mosaic" (see Figure 8.3) from Pompeii that evidently replicates a painting from the early third century BCE, in which a massive and highly detailed battle between Macedonians and Persians is defined as a dramatic contrast of character between Alexander and

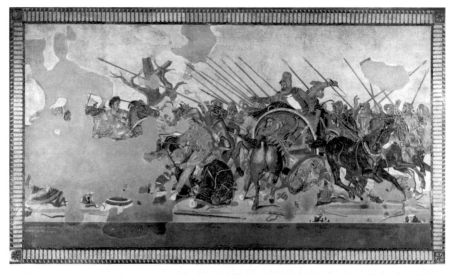

FIGURE 8.3 "Alexander Mosaic," late second century BCE. Monumental mosaic after a painting of the early third century BCE. From the House of the Faun, Pompeii. Naples, National Archaeological Museum. Photograph by David Lees/Corbis/VCG via Getty Images.

Darius III (Stewart 1993: 130–50; Cohen 1997; Moreno 2001). The restricted use of color—often viewed as illustrating the notion of a four-earth color palette or *tetrachromy* described in later sources (Brecoulaki 2006a)—may be best understood as a powerful demonstration of tonal naturalism in Greek painting. It presents the epic-worthy battle devoid of eye-distracting color. The bright light on glistening skin, glittering and gleaming panoplies of metallic armor, and sharp, dark shadows emphasize the directness and immediacy of this terrestrial "actual" event on a foreign battle landscape.

Between the fourth and first centuries BCE, a wide range of colorful figural painting is also preserved on painted stelai and smaller funerary slabs (*loculi*) from across the eastern Mediterranean (Plantzos 2018: 257–62). Increasingly, discoveries of painting on marble sarcophagi and other luxury goods, most often exported from Greek workshops, expand our understanding of classical Greek painting (for notable examples, see Sevinç et al. 2001; Botti and Setari 2009; Georgiou 2009; Brecoulaki et al. 2014).

During the fourth century BCE, the remarkable and revolutionary developments of painting are increasingly manifest in marble sculpture. The new intimate mutual dependence of painting and sculpture is arrestingly exhibited on the so-called "Alexander Sarcophagus" from around 320 BCE, the best-preserved masterpiece of Greek sculptural polychromy (Von Graeve 1970; Brinkmann and Wünsche 2007: 150–71; Blume 2015: 281–7). The long friezes of the massive "jewel box" marble chest show dramatic battles between Macedonians and Persians, and Greeks and Persians in a royal lion hunt in a rich, wide palette—both bold and subtle—of bright yellows, reds, violets, blues, browns, and added white. The miniaturistic-painted details, painted modeling shadows, and highlights were complemented with numerous bronze attributes. This pictorial use of color draws the eyes in to the complex scenes to see bright juxtapositions of color, ascertain painted details, and appreciate the narrative characterization of the active combatants in the midst of the crowded and deeply carved scenes of dramatic conflict. The color and compositions no doubt derive closely from contemporary royal court painting; the relief's brilliant color displays the chromatic opposite of the reduced palette of the "Alexander Mosaic" and brings us closer to the range of color displayed in luxury furniture from Macedonian tombs.

Other marble sculptures display a new expanded and nuanced range of surface finishes and increased translucent polishes on flesh areas. These were probably linked with the new developments in wax encaustic painting and a new repertoire of subtle visual effects, which enhanced contemporary naturalistic styles in sculpture. The famed life-size nude painted marble statue of Aphrodite, dedicated as a temple image at Knidos by Praxiteles (and allegedly modeled off Phyrne) from *c.* 350 BCE, reportedly had a luminous, translucent, lifelike skin color (compare "Pseudo-Lucian" in Lucian 1967a: *Affairs of the*

Heart (Amores), 13–16). The sculptor is said to have most prized his statues that his collaborator, the celebrated painter Nicias, had applied his hand to (Pliny the Elder 1952: 35.133). The representation of skin color (*andreikelon*) was more than simple naturalism: contemporaries viewed it as a key aspect of personality and character as evident in contemporary painting, and vestiges of such color is securely evidenced on free-standing marble sculpture (Abbe et al. 2012; Brecoulaki 2015). If the life-size Knidian Aphrodite represented a kind of humanization of the divine, the opposite end of the wide polychromatic spectrum of color and materiality in the Hellenistic period arguably was Bryaxis' highly influential statue of the syncretic Graeco-Egyptian deity Serapis at Alexandria from around 300 BCE. This enthroned Pheidian-style temple colossus was created from an amalgam of gold, silver, lead, and tin shavings, ground precious stones, bitumen, and deep-blue dye from funeral rituals of Osiris and Apis. Its dark blue-black, saturated, glittering appearance—displayed in the dim confines of the Greco-Egyptian temple—presented a captivating and mysterious image whose seemingly wet and dark material evoked traditional Egyptian notions of fertility and cosmic regeneration and inspired numerous dark black-blue stones of the god in later antiquity (Pollitt 1986: 279–80; Gregarek 1999: 81–3).

A rich, colorful variety of painting and gilding survives on the extant bronze and marble sculpture from the Hellenistic period (Blume 2015; Descamps-Lequime 2015). The well-studied corpus of marble sculpture from Delos displays an expanded palette of color with an increased penchant for luminous subtle blues, pinks, and light greens combined with both localized and more extensive gilding. Combining such coloration with nuanced skin tones, these marble sculptures display an unprecedented gleaming brightness and chromatic lightness on marble sculpture (Bourgeois and Jockey 2005, 2010).

Modest scale terra-cotta sculptures (so-called *Tanagras*) from this period suggest the overall impression, now fragmentary on marble, and the variety of matte pastel washes of color, varied surface treatments of gilding, and nuanced pictorial effects of shading and highlights (Jeammet 2010). Hellenistic texts describe how the delicate surfaces of statues required care and maintenance through surface coatings of beeswax and oil (*ganosis*) and re-polychroming of statues (Bourgeois 2014). A remarkable, finely finished marble head of the Ptolemaic Queen Berenice II from Egypt dating to the second half of the third century BCE displays an unprecedented complex sequence of painting and gilding, including most rarely an unpigmented ancient wax layer on the marble surface, evidently for a pseudo-chryselephantine effect (Bourgeois 2016). Such transformations and alterations underscore how changes in color and materiality could redefine the ontological statuses of statuary over their long and often complex lives.

ROMAN, LATE REPUBLIC TO IMPERIAL, LATE ANTIQUE, *c.* 100 BCE–600 CE

Between the late third century and first centuries BCE, the Roman elite acquired, most often as plunder, vast amounts of Greek art, particularly paintings and statuary, whose expansive and nuanced chromatic range, sumptuous material, and craft sophistication stood in striking contrast to their own relatively modest visual traditions. By the late Republican period, Rome had become a museum-like repository of recontextualized earlier Greek art (see Pliny's *Natural History* books on art) and the leading center of patronage for the artistic traditions of the Hellenistic Greek world. White marble, an imported foreign luxury material in Rome and its environs, emerged as a leading prestige material in Roman culture first at home and gradually across the empire. Spurred both by Hellenistic art-historical theory and Roman priorities, earlier Greek chromatic styles were reframed and redeployed in Roman contexts, where they acquired new symbolic connotations and values (artistic, cultural, moral, and religious).

In the late Republic and Augustan age, agendas of cultural redefinition and revival were intimately tied to the color and materiality of art in both public and private life. While this can be tracked in detail in the rapidly changing chromatic styles of domestic decoration, the evidence on marble and bronze sculpture is more limited. The remains of polychromy on key public monuments, such as Augustus of Prima Porta and the *Ara Pacis*, should help clarify the coloration of their "classicizing" style in this period,[4] which also saw a brief self-conscious revival of an earlier Italic tradition of polychrome terra-cotta sculpture in archaistic (*tuscanicus*) style and the conspicuous redeployment and replication of classical Greek marble sculptures.[5]

The colors of Roman art in the imperial period from the first to third centuries CE display a deep continuity with the Greek inheritance with new emphases on the naturalistic coloration afforded by painted marble and a striking expansion of statuary in colored luxury stones. Both trends are best evidenced in Rome and central Italy and appear to be the results of Roman patronage. At present, we have little sense of regional and cultural chromatic differences across the empire in art. *Emblemata* (floor mosaics imitating self-contained panel-paintings in stone) may provide some indication of different regional chromatic styles in panel painting; regional and local polychromatic trends in sculpture remain dimly perceived beyond the distribution and styles of sculptural media across the empire. From the third century CE onward, while art in the private sphere appears to continue the naturalistic chromatic traditions of Greek art, imperial imagery displays an increased use of color and material symbolism to make emphatic visual distinctions regarding the emperor, imperial family, and administration, as strikingly evident in the imperial distribution of purple porphyry sculpture during and after the Tetrarchy (rule of four, *c.* 293–306 CE).

Gilding on bronze statuary, evident in both imperial and private statuary in the first century CE, increasingly became an imperial domain. In late antiquity, the imperial dress costumes and regalia of imperial statues display increased uses of color and materiality with an emphasis on sheen and luster to visually distinguish the splendor of the imperial office.

Painting

No examples of wooden panel paintings survive from ancient Rome and central Italy, an enormous loss to our understanding of what many contemporaries thought to be the most celebrated art (Pliny the Elder 1952: 35.1). The large corpus of colorful Roman domestic fresco wall painting with Greek themes (from Italy and beyond) has long served as a proxy form of evidence for genres of Greek painting from the classical and Hellenistic periods, including large-scale figure painting (*megalographia*), landscape painting (*skenographia*), and still lifes (*xenia*). Representations of polychrome sculpture also abound in this context (Moormann 1988). The coloration of such paintings, however, requires careful contextualized framing within the evocative spaces of the Roman house as these paintings were fictive decoration. Both illusionary and allusionary, they were manifestly not depictions of real, actual objects, nor in the case of painting did they seek to be exact reproductions of earlier Greek works. Painted representations of fictive panel picture galleries (*pinacothecae*), such as those at the Villa delle Farnesina from the late first century BCE, underscore the fantastical while contrasting the chromatic styles of earlier Greek panel painting: the smaller white ground panels executed in a linear style and restricted palette resemble classical painting from the mid-fifth century BCE, while the larger central focus presents a more "developed" nuanced atmospheric coloristic style akin to painting from the fourth century BCE (Rouveret 2015; Jones 2019: 204–15). An important point of comparison for the former style is a group of painted marble panels from Herculaneum and Pompeii that display exquisite underdrawing and a limited, seemingly classicizing, chromatic palette (Lenzi 2016). The chromatic conventions of other important contemporary forms of panel painting in Rome and Italy—civic, historical, religious, and portraiture, presumably often executed in less conspicuously artful modes—generally remain unclear.

Roman Egypt preserves the only extant corpus of wood panel painting from classical antiquity. Approximately one thousand surviving funerary mummy ("Fayum") portraits executed in wax encaustic and tempera from the early first century to mid-third century CE demonstrate a local mixture of Greco-Roman painting and Egyptian funerary traditions (Borg 2010; Svoboda and Cartwright 2020). Many of the encaustic paintings are of exquisite quality, displaying nuanced coloration and the delicate effects of light. These extraordinarily memorable and striking images demonstrate the visually arresting immediacy of

painting in the classical Greek craft tradition as well as a powerful sense of the lifelike presence of individualized naturalistic portraiture in the Roman world (see Plates 5.1 and 5.2). Their predominantly youthful, gendered skin tones and chromatic opulence of luxury textiles, jewelry, and added gold leaf were strongly linked to Egyptian funerary traditions. Approximately fifty panel paintings (many fragmentary) depicting pagan deities from the second and third centuries CE are, in contrast, generally of more prosaic quality and coloration (Rondot 2013).[6] The "Severan Tondo" is a more unique survival (see Figure 8.4); it is the only example of a painted imperial portrait, a ubiquitous type of painting in ancient Roman civic life. Representing the family of Septimius Severus, *c.* 199–211 CE (with the prince Geta erased after a *damnatio memoriae* in 212), the painting is executed in a quick, intuitive manner. Color is concentrated on the imperial bejeweled crowns, colorful festival costumes, and scepters, all of which became increasingly important chromatic markers of imperial distinction

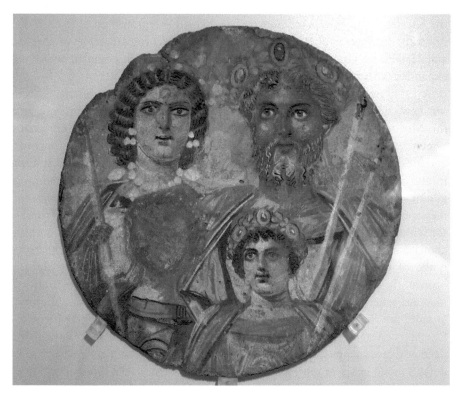

FIGURE 8.4 Painted wooden panel with family portrait of Septimius Severus, Julia Doman, Caracalla, and Geta (erased). From Egypt, *c.* 199–211 CE. Berlin, Altes Museum, Antikensammlung. Photograph by Carole Raddato. Wikimedia Commons. https://commons.wikimedia.org/wiki/File:Carole_Raddato_(13543792233).jpg. Public domain.

in this period; particular attention was focused on rendering the skin tones of the elder imperial couple (Sand and Schmuhl 2017).

The complete absence of wooden panel painting from the mid-third century until the early sixth-century portrait "icons" from Sanai and similar seventh-century material from Rome greatly impairs our subsequent understanding of painting in late antiquity (Marsengill 2018). The continuation of naturalistic color in painting in the period, often with a greater emphasis on outline and shadow, is partially preserved in other media, including, most notably, illustrated codex manuscripts executed in tempera. The early fifth-century CE *Vatican Virgil* notably displays nuanced shading, atmospheric perspective, and a subtle range of pastel colors (Wright 1993).

Sculpture

The vast corpus of sculpture from the late Republican and Roman imperial periods preserves the largest and most diverse range of sculptural polychromy from classical antiquity, as has begun to emerge in sustained research only in the last decade (Liverani and Santamaria 2014; Østergaard and Nielsen 2014; Abbe 2015; Bracci et al. 2018). In general, the polychromatic range of classical and Hellenistic Greek sculpture continues in this period, complemented and expanded with an unprecedented range of colorful lithic materials.

A distinctive aspect of Roman sculpture is so obvious that it is often assumed: the new, wide, and increased importance of white marble sculpture across the Mediterranean at an unprecedented scale. Today, the present chromatic sameness of the large numbers of typologically similar white marble portraits and ideal sculptures is fundamentally misleading of their once colored variation in antiquity. Each was individually carved and polychromed—with painting, gilding, inlay, and other forms of color—in order to define its meanings and messages in its immediate context. The increased and widespread use of marble for sculpture in the Roman period reflects, among other things, a broad cultural choice for a sculptural medium that offered a much wider and more expansive range of colorful painting than the other principal medium of sculpture, bronze. (It is highly ironic today that the choice for this now visually uniform medium reflected a preference for a wider range of polychromy in antiquity.) Despite the range of painting afforded, it appears that a core kind of true-to-life nuanced naturalistic color possible on marble also appears to have had a deep and broad appeal in Roman culture and came, over time, to be a kind of default mode in visual representation. Already evident in the rapid adoption of marble in portraiture and in the form of the portrait bust by the first century BCE, the powerfully intimate statue format of the portrait bust highlighted the marriage of naturalistic painting and marble. The broad cultural choice for marble is also, of course, manifest in the large-scale replication of famous classical Greek bronzes (*opera nobilia*) into marble. Perhaps most interesting is

the "copying"—actually, chromatic and material reformulation—of complex masterpieces that evidently transcended traditional categories of painting and sculpture in antiquity, such as the Laocoon (Pliny the Elder 1962: 36.37).

Variation of color on seemingly "identical" Roman replicas of earlier Greek works is increasingly recognized, including Amazons of the Sciarra/Wounded type, nude Polykleitan figures, and archaistic statues of Artemis (Bourgeois and Jockey 2005; Brinkman et al. 2011; Østergaard 2015). While differences in coloration could occasionally be stark, most often it appears to have been subtle and may have been linked with Roman conceptions of Greek styles in ways that are only beginning to emerge. The sophistication and nuanced techniques of painting on marble are powerfully demonstrated by the Treu Head, an ideal head most likely representing Athena found on the Esquiline Hill in Rome, with exceptionally well-preserved facial and hair coloration (Verri et al. 2014). Numerous marble portraits from the Roman period preserve faint remains of color, most often underpainting on the hair, in the eyes, and vestiges of flesh coloration, such as the Copenhagen Caligula (Østergaard 2017). The costumes of many Roman portraits preserve legible remains of painting, and the importance of color coding in civic costumes both in the Latin west and the Greek east is increasingly recognized (Liverani 2018). The celebrated pairing of purple and gold as materials of royal status are found in some statues, including the imperial costume of the emperor, which acquires greater significant in context as part of the imperial cult (for example, Freyer-Schauenberg 2002).

In the second and early third centuries CE marble sculptures, especially contemporary portraits, display increasingly refined marble carving and finishing techniques. Textiles acquire a variety of contrasting surface textures reflecting their different materials; elaborate, fashionable hairstyles become rendered in intimate detail and are often deeply drilled to display three-dimensionality and depth; eyes receive drilled pupils and incised irises to highlight the effects of light and shadow (c. 130s CE, during the reign of Hadrian); and flesh areas are given high polishes that enhance marble's translucency. This was not an era of monochromatic sculpture as is sometimes still explicitly claimed (or tacitly thought). The overall aim of such practice was to create heightened realistic and dramatic effects akin to contemporary modes of self-stylization. Numerous details previously rendered in paint (eyes, eyebrows, hair, beards, and so forth) were now increasingly rendered in the marble itself, suggesting both the increased intimacy between painting and sculptural definition and a preference for true-to-life hyper-naturalism, often realized through manipulations of light with gilded highlights in hair (Skovmøller and Therkildsen 2015; Abbe forthcoming) and translucent marble. Such craft mastery transforms marble into a gem-like material in the best works, such as the excellent portrait bust of Commodus as Hercules from around 192 CE. Such works were arguably the most technically refined and optically exquisite polychrome marble sculptures of

antiquity. Many of these changes in marble polychrome finish were undoubtedly related to changes in the indoor display environments of such works, including the dramatically light-filled forms of architecture that were adorned with polychromatic colored stone floors and wall revetment (*opus sectile*).

Contemporary bronze portraits in the second and third centuries CE, in contrast, generally display a reduction in their range of polychromy: color inlay decreased, eyes became cast-in as part of production, and gilding became more widespread (often to disguise a debased leaded alloy). In general, bronze statuary increasingly became a symbolic honor devoid of chromatic variation, even at the highest level, such as the equestrian statue of Marcus Aurelius (Lahusen and Formigli 2001). There were, however, notable exceptions, such as a splendid inlaid imperial military cloak (*paludamentum*) from Volubilis with highly colored (gold, silver, purple, black, red, yellow, and white) figural friezes depicting barbarian captives (Aucouturier et al. 2017).

High-quality sculpture carved from a rainbow-like spectrum of colorful stones was a distinctive aspect of Roman sculpture from the first to early third centuries CE (Gregarek 1999). Rare lithic materials (including red, green, and black marbles; graywackes; porphyric stones; and alabasters) were quarried and gathered from across the empire, often by the imperial administration. The production of such luxury sculpture was concentrated in Rome and its environs, but was emulated elsewhere using local resources. In Rome, many of these sculptures represented exotic foreign myths and gods from their material's distant geographical origins: the mottled violet and white "Phrygian marble" (*marmor phrygium*) was used to depict mythological figures associated with the area in Asia Minor, including Ganymede, Attis, and Marsyas. High polishes enhanced the natural polychromy of these variegated stones, but painting could also enhance nature's gifts, such as on a recently excavated statue of the flayed satyr Marsyas in *marmor phrygium* with added red painting (Agnoli 2014).

Our evidence for applied polychromy in Roman marble sculpture (white and colored) after the mid-third century CE is more limited. Ideal sculpture, generally of smaller scale, appears to have continued the naturalistic coloration of the Greek tradition, possibly with an increased use of gilding, as evident in a group of third- and fourth-century CE statuettes from Corinth (Stirling 2008). Similar trends are found in Roman metropolitan sarcophagi (Siotti 2017).

Purple porphyry (*lapis purpureus*), an extremely hard stone from Egypt, was emphatically used in imperial portrait statuary (and architecture) during the Tetrarchy, both for its royal color and its durable material symbolism (Del Bufalo 2012). A small, restricted number of imperial portrait statues had been carved in porphyry to represent the *toga purpurea* of the emperor in the first and second centuries CE with flesh areas added in another material, presumably white marble. During the Tetrarchy imperial workshops in Alexandria produced images of the new imperial leaders in a new direct style in a range of formats

that were exported to centers of the imperial administration. These monolithic images were carved entirely of porphyry. The extent and nature of their added polychromy, including flesh coloration, is unclear. Eyes were clearly prepared for inlay. The bejeweled crowns, detailed royal insignia, presumably had painted and gilded definition, as may have the color-coded textile garments of the Tetrarchs. Small numbers of imperial statues in porphyry continued to be produced into the sixth century CE.

A newly discovered group of spectacularly painted marble reliefs from an early Tetrarchic imperial building at Nicomedia captures the importance of purple in contemporary imperial costumes (Ağtürk 2018; Abbe and Ağtürk 2019). On one relief, in a culminating scene of state ceremony, the co-rulers Diocletian and Maximian fraternally embrace, awash in sumptuous purple and gold imperial dress of the new imperial order. These painted reliefs also shed important light on the use of color in Roman state ("historical") relief (elsewhere only vestigial) and reward close comparison with the colorful wall paintings showing Tetrachic court rituals at Thebes, Egypt (Jones and McFadden 2015).

Our evidence for sculptural polychromy from the fourth to sixth centuries CE is largely indirect, save for a few isolated pieces. Marble portrait honors—increasingly restricted to the imperial family and administration—display very hard, porcelain-like polishes that enhanced the luster and translucency of the substrate. Some examples retain faint, barely discernible vestiges of painting that appear to have represented luxurious patterned textiles. Portrait heads display an increased use of cuttings (often deep) for inlaid material, most commonly on the eyes, diadems, crowns, and other imperial regalia. A sixth century CE portrait of an empress ("Ariadne") from Rome preserves inset black-stone eyes, remains of gilding on a large bonnet, and a diadem with cuttings for inlaid glass or gemstones to create an enhanced sumptuous appearance of polychromatic materiality (Liverani 2009). Such sculptures reflect the increased colorful and mixed-media visual splendor of the imperial image in court ceremony as described in contemporary panegyrics. This last generation of polychrome statues in the ancient world came to be replaced by other portrait media in the seventh century, including dazzlingly colorful gold-backed mosaics (San Vitale, Ravenna) and more intimate, portable forms of "icon" painting.

CHAPTER NINE

Architecture and Interiors

STEPHAN ZINK

Contradictory ideas of architectural polychromy have always influenced how we envision the world of antiquity. Neoclassicists of the nineteenth century pictured classical Greeks amidst shiny white marble temples and milky statues. But already then, bold pioneers such as Jacques Ignace Hittorff (1851) and Gottfried Semper (1860) challenged this view through vivid color reconstructions and thus provoked what came to be known as the "polychromy debate" (Prater 2004; Grand-Clément 2009; Hassler 2014). With regard to architecture, the debate focused on the question of the extent to which color accentuations had modified the exterior appearance of Greek stone temples. Even if nineteenth-century reconstructions of architectural polychromy often followed a strong artistic and/or idealistic agenda (Hennemeyer 2017; Zink forthcoming), early on-site observations laid important foundations for research on ancient architectural coloring. Since the 1980s, this field has gained new momentum (Schwandner 1985; Bankel 1993; Brinkmann 1994), and it is now increasingly coupled with high-end methods of optical and physico-chemical analysis.

What *do* we know today on the architectural polychromy of the Greco-Roman world? How colorful or how monochrome white was the built environment of antiquity? The present survey attempts to answer these questions by tracing the general characteristics and the developments of Greco-Roman architectural polychromy between *c*. 900 BCE and 400 CE (Zink 2019). It will outline both the material variety and artistic complexity of ancient architectural coloring, which, as with ancient architecture in general, was strongly affected by regional traditions and case-by-case solutions. Despite this heterogeneity, some color concepts were

universally shared across the Greco-Roman world. Moreover, during the Hellenistic and Roman periods, several different polychrome color schemes coexisted that reflected the multiple functions and meanings of architectural polychromy.

Coloring or surfacing was more than a simple embellishment of architecture. As an integral part of design and construction knowledge, it paralleled material, technical, and structural innovations and engaged with other artistic genres such as sculpture, painting, pottery, metalwork, and stucco. Two principal techniques used for coloring architectural surfaces advanced these engagements. The first was the exploitation of natural color/texture of materials such as stone, stucco, metal, wood, or glass; the second was the use of coatings such as paint or gilding. In practice, the two techniques were often combined, and further surface treatment such as polishing or waxing was added for finishing touches. Thus, ancient architectural polychromy is no longer understood simply as the color coating of marble (for example, Borrmann 1888), but as the entirety of interior and exterior surface effects (as in Mattern 1999; Hellmann 2002: 229–56; Zink 2014, 2019).

The state of evidence on Greco-Roman architectural polychromy, however, is notoriously problematic. Decay and weathering have reduced original surfaces to fragments, sometimes even microscopic traces, and color coatings are especially difficult to differentiate from natural phenomena. Buildings were also restored and repainted during antiquity, and it can be difficult to determine which phase of a surface has survived. Lastly, even the data gathered through modern scientific analysis are open to interpretation. It is practically impossible, therefore, to retrieve the complete color scheme of an ancient building with all its technical, artistic, material, and visual subtleties, and we must keep in mind that all color reconstructions are always a reflection of time-dependent states of knowledge and priorities (Hennemeyer 2017; Zink forthcoming).

THE "ARCHAIC COLOR TRIAD" AND ITS GRECO-ROMAN RECEPTION

During the seventh and sixth centuries BCE, architects in mainland Greece began to build in massive stone and developed a common architectural language known as the Doric columnar order. Simultaneously, they adopted a color scheme that became the basis for architecture and its associated sculpture (Figure 9.1). It is generally known as the "archaic color triad" (Walter-Karydi 1986) and was a combination of dark (black or blue), red (or purple), and light (white, cream, or the natural light/white of stone). This triple scheme, with some variations, can be found on architectural surfaces throughout Greco-Roman antiquity in both interiors and exteriors and was the most traditional and antiquity's most enduring architectural color code. Because of its early use in sacred contexts, it seems to have become a marker for identifying sacred or public buildings.

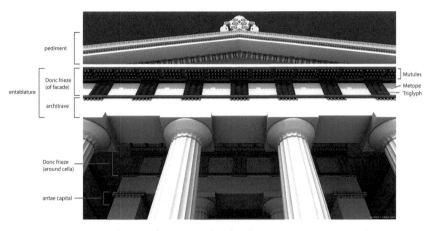

FIGURE 9.1 Aegina, late Archaic Temple of Aphaia, *c.* 500 BCE. Digital reconstruction of the color scheme. © Hansgeorg Bankel, visualization by Valentina Hinz and Stephan Franz, with annotations by Stephan Zink.

The early development of Greek architectural polychromy remains obscure, but many traditions may have existed to which Greek architects could connect. Toward the end of the second millennium BCE, when Helladic and Minoan societies collapsed, a large repertoire of architectural surfacing was commonly applied in the later Greek mainland, including painted wall plaster, colored stones, and metal sheeting (Normann 1996: 25–33; Chapin 2014). Greek artisans seem to have abandoned these techniques during the Dark Ages (eleventh to mid-ninth centuries BCE), but they survived in the eastern Mediterranean, especially in Egyptian and neo-Assyrian architecture (Lee and Quirke 2000; Matthews and Curtis 2012).

The specific precursors of the archaic color triad are unknown. Perhaps the polychromy of architectural terra-cotta prompted its application to stone surfaces, as the terra-cotta roofs of the earliest monumental Greek buildings (late seventh century BCE) were painted in a similarly limited color palette, combining white/cream, black/gray, and various shades of red-purple. This triad was common for Archaic architectural terra-cotta from Ionia to Sicily and up the Italian Peninsula (Åkerström 1966: 201; Summitt 2000: 76).

From the sixth century BCE, the triple color scheme was a fixed part of Doric temples (compare Figure 9.1). Their limestone surfaces were coated with fine white plaster and painted, or if they were built in fine-grained marble, pigments could be applied by using organic binders such as egg white, animal glue, or oil. Ornamental patterns were not usually carved into the stone but were painted using solid, dense hues and clear contours; polar alternation and rhythmic repetition of colors was the guiding principle (Hellmann 2002: 230, 232; Koenigs 2008: 714–15). Terra-cotta continued to be used for roofs and their

decorative elements (antefixes), but the overall color effects of painting on stone were brighter and more intense than on terra-cotta, where colored and fired slips were used (Koch 1912: 11–14; Winter 2009: 519–23). The basic pigment palette, which was universally applied in both Greek and Etrusco-Roman architecture, was mostly set from the Archaic period onward and included iron oxides of local origin (in shades of red, yellow, green, and brown); artificially produced pigments such as Egyptian blue, lead white, calcium carbonate white, and orpiment; and organic colors such as carbon black. More precious pigments such as green malachite, blue azurite, and red cinnabar were usually reserved for special and more protected surfaces or for architectural sculpture (Pliny the Elder 1952: 35.12.30; Vitruvius 1998: 7.5.7–8; Hellmann 2002: 239; Bankel 2004: 80, 83; Brecoulaki 2006a, 2014).

Greek Doric temples (like all others) were never fully polychrome. They typically had a white or light architectural body, with color variation predominantly on the upper parts to highlight specific structural or decorative elements (compare Figure 9.1). We can identify some general principles of coloration. Red was applied to horizontal parts of the entablature, and blue/black to the vertical elements; metopes (the rectangular fields of a Doric frieze) had backgrounds in white (painted or natural stone color) or, more rarely, dull red so as to contrast with the adjacent triglyphs (vertically grooved elements). The backgrounds of pediments were kept in white (painted or natural) or dark/blue (Summitt 2000: 80–133, 177–8, 185–211; Hellmann 2002: 230, 232).

The archaic color triad, however, was not exclusively associated with the Doric order. It also appears on the Treasury of the Siphnians at Delphi (530–25 BCE), the only comprehensively known color scheme of an Archaic building in the Ionic style (Brinkmann 1994; Summitt 2000: 133–6, 139–41). During the classical period (c. 480–320 BCE), the triad continued to play a fundamental role for Doric, Ionic, and Corinthian orders, although now more often in concert with other colors, in particular green and yellow (Koch 1955: 96–108; Harrison 1988). However, even for famous buildings such as the Parthenon (432 BCE), the color scheme remains only partially known. The color reconstructions of its Ionic frieze, for example, are based on analogies with the Hephaisteion at Athens, and not on any remaining pigments on the frieze itself (Jenkins 2006: 42–3; Vlassopoulou 2010; Neils 2016: 173–5).

The Hellenistic kings of Macedonia appropriated the venerable triple color code for their tombs (later fourth and third centuries BCE), as can be seen in the uniquely well-preserved and stucco-painted tomb facades at Aigai (modern Vergina) and Mieza (modern Lefkadia-Naoussa) (see Figure 9.2). At the other side of the Aegean, in Hellenistic Ionia, the triple color scheme was found in such diverse contexts as the Mausolea of Halicarnassus (Jenkins and Middleton 1997: 35–41) and Belevi (Praschniker and Theueur 1979: 61–5), on the Ptolemaion at Limyra (Stanzl 2015: 183–4), as well as on the monumental Ionic

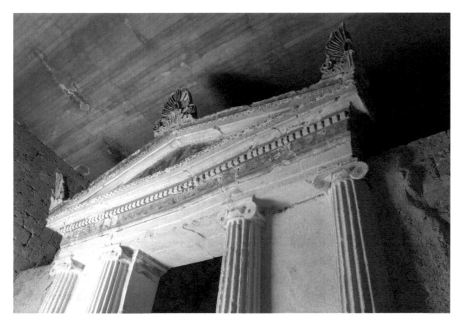

FIGURE 9.2 Lefkadia, Tomb of the Palmettes (third century BCE). Photograph by
Vassiliki Feidopoulou. Wikimedia Commons. https://commons.wikimedia.org/w/index.
php?curid=73161388.

temples of Priene and Didyma (Rayet and Thomas 1877–80: 21–3, 80–1, plates
13–14; Koenigs 2015: 41–3).

On the facades of these temples, a new deep carving style seems to have
implied an unprecedented waiving of color on architectural ornaments
(Summitt 2000: 272, 282–93). Their raised parts, which were most exposed
to sun and weathering, were now sometimes left white, and only the deep-
lying backgrounds were painted in the traditional blue or red. Therefore, the
adoption of the archaic color triad remained independent of the choice of
columnar order, and aesthetic variations depended primarily on the quantity
and form of the ornaments that were rendered in color.

During the fourth through second centuries BCE, Italic architecture
increasingly absorbed the repertoire of Greco-Hellenistic architecture, but
the role of color in the hellenization of Roman architecture requires futher
investigation. A few findings suggest, however, that the archaic color triad
remained a traditional visual formula also on the Italian Peninsula. A small
Doric temple at Selinunte (Temple B), which dates to *c.* 300 BCE, when the
city was still under Carthaginian control, featured the typical Doric tri-chromy
(Marconi 2012). From Roman Cumae (near modern Naples), a former
Greek colony, we know a late fourth-century BCE temple with a Doric stone

entablature on a wooden architrave that was revetted with terra-cotta plaques in the typical Etrusco-Italic fashion. Both the stone and terra-cotta elements show the traditional color triad (Rescigno 2010). Further, decorative friezes in third-century BCE Etruscan tombs, for example the Tomba della Quadriga Infernale at Sarteano, feature it as well (Pallecchi et al. 2009).

The Roman architectural writer Vitruvius (1998: 4.4.2), in the 20s BCE, was still aware that blue triglyphs were an ancient mode of coloring and reminiscences of the archaic color triad can be found later and elsewhere in the Roman Empire. In Pompeii, the portico of the Temple of Apollo was restored after the earthquake of 62 CE, and the Doric-style decoration of its stucco-coated entablature was replaced with ornaments in the latest fashion. But even the new avant-garde design was painted in the traditional base colors of blue, red, and white, although with a few added elements in yellow (Mazois and Gau 1838: 112). This example, too, shows that an innovative architectural design did not necessarily imply an innovative color scheme. Vaulted stucco ceilings of the imperial period also regularly featured the triple color scheme, and it appeared in functionally diverse spaces such as tombs, baths, or cultic rooms. In addition, the basic color red could be varied to dark red or purple, while blue sometimes ranged from green-blue to turquoise (Mielsch 1975).

VARIEGATION AND DIFFERENTIATION: COLOR COATINGS ON EXTERIORS

The search for ever-greater variegation as well as differentiation of both colors and materials was one of the grand leitmotifs of Greco-Roman architectural polychromy. In critical art theory of the classical period, the idea was known as *poikilia* (Grand-Clément 2015), and it finds its conceptual counterpart in the Latin term *varietas*, which became a universal sign of wealth during the early imperial period (Dubois-Pelerin 2008: 131; Barry 2011: 64–71). The best-known examples are the earlier (*c.* 570 BCE) and the later temples of Aphaia at Aegina (*c.* 500 BCE), both of which deployed green as a subordinate color to enhance the basic color triad (compare Figure 9.1). Elsewhere on these buildings, color differentiation depended on lighting conditions. Both temples had Doric friezes on the facade as well as on the *pronaos* (a portico at the front of a temple), always featuring the typical color rendering in red, white, and blue. But on the facade, where the ornaments were exposed to sunlight, the colors were darker than inside the shady *pronaos* (compare Figure 9.1). Lastly, color differentiation could also express visual hierarchies and values. At the later Aphaia temple, the most expensive and brightest pigments, including green malachite, blue azurite, and red cinnabar, were reserved for the particularly prestigious and protected surfaces of the antae

capitals, which crowned the piers at either side of the entrance to the cella (inner chamber) (Schwandner 1985: 130, 136–40; Bankel 1993: 111–13; 2004: 80, 83).

During the classical period, famous painters and other artists were involved in embellishing architectural facades. Some specialized in painting artistically challenging surfaces such as architectural sculptures, which were now rendered in more complex color palettes (Hellmann 2002: 232, 234; Brecoulaki 2016: 673–4). For architectural ornaments, however, the color choices remained limited to white, black, and hues of red (rarely pink), light and dark blue (rarely turquoise), green, brown, and yellow. Generally, exterior color variegation was achieved through the rhythmic alternation of colors rather than an extremely varied color palette. Two capitals from the Athenian Agora, which preserve exceptional amounts of their original coloring, demonstrate another strategy for increasing variegation. Although identical in form and ornamentation, the capitals were rendered with strikingly different color combinations (Meritt Shoe 1996: 154; Brinkmann 2016: 97–8). If they really come from the same building, as there is reason to assume, they indicate that color schemes could also vary on a single building even from one architectural member to another, perhaps because of spatial context, light, or viewing angles.

In contrast to Greece and Ionia, where limestone or marble temples were rather common, Etrusco-Italic temples of the Archaic and republican periods were often constructed with wooden entablatures that needed protective cladding in terra-cotta (Figure 9.3). The terra-cotta surfaces permitted an almost overcharged ornamentation in color. This overall density of ornament and color, rather than a substantially different color palette, must have differentiated Etrusco-Italic from Greek columnar facades. Archaic Etrusco-Italic architectural terra-cotta from the period of 575–480 BCE shows a palette that included light and dark brown, gold (a mix of yellow ochre and gray) and, after 530 BCE, green and blue or gray-blue (Winter 2009: 520–1). For the periods between the mid- to late Republic (fourth to second centuries BCE), we possess an enormous corpus of architectural terra-cotta but still lack a comprehensive study of their color schemes. Generally, however, the rule seems to be: the later the building, the more color variations were possible. The so-called Campana plaques of the late republican and early imperial periods (first century BCE to first century CE) show the range of chromatic options. The plaques, which were used as revetments for porticos and *impluvia* (openings in the atria of houses) or inserted into walls, could feature extremely variegated and almost screamingly bright color rendering or even white monochromy, probably a reference to white stucco or marble (for example, Pellino 2006: 52–3, plates XII and XIII; Pesando 2010; Zink 2014: 238).

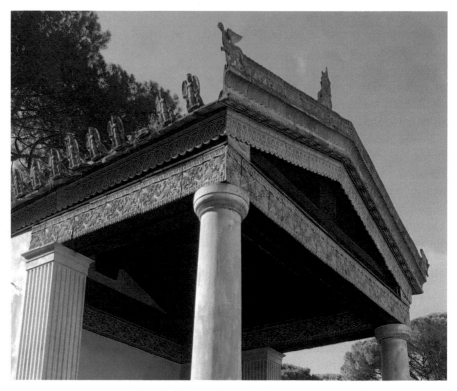

FIGURE 9.3 Etrusco-Italic temple from Alatri (third century BCE). Detail of 1:1 reconstruction (carried out in 1890) in the courtyard of the Museo Nazionale Etrusco di Villa Giulia in Rome. © Jens Pflug.

In Roman republican architecture, with its stone columns and entablatures in tufa or travertine that were usually stucco-coated and painted, the few scattered traces that we know do not allow conclusions on color schemes (Mattern 1999: 24–6). Some temples, however, seem to feature extensive coloration of their exterior surfaces in red or yellow, or had the lower part of the column shafts painted red (Phleps 1930: 20; Mattern 1999: 26). The rock-cut facade of the Tomba Ildebranda at Sovana in southern Tuscany (third century BCE) is the only structure that provides a more comprehensive insight into republican architectural polychromy (Figure 9.4).

Carved out of tufa and stucco-painted, this temple tomb shows a color scheme in which white and red dominated. Red was used abundantly for highlighting the column bases, the dado behind them, and the edge of the roof (*sima*). The coloring was meant to single out entire architectural elements from a distance view (Barbieri et al. 2013: 25–34; Barbieri 2015). It is striking that, unlike in the archaic color triad, blue was not used as a primary color; instead we find mostly green and yellow in the ornaments of capitals and entablature. Perhaps

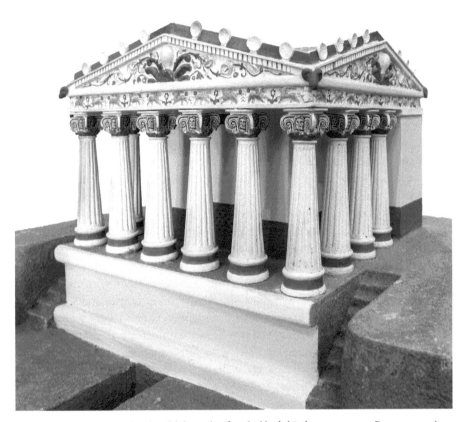

FIGURE 9.4 Sovana, Tomba Ildebranda, first half of third century BCE. Reconstruction model with polychromy in the Archaeological Museum of Savona. © M. Hofmann modified by Stephan Zink.

this deviation from the traditional Greek color triad indicates a local Etrusco-Italic tradition.

Before the opening of the Italic white marble quarries at Luni (modern Carrara) in the 50s BCE, marble was a rare commodity in Italy (Fant 1999). The temple of Jupiter Stator, dedicated shortly after 146 BCE, was Rome's first marble temple, and both the building material and the architect were Greek imports (Velleius Paterculus 1924: 1.11.5; Vitruvius 1998: 3.2.5). Of course, Romans were used to seeing perfectly white stucco surfaces, which could take on a unique brilliance and shine through the addition of marble powder (Varro 1935: 1.59.3; Pliny the Elder 1962: 36.55.176–7; Vitruvius 1998: 7.3.6 and 7.6.1). But a real marble temple was a rare eye-catcher in Rome. Therefore, victorious generals of the late Republic dedicated temples in imported Pentelic marble (Temple of Mars, 132 BCE; Round Temple at the Tiber, c. 100 BCE).

In Augustan temple design, a color scheme of white and gold/yellow was favored and probably stood in a Hellenistic tradition (See Zink et al. 2019). The literary references to Rome's *aurea templa*, which are our primary evidence, make clear that both white and gold were regarded as absorbents of divine essence, as well as signifiers of social status (Gros 1976: 40–1; Barry 2011: 25). At the Palatine temple of Apollo (28 BCE), a limited surface analysis suggests a color scheme with gilded Corinthian marble capitals and an entablature painted predominantly in yellows—perhaps one of the *aurea templa* mentioned in the texts (Zink and Piening 2009). Other observed color traces on marble temples in Rome are rare but indicate rather limited and quite strategic color accentuations (Mattern 1999: 27). From the provinces, however, we also know of stone architecture with more extensive coloring (for example, the Igel column, Trier, *c*. 250 CE).

The stucco-painted facades of early imperial Pompeii and Herculaneum allow us to identify other phenomena that seem to have been Roman specialties. Following the earlier regional tradition, the lower third of column shafts were regularly painted in red or yellow, often in correspondence with the color of adjacent dados. Similarly, the facades of ordinary street houses and shops often had a lower zone in red or yellow and an upper zone in light/white. More elaborate, faux white-stuccoed ashlar masonry could feature joints that were painted in either red or blue or even with fine ornamental patterns (Phleps 1930: 20–2). This tendency to stage walls as artistic and ornamental surfaces can also be seen in the meshwork patterns of unplastered reticulate or brickwork masonry at Ostia. Sometimes, their exterior walls integrated decorative patterns composed from differently colored stones or bricks (22–4).

During the first and second centuries CE, facades featuring exposed brickwork introduced a new aesthetic to the urban landscapes of the Roman Empire. Many, however, which today appear in naked brickwork, once had subtle color refinements. Their surfaces could be homogenized with a fine wash in red/rose while the joints between the bricks were sometimes highlighted in white. Often, decorative elements such as pilasters, capitals, or modillions (ornate brackets supporting cornices) were composed of differently colored bricks or accentuated with color coating (Phleps 1930: 24–5). The exterior of the early fourth century CE Aula or Basilica of Constantine at Trier was once rendered in a warm white tone with intense red accentuating the outlines and depths of architectural forms; only the window jambs featured floral and figural motives in golden ochre against purple grounds (Figure 9.5; Riedl and Funke 2013).

Both the dominance of red and white as well as the planar mode of coloring, which unified all parts of the facade, seem reminiscent of the Roman Italic tradition as we find it already at Sovana's Tomba Ildebranda (compare Figure 9.4) or on the facades of Pompeii.

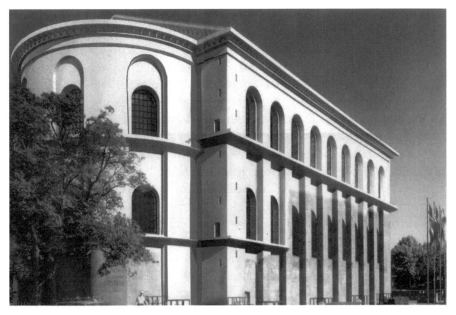

FIGURE 9.5 Trier, Basilica of Constantine or Aula Palatina (early fourth century CE). Color reconstruction and, in the lower register, current state of preservation. © Klaus-Peter Goethert and H&S Virtuelle Welten GmbH, with additions from Nicole Riedl and Friederike Funke.

EXTERIOR COLORING WITH BRONZE, GOLD, AND STONE

Over the course of Greco-Roman antiquity, the material colors of bronze, gold, and stone gained importance for the enrichment of exterior color palettes. Glass was also used, but it always remained a rare material for exterior polychromy. Early on, bronze populated almost every part of monumental architecture, and its colors could be quite varied, depending on the alloy (Pliny the Elder 1952: 33.8.57 and 34.40.140–1). Particularly lavish Archaic temples at Sparta and Delphi are known in the textual sources as "brazen houses" (Pausanias 1965–9: 3.17.3–5; 10.5.1 and 9; Philostratus 2005: 6.11; Pindar 2012a: *Paean* 8), and findings of thin bronze sheeting suggest that these were fully metal cladded buildings (Normann 1996: 25–42; Kane 2006). Bronze was also coated with gold or silver leaf to create reflective highlights (Pliny the Elder 1952: 33.61–4). To my knowledge, the earliest archaeologically known example of gold leaf on a Greek temple facade comes from the Archaic Artemision at Ephesos (around 550 BCE); its exterior Ionic capitals featured a gilded lead band to accentuate the spiral of its volute (a scroll-like ornament) (Jenkins 2006: 38, fig. 19). An

Archaic roof antefix (a decorative element at the edge of a roof) in terra-cotta from Capua (southern Italy) also carried traces of gilding (Koch 1912: 13, 39). The famous Archaic temples of Apollo at Delphi as well as of Jupiter Capitolinus at Rome may have set the standards for gilded bronze acroteria (rather large ornamental features at the apex or corner of a pediment), which remained a common marker of sacred architecture throughout Greco-Roman antiquity (for Delphi and Rome, see Herodotus 1920–25: 1.50; Livy 1926: 10.2; Pausanias 1965–9: 5.10. 4).

The application of gold leaf seems to have become quite common for monumental/public architecture during the classical period. The evidence is, however, exclusively epigraphic or based on observations of nineteenth-century travelers (Athens, Erechtheion: IG I³, 476, lines 54–5, 351–3; Epidauros, Temple of Asclepios: IG IV² 102, lines 81 and 136; Delos: ID 161, A, line 73; Hellmann 1992: 336–7; Summitt 2000: 206, 211, 210–20).[1] For the Athenian Parthenon, accentuations with gilding are often assumed (and are indeed likely), but no empirical evidence has survived (Zambon 2012). In addition to gold, inserted glass beads were responsible for reflective and sparkling color effects on the exterior capitals of the Erechtheion at Athens (406 BCE; Stern 1985; Jenkins 2006: 128–9, fig. 117).

Vitruvius (1998: 4.1.9) saw in metalworking the origins of the Corinthian capital, and indeed, with its highly sculptural form, the Corinthian capital lends itself to an execution in massive bronze. Our earliest known example of a Corinthian bronze capital (a stone core with attached metal pieces, which, however, are not preserved) may really be from fourth-century BCE Corinth (Scahill 2009). Later, in Roman architecture, gilded bronze capitals became state of the art—they were deployed at the Porticus Octavia (167/166 BCE) and the Augustan Pantheon (29 BCE) in Rome (Pliny the Elder 1952: 34.3.13 and 34.7.1), but also in the East, at the Temple of Bel in Palmyra, Syria (early first century CE) and the Propylon of the Temple of Jupiter at Baalbek, Lebanon (second century CE; Mattern 1999: 13–14). Exterior stone facades of public monuments often preserve attachment points for other (gilded) bronze adornments, which were meant to create reflective highlights or contribute to material/chromatic variation (Normann 1996: 52–3). A famous yet controversial example is the dowel holes in the pediment of the Pantheon in Rome from around 125 CE, which suggest an entire pedimental decoration in metal applications (Barry 2014; for other examples, see Mattern 1999: 10–12). Further uses of architectural metals include grills that were installed between columns (Normann 1996: 67–76), gilded bronze and silver shields or round medaillons (*clipei*) on facades (Pliny the Elder 1952: 33.18.57 and 35.3.13; Livy 2018: 35.10.12), or even entire roofs in gilded bronze tiles, which were highly admired (Pliny the Elder 1952: 33.18.57, 36.4.45, 34.6.13; Cicero 1948–53: 4.69; Seneca the Elder 1974: 1.64; Ovid 1989: 6.261; Virgil 2000:

8.347; for the few archaeological remains, see Mattern 1999: 14). Temple doors, which were always a place of special artistic articulation, were sheeted with bronze or decorated with reliefs in wood or even ivory (Mattern 1999: 15–21). During the Augustan period, *litterae aureae* (gilded bronze inscriptions) became a hallmark of Roman public monuments and soon a manifestation of imperial authority (Posamentir and Wienholz 2012; Trillmich 2014).

Another key material for exterior polychromy were polishable stones in different colors, the so-called colored marbles. Their use led to a veritable aesthetic revolution in ancient architecture during the Roman late Republic and the early empire. Of course, stone polychromy had earlier precursors, and these are worth noting in order to understand the significance of the later development. Some Greek Archaic buildings had architectural members, such as column bases, shafts, or capitals, carved from different types of marbles or limestones (Paestum, Temple of Hera; Samos, Heraion), but color differentiations were rather subtle, usually with the darker stones at the bottom and the lighter on top (Hellmann 2002: 230; Hoepfner 2002: 38). The same restrained use of stone color appears in the classical period, when a limited amount of blue-gray limestone was used as background for sculptural friezes and in contrast with the principal building material, which was light marble or limestone (for example, the Propylaia and Erechtheion at Athens or the Temple of Apollo at Bassae; Summitt 2000: 210–11; Koenigs 2008: 716). The Hellenistic monarchs, however, really prepared the ground for the Roman development, as they advanced stone polychromy as a visual message of luxury and abundance.

The Mausoleum at Halicarnassus (350 BCE) is one of the earliest known examples of the use of different stone types on all levels of a facade, notably in concert with the traditional painted accentuations in red and blue (Jenkins and Middleton 1997: 39, plate 21). Soon thereafter, the use of colored stones became particularly important for the Ptolemies in Egypt, who had inherited the long Pharaonic tradition of building with colored stones. We know of many architectural members from Hellenistic Alexandria that were carved from colorful granites, diorites, basalts, and alabasters (Gans 1994). Their material and chromatic variation was a sign of wealth and authority, while the very use of colored stones may have created a symbolic connection to Pharaonic architecture.

At the end of the second century BCE, the arrival of colored marbles in Rome and central Italy offered new possibilities to add weather-resistant color effects to exterior facades. Colored marbles became the luxurious alternative to painting on stucco, terra-cotta, or white marble. Because of their distant origins, they were also regarded as a visual and material metaphor for Rome's territorial expansion (Mattern 1999: 22–3; Bradley 2006). While the earliest appearances of colored stones seem to have been limited to interiors (see below), during the latest Republican and early Augustan periods, smaller columnar orders of

exteriors began to deploy colored marble shafts. The portico of the Palatine sanctuary of Apollo (28 BCE or shortly thereafter) had shafts in yellow *giallo antico*, which Propertius described as "golden" (Propertius 1999: 2.31). Podia were also revetted with colored marble (Mattern 1999: 22; Barry 2011: 61–2). But the facades of the large Augustan temples with their fifty Roman-foot columns presented themselves in the local white marble from Luni (Carrara), which was highly appreciated for its *candor*, its special whiteness. The importance of white marbles is shown by the fact that Roman authors knew many terms to designate the different colors of their white (Bradley 2006).

During the early imperial period, when colored marbles became available in larger quantities and formats, we see the appearance of a new aesthetic, which contrasted with the traditional Greco-Roman temples with their white/light body and painted color accentuations. Now monumental facades could rely on a juxtaposition of naturally colored stones rather than on accentuations with paint. One of the earliest examples is found at Philae in Egypt. The facade of an Augustan temple in pure Greco-Roman (and not local Egyptian) style deployed a color scheme that was based entirely on architectural members carved from brown sandstone, red Aswan granite, and black diorite (McKenzie 2007: 166, fig. 286). From the mid-first-century CE onwards, even in Rome, more and more facades deployed large monolithic column shafts in light gray, red/rose, and red/purple Egyptian granites or in green *cippolino*. The colored shafts contrasted with bases, capitals, and architraves in white marble. Bronze features (with or without gilding) completed this new aesthetic, which became a visual marker of the Roman Empire. Among the various colored stones, it was purple porphyry, perhaps echoing the purple/golden *toga picta* of the Roman triumph, that came to symbolize the political, social, and religious authority of the Roman Emperor (Bradley 2009a: 202–11).

THE SPLENDOR AND COMPLEXITY OF INTERIORS

The full palette of material and chromatic splendor was always reserved for interior spaces, where surfaces were protected from weathering. Other phenomena, which were common in (but not limited to) interiors include the illusionistic imitation of one material by means of another (for example, the painted imitation of stone), as well as intermediality, the use of the same decorative motifs and color schemes in different artistic media. Of course, complex interiors also required adequate natural lighting.

For the Greek Archaic period, however, our knowledge on interior surfacing is very fragmentary. The interior walls of Archaic Greek and Etruscan temples were certainly plastered and painted, but we rarely know anything about their specific schemes other than the use of black, red, white, and yellow (Broneer 1971: 33–5, plates A–C; Summitt 2000: 69–71; for Etruscan, see Andersen

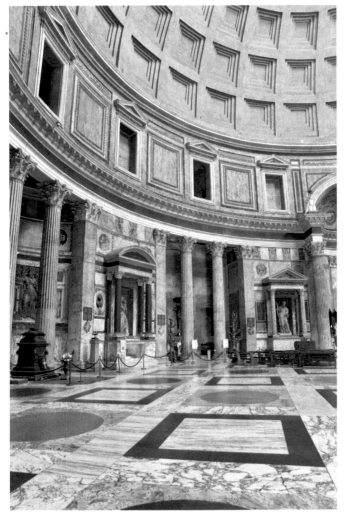

FIGURE 9.6 Rome, Pantheon (*c*. 120 CE). View of the interior, which preserves much of the original decoration in various colored marbles. © Stephan Zink.

1998: 94–5). Substantial evidence on the color rendering of walls and wooden ceilings can also be found in Etruscan tombs, but it is difficult to determine how far these reflected real domestic or sacred interiors (Andersen 1998: 209). As to floors, the findings from the houses at Phrygian Gordion (ninth and eighth century BCE) are remarkable with their geometric patterns in dark blue, dark red, and white (a forerunner of the archaic triad) (Rose 2017; Zink 2019: fig. 2). In mainland Greece, however, the earliest known pebble floors (Sparta

and Delphi) appear a century later (seventh and sixth centuries BCE) and were still unpatterned (Dunbabin 1999: 5; Hellmann 2002: 251).

Effects of interior coloring also depended on furniture and artworks such as cult statues, paintings, metal lamps, curtains, carpets, and so forth. The *Pitsa pinakes* (sixth century BCE) are unique examples of painted wooden boards, which may have once hung on the walls of a temple *cella* (Brecoulaki 2016: 683–4; see also Plate 4.2). For the natural lighting of objects and surfaces (and for ventilation), Greek temples had small window slits or larger openings, or roof tiles with small holes, so-called *opaia* (Miles 2016: 207). The temple of Sangri on Naxos (*c.* 530 BCE) even had translucent marble roof tiles, which must have created a spectacular "light dome" (Ohnesorg 2011). At Olympia, the *cella* of the temple of Zeus (457/456 BCE), which housed Phidias' chryselephantine (gold and ivory) statue of Zeus, featured a shallow basin in front of the statue that was once filled with olive oil (Pausanias 1965–9: 5.11.10). A possible explanation is that the oil reflected the light that entered through the main door or an opening in the roof and thus illuminated the gilded statue (Hennemeyer 2011). The light may also have interacted with a glass frieze, of which pieces were found in Phidias' nearby workshop (Mallwitz and Schiering 1964: 23–4, 145–56, plates 39–44).

The late classical development of the so-called Structural (or Masonry) Style was of lasting importance. This decorative wall scheme used painted plaster and three-dimensional stucco elements to imitate the exterior of public and sacred buildings. It first appeared in private houses at Athens, Olynthus, and Eretria and followed a fixed tripartite composition: a colored dado on a base molding, a main zone with faux painted ashlar masonry in colorful stones of all sorts, and a cornice molding with a frieze (Figure 9.7). Soon it became an international formula for elite interior decoration in public and private contexts. At the end of the fourth century BCE, colorful faux-painted ashlar masonry was also seen on central Italic soil (the Etruscan Tomba Francois at Vulci), and in the second century BCE, it continued in the form of the so-called First Pompeian style of wall painting (Walter-Karydi 1998: 33; Hellmann 2002: 246–50; Mulliez 2014; Brekoulaki 2016: 670–9).

Late classical artisans also developed two new types of decorative floors. The first featured thinly cut stone tiles in white, gray, and black, a forerunner of the Roman *opus sectile*. It appeared first in sanctuaries (Epidauros, Delos), which were often laboratories for new design developments (Dunbabin 1999: 5–6, 254; Hellmann 2002: 260; Koenigs 2008: 717; Brekoulaki 2016: 682). The second type were mosaics. The earliest examples were still made of pebbles, with mostly bichrome (black/gray and white) ornaments and only sporadic accentuations with other colors. But with the use of regularly cut stone tesserae (*opus tessellatum*) from the third century BCE on, the color palettes of mosaics became more nuanced (Dunbabin 1999: 18–38; Brekoulaki 2016: 675–9). The

FIGURE 9.7 Athens, wall decoration in the Structural (or Masonry) Style, late second to early first century CE. Wirth 1931. Public domain.

sophisticated *opus vermiculatum* could use up to a million minuscule tesserae of colored stones, glass, and faience on a single floor to create intricate color gradation, optical fusion, plasticity, trompe-l'oeil realism and naturalism—the most famous example is the so-called "Alexander Mosaic" in the House of the Faun at Pompeii (see Figure 8.3) (Dunbabin 1999: 29–52; Brecoulaki 2016: 675–9).

On ceilings, stone coffers offered possibilities for lavish color rendering. Beginning in the fourth century BCE, their protected surfaces were a preferred place to apply the lavish painting technique known as *encaustic*, which used

wax and oil as binding agents (for which, however, the evidence is still mostly literary: Erechtheion: IG I³, 476, lines 270–2; Epidauros: IG IV2, 102, lines 21–2, 29, 49, 58, 108, 300–1; Pliny the Elder 1952: 35.5.12; Hellmann 2002: 240; Brecoulaki 2016: 652)[2]. Common motifs for the central fields of ceiling coffers were gilded or painted stars or floral motifs set against a blue background and framed by polychrome Ionic moldings. The best examples are from the Athenian Propylaia, the Erechtheion, and the Hephaisteion (Normann 1996: 96–100, 110–11; Summitt 2000: 206; Miles 2016: 210; Zink 2019: fig. 1). Artistic painting techniques also affected the rendering of architectural ornaments. Since the fourth century BCE, ornaments in (semi-)shaded interior or exterior locations could be painted on smooth moldings in an illusionistic manner, just as if they were actually carved (for the compilation of evidence, see Summitt 2000: 228–9, 245–6, 266–9, 276–80, 288; Stanzl 2015: 183–4; Zink 2019: fig. 10).

During the Hellenistic period (fourth to first century BCE), the wealth of royal potentates boosted the use of extravagant materials and colors. Ancient authors report that the palace of King Mausolos (c. 350 BCE) was the first building to have wall surfaces in colored stone (Vitruvius 1998: 2.8; Pliny the Elder 1962: 36.6), while in the palaces of the Ptolemies at Alexandria, colored stone surfaces appeared in concert with gold, ivory, precious stones, and ebony (Kallixenos in Athenaeus 2006–2012: V. 196a–197c and 204d–206c; Lucan 1928: 10.5.111). Gold, the material traditionally associated with the divine, seems to have gained in importance for the coloring of architecture, just as for Hellenistic sculpture (Blume 2015: 104). Ptolemy IV's floating palace, also in Rome, had Corinthian capitals in ivory and gold supporting a gilded entablature (Atheneus 2006–2012: V. 205c); and a striking number of Corinthian capitals from Egypt and the southern Levant featured gilded or yellow acanthus leaves, volutes, cauliculi, and helices, all set against a (dark) red or purple background.[3] Interestingly, such schemes also appear in some of the wall paintings of the so-called Second Pompeian style (Foerster 1995: 112–13; McKenzie 2007: 103).

In the first century BCE, wall surfaces in colored marbles found their way into Roman elite households. Soon, anyone aspiring to social status needed to have these *crustae marmoris* (Pliny the Elder 1962: 36.48), ideally (but probably rarely) along with gilded or painted coffered ceilings (Pliny the Elder 1952: 33.18.57; Pausanias 1965–9: 5.10.5; Normann 1996: 183). But in Italic/Roman contexts, the use of colored marbles as well as most other surfacing techniques of Greco-Hellenistic origin were brought to genuinely new levels of application. Artisans began to embellish colored marble panels with friezes in gold leaf (Pliny the Elder 1952: 33.57; Dubois-Pelerin 2008: 143) and invented *opus interrasile* (Pliny the Elder 1952: 35.2–3), a new technique of

inlaying stone panels with other colored stones or glass to create polychrome frieze compositions or images—a veritable "painting in stone" (Pliny the Elder 1952: 35.3; Dubois-Pelerin 2008: 152–8). Additionally, complex architectural members such as capitals and pilasters were assembled as three-dimensional collages of differently colored stones (Filippi 2005: 36–48, 52–65). From the first century CE onwards, entire wall friezes and revetments were composed of colored glass paste (Barry 2011: 111–12; Lepinski 2016: 737–8). And mosaics were no longer only for floors, but became a decorative tapestry for walls, columns, and even pediments (Sear 1977: 82–3; Dunbabin 1999: 243–4; Zink 2014: 253). The most luxurious interiors had columns with colored marble shafts in combination with gilt bases/capitals and metal attachments in silver or gold, sometimes with inlaid gemstones (seen in a wall painting at Oplontis [south of Naples], Villa A, Triclinium 14; Dubois-Pelerin 2008: 140–7). Not to forget, with the invention of window glass during the first century CE, interiors were increasingly filled with a diffuse light that gave new life to interior surfacing and coloring (Sperl 1990: 65–70; Guidobaldi et al. 2015; Lepinski 2016: 738–9).

Roman building patrons developed a veritable obsession with the display of color variations through stones; the early imperial *Casa di Cornelius Rufus* at Pompeii and the *Casa del Rilievo di Telefo* at Herculaneum featured up to forty different types of colored marbles on walls and floors (Dubois-Pelerin 2008: 166). The latter also provides a rare insight into the interplay of a marble-tiled floor with a wooden ceiling featuring painted coffers in blue with white, green, red, and gilded ornaments (Savalli et al. 2014; Camardo and Notomista 2015; Zink 2019: fig. 28). However, it would be too simple to see color abundance as the only guideline for Roman interior designers. Some patrons in Rome, including the emperors themselves, favored floors in a more restrained color palette. During the Claudian/Neronian period, the so-called *quadricromia neroniana* reduced color effects to the combination of green serpentinite, purple porphyry, yellow Numidian marble, and white-red/dark veined *pavonazetto* (Guidobaldi 2003: 30) (Figure 9.8). Another example of interior color reduction, perhaps driven by cost, is mosaic floors in black and white, which were particularly common in the western parts of the empire. One should not forget that decorated stucco ceilings of the imperial period were also sometimes left entirely or mostly white (Mielsch 1975). In the Pantheon (*c*. 125 CE), the most famous example of a Roman interior space, eight different marbles from all across the empire were used for the facing of floors and walls (Figure 9.6) (Heilmeyer 1975: 333–4; Bitterer 2010: 163). Such floor and wall incrustations in colored marbles remained a signature of Roman architecture throughout the empire.

I end this survey by turning to one of the most interesting cases of material imitation and intermediality, the reception room of the so-called House

FIGURE 9.8 Rome, Palatine Hill, detail of an *opus sectile* floor in "quadricromia Neroniana," probably from the Aula of Nero's Domus Aurea. © Dörte Blume.

next to the Porta Marina at Ostia from the end of the fourth century CE (Barry 2011: 112–21; Kiilerich 2014, 2016). It was clad with colored marble incrustations, which imitated precious panel paintings as well as a facade in reticulate masonry and brickwork, as it was usually seen only in contemporary streetscapes (Figure 9.9). The possibilities of interpreting this arrangement are manifold. Perhaps the owner wanted to brag that he could afford to imitate cheap tufa and brickwork in precious colored marbles; perhaps he wanted to make a philosophical point on material metamorphosis and the question of appearance and essence; or perhaps it was simply a witty play on established viewing habits. We do not know. In any case, this example demonstrates that architectural surfacing maintained a high level of sophistication into late antiquity; and, on a more general level, it reminds us that, with the architectural surface, we often miss a key component in understanding the multiple meanings of Greco-Roman architecture.

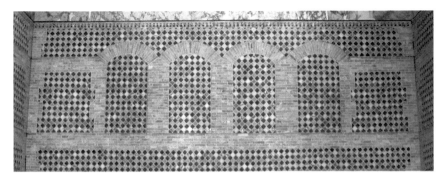

FIGURE 9.9 Ostia, Aula from the building outside of Porta Marina (*c.* 393/394 CE). Detail of wall incrustation in colored marble imitating brickwork and *opus sectile* wall facing. © Brent Nongbri.

Artifacts

ELLEN SWIFT

Color in the artifacts of antiquity is a neglected topic. Recent literature examines texts, monuments, pigments, and art-historical sources (for example, Gage 1999; Davies 2001; Jones and MacGregor 2002; Tiverios and Tsiafakis 2002; Rouveret et al. 2006). Where artifacts have been mentioned, this has largely been from the perspective of what texts say about colored objects (for example, Cleland and Stears 2004; Bradley 2009a). Yet artifact evidence has much to offer in its own right. Scholars working on artifacts have documented color information in studies of particular objects across diverse periods and regions, although interpretation is limited and still overwhelmingly text-reliant.

The materials most useful for an exploration of color are those whose original colors survive well, for example, stone, glass, and related materials such as Egyptian faience (a glazed quartz-based substance), enamel (glass fused to a metal, ceramic, or glass substrate), ceramics, and to a lesser extent, metal. In this chapter, I will consider what artifacts made in these materials can contribute to our knowledge of color conceptions in antiquity, and how they can be used to explore new areas. Drawing on scholarship that explores agency in the past (Gell 1998; Young 2006: 175–82; Swift 2009: 105–38), I will focus particularly on how color works. What tasks does it perform in various situations? What are the social functions of colored artifacts? We will examine perceptions of color, symbolism, the imitative properties of color, color-coding and practical uses of color, and aesthetics.

PERCEPTIONS OF COLOR

In scientific terms, three particular qualities of color relate to physical phenomena, hue (color value), lightness (closeness to white or black, also called *tone*), and saturation (vividness or color strength) (Jones and MacGregor

2002: 4; Osborne 2004: 38–43; McDonald, this volume). They may have been used as defining criteria to varying degrees in antiquity. There has been much debate over ancient color terms and how these map on to modern conceptions of color, using linguistic and textual evidence that will not be repeated here (see McDonald, this volume). We can note, though, how material evidence can contribute to such debates. Artifact color can degrade through time, discussed for instance by Bateson with regard to enamel (Bateson 1981: 3), yet examples in which preservation is good can suggest features of the color systems of ancient cultures. For instance, the former proposition, based on linguistic evidence, that ancient Egyptians did not distinguish between green and blue can be refuted through reference to representations of the sky in Egyptian painting, which is always shown as blue rather than green (Warburton 2004: 128).[1]

A more specifically artifactual example from dynastic Egypt is colored faience. From studies of its chemical composition, it has been suggested that red and brown coloration were not intentionally distinguished until the eighteenth dynasty (Kaczmaraczyk and Hedges 1983: 144). Yet in examples such as this, it can be difficult to isolate the causal factor—is it the lack of attention to this hue distinction, or the absence of the necessary technological competence to achieve it? (Moorey 1991: 184–5).

Types of objects not dependent on technology to create particular hues are perhaps more useful. Using textual evidence, it can be documented that the color purple slowly came to be associated with materials other than purple dye from the first century CE onwards. Its imperial connotations also became more firmly established (Bradley 2009a: 202–7; see also Llewellyn-Jones and Olson and Wharton, this volume). Artifact evidence corroborates this, in that purple gemstones such as amethyst become more popular for the imperial portrait from the third century CE onwards. The imperial portrait, however, is also found preferentially on blackish and dark blue gemstones, such as sapphire and nicolo.[2] These colors may also have been viewed as acceptably representing the imperial color and show that hues are either categorized differently to our modern definitions or that hue is not the only criterion used.

With regard to how color definitions extend beyond hue, once written documents become available in antiquity, they shed considerable light on how colors were defined and understood, which makes clear that ancient color terms could encapsulate a range of qualities, of which hue was only one (Bradley 2009a). For instance, ancient discussions of color appear to show particular interest in surface qualities (reflectivity, texture, shine, and so forth).[3] Artifact evidence can also contribute here by providing evidence of material choice or grouping by qualities other than hue in some cases—for instance, by lightness. Ancient Mesopotamian cylinder seals, for instance, favor lighter toned stones (marble, calcite) that occur in a variety of hues in the early dynastic period, even though darker stones that were also easy to work were available (Moorey 1991: 75). Hue distinctions may have been unclassified or felt unimportant.

Coffins from dynastic Egypt provide a more detailed example. Using color combinations, Taylor divides them into five categories: white background with polychrome decoration, black background with gold/yellow decoration, gold/yellow background with polychrome decoration, red background, and blue background with gold/yellow decoration (Taylor 2001: 165–7). Yet, if we consider the tonal range of the background colors rather than their hues, we could make a different grouping, including in one group those with light-colored backgrounds (white, yellow, or gold) and polychrome decoration, and in another those with dark colored backgrounds (blue or black) and gold/yellow decoration. The possibility of aggregating the color schemes in this way could suggest that lightness was considered to be more important than hue in deciding what kind of decoration should be applied. Some figurative amulets from dynastic Egypt also occur predominantly in particular tonal ranges, for instance, stone phallus amulets occur predominantly in dark stones (Andrews 1994: 71, 76–7). Glass gaming counters found in provincial Roman burials provide another example (Figure 10.1).

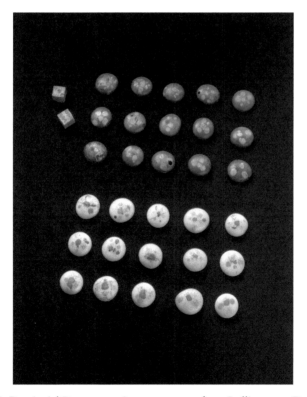

FIGURE 10.1 Provincial Roman gaming counter set from Lullingstone Roman Villa. Artist: J. Bailey. Detail of gaming counters and dice excavated from the Mausoleum at Lullingstone Roman Villa, Eynsford, Kent, 1991. Photograph by English Heritage/ Heritage Images/Getty Images, via Getty Images.

One Roman board game involved two players, each possessing about fifteen counters (Schädler 2007: 362). The most common combination in grave assemblages is a set of light counters for one player, and a set of dark ones for the other.[4] A few sets include a wider variety of colors, which, however, can still be grouped into categories of light and dark colored pieces.[5] The evidence suggests that lightness/darkness is the organizing principle, not hue. Lightness also appears to have been important in distinguishing ceramic drinking vessels from the end of the first century CE onwards in the Roman northwest provinces (Symonds 1992: 11; see also below).

COLOR SYMBOLISM

Color use is often obviously symbolic. It has been argued that hues in the natural environment have created enduring cross-cultural hue associations, for instance, green with vegetation (Wierzbicka 1990: 115–25; Chapman 2002: 50–1). Such associations are sometimes used to suggest the symbolic meaning of ancient colored artifacts, especially in prehistoric contexts where information on color meaning from texts is lacking.[6] Yet there are several problems with such analyses, as elucidated in previous studies. The assumption that colors in the past were understood and categorized primarily in terms of hue, and that divisions between hues necessarily mirror modern categorizations (see above) is untenable. In addition, color symbolism has to be considered contextually, that is, what color connotes in particular situations rather than ascribing single unchanging meanings to color (Chapman 2002: 47–9; Young 2006: 178–9).

Artifacts with figural decoration can provide information on context that allows us to reach a nuanced understanding of color connotations for individual objects. For example, porphyry, with its reddish-purplish hue, was much used for imperial Roman statuary, and developed strong imperial associations (Delbrueck 1932; Bradley 2009a: 202–5; McFadden 2015: 142; Olson and Wharton, this volume). However, its use in the late Hellenistic to early Roman period for *situlae* (wine buckets) decorated with Bacchic figures suggests that the color of the porphyry, in this particular context, was chosen to represent the color of wine (Delbrueck 1932: 201–2, plate 93; Lapatin 2015a: 259, plate 136).[7] Similarly, the Lycurgus Cup, made from dichroic glass that appears green in reflected light and red in transmitted light (Scott 1995: 92), combines a Bacchic theme appropriate for feasting (Swift 2009: 133) with hues that, given the context, could be suggested to represent the living vine (represented on the cup) and the transformation of its grapes into wine.

Glass flagons decorated with Bacchic imagery also occur in (rare) wine-colored purple glass (Whitehouse 2001: 127–9, cat. no. 633, dating to the fourth or fifth century CE; Metropolitan Museum of Art, accession no. 17.194.226). An earlier example is the particular association of coral-red gloss with ceramic

wine vessels in late Archaic and early classical Greece (Cohen 2006: 49). Representations of Bacchus/Dionysius in amethyst, known from Hellenistic and Roman period intaglios (engraved gemstones), are linked in textual evidence to the belief that amethyst could prevent drunkenness (Johns 1996: 78; Plantzos 1999: 111). This belief was probably due to the sympathetic magic generated by its similarity in color to wine. This raises the possibility that the imitative properties of color were not merely representational but actively generative (discussed further below).[8] Amber carvings representing a solar symbol provide a further example (Causey 2011: 23). The color of the amber in this instance signified the color of the sun. Amber was sometimes backed with silver or gold foil (in seventh-century BCE Greek, Etruscan, and Campanian objects), creating an almost mirror-like effect. This corresponds with textual references to "shining" amber, which may have been felt to be generative rather than reflective (41–4, 79).

Ancient Egyptian amulets provide further evidence of colored stones or materials favored because they represent specific entities in their "correct" colors, for instance, green-colored stone chosen for frog amulets or red stones used for depictions of the rising sun on the horizon (see Figure 10.2). Color (and material) choice will have been important to the sympathetic magic believed to have been generated by such objects (Andrews 1994: 63, 65, 89).

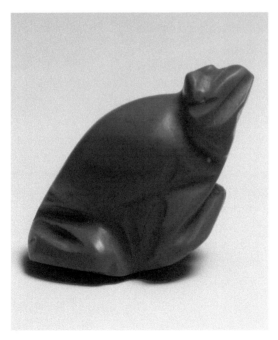

FIGURE 10.2 Egyptian late period/Hellenistic jasper frog amulet. The Metropolitan Museum of Art, The Cesnola collection. Accession number 74.51.4448.

Although not invariable, there are many further instances of colored materials being chosen for a figural object because it is considered to be appropriate to the subject, for instance, jet or very dark-colored glass used for Roman rings and pendants depicting Africans,[9] brown glass used for Roman bottles similar in size and shape to dates (Figure 10.3) (Stern 1995: 91–4), and depictions of lions on late antique pendants and discs predominantly in yellow-brown glass rather than the much commoner greens and blues.[10]

These uses reflect wider Roman concepts of decoration, in which appropriateness was highly valued, and they link to object-centered experiences of color in antiquity discussed further below (see also Rowland and Howe 1999: 151; Swift 2009: 16–17). Colors are also sometimes used as pigments on artifacts to depict figure-subjects in "realistic" colors, as is seen in wider art media.[11] A less obvious example is the way in which early Roman cameo glass vessels (c. 25 BCE–50/60 CE) do not copy the prototype of cameo glass, sardonyx (typically banded in brownish tones), but occur most often with opaque white

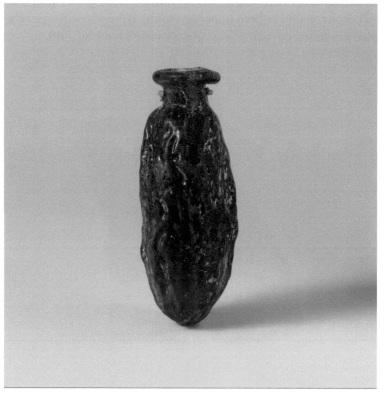

FIGURE 10.3 Roman glass date bottle. The Metropolitan Museum of Art, Edward Moore collection, bequest of Edward Moore, 1891. Accession number 91.1.1295.

figure decoration on a translucent (sky-)blue background (Whitehouse 1991: 19, 26). By contrast, use of color is sometimes wholly non-figural. In Romano-British enameled zoomorphic brooches, the colors chosen are not the natural colors of the animals depicted. A combination of blue and red enamel is, for instance, very common, relating directly to Iron Age traditions (see Bateson 1981: 7–17 and 41–4). Similarly, some faience amulets from dynastic Egypt, for example, hedgehogs and hares that occur mainly in green, do not show figural use of color either, an interesting difference from those made from semi-precious stones (Andrews 1994: 64; see also Figure 10.2). They perhaps imitate turquoise.

We can also consider color symbolism more broadly. Color in artifacts, as a memorable feature, creates associations of diverse kinds (Osborne 2004: 58). It can connote exoticism or geographical origin (Chapman 2002: 61; Jones and MacGregor 2002: 10; Jones 2004: 73), luxury and power (Bradley 2009a: 100–1, 190), or a distinct era, through having been current at a certain time (Jones 2004: 75; Young 2006: 174). The use of specific colors might evoke various memories or emotions because of their particular associations (Jones and MacGregor 2002: 12; Jones 2004: 74–5; Bradley 2013: 131–2, 139–40). In addition, color changes in materials can signify aging, mutability, or dynamism (Young 2006: 180). Let us now examine some archaeological artifacts from antiquity that may have acted in this way.

The associations of particular colored materials with their area of origin is well-documented in textual evidence. Archaeological evidence can contribute to this knowledge through its ability to document the exact origin of colored materials probably valued for the exoticism indexed by their vivid color. Examples are the origin of lapis lazuli in Afghanistan, imported into Mesopotamia from 3500 BCE onwards (Herrmann 1968; Dubin 2009: 30), or Baltic amber, traded from the Mycenaean period (Causey 2011: 34–7). Colored objects, especially grave goods, may also have connoted place or origin in preliterate societies, for instance in prehistoric Europe (Chapman 2002: 61; Cooney 2002; Jones 2004: 73; Hoecherl 2015: 33–4).

In antiquity, tradition and continuity were valued, so associations of artifact colors with discrete chronological periods may not occur as often as in the recent past. Yet there are periods of innovation in artifact color. We can suggest that in periods such as the Hellenistic and early Roman, when older artifacts such as gems were collected (Prioux 2014: 54–71), old and new artifacts would have existed alongside one another and could have been distinguished through their typical colors. In the earlier classical Greek and Hellenistic periods, for example, pale gemstones were favored, such as blue or white chalcedony (Boardman 2001: 211–15), while vivid, saturated colors such as red carnelian became popular in the Hellenistic period (Plantzos 1999: 36). These color differences may relate to the availability of materials (Boardman 2001: 215), yet

the use of particular colored materials would also have come to connote their periods of production, especially for those living through periods of transition. Those who acquired antique stones would have recognized the differences from contemporary products. Color may have assisted in the characterization of such objects as heirlooms. In another example, the rapid uptake and equally swift rejection of first century CE Roman molded glass vessels in strong translucent colors may relate to the way in which these, firstly, signified innovation (with the introduction of completely new hues for glass such as emerald green), and ultimately, became old-fashioned by comparison to colorless glass. Strong colors may also have come to connote the old production method of molding, soon replaced by blown glass (on trends in glass, see Fremersdorf and Fremersdorf 1984; Grose 1991; Price and Cottam 1998: 15–16).

The materials used for many colored artifacts have changed in color over time, for example the patination or oxidation of metal surfaces or the darkening of materials such as ivory and amber (Causey 2011: 38), both caused by ongoing exposure to the air. Such changes index their particular age and may have been understood by users in this way. Deliberately patinated metals, such as purple-black copper-gold alloys, were certainly highly valued, although perhaps more in the creation of polychrome objects than as purposely antiqued pieces.[12] Value for the patinated color appearance of antique metal artifacts can be suggested by using evidence from some extant artifacts in a different material. Some Roman bone and even ivory artifacts, such as dice, hinges, and hair-pins, have been deliberately dyed light green,[13] probably to mimic oxidized copper (which they closely resemble).[14] The use of green-dyed hinges on Roman furniture, for instance,[15] could have been used to create the impression of heirloom items.[16]

COLORED ARTIFACTS USED TO IMITATE PRECIOUS MATERIALS

Ancient texts make clear the fundamental relationship between color terms and particular materials and the range of qualities that they possessed. In many instances, color terms are directly derived from those for particular materials; for instance, in Egyptian the word for blue takes its name from lapis lazuli (Warburton 2004: 128–9). Bradley suggests that many color terms carried the additional connotations of material qualities; for instance "marbled" also encapsulated the sensations of coldness and smoothness as well as a white color. "Object-centered" experiences of color, he argues, were fundamental in antiquity (Bradley 2013; see also Clarke 2004: 137–8). A vast array of artifact evidence from diverse periods and regions shows that the relationship between color and materials was indeed extremely important, particularly in the way that colored materials were made to imitate other highly valued materials. In a sense, we have already seen this above when discussing symbolism—colors

for artifacts were chosen to imitate real-world colored phenomena such as the sun, and thus acquired symbolic value. Choices about color are therefore often choices about materials, and/or about what is represented, and hue cannot be considered in isolation (Swift 2003: 345).

The two principal materials that were used imitatively are metal and glass. Each shares properties beyond hue with the materials imitated (such as durability, shine, and the way that the color permeates the material rather than existing as a painted layer), suggesting that it was important to imitate a range of qualities. This is not just a matter of attempting to deceive, as mentioned below. Less commonly, textual sources suggest that precious materials themselves were treated to alter or enhance their color, mostly imitatively, for example, the dyeing of rock crystal to resemble amethyst or emerald (see Bradley 2009a: 105, 152; Lapatin 2015a: 110). It is difficult to identify this in the archaeological record. Some extant material exists for the Achaemenid period in Mesopotamia, namely agate cylinders artificially dyed (Moorey 1991: 76).

Considering metal first, metal alloys exist in a range of colors dependent on the proportions of the metals included. Natural gold, for instance, is a pale color, because it can contain up to 20 percent silver (Hoecherl 2015: 21). Alloys of various hues can also be intentionally created. In antiquity, copper alloy with a high percentage of tin may have been deliberately created to imitate gold or silver, because otherwise they offer few advantages. They are challenging to create and have poor mechanical qualities; yet they appear from the prehistoric period onwards (Gillis 1999; Fang and McDonnell 2011: 52–60). Alloying copper with zinc instead of tin produces a yellow color similar to gold, notably in the Roman coin denomination of the sestertius (Fang and McDonnell 2011: 60). There is demonstrably no intention to deceive the user into thinking that the coin is gold, since the gold denomination, the aureus, has a much smaller diameter. Copper alloys also have other different qualities to precious metals, for instance, better durability, which will have been obvious to users. Instances where deception might have been practiced includes gilded objects, known from the third millennium BCE in the Middle East.[17] In some instances, particular alloy colors appear to have been chosen to enhance the authenticity/power of the object, for instance, Roman betrothal/marriage rings depicting clasped hands. A wide range of materials is used for Roman finger-rings, including precious and non-precious metals, and other materials such as ivory, glass, and jet. Yet finger-rings with the clasped hands motif are invariably made from either gold (the majority) or copper-alloy,[18] suggesting that the yellowish color was important. The copper-alloy examples imitate gold betrothal/marriage rings in which the gold probably had amuletic significance.

The other material that is commonly used in an imitative way is glass, which can be used successfully to achieve quite close imitations of precious materials. Glass as a material was also valued in its own right and, with care, we can

make some distinctions between different uses of glass: firstly, colored glass used as a precious material in itself; secondly, glass that has been colored (or decolorized) in order to practice deception through its close resemblance to precious/semi-precious stones; and thirdly, glass that is a cheaper imitation of precious materials, but in which imitation is a more complex phenomenon, discussed further below.

Early uses of colored glass, for instance, during the eighteenth and nineteenth dynasties in Egypt, occurred in a period in which knowledge of glass technology was not widespread, and so the production of glass could be carefully controlled by elite rulers (Duckworth 2012: 309). Descriptions of glass in contemporary texts characterize it as an artificial version of precious materials. Yet notwithstanding this, Duckworth suggests that as a result of its demanding technological requirements, glass enjoyed its own intrinsic value. She cites, for instance, the existence of glass vessels decorated with lighter colored trails that make no attempt to imitate the veining of precious stones (320). A similar phenomenon is the widespread existence of multicolored individual glass beads throughout antiquity, which do not mimic precious stones and must have been valued in their own right, perhaps more so in periods when glass technology was new.[19] The technological demands of manufacturing particular colors, such as opaque red, may have meant that these were especially valued. It has also been proposed that colorless glass, also technically difficult to produce, was of intrinsically high status in ancient civilizations such as the Assyrian, Babylonian, Persian, and classical Greek (Stern 1997: 193–6; Boardman 2001: 211).

Glass technology became much more widely available in subsequent periods, and certainly during the Roman and late antique periods colored glass was sometimes used deceptively in place of precious stones in jewelry. In these examples, the jewelry itself is made from gold, and the glass settings are sometimes only identified as such through modern scientific analysis.[20] Hellenistic, Roman, and later jewelry items also occur with a mixture of glass and precious stones (Swift 2003: 346–7).[21] Yet some Roman glass-bead necklaces and bracelets that superficially resemble precious stone jewelry had copper-alloy fittings that did not successfully mimic gold (Swift 2003).

Many instances in antiquity of the apparent imitation of precious materials in colored glass are ambiguous in nature. They are not sufficiently close to the original materials to deceive the viewer successfully. Similarities between "black" (very dark, black-appearing) glass objects and those in jet or obsidian suggest that "black" glass may have been used in some Roman provincial areas as a substitute (Cosyns 2015: 190–5), yet they fail to reproduce the exact qualities of the more valuable materials. The lack of crispness of the edges in molded imitations and the different overall texture and shine undercut the success of the copying and suggest that the motivation for the production of the objects is more complicated. Likewise, faience "imitations" of lapis lazuli and turquoise

in dynastic and later Egypt and Minoan Crete share hue and high shine with the precious stones, but are readily distinguished from them (Andrews 1990: 37; Dubin 2009: 43).[22]

The imitation of rock crystal through the use of decolorized glass is known in ancient Mesopotamia and was widespread later on, for instance, in the Roman period. It is attested specifically in textual sources, though scholars disagree about the derivation of Roman glass-cutting techniques from those of crystal cutting (Vickers 1996; Stern 1997).[23] Yet blown or molded glass forms would not have been sufficiently similar to the originals to deceive the user (Stern 1997: 203), and the increasing popularity of colorless glass vessels for tableware in the second to third centuries CE shows that such glass was regarded as desirable in its own right with an increasingly remote connection to the imitation of scarce luxury forms.[24] Colorless glass probably became widely popular, with a higher status than colored glass, because the technical demands of decolorization created a more expensive product (Stern 1997: 193). Use for tablewares and the corresponding absence of use for storage vessels such as bottles also indicates its comparatively higher value (Price and Cottam 1998: 16, 191–211). Such distinctions between table- and storage-wares would have been made only by those who could afford colorless glass. Commonly occurring second- and third-century CE colorless glass vessel forms expressed status through their own materials, not only because of their imitation of any imaginary elite prototype, but also because they created new associations and resonances through their daily contexts of use.

Occasionally, we can find an example of the way in which colors on artifacts became abstracted from the materials and qualities with which they were initially associated, for example, the colored intaglios depicting the emperor mentioned above.[25] Other examples include intaglio finger-rings with representations of chariot-racing, showing the four chariot teams popular in late antiquity, with the blue, green, red, and white factions in appropriately colored materials (documented by Savay-Guerrez and Sas 2002). In addition to these more abstract uses, color can also be used to link things together or to distinguish them from one another (Young 2006: 180).

COLOR CODING

How colors were used to codify objects (especially vessels) in antiquity, often for practical purposes, can be readily investigated through archaeological evidence. An early example is the deployment of different colors for inner and outer coffins in some periods of dynastic Egypt (Taylor 2001: 165). At Ur in ancient Mesopotamia in the mid-third millennium BCE, certain vessel forms occur in particular stone types (steatite and calcite) whose distinctive color ranges may thus have functioned as a form of color coding (Woolley 1934: 79;

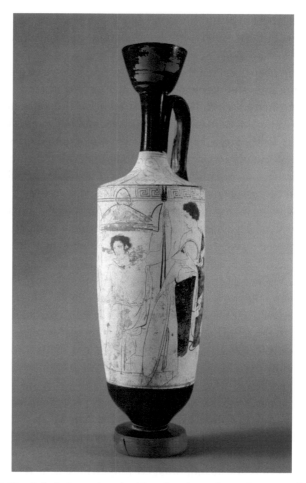

FIGURE 10.4 Greek *lethykos* colored white, showing a funeral scene. Ethnikó Arheologikó Moussío (National Archaeological Museum), Athens. Photograph by DeAgostini/Getty Images, via Getty Images.

Moorey 1991: 45–6). Evidence relating to vessels in ceramic and/or glass exists from both the Greek and Roman periods. In Archaic and early classical Greek pottery, a white ground was particularly associated with the *lekythos* vessel form used in funerary contexts (Figure 10.4), and coral-red with wine-carrying vessels (Cohen 2006: 49–50; Mertens 2006: 190).

Each, no doubt, had symbolic connotations (see above), yet in addition, the form and color of the vessel could be used to correctly identify its function. Pottery forms were also distinguished by color in subsequent periods. Symonds identifies the existence of color coding in ceramic tablewares in the northwestern Roman provinces from the end of the first CENtury CE, with food vessels in red,

drinking vessels in black, dark red, and dark green (all dark tones, see above), flagons and similar forms in white or buff, and cooking pots and storage vessels in gray (Symonds 1992: 11; Steures 2002). These examples show a different use of color to modern norms, which use color and pattern to create matching sets of tableware. The association of particular foods or vessel functions with particular colors, in addition to indicating the purposes of the vessels, probably also had ritual significance in provincial Roman dining practices.

Considering glass vessels, early Roman *pyxides* (first century CE) in molded translucent glass occur invariably in an emerald green color, despite the availability of a range of other colors (as seen in other molded forms). The color could have indicated particular contents (Grose 1991: 8). Collyrium (eye-lotion) stamps often occur in green stone, a color that may have indicated use for eye medicines in particular (Baker 2011: 173). Color coding is also used in jewelry, particularly to create matching sets of objects (*parures*), evident from surviving Roman hoards with a themed color across different pieces of jewelry (Swift 2003: 336). The possession of a set of jewelry of this kind may have connoted sophisticated aesthetic choices as well as the ability to purchase expensive gemstones.

AESTHETICS

As described above, color choice in antiquity was heavily dependent on factors such as materials and associations. Accordingly, the aesthetics of particular color and material choices in antiquity relate in some degree to their qualities of resemblance or association (Young 2006: 174). It is difficult to distinguish aesthetic choices from the limitations created by technological challenges in particular periods.[26] Yet the way colors were used on artifacts provides some insight into aesthetic values and preferences. An early Bronze Age necklace from Britain (Woodward and Hunter 2015: 319–24, ID273), for instance, combines jet and bone, using the darker material for the beads and the lighter one for the spacer plates between them in a deliberate juxtaposition of different color tones and shapes. Monochrome necklaces made from one material (see Figure 10.5), and those in two, three, or four differently colored materials also exist (catalogued in Woodward and Hunter 2015: 261–454), recognizably different in their aesthetic effects, which may have been a component in their wider symbolic or ritual purpose.

Color and shape were often used together as distinguishing features in antiquity, for instance in gaming pieces from the tomb of Tutankhamun in Egypt or in provincial Roman glass beads (Tait 1982: 29–30; Swift 2003: 336–41). If we consider color combinations on artifacts across a wide geographical and chronological span, strongly contrasting color is favored, particularly blue and red used together.[27] Examples include Iron Age and provincial Roman

FIGURE 10.5 Fragment of an early Bronze Age monochrome necklace in jet. The British Museum, accession number 1870,1126.1. © The Trustees of The British Museum.

enamelwork and Mesopotamian and Egyptian jewelry (see Figure 10.6).[28] These strongly contrasting hues enhance the color differences (Osborne 2004: 20, 58) and thus the perception of vivid color on the object, even to the extent of dazzling the viewer in a powerful display of agency (Jones and MacGregor 2002: 15). Conversely, classical Greek and Hellenistic jewelry shows a strong preference for combinations of blue with green, a subtler combination of colors which has quite a different visual effect.[29] Different color choices in gemstones for intaglios, favoring pale colors, are also seen in the classical Greek period compared to later periods. These brief examples illustrate the aesthetic component in color choices, and the color aesthetics that could be utilized to activate the powerful qualities of colored objects that existed by virtue of their materials and associations.

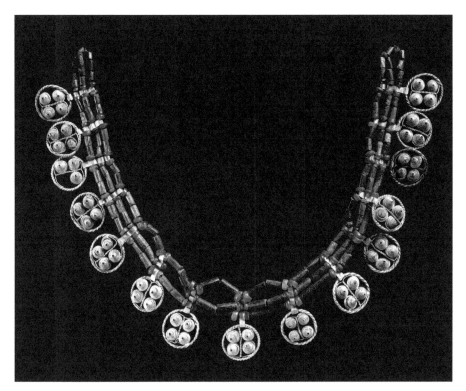

FIGURE 10.6 Mesopotamian jewelry set with carnelian and lapis lazuli from Ur.
Photograph by DEA / A. DE GREGORIO/De Agostini, via Getty Images.

DISCUSSION

It is evident that an investigation of colored artifacts can bring much to our
understanding of the wider subject of color in antiquity. Extant colored artifacts
constitute an independent set of evidence, up to now very neglected, which can
be used to offer significant, new perspectives.

How does artifact evidence contribute to existing debates about the nature
and meaning of color? Using the evidence of texts from the Roman period,
Bradley illuminates different modes of thinking about color, which are evident
in a range of philosophical and literary texts, and studies how color categories
were used in their writings. Concepts of color included, firstly, uses of pigments
to make figural representations (for instance brown used to represent things
like tree branches or animal fur), and secondly, object-centered ideas, in which
a color evokes a particular substance and its associated qualities (this can also
apply to pigments that were defined as materials, for instance, lapis lazuli).

Thirdly, more abstract uses occur, in which color terms are used descriptively in their own right—that is, detached from any "natural" associations (Bradley 2009a). One of the significant contributions of artifact evidence is that it allows us to explore the way in which these theoretical concepts of color map onto actual practice, and their presence or absence in wider society beyond the educated elite. The previously documented range of uses of color in artifacts, which include abstract uses in very ordinary items such as glass beads, show much divergence from the focus on figural representation using pigments and material authenticity (object-centered color associations) that are evident in written elite texts that discuss color, for instance, those of the Roman period analyzed by Bradley (2009a: 87–110), suggest that in wider, nonelite society other concepts of color existed.[30]

Additionally, what can artifact evidence offer for our understanding of the social functions of color? Color is used on ancient artifacts to create associations of diverse kinds (for instance, in relation to time, space, and value) and so to actively contribute to social interactions (Jones and MacGregor 2002: 9–12). Color is essential in the creation of status and value as expressed in the relationship between colors and valuable materials. It thus ensures special treatment for certain objects. Through its associations, color becomes important not only in the communication of status but in wider social functions such as commemoration (heirloom artifacts that represent times past) or cultural affiliation.

Color also has important functions in ordering and classifying the material world so that it can be successfully navigated by social actors of requisite cultural knowledge. Color coding is a deeply cultural activity, which, like other material culture practice, helps to constitute people as participants within a particular culture or, conversely, to exclude outsiders. It has been newly established from the archaeological artifacts considered here that lightness was an important factor in color categorization in antiquity. It may in some instances have been more important than hue in color coding, possibly because lightness differences rather than hue differences are more visible in poorly lit conditions.[31] Color coding by lightness may also relate to practical uses of color properties in particular social contexts, for instance by lamplight. Color coding based on hue, by contrast, shows a daytime ordering of the world.

Finally, it can be suggested that color transforms and empowers objects for their users in antiquity, particularly through color imitation. Previous discussions, based on textual evidence, show how color imitation was admired culturally, for instance, in first-century Rome (Bradley 2009a: 110; Lao 2011: 51). Yet, as documented above, color imitation in artifacts was extremely widespread in antiquity, occurring in diverse cultures and periods, and in artifacts of widely varying social value. The significance of color imitation in the ancient world, therefore, extends well beyond educated discourse on

authenticity in one particular cultural setting. Emulation for prestige purposes is undoubtedly a factor (Swift 2003). Many precious materials in antiquity, however, were also felt to possess protective qualities.[32] If we take into account theories of the relationship between image and prototype in antiquity (Freedberg 1989: 292–3), of sympathetic magic,[33] and the existence in antiquity of "object-centered" experiences of color, a strong motivation for imitation would have been the ability of those imitations to acquire the beneficial properties of the original precious materials. Such an interpretation is further supported by the way in which imitative properties extend beyond hue to other qualities such as surface reflectivity, hardness, and the way that color permeates a material. Color imitation in antiquity is not merely representational, therefore, but also transformational. This further helps to explain how colored amulets made from more ordinary materials, including human-manufactured substances such as copper alloy and glass (see particular examples discussed above), could have been perceived to be actively protective by ancient users, despite their prosaic origins. The color properties and other qualities that they shared with precious materials transformed them into versions of precious substances with active power.

CONCLUSION

In this chapter, I have offered a synthesis drawing on the evidence base that is available for colored artifacts across a wide chronological range, and suggested that approaches to interpretation need to be broadened so that they extend beyond equating artifact colors with general symbolic values. I have illustrated, through brief case studies, how and why colors were used on artifacts, how we can combine available sources of evidence to achieve a better understanding of both theoretical concepts of color, and what was achieved through the deployment of color, particularly its function in the social context. There is a diversity of possible interpretations to which we need to be sensitive, for instance, multiple symbolic and associative relationships. Clearly there is scope for much further work, which if the approaches outlined above are taken forward, has the potential to transform our understanding of the roles of color in ancient societies.

NOTES

Introduction

1. I use scare quotes around the word *purple* because that word in English does not accurately convey the broad hue range and visual properties of products made with these dyes; see Bradley 2009a: 189–97; Bassi and Wharton, and Olson and Wharton in this volume, with associated references.

2. Reported on the BBC documentary *Horizon* (2011); on National Public Radio's Radiolab (2012); and by Kevin Loria (2015) in *Business Insider*.

3. I do not think it is clear whether Gladstone thought the ancient Greeks could not "see" colors for which they did not have names. Carole Biggam (2012: 12) thinks he means the Greeks could not see them; I am inclined to think Gladstone merely thought they were not good at *distinguishing* hues. To use a modern analogy: if a person does not know the color categories beige or taupe, does it mean she cannot see those colors? In one sense of "see" she certainly can: there is no doubt that she has a subjective visual impression of them. In another, she cannot, since she cannot identify them as distinct color categories, and both would probably appear to her just as different variations of the same color.

4. We should note that Gladstone worked primarily on Homeric color language, which for many reasons is not typical of ancient Greek as it developed over the next centuries. Although Greek poetry continued to exploit the semantically vague and inclusive nature of the Greek color lexicon—a topic fully explored in every chapter of Irwin (1974)—the discussions of color by the Greek philosophers show that the ancient Greeks were perfectly capable of thinking and speaking abstractly about color as Katerina Ierodiakonou demonstrates in her chapter, in this volume. My examination of the color language that Julius Pollux uses in his discussion of the colors used on dramatic masks, which employs over twenty different color terms (Pollux 1900–1937: 4.99–154), shows that when necessary, the Greek color lexicon could be very precise and nuanced (see Bassi and Wharton, in this volume). For a fuller discussion of the development of ancient Greek color language, see Katherine McDonald's chapter, in this volume. The situation for Latin is similar, and Bradley (2009a) explores the materially focused color meanings of Latin color

terms throughout his book. However, evidence from Pliny the Elder and other technical and medical authors shows that the Romans, too, were quite capable of forming precise and abstract color conceptions and categories (Fruyt 2006: 13–47; Wharton 2016).

Chapter 1

1. Scientific inquiry in the modern understanding, which entails systematic experimentation, measurement, and the formulation and testing of hypotheses, did not exist in antiquity, although many ancient philosophers wrote extensively about the natural world. The word *science* in the chapter heading, therefore, refers somewhat loosely to what was called "natural philosophy" up to the time of Isaac Newton.
2. The numbers and letters appearing in some references are the standard form of reference to texts as used by classicists. The reader will be able to find the required text in the reference provided in the bibliography.

Chapter 2

1. For the dyed garment, see Giessen, Universitätsbibliothek, Papyrussammlung, inv. 41, (*P. Giss.* 20); Bagnall and Cribiore 2006: 152–3; Martelli 2014: 119. For the panel, see Walker and Bierbrier 1997: 122–3, no. 118; Fournet 2004; Salvant et al. 2018: 816; Phoebe A. Hearst Museum of Anthropology, no. 6-21378a verso. The portrait is likely Antonine in date (140–160 CE) and was excavated at Tebtunis, Egypt in 1899/1900. I thank Caroline Cheung for introducing me to this potrait.
2. Indeed, when the merchant advised Augustus to hold the garment up higher and look up at it, Augustus quipped that he would need to walk around in a sunny place (*solarium*) in order for the Roman people to consider him well dressed.
3. These texts have been called "practical recipe books intended for metal workers, jewelers, dyers, and artisans" (Jensen 2008: 5).
4. For a concise summary of what a purple dye shop might need, see Wilson 2004: 160.
5. This color in Greek is denoted by the adjective *kokkinos*, which is most likely kermes.
6. For a further examination of the grading of quality for dyes and especially pigments, see Becker forthcoming-b.
7. Sinopis red ochre could be found in Pontus, Egypt, the Balearic Islands, Africa, Lemnos, and Cappodocia (Pliny the Elder 1952: 35.13).
8. See Kreuzner (2013) for experimental archaeology using these recipes to make dyes.

Chapter 3

1. On color in ancient Greece, see Gladstone 1858: 433; 1877; Platnauer 1921; Maxwell-Stuart 1981; Rutherford-Dyer 1983; Stulz 1990; Blum 1998; Clarke 2004; Ferrence and Bendersky 2004; Cleland 2005; Ierodiakonou 2005a; Grand-Clément 2011, 2016; Bradley 2013; Koutsakou 2013; Benda-Weber 2014; and Brøns 2017 and forthcoming.
2. On which, see Gladstone 1858: 488; 1877; Platnauer 1921; Irwin 1974: 6–7; Bradley 2009a: 14–15; and Grand-Clément 2011: 11–15.
3. Clarke (2004: 132) calls this "a Kodachrome world."
4. See also Cleland 2004a: vii; and Grand-Clément 2016: 122–3. As a common phenomenon in many languages, see Biggam 2012: 5–6.
5. For its history, see Rutherford-Dyer 1983.

6. White: Homer (1999: 3.141); saffron: Homer (1999: 19.1); purple: Homer (1999: 24.796); black: Homer (2003: 2.182–3); decorated: Homer (1995: 18.293; 1999: 3.125–8, 6.289, 6.294); multicolored: Homer (1999: 5.735). There is some scholarly debate as to whether such color and pattern was embroidered or woven in: see Abrahams 1908: 38, 89, 100, 102–3; Wace 1948; Barber 1991: 372–83; and Droß-Krüpe and Paetz gen. Schieck 2014.

7. See also Wees 2005; Olson 2017: 105–7, with references.

8. "IG" stands for *Inscriptiones Graecae*, a project of the Berlin-Brandenburgische Akademie der Wissenschaften, which aims to record and publish all known inscriptions of Ancient Greece. The title of the IG volume cited in this chapter is: IG II2: *Inscriptiones Graecae II and III: Inscriptiones Atticae Euclidis anno anteriores*.

9. It is unclear whether these were made specifically for the grave or not (Lee 2015: 273n.47).

10. On Greek male clothing, see Cohen 2001.

11. On purple in antiquity, see Reinhold 1970; Bradley 2009a: 189–211; Grand-Clément 2011: 164–8, 328–39; and 2016.

12. For purple in Magna Graecia (Greek settlements in southern Italy), see Athenaeus 1951: 12.518e, 521b and d.

13. Gage (1993: 26) states purple has "important meanings" in antiquity because it was classed with red, "representative of fire and light."

14. See Aristotle 1970: 547a.4–13; and Vitruvius 1998: 7.13. There is a solid bibliography on purple dye in antiquity: Longo 1998b; Bradley 2009a: 189 with references; Cardon et al. 2011; Constantinidis and Karali 2011; and Alfaro Giner and Martínez 2013. On variability of the color, see Giacometti 1998. On modern experimentation with ancient techniques of shellfish dyeing, see Kanold and Haubrich 2008, with references.

15. Alexander reportedly brought back shimmering Greek purple cloth two centuries old from Persia (Plutarch 1919: *Alexander*, 36; Diodorus Siculus 1963: 17.70).

16. For further references, see Stulz 1990: 121–53.

17. In one work, Plato (2013: 4.421c–d) states that purple was the most beautiful color, but elsewhere he condemns purple as being an unnecessary foreign luxury and an effeminate practice (Diogenes Laertius 1925: 2.8.78; Plato 1926: 847c).

18. On gold in Greek antiquity, see Williams and Ogden 1994: 10–26; and Grand-Clément 2011: 317–28.

19. Lucretius (1992: 2.830) calls *poenicus* the "brightest colour of all" (*color clarissimus multo*, 6.830). Pliny the Elder (1983: 9.130) states that "concharum ad purpuras et conchylia—eadem enim est materia, sed distat temperamento—duo sunt genera" (the shellfish supplying the purple dyes and scarlets—the material of these is the same but it is differently blended—are of two kinds).

20. This garment is sometimes described as a cloak, but surely it is a tunic that is meant, as cloaks are impractical in battle (Wees 2017: 218). The tunics were known as *phoinikides*: Xenophon 1925: *Constitution*, 11.3; see also Aristophanes 1998a: *Acharnians*, 320; 2000: *Lysistrata*, 1140.

21. See Euripides 2005: *Hecuba*, 468; Homer 1999: 8.1, 19.1, 23.227; Aristophanes 2002: *Assemblywomen*, 329, 331–2; Hesiod 2018: 273, 358; and Aristophanes 2000: *Lysistrata*, 44, 47, 51, 219–20.

22. See also Gellius 1927: 2.26.5–6. Llewellyn-Jones (2003: 226–7) also points out that women in many cultures wear red bridal veils, symbolic of eroticism, ripeness, and fertility.

23. Ferrence and Bendersky (2004: 206–13) note that saffron was used in folk medicine as an aphrodisiac, an abortifacient, a contraceptive, and to induce labor, promote lactation, enhance fertility, and to treat chronic uterine hemorrhage.

24. The *toga virilis* was assumed at the family's discretion when a young man was considered by his family to be mature enough, usually age fifteen or sixteen. See Olson 2017: 48–9; and Rothe 2020: 64.

25. On the *toga candida,* see Rothe 2020: 102–3; on the *toga pulla,* see Heskell 1994: 141; Stone 1994: 15; Rothe 2020: 103–4; and Llewellyn-Jones, this volume.

26. See also Livy 1919: 1.8; 1949: 30.15.11; 2017: 31.11.11; Diodorus Siculus 1939: 5.40; and Florus 1984: 1.1.5.

27. Dionysius uses the Greek term *halourgēs* (sea purple), referring to the same kind of dye. See also Reinhold 1970: 39.

28. Roman boys and girls could also wear the *toga praetexta* before reaching adulthood. See Sebesta 2005; and Olson 2017: 47.

29. These conventions seem to have been adhered to rather loosely, however. See Olson 2017: 18–20.

30. For a description of the *toga picta,* see Olson 2017: 49–50.

31. On *minium*'s price, see Becker, this volume.

32. For general treatments of the evolution of the triumph, see Bonfante Warren 1970; Versnel 1970; and Goldbeck and Wienand 2017.

33. On this dye, see Cardon 2007: 609–19; and Becker, this volume.

34. On Pliny's role in training consumer tastes, see Lao 2011; and Wharton forthcoming.

35. For information about Roman dining culture in general, see Ellis 1997; Gold and Donahue 2005; Hudson 2010; and Stephenson 2016. For information about colored interior decorations and marbles, see Bradley 2006; and Zink, this volume.

36. See, however, André 1949: 83–4, 181–2, 192.

Chapter 4

1. For notable exceptions, see most recently Deacy and Villing 2004; Carastro 2009; Grand-Clément 2010, 2011: 396–417; 2016, 2017; Stager 2016.

2. Translation adapted from Theodorakopoulos 2007: 323.

3. *Homeric Hymn to Demeter*, lines 275–9; *Homeric Hymn to Aphrodite*, lines 171–5: see Platt 2011: 64–7. On the anonymity of Catullus' lover here, see Feeney 1992.

4. See Bradley 2011: 6, 40 (with further bibliography). Pliny the Elder claims that the quintessential "wedding color" in Rome is *luteum* (which refers to hues in the yellow-red range), implying that it is specifically used for the *flammeum* (Pliny the Elder 1969: 21.46).

5. On the *Hymn to Demeter*, see especially Richardson 1974; Foley 1994; Suter 2002; Clay 2006: 202–66. On epiphany in the hymn, see Platt 2011: 60–72. All translations of the *Homeric Hymns* are from West 2003.

6. For Democritus (Diels and Kranz 1951: Democritus A135), the basic colors comprise black, white, red (*erythros*), and *chlōros* "greenish-yellow"; and for Plato (2000: 67c4–68d7), black, white, and red are accompanied by *to lampron* "the bright." See Ierodiakonou 2005a, b, and 2009; and Sassi 2009: 280–5.

7. The *Hymn to Demeter*'s relationship to specific Greek sites and rituals is notoriously problematic: see Clinton (1992) and Suter (2002), who both emphasize its allusions to the "agrarian" Thesmophoria (a religious festival held in honor of Demeter and Persephone) as well as the Underworld aspect of the Eleusinian Mysteries.

8. See Bradley (2011: 1–6), who points out that, in Greek, *xanthos* is also applied to sand, honey, and wax. On its application to the hair of goddesses and heroes, see Grand-Clément 2011: 307–8.

9. In the Homeric epics, the epithet *kuanochaitēs* is more commonly applied to Poseidon: see Irwin (1974: 89–91), on the problematic translation of *kyaneos* as "blue-black" when applied to hair. On the rich associations of *kyaneos* and its relationship to the use of lapis lazuli in images of male gods such as Zeus and Hades, see Stager 2016.

10. On the association of *kyaneos* with the hair of mature masculine bodies, see Irwin 1974: 89–92; and Stager 2016.

11. Pausanias 1965–9: 8.5.8; see Irwin 1974: 184 (who also mentions the cult of Aphrodite *Melainis*, see Pausanias 1965–9: 8.6.5); Platt 2011: 270–5.

12. Note that in later versions of the myth, the fatal flower is a violet or lily (Ovid 1977–84: 5, lines 390–2; Pausanias 1965–9: 9.31.9; see Suter 2002: 55–6).

13. On the production and consumption of *kykeon* (which had religious, medicinal, and possibly psychotropic associations), see Richardson 1974: 344–8.

14. See Abbe, this volume. On the significance of color for images of the gods in particular, see Brinkmann and Wünsche 2007; Ridgway 1999: 103–42; Stager 2016 and forthcoming.

15. On *ganōsis*, see, for example, Manzelli 1994: 101–15; Palagia 2006: 260–1; Bradley 2009b: 13–14.

16. On rituals of washing and dressing sacred images, see, for example, Barber 1992 (on the Athena Polias).

17. Euripides 2005: *Hecuba*, lines 468–72; see Barber (1992) and Grand-Clément (2016), who argues that *anthos* suggests the best quality dye, which she identifies as purple murex. On the Athena Polias more generally, see Mansfield 1985 (who argues that the statue's *peplos* was saffron-dyed and embroidered with purple patterns and figures); Platt 2011: 91–8.

18. Metropolitan Museum, New York, inv. 50.11.4, attributed to the Group of Boston, dated 360–50 BCE. The krater has come to play a paradigmatic role in scholarship on the sacred image, especially in discussions of *ganōsis*: see Manzelli 1994; Bradley 2009b: 445; Marconi 2011 (with further bibliography); Platt 2014: 204–7; and Stager 2016: 98–9.

19. On the desirable properties of marble and its relationship to the term *marmairō*, "to glitter or shine," see Neer 2010: 76–7.

20. The so-called "Peplos Kore" (Athens, Acropolis Museum 679, dated *c.* 530 BCE) has now been revealed as a statue of Artemis, thanks to the painted iconography of animals that pigment analysis revealed on her garment, see Brinkmann 2007.

21. On the Aphrodite of Knidos, see (from a vast bibliography) Havelock 1995; Ridgway 2004: 712–25; Corso 2007: 9–186; Platt 2011: 183–211; and Haynes 2013.

Chapter 5

1. For Tyrian purple, see also the poet Martial 1993: 8.10.1.

Chapter 6

1. This chapter uses the terminology as presented by Biggam, although readers should be aware that other scholars use these (and other terms) differently.

2. The emergence hypothesis (EH) states that (a) it is possible for languages not to have early BCCs including all possible hues (as in Berlin and Kay's model), so that, for example, the category of DARK may not include the concept of BLUE, for which there might simply be no word; and that (b) these concepts may emerge as BCCs at a later stage rather than being present within basic macro-categories (extensive categories) from the beginning. This scenario has been suggested as an alternative to the UE model, but the slight evidence for EH may also be interpreted as compatible with the UE model (Kay 1999).

3. In New Testament Greek, the semantic field of *chlōros* is still fairly wide. For example, "and all the *chlōros* grass was burnt up" (Rev. 8:7) translated in the Vulgate as *viridis* and in English usually as *green*, compared to "and I looked, and behold a *chlōros* horse: and his name that sat on him was Death" (Rev. 6:8), translated in the Vulgate as *pallidus* and in English usually as *pale*. Many thanks to Matthew Scarborough for this example. Translations from the King James Version of the Bible.

4. The main body of this chapter has not dealt with Mycenaean Greek, the earliest attested form of the language. Because of the nature of the Linear B sources, which mainly record commercial transactions and palace records, we do not have access to the full range of color terms in Mycenaean Greek. (Linear B is an early form of Mycenaean syllabic script that predates the Greek alphabet.) Many of the attested color terms are likely to refer to particular dyestuffs or objects, and therefore would not necessarily meet the criteria for BCTs. For example, there are a few different attested terms with meanings close to "red," "red-brown," or "red-purple": *po-pu-re-ja*, *e-ru-ta-ra*, *pu-ru-wa*, and *po-ni-ki-jo*. The term *po-pu-re-ja* refers to murex dye and the red-purple color it produces, while *e-ru-ta-ra* could be madder or safflower, and *po-ni-ki-jo* could also be madder or another dye plant (Nosch 2004: 33–6). The color *pu-ru-wa* may refer to the color of naturally red hair or wool, as *pyrros* does in classical Greek.

5. This close link between adjectives and material referents might also be found in other kinds of Latin adjectives, beyond color terms. For example, *glaber* (smoothness) is used of objects such as eggs and bald heads, whereas *teres* (rounded, smooth) is more commonly applied to plants. Many thanks to William Short for this comparandum.

6. Note that Lyons (1999: 66) gets the etymology of these terms the wrong way round. The Sabellic languages were Osco-Umbrian languages of central and southern Italy, later replaced by Latin.

7. See Gellius: "And Virgil could have said, when he wanted to indicate the green color of a horse, *caerulus* rather than *glaucus*, but he preferred to use a more familiar Greek word rather than a rare Latin one" (Gellius 1927: 2.26.18; author's translation).

Chapter 7

1. Other studies include Kober 1932; Osborne 1968; Rowe 1977; and C. James 1996: ch. 3. André (1949: 260–3, 345–51) provides a detailed overview of the semantics of Latin color terms along with an exploration of common color associations and themes, while Baran (1983) traces the diachronic development of Latin color expressions. More focused studies of color in Latin literature include Edgeworth's (1992) examination of the *Aeneid* and Clarke's (2001, 2003) inquiries into lyric and elegiac poetry. Bradley's (2009a) introduction provides an overview of the bibliography of research on color in antiquity.

2. This is a common phenomenon in the world's languages, see Biggam 2012: 1–8; and Kay et al. 2009.

3. The ancients were not "color blind" as is sometimes asserted, a view that is often attributed to William Gladstone (1858), although he himself explicitly denied that characterization (Gladstone 1877). See the Introduction and McDonald, this volume.

4. For the Romans' passion for colored marbles, see Zink, this volume; and Bradley 2006.

5. For further discussion of colored textiles used in Aeschylus' *Agamemnon*, see Llewellyn-Jones, this volume.

6. See also Gladstone 1858: 488–90; Platnauer 1921: 155; Gernet 1957; C. James 1996: ch. 3; Gage 1999: 12–13; and Christol 2002: 29–30. In her survey of Greek color terms, James concludes that "Black and white are defined as the fundamental primary colours, and tend to be seen as aspects of light and dark" (C. James 1996: 61).

7. See Wallace 1927: 29; Irwin 1974: chs. 4 and 5; Rowe 1977: 23–33. See also Lloyd (1966: 16, 42–7, and especially 376–7) on light and dark as opposites in Greek philosophy. It is noteworthy that Irwin devotes two chapters of her book *Color Terms in Greek Poetry* to the contrast between dark and light.

8. The examples in Homer are *Iliad* (Homer 1999: 2.834, 11.332, and 16.687); *Odyssey* (Homer 1995: 12.92 and 17.326). Compare Hesiod, *Works and Days* (Hesiod 2018: 153–5). Irwin lists a number of attributions of "black" (*melas*) in Greek literature: black emotions (1974: 135–9 and 144–55); black night (158–73), and black death (173–82). Wallace (1927: 62) provides a complete list.

9. *Thanatos* (death) and *kēr* (black) are equated in Homer (1995: 2.283, 3.242, 15.275, 22.14, 24.127).

10. These examples also suggest a correlation between luminosity and liquids. As noted above, in addition to its unique attribution to blood by Homer (1999: 17.361), *porphyreos* "dark" or "red" is also used of waves (*kyma*) and the sea (*hals*).

11. On this topic, see Scullion 1994: 89–128; and Sophocles 2011: lines 815–65.

12. Light is associated with life elsewhere in Latin literature; for example, Terence 2001: *Hecyra* [*The Mother-in-Law*] 852; Lucretius 1992: 3.849, 1033; Cicero 1989: 3.1.2.

13. *Purpureus'* range of hue reference includes much of what we would call "red" as well as much of our purple, violet, and even brown, as well as bright (André 1949: 94–102; Bradley 2009a: 48–50, 190).

14. Bradley (2009a) argues that this shows that the Romans had few abstract color concepts. I think that this is unlikely (see Wharton 2016); instead, I think that Roman writers preferred "material" color terms because of their semantic richness, not because of undeveloped abstract color cognition.

15. Some of these qualities are also suggested by *purpureus*, insofar as readers connected the adjective with the expensive shellfish dye made from the *purpura* mollusk and the luxury products made from it that the Romans prized.

16. For many examples in Latin poetry, see André 1949: 346–7.

17. For a reuse of the stained-ivory and the lilies-among-roses similes, see Ovid's *Amores* (1977: 2.5.34–42), where Ovid alludes to this passage in the *Aeneid* to highlight (by contrast) his own lover's salaciousness.

18. Based on a word count performed by Wharton on all extant tragedies attributed to Seneca, excluding the *Octavia*, which scholars agree was not written by him.

19. On this eclipse, see Shelton 1975; and Volk 2006.

20. See *De Tranquillitate Animi* 1.8, where Seneca criticizes the luxury of houses where "the very roofs glitter [*fulgent*]" (Seneca the Younger 1932).
21. For the connections in Seneca's tragedies to Stoic cosmology, see Lapidge 1989: 1383–4; Rosenmeyer 1989: 148–59; Schmitz 1993; and Volk 2006.

Chapter 8

1. For recent research on painting, see Rouveret et al. 2006; Descamps-Lequime 2007; Pollitt 2014; Jockey 2018; and Plantzos 2018. For recent reseach on sculpture, see Brinkmann et al. 2010; Formigli 2013; Bourgeois 2014; Liverani and Santamaria 2014; Østergaard and Nielsen 2014; Brinkmann et al. 2017a; and Bracci et al. 2018.
2. Publications on these remarkable discoveries are forthcoming by Eleni Aggelakopoulou and Giovanni Verri.
3. Plantzos (2018) presents a lavishly illustrated critical introduction to this material.
4. For preliminary findings, see Liverani 2003, 2004; Caneva 2010: 131–40; and Rosini 2010.
5. A contextualized example of the highly flexible variagation (*varietas*) use of color and materiality in both painting and sculpture in this period is the *Aula del Colosseo* in the Forum of Augustus, see Ungaro 2004. For archaistic terra-cotta, see Hallett 2018. Greek originals: Temple of Apollo Sosianus; replicas: Erechtheion caryatids in the Forum of Augustus. On "white" sculpture in the Augustan age, see Mandel 2010.
6. Note also a remarkable group of third-century CE wooden painted shields from Dura Europos, one depicting an *Amazonomachy* (Amazon battle) (Passeri et al. 2017).

Chapter 9

1. "IG" stands for *Inscriptiones Graecae*, a project of the Berlin-Brandenburgische Akademie der Wissenschaften, which aims to record and publish all known inscriptions of Ancient Greece. The titles of the IG volumes cited in this chapter are as follows: IG I³: *Inscriptiones Graecae I: Inscriptiones Atticae Euclidis anno anteriores*; IG IV²: *Inscriptiones Graecae, IV: Inscriptiones Argolidis.* "ID" refers to the inscription number in Dürrbach et al. (1926–72).
2. For the IG numbers, see note 1 above.
3. A *cauliculus* (plural: *cauliculi*) refers to one of the stems which both emerge from and terminate in leaves on Corinthian capitals. A *helix* (plural: *helikes*) refers to any spiral form, such as volutes, occurring on Corinthian or Ionic capitals.

Chapter 10

1. See also Warburton (2008) and Schenkel (2007, 2019) for more recent linguistic studies of Ancient Egyptian's color terms for green and various shades of blue.
2. Amethyst (three examples), sapphire (four), and nicolo (three) are the principal gemstones used for Constantinian imperial portraits (Spier 2007: 20–2). There are also third-century CE examples in amethyst, for example, of Caracalla (Spier 2007: 17) and Gallienus, British Museum, acc. no. 1925,0715.3. See Gage (1993: 25) on ancient definitions of purple.

3. See Bradley (2009a: 6–7; 2013) on the Roman imperial period; L. James (1996: 124–7) on Byzantium; Gage (1993: 25) on purple valued for its luster; and Chapman (2002: 48), Clarke (2004), and Warburton (2004) on color terms.

4. I have collated burial data for the Roman northwestern provinces, for example: Lankhills (Hampshire), fifteen black counters and about ten white; Krefeld-Gellep (Germany), ten black and about sixteen white; Lullingstone (Kent), fifteen each of brown and white (Clarke 1979: 252–4); an Iron Age burial at Stanway (Essex), thirteen each of white and blue; a Roman burial at Neudorf-Bornstein (Germany), twenty-four black and eighteen white (Schädler 2007: 365); additionally, a hoard at Corbridge (Northumberland) contained twenty-three black and thirty-one white (Allason-Jones and Bishop 1988: 43).

5. Examples include: a Roman burial at Bonn with dark-toned counters in deep blue (nine), black (three), and purple (three), and lighter-toned counters in millefiori glass (twelve) and a Samian base (one); a Roman burial at Winchester (Hampshire) with dark-toned counters in black (four) and blue (two), and light-toned counters in white (twelve) (Clarke 1979: 253–4).

6. For example, Bar-Yosef Mayer and Porat (2008) correlate the appearance of green beads with the birth of plant cultivation.

7. On "appropriateness" in Roman artifacts, see Swift 2009. Bradley (2009a: 202–5) discusses the Roman imperial connotations of porphyry.

8. On image and prototype in the ancient world, see Freedberg 1989: 292–3.

9. For glass examples, see Bianchi 2002: 285. For jet examples, see Henkel 1913: cat. nos. 1653, 1661 and 1665. See also Eckardt (2014: 86–8) for amuletic depictions of Africans.

10. I have collated data from Whitehouse 2003: 13–43. Of fifteen examples with lion imagery, ten are in yellow-brown glass (cat. nos. 885–93 and 897), four are yellow-green (cat. nos. 894–6 and 898), and one is blue (cat. no. 899). This compares to about 25 percent of pendants and discs in the catalog overall in yellow-brown glass, and about 50 percent in green-blue shades. The pendants and discs date from between the fourth and seventh centuries CE. See also Arveiller-Dulong and Nenna (2011): nineteen glass lion pendants of which twelve are yellow-brown and two are yellow-green (cat. nos. 54–83).

11. For example, reddish-purple used for wine, flames, and blood, and white for the hair of the elderly, on classical Greek vases (Wehgartner 2002: 89) or colors used in early Roman figural enamelled glass vessels (Rütti 1991).

12. Gumlia-Mair (1995) discusses the development of patinated metals. See also Jacobson and Weitzman (1992) on Roman colored bronzes.

13. Ferrand et al. (2014) describe the process and give examples. See also MacGregor 1985: 67, 70. For further examples of green-stained dice, see Fitzwilliam Museum accession no. 103.146; Museum of London accession no. 1349; and Tongeren Museum (Belgium) accession no. 318.

14. For further information about patinated artifacts as an index of age and status, see McCracken (1990: 32–7).

15. Ferrand et al. (2014: 1038) cite an example from Pompeii.

16. Roman furniture was prized for its heirloom value. See Mastrorosa 2015: 102–3; and Lazzaretti 2014: 100–1.

17. Oddy (1993: 171–81) provides a survey and developmental history.

18. Data given in Swift (2017: appendix 6). Of twenty-five examples, only one in iron would originally have been silvery in color (representing 4 percent of the data

sample). This can be compared to the overall materials profile for 1,140 finger-rings, which show much higher proportions (21 percent) of silvery-toned metals (silver or iron). See also Vikan (1990: 146) on late antique marriage rings occurring disproportionately in gold.

19. See, for example, Arveiller-Dulong and Nenna (2011) for examples of multicolored beads from diverse cultures (dynastic Egyptian, Punic, Hellenistic, and Roman).

20. For instance, an analysis of the seventh-century CE Mytilene Hoard (Katsaros and Ganetsos 2012).

21. For instance, in the Thetford late Roman hoard (Johns and Potter 1983: cat. nos. 29 and 31). Arveillier-Dulong and Nenna catalog a Hellenistic example (2011: cat. no. 375).

22. See also Polinger Foster (2008) on Minoan faience and Moorey (1991: 171–86) on ancient Mesopotamian faience.

23. On Mesopotamian imitations, see Moorey 1991: 201. The use of colored glass to imitate agate is clearly related (Lapatin 2015a: fig. 23). See also glass paste imitations of sardonyx used for Roman cameos, for example, British Museum accession nos. 1923, 0401.976–97.

24. See Price and Cottam (1998: 15–16) on Romano-British glass, reflecting wider Roman imperial trends; and Fremersdorf and Fremersdorf (1984) on colorless glass produced at Cologne. See also Vickers (1996) on the topmost elite who may have owned semi-precious stone vessels.

25. As suggested by Bradley (2009a: 197–205) using textual evidence.

26. Red was not commonly used for glass throughout antiquity, because it was comparatively difficult to produce. See, for instance, Moorey 1991: 212–14.

27. Complementary colors are produced in the eye as an after-image following observation of a particular hue. See Osborne 2004: 13–27. They are thus cross-cultural phenomena.

28. See Bateson (1981: 7–18, 68) for enamel, and Andrews (1990: 101–98) for Egyptian jewelry colors. Woolley (1934: plates 131–6) shows examples of jewelry from the royal cemetery at Ur.

29. Ogden and Williams (1994: 46). See, for example, cat. nos. 18, 22, 76, 81, 87, 88, 103, 120, and 165.

30. See also Wharton (2016) for textual evidence for abstract color concepts among the Roman artisan class.

31. See Jones and MacGregor (2002: 9–10) on lighting conditions and color perception.

32. Puttock (2002: 99–104), referring to Pliny the Elder on gold (1952: 33.84); on jet (1962: 36.142–3); on amber (1962: 37.51); on amethyst (1962: 37/124); and on coral (1963: 32.22–4).

33. Gordon (1999: 236–5) gives some examples from classical texts demonstrating belief in sympathetic magic, for instance, Pliny's description of (red) coral as resistant to fire, see Pliny the Elder 1963: 32.22–4.

BIBLIOGRAPHY

9th International Round Table on Polychromy in Ancient Sculpture and Architecture. n.d. "Home." Available online: https://www.9thpolychromyroundtable.com/ (accessed May 20, 2020).

Abbe, Mark. B. 2015. "Polychromy." In Elise A. Friedland, Melaine Grunow Sobocinski, and Elaine K. Gazda (eds.), *The Oxford Handbook of Roman Sculpture*. New York: Oxford University Press.

Abbe, Mark. B. Forthcoming. "*Politura* and Polychromy on Ancient Marble Sculpture." In Kaja Kollandsrud and Bente Kiilerich (eds.), "Perceiving Matter: Visual, Material and Sensual Communication from Antiquity to the Middle Ages and Beyond." Special issue of *CLARA Classical Art and Archaeology*.

Abbe, Mark. B., and Tuna Şare Ağtürk. 2019. "A New Corpus of Painted Imperial Roman Marble Reliefs from Nicomedia: A Preliminary Report on Polychromy." *Technè*, 48: 100–9.

Abbe, Mark B., Gina E. Borromeo, and Scott Pike. 2012. "A Hellenistic Greek Marble Statue with Ancient Polychromy Reported to be from Knidos." In Anna García-Moreno, Pilar Lapuente, and Isabel Rodà (eds.), *Interdisciplinary Studies on Ancient Stone*. Tarragona: Institut Català d'Arqueologia Clàssica.

Abrahams, Ethel. 1908. *Greek Dress*. London: Murray.

Aelian. 1997. *Historical Miscellany*. Edited and translated by N.G. Wilson. Cambridge, MA: Harvard University Press.

Aeschylus. 2008a. *Oresteia; Agamemnon; Libation-Bearers; Eumenides*. Edited and translated by Alan H. Sommerstein. Cambridge, MA: Harvard University Press.

Aeschylus. 2008b. *Persians; Seven Against Thebes; Suppliants; Prometheus Bound*. Edited and translated by Alan H. Sommerstein. Cambridge, MA: Harvard University Press.

Agnoli, Nadia. 2014. *Marsia: La superbia punita*. Rome: De Luca.

Ağtürk, Tuna Şare. 2018. "A New Tetrarchic Relief from Nicomedia: Embracing Emperors." *American Journal of Archaeology*, 122: 411–26.

Åkerström, Ake. 1966. *Die architektonischen Terrakotten Kleinasiens, Text*. Lund: Gleerup.

Alexander of Aphrodisias. 1901. *Alexandri Aphrodisiensis in librum de sensu commentarium*. Edited by Paul Wendland, *Commentaria in Aristotelem Graeca*, vol. 3.1. Berlin: Reimer.

Alfaro Giner, Carmen, and M. Julia Martínez. 2013. "Purpur und Macht an den Küsten des Mittelmeerraumes." In Michael Tellenbach, Regine Schulz, and Alfried Wieczorek (eds.), *Der Macht der Toga: Dresscode im Römischen Welt*. Regensburg: Schnell and Steiner.

Alfaro Giner, Carmen, Jean-Pierre Brun, Philippe Borgard, and Raffaella Pierobon Benoit, eds. 2011. *Textiles y tintes en la ciudad antigua … Actas del III Symposium Internacional sobre Textiles y Tintes del Mediterráneo en el Mundo Antiguo, Nápoles, 13 al 15 de noviembre, 2008*. Valencia: Universitat de València; Naples: Centre Jean Bérard.

Allason-Jones, Lindsay, and Mike C. Bishop. 1988. *Excavations at Roman Corbridge: The Hoard*. London: Historic Buildings and Monuments Commission for England.

Allen, Grant. 1879. *The Colour-Sense, Its Origin and Development: An Essay in Comparative Psychology*. London: Trübner.

Amandry, Pierre. 1991 "Les fosses de l'Aire." In École Française d'Athènes, *Guide de Delphes: Le musée*. Paris: Boccard.

Ammianus Marcellinus. 1939. *Ammianus Marcellinus*, vol. 3. Translated by John Rolfe. Cambridge, MA: Harvard University Press; London: Heinemann.

Anacreon. 1988. *Greek Lyric*, vol. 2, *Anacreon, Anacreontea, Choral Lyric from Olympus to Alcman*. Edited and translated by David A. Campbell. Cambridge, MA: Harvard University Press.

Ancient Polychromy Network. n.d. Available online: http://www.ancientpolychromynetwork.com (accessed May 20, 2020).

Andersen, Helle Damgaard. 1998. "Etruscan Architecture from the Late Orientalizing to the Archaic period (c. 640–480 B.C.)." PhD thesis, University of Copenhagen.

André, Jacques. 1949. *Étude sur les termes de couleur dans la langue latine*. Paris: Klincksieck.

Andrews, Carol. 1990. *Ancient Egyptian Jewellery*. London: British Museum Publications.

Andrews, Carol. 1994. *Amulets of Ancient Egypt*. London: British Museum Press.

Andronikos, Manolis. 1994. *Βεργίνα II: Ο τάφος της Περσεφόνης* (Vergina II: The Tomb of Persephone). Athens: Archaeological Society in Athens.

Apollonius Rhodius. 2008. *Argonautica*. Edited and translated by William H. Race. New edn. Cambridge, MA: Harvard University Press.

Apuleius. 2017. *Apologia; Florida; De Deo Socratis*. Edited and translated by Christopher P. Jones. Cambridge, MA: Harvard University Press.

Aristophanes. 1998a. *Aristophanes*, vol. 1, *Acharnians; Knights*. Edited and translated by Jeffrey Henderson. Cambridge, MA: Harvard University Press.

Aristophanes. 1998b. *Aristophanes*, vol. 2, *Clouds; Wasps; Peace*. Edited and translated by Jeffrey Henderson. Cambridge, MA: Harvard University Press.

Aristophanes. 2000. *Aristophanes*, vol. 3, *Birds; Lysistrata; Women at the Thesmophoria*. Edited and translated by Jeffrey Henderson. Cambridge, MA: Harvard University Press.

Aristophanes. 2002. *Aristophanes*, vol. 4, *Frogs; Assemblywomen; Wealth*. Edited and translated by Jeffrey Henderson. Cambridge, MA: Harvard University Press.

Aristotle. 1831–70. *Aristotelis Opera edidit Academia Regia Borussica*. Edited by Immanuel Bekker. 5 vols. Berlin: Reimer.

Aristotle. 1936. *Minor Works*. Translated by W.S. Hett. London: Heinemann; Cambridge, MA: Harvard University Press.

Aristotle. 1970. *History of Animals*. Edited and translated by A.L. Peck. 3 vols. Cambridge, MA: Harvard University Press; London: Heinemann.

Aristotle. 1984. *The Complete Works of Aristotle*. Edited by Jonathan Barnes. 2 vols. Princeton, NJ: Princeton University Press.

Aristotle. 1987. *The Poetics of Aristotle, Translation and Commentary*. Translated by Stephen Halliwell. Chapel Hill: University of North Carolina Press.

Aristotle. 1999. *Aristotle: Poetics; Longinus: On the Sublime; Demetrius: On Style; Poetics*. Edited and translated by Stephen Halliwell. Corrected 2nd edn. Cambridge, MA: Harvard University Press.

Aristotle. 2016. *Aristotle: De anima*. Translated by Christopher Shields. Oxford: Oxford University Press.

Armstrong, David, and Ann Ellis Hanson. 1986. "Two Notes on Greek Tragedy: 1. The Virgin's Voice and Neck: Aeschylus, *Agamemnon* 245 and Other Texts." *Bulletin of the Institute of Classical Studies*, 33(1): 97–102.

Arnott, William Geoffrey. 1979. *Menander*. Cambridge, MA: Harvard University Press.

Arveiller-Dulong, Véronique, and Marie-Dominique Nenna. 2011. *Les verres antiques du Musée du Louvre*. Paris: Somogy.

Athenaeus. 1951. *The Learned Banqueters*. Edited and translated by C.B. Gulick. 7 vols. Cambridge, MA: Harvard University Press; London: Heinemann.

Athenaeus. 2006–2012. *The Learned Banqueters*. Edited and translated by S. Douglas Olson. 8 vols. Cambridge, MA: Harvard University Press.

Aucouturier, Marc, François Mathis, and Dominique Robcis. 2017. "Les bronzes noirs antiques—nouvelles observations et mécanismes de creation." *Technè*, 45: 114–23. Available online: https://journals.openedition.org/techne/1345 (accessed May 21, 2020).

Bagnall, Roger S., and Raffaella Cribiore. 2006. *Women's Letters from Ancient Egypt, 300 BC–AD 800*. Ann Arbor: University of Michigan Press.

Baker, Patricia. 2011. "Collyrium Stamps: An Indicator of Regional Medical Practices in Roman Gaul." *European Journal of Archaeology*, 14: 158–89.

Baker, Patricia. 2016. "Medicine." In Louise Revell and Martin Millett (eds.), *The Oxford Handbook of Roman Britain*. Oxford: Oxford University Press.

Bakola, Emmanuela. 2016. "Textile Symbolism and the 'Wealth of the Earth': Creation, Production and Destruction in the Tapestry Scene of Aeschylus' *Oresteia*." In Giovanni Fanfani, Mary Harlow, and Marie-Louise Nosch (eds.), *Spinning Fates and the Song of the Loom: The Use of Textiles, Clothing and Cloth Production as Metaphor, Symbol and Narrative Device in Greek and Latin Literature*. Oxford: Oxbow.

Baldes, Richard. 1975. "Democritus on Visual Perception: Two Theories or One?" *Phronesis*, 20: 93–105.

Bankel, Hansgeorg. 1993. *Der spätarchaische Tempel der Aphaia auf Aegina*. Berlin: De Gruyter.

Bankel, Hansgeorg. 2004. "Farbmodelle des spätarchaischen Aphaia-Tempels von Ägina." In Vinzenz Brinkmann and Raimund Wünsche (eds.), *Bunte Götter: Die Farbigkeit antiker Skulptur; Eine Ausstellung der Staatlichen Antikensammlungen und Glyptothek München*. Munich: Hirmer.

Baran, Neculai V. 1983. "Les caractéristiques essentielles du vocabulaire chromatique latin: Aspect général, étapes de développement, sens figurés, valeur stylistique, circulation." In Wolfgang Haase (ed.), *Aufstieg und Niedergang der Römischen Welt*, part 2, vol. 29 (1). Berlin: De Gruyter.

Barber, Elizabeth J.W. 1991. *Prehistoric Textiles: The Development of Cloth in the Neolithic and Bronze Ages*. Princeton, NJ: Princeton University Press.

Barber, Elizabeth J.W. 1992. "The Peplos of Athena." In Jennifer Neils (ed.), *Goddess and Polis: The Panathenaic Festival in Ancient Athens*. Princeton, NJ: Princeton University Press.

Barbieri, Gabriella. 2015. "Il colore nelle architetture funerarie di Sovana: La tomba dei Demoni Alati e altri monumenti policromi." *Journal of Fasti Online*, 343: 1–16.

Barbieri, Gabriella, Gianna Giachi, and Pasquino Pallechi. 2013. *Polychrome Rock Architectures: Problems of Colour Preservation in the Etruscan Necropolis of Sovana*. Pisa: Serra.

Barry, Fabio. 2011. "Painting in Stone: The Symbolism of Colored Marbles in the Visual Arts and Literature from Antiquity until the Enlightenment." PhD thesis, Columbia University.

Barry, Fabio. 2014. "The Pediment of the Pantheon: Problems and Possibilities." In Robert Coates-Stephens and Lavinia Cozza (eds.), *Scritti in onore di Lucos Cozza: Lexicon topographicum urbis Romae – Supplementum VII*. Rome: Quasar.

Barthes, Roland. 2005. *The Language of Fashion*. Oxford: Berg.

Bar-Yosef Mayer, Daniella E., and Naomi Porat. 2008. "Green Stone Beads at the Dawn of Agriculture." *Proceedings of the National Academy of Sciences of the United States of America*, 105(25): 8548–51.

Bateson, J.D. 1981. *Enamel and Enamel-Working in Iron Age, Roman and Sub-Roman Britain*. Oxford: BAR.

Becker, Hilary. Forthcoming-a. *Commerce in Color: The Mechanics of the Roman Pigment Trade*.

Becker, Hilary. Forthcoming-b. "Grading for Color: Pliny's Hierarchy of Pigment Quality." In A. Anguissola (ed.), *Materiality in Pliny the Elder's Natural History*. Brepols.

Beeston, Ruth F., and Hilary Becker. 2013. "Investigation of Ancient Roman Pigments by Portable X-ray Fluorescence Spectroscopy and Polarized Light Microscopy." In Ruth Ann Armitage and James H. Burton (eds.), *Archaeological Chemistry VIII*. Washington, DC: American Chemical Society.

Bell, Sinclair. 2014. "Roman Chariot Racing." In Paul Christesen and Donald G. Kyle (eds.), *A Companion to Sport and Spectacle in Greek and Roman Antiquity*. Chichester: Wiley Blackwell.

Benda-Weber, Isabella. 2013. "Textile Production Centres, Products and Merchants in the Roman Province of Asia." In Margarita Gleba and Judit Pásztókai-Szeöke (eds.), *Making Textiles in Pre-Roman and Roman Times: People, Places, Identities*. Oxford: Oxbow Books.

Benda-Weber, Isabella. 2014. "*Krokotos* and *Crocota Vestis*: Saffron-Coloured Clothes and Muliebrity." In Carmen Alfaro Giner, Michael Tellenbach, and Jónatan Ortiz García (eds.), *Production and Trade of Textiles and Dyes in the Roman Empire and Neighbouring Regions: Actas del IV Symposium Internacional sobre Textiles y Tintes del Mediterráneo en el Mundo Antiguo (Valencia, 5 al 6 de noviembre, 2010)*. Valencia: Universitat de València.

Berlin, Brent, and Paul Kay. 1969. *Basic Color Terms: Their Universality and Evolution*. Berkeley: University of California Press.

Bernabò Brea, Luigi. 1981. *Menandro e il teatro greco nelle terracotte liparesi*. Genoa: SAGEP.

Bessone, Luigi. 1998. "La porpora a Roma." In Oddone Longo (ed.), *La porpora: realtà e immaginario di un colore simbolico: Atti del convegno di studio, Venezia, 24 e 25 Ottobre 1996*. Venice: Istituto Veneto di Scienze, Lettere, ed Arti.

Betancourt, P.P., and M.H. Wiener. 1999. *Meletemata: Studies in Aegean Archaeology Presented to Malcolm H. Wiener as he Enters his 65th Year*. Liège: Université de Liège.

Bianchi, Robert Steven. 2002. "Glass in the Graeco-Roman World." In Robert Steven Bianchi, Birgit Schlick-Nolte, G. Max Bernheimer, and Dan Barag (eds.), *Reflections on Ancient Glass from the Borowski Collection, Bible Lands Museum, Jerusalem*. Mainz: Philipp von Zabern.

Biggam, C.P. 2012. *The Semantics of Colour*. Cambridge: Cambridge University Press.

Bitterer, Tobias. 2010."Marmorverkleidung stadtrömischer Architektur: Öffentliche Bauten aus dem 1. Jahrhundert v. Chr. bis 7. Jahrhundert n. Chr." PhD thesis, University of Munich.

Blakolmer, Fritz. 1999. "The History of Middle Minoan Wall Painting: The 'Kamares Connection'." In P. Betancourt and M.H. Wiener (eds.), *Meletemata: Studies in Aegean Archaeology Presented to Malcolm H. Wiener as he Enters his 65th Year*. Liège: Université de Liège.

Blakolmer, Fritz. 2000. "Zum Charakter der frühägäischen Farben: Linear B und Homer." In Fritz Blakolmer (ed.), *Österreichisch Forschungen zur Ägäischen Bronzezeit 1998: Akten der Tagung am Institut für Klassische Archäologie der Universität Wien, 2.–3. Mai 1998*. Vienna: Phoibos.

Blakolmer, Fritz. 2004. "Colour in the Aegean Bronze Age: From Monochromy to Polychromy." In Liza Cleland and Karen Stears (eds.), *Colour in the Ancient Mediterranean World*. Oxford: John and Erica Hedges.

Blum, Hartmut. 1998. *Purpur als Statussymbol in der griechischen Welt*. Bonn: Habelt.

Blume, Clarissa. 2015. *Polychromie hellenistischer Skulptur: Ausführung, Instandhaltung und Botschaften*. Petersberg: Imhof.

Boardman, John. 2001. *Greek Gems and Finger Rings*. London: Thames and Hudson.

Böhme-Schönburger, Astrid. 1997. *Kleidung und Schmuck in Rom und den Provinzen*. Stuttgart: Württembergisches Landesmuseum.

Bonfante Warren, Larissa. 1970. "Roman Triumphs and Etruscan Kings: The Latin Word *Triumphus*." In Robert C. Lugton and Milton G. Saltzer (eds.), *Studies in Honor of J. Alexander Kerns*. The Hague: Mouton.

Borg, Barbara. 2010. "Painted Funerary Portraits." In Willeke Wendrich, Jacco Dieleman, Elizabeth Frood, and John Baines (eds.), *UCLA Encyclopedia of Egyptology*. Los Angeles: University of California, Los Angeles. Available online: http://escholarship.org/uc/item/7426178c (accessed May 21, 2020).

Borgard, Philippe and Marie-Pierre Puybaret. 2004. "Le travail de la laine au début de l'empire: l'apport du modèle pompéien; Quels artisans? Quels équipements? Quelles techniques?" In Carmen Alfaro Giner, John Peter Wild, and Benjamí Costa Ribas (eds.), *Purpureae vestes: Actas del I symposium internacional sobre textiles y tintes del mediterráneo en época romana (Ibiza, 8 al 10 de noviembre, 2002)*. Valencia: Consell Insular d'Eivissa i Formentera; Universitat de València.

Borgard, Philippe, Jean-Pierre Brun, Martine Leguilloux, and Marie Tuffreau-Libre. 2003. "Le produzioni artigianali a Pompei: Richerche condotte dal Centre Jean Bérard." *Rivista di studi pompeiani*, 14: 9–29.

Borgard, Philippe, Marie-Pierre Puybaret, María Julia Martínez, and Roger Zérubia. 2014. "Le bleu pompéien: V 1.4, un atelier antique pratiquant la teinture de cuve." In Carmen Alfaro Giner, M. Tellenbach, and Jónatan Ortiz García (eds.), *Production and Trade of Textiles and Dyes in the Roman Empire and Neighbouring Regions: Actas del IV symposium internacional sobre textiles y tintes del mediterráneo en el mundo antiguo (Valencia, 5 al 6 de noviembre, 2010)*. Valencia: Universitat de València.

Bornstein, Marc H. 2007. "Hue Categorization and Color Naming: Cognition to Language to Culture." In Robert E. MacLaury, Galina V. Paramei, and Don Dedrick (eds.), *Anthropology of Color*. Amsterdam: John Benjamins.

Borrmann, Richard. 1888. "Polychromie (der Bauwerke)." In August Baumeister (ed.), *Denkmäler des klassischen Altertums zur Erläuterung des Lebens der Griechen und Römer in Religion, Kunst und Sitte*. Munich: Oldenbourg.

Botti, Angelo, and Elisabetta Setari, eds. 2009. *I marmi dipinti di Ascoli Satriano*. Milan: Electa.

Bourgeois, Brigitte. 2016. "*Ganôsis* et réfections antiques de polychromie: Enquête sur le portrait en marbre de Bérénice II au Musée royal de Mariemont." *Cahiers de Mariemont*, 40: 64–85.

Bourgeois, Brigitte, ed. 2014. *Thérapéia: polychromie et restauration de la sculpture dans l'Antiquité*. Paris: Centre de Recherche et de Restauration des Musées de France.

Bourgeois, Brigitte, and Philippe Jockey. 2005. "La dorure des marbres grecs: Nouvelle enquête sur la sculpture hellénistique de Délos." *Journal des Savants* 2: 253–316.

Bourgeois, Brigitte, and Philippe Jockey. 2010. "The Polychromy of Hellenistic Marble Sculpture in Delos." In Vinzenz Brinkmann, Oliver Primavesi, and Max Hollein (eds.), *Circumlitio: The Polychromy of Antique and Medieval Sculpture*. Munich: Hirmer.

Bracci, Susanna, Gianna Giachi, Paolo Liverani, Pasquino Pallecchi, and Fabrizio Paolucci, eds. 2018. *Polychromy in Ancient Sculpture and Architecture*. Livorno: Sillabe.

Bradley, Mark. 2004. "The Colour 'Blush' in Ancient Rome." In Liza Cleland and Karen Stears (eds.), *Colour in the Ancient Mediterranean World*. Oxford: John and Erica Hedges.

Bradley, Mark. 2006. "Colour and Marble in Early Imperial Rome." *Proceedings of the Cambridge Philological Society*, 52: 1–22.

Bradley, Mark. 2009a. *Colour and Meaning in Ancient Rome*. Cambridge: Cambridge University Press.

Bradley, Mark. 2009b. "The Importance of Colour on Ancient Marble Sculpture." *Art History*, 32: 427–57.

Bradley, Mark. 2013. "Color as Synaesthetic Experience in Antiquity." In Shane Butler and Alex Purves (eds.), *Synaesthesia and the Ancient Senses*. Durham: Acumen.

Branham, Robert Bracht. 1989. *Unruly Eloquence: Lucian and the Comedy of Traditions*. Cambridge, MA: Harvard University Press.

Brecoulaki, Hariclia. 2006a. "Considérations sur les peintres tétrachromatistes et les *colores austeri et floridi*: L'économie des moyens picturaux contre l'emploi de matériaux onéreaux dans la peinture ancienne." In Agnès Rouveret, Sandrine Dubel, and Valérie Nass (eds.), *Couleurs et matières dans l'Antiquité: Textes, techniques et pratiques*. Paris: Rue d'Ulm.

Brecoulaki, Hariclia. 2006b. *La peinture funéraire de Macédoine: Emplois et fonctions de la couleur, IVe–IIe siècles av. J.-C.* Athens: Centre de Recherche de l'Antiquité.

Brecoulaki, Hariclia. 2014. "'Precious Colours' in Ancient Greek Polychromy and Painting: Material Aspects and Symbolic Values." *Revue archéologique*, 57(1): 3–35.

Brecoulaki, Hariclia. 2015. "Greek Painting and the Challenge of *Mimesis*." In Pierre Destrée and Penelope Murray (eds.), *A Companion to Ancient Aesthetics*. Malden, MA: Wiley.

Brecoulaki, Hariclia. 2016. "Greek Interior Decoration: Materials and Technology in the Art of Cosmesis and Display." In Georgia L. Irby (ed.), *A Companion to Science, Technology, and Medicine in Ancient Greece and Rome*. Chichester: Blackwell.

Brecoulaki, Hariclia, Giorgios Kavvadias, and Giovanni Verri. 2014. "Colour and Luxury: Three Classical Painted Marble *Pyxides* from the Collection of the National Archaeological Museum, Athens." In Jan Stubbe Østergaard and Anne Marie Nielsen (eds.), *Transformations: Classical Sculpture in Colour*. Copenhagen: Ny Carlsberg Glyptotek.

Brecoulaki, Hariclia, Giorgios Kavvadias, Vasiliki Kandarelou, J. Stephens, and A. Stephens. 2017. "Colour and Painting Technique on the Archaic Panels from Pitsa (Corinthia)." In Stephan T.A.M. Mols and Eric Moorman (eds.), *Context and Meaning: Proceedings of the Twelfth International Conference of the Association Internationale pour la Peinture Murale Antique, Athens, September 16–20, 2013*. Leuven: Peeters.

Brinkmann, Vinzenz. 1994. *Beobachtungen zum formalen Aufbau und zum Sinngehalt der Friese des Siphnierschatzhauses*. Ennepetal: Biering and Brinkmann.

Brinkmann, Vinzenz. 2003. *Die Polychromie der archaischen und frühklassischen Skulptur*. Munich: Biering and Brinkmann.

Brinkmann, Vinzenz. 2007. "Girl or Goddess? The Riddle of the 'Peplos Kore' from the Athenian Acropolis." In Vinzenz Brinkmann and Raimund Wünsche (eds.), *Gods in Color: Painted Sculpture of Classical Antiquity*. Munich: Stiftung Archäologie.

Brinkmann, Vinzenz. 2008. "The Polychromy of Ancient Greek Sculpture." In Roberta Panzanelli, Eike Schmidt, and Kenneth Lapatin (eds.), *The Color of Life: Polychromy in Sculpture from Antiquity to the Present*. Los Angeles: J. Paul Getty Museum.

Brinkmann, Vinzenz. 2010. "Statues in Colour: Aesthetics, Research and Perspectives." In Vinzenz Brinkmann, Oliver Primavesi, and Max Hollein (eds.), *Circumlitio: The Polychromy of Antique and Mediaeval Sculpture*. Munich: Hirmer.

Brinkmann, Vinzenz. 2017. "A History of Research and Scholarship on the Polychromy of Ancient Sculpture." In Vinzenz Brinkmann, Renée Dreyfus, and Ulrike Koch-Brinkmann (eds.), *Gods in Color: Polychromy in the Ancient World*. San Francisco: Fine Arts Museums of San Francisco.

Brinkmann, Vinzenz, ed. 2016. *Athen—Triumph der Bilder: Eine Ausstellung der Liebieghaus Skulpturensammlung, Frankfurt am Main, 4. Mai bis 4. September 2016*. Petersberg: Imhof.

Brinkmann, Vinzenz, and Raimund Wünsche, eds. 2007. *Gods in Color: Painted Sculpture of Classical Antiquity* [Exhibition catalog: Arthur M. Sackler Museum, Harvard University.] Munich: Stiftung Archäologie, and Staatliche Antikensammlungen und Glypothek.

Brinkmann, Vinzenz, and Ulrike Koch-Brinkmann. 2017. "On the Polychromy of Ancient Sculpture." In Vinzenz Brinkmann, Renée Dreyfus, and Ulrike Koch-Brinkmann (eds.), *Gods in Color: Polychromy in the Ancient World*. San Francisco: Fine Arts Museums of San Francisco.

Brinkmann, Vinzenz, Oliver Primavesi, and Max Hollein, eds. 2010. *Circumlitio: The Polychromy of Antique and Mediaeval Sculpture*. Munich: Hirmer.

Brinkmann, Vinzenz, Ulrike Koch-Brinkmann, and Heinrich Piening. 2011. "Alte Gewänder in Neuem Look, Beobachtungen zu den Farben der pompejanischen Artemis." In Vinzenz Brinkmann and Max Kunze (eds.), *Die Artemis von Pompeji und die Entdeckung der Farbigkeit griechischer Plastik*. Ruhpolding: Rutzen.

Brinkmann, Vinzenz, Renée Dreyfus, and Ulrike Koch-Brinkmann, eds. 2017a. *Gods in Color: Polychromy in the Ancient World*. San Francisco: Fine Arts Museums of San Francisco.

Brinkmann, Vinzenz, Ulrike Koch-Brinkmann, and Heinrich Piening. 2017b. "Ancient Paints and Painting Techniques: Methods of Investigation." In Vinzenz Brinkmann, Renée Dreyfus, and Ulrike-Koch Brinkmann (eds.), *Gods in Color: Polychromy in the Ancient World*. San Francisco: Fine Arts Museums of San Francisco.

Brisson, Luc. 1999. "Plato's Theory of Sense Perception in the *Timaeus*: How it Works and What it Means." In John J. Cleary and Gary M. Gurtler (eds.), *Proceedings of the Boston Area Colloquium in Ancient Philosophy*, vol. 13. Leiden: Brill.

Broackes, Justin. 1999. "Aristotle, Objectivity, and Perception." *Oxford Studies in Ancient Philosophy*, 17: 57–113.

Broadie, Sarah. 1993. "Aristotle's Perceptual Realism." *Southern Journal of Philosophy*, 31(suppl.): 137–59.

Brøns, Cecilie. 2017a. *Gods and Garments: Textiles in Greek Sanctuaries in the 7th to 1st Centuries BC*. Oxford: Oxbow.

Brøns, Cecilie. 2017b. "Sacred Colours: Purple Textiles in Greek Sanctuaries in the Second Half of the 1st Millennium BC." In Hedvig L. Enegren and Francesco Meo (eds.), *Treasures from the Sea: Sea Silk and Shellfish Purple Dye in Antiquity*. Oxford: Oxbow Books.

Broneer, Oscar. 1971. *Isthmia, 1: Temple of Poseidon*. Princeton, NJ: American School of Classical Studies.

Brøns, Cecilie. Forthcoming. "The Colors of Ancient Greek Dress." In Alicia Batten and Kelly Olson (eds.), *Dress in Mediterranean Antiquity: Greeks, Romans, Christians, Jews*. London: Bloomsbury.

Brøns, Cecilie, and Marie-Louise Nosch, eds. 2017. *Textiles and Cult in the Ancient Mediterranean*. Oxford: Oxbow Books.

Brøns, Cecilie, Amalie Skovmøller, and J. Gisler. 2017. "Colour-Coding the Roman Toga: The Materiality of Textiles Represented in Ancient Sculpture." *Antike Kunst*, 60: 55–79.

Brouillet, Manon. 2016. "Des chants en partage: L'épopée homérique comme expérience religieuse." PhD thesis, École des Hautes Études en Sciences Sociales, Paris.

Brun, Jean-Pierre, Martine Leguilloux, Philippe Borgard. 2002. "Pompéi: Recherches sur les productions artisanales." *Mélanges de l'Ecole française de Rome: Antiquité*, 114(1): 470–81.

Buchi, Ezio, and Alfredo Buonopane. 2005. "Le etichette plumbee rinvenute a Feltre: aspetti onomastici, lessicali, economici e tecnici." In Gianni Ciurletti and Nicoletta Pisu (eds.), *I territori della Via Claudia Augusta: incontri di archeologia = Leben an der Via Claudia Augusta: archäologische Beiträge*. Trent: TEMI.

Bultman, Rudolf. 1948. "Zur Geschichte der Lichtsymbolik im Altertum." *Philologus*, 97: 1–36.

Burkert, Walter. 1977. "Air-Imprints or *Eidola*: Democritus' Aetiology of Vision." *Illinois Classical Studies*, 2: 97–109.

Burnham, Barry C., and J.S. Wacher. 1990. *The Small Towns of Roman Britain*. Berkeley: University of California Press.

Burnyeat, Myles. 1992. "Is an Aristotelian Philosophy of Mind Still Credible? A Draft." In Martha Nussbaum and Amélie Oksenberg Rorty (eds.), *Essays on Aristotle's* De anima. Oxford: Oxford University Press.

Burnyeat, Myles. 1995. "How Much Happens When Aristotle Sees Red and Hears Middle C? Remarks on *De anima* 2.7–8." In Martha Nussbaum and Amélie Oksenberg Rorty (eds.), *Essays on Aristotle's* De anima. Oxford: Oxford University Press.

Cairns, Francis. 2005. "Lavinia's Blush (Vergil *Aeneid* 12.64–70)." In Douglas L. Cairns (ed.), *Body Language in the Greek and Roman Worlds*. Swansea: Classical Press of Wales.

Caley, Earle Radcliffe, trans. 1926. "The Leyden Papyrus X: An English Translation with Brief Notes." *Journal of Chemical Education*, 3(10): 1149–66.

Caley, Earle Radcliffe, trans. 1927. "The Stockholm Papyrus: An English Translation with Brief Notes." *Journal of Chemical Education*, 4(8): 979–1002.

Camardo, Domenico, and Mario Notomista. 2015. "The Roof and Suspended Ceiling of the Marble Room in the House of the Telephus Relief at Herculaneum." *Journal of Roman Archaeology*, 28: 39–70.

Cameron, A. 1976. *Circus Factions: Blues and Greens at Rome and Byzantium*. Oxford: Clarendon Press.

Campbell, David A., ed. and trans. 1991. *Greek Lyric*, vol. 3, *Stesichorus; Ibycus; Simonides, and Others*. Cambridge, MA: Harvard University Press.

Campbell, David A., ed. and trans. 1992. *Greek Lyric*, vol. 4, *Bacchylides; Corinna, and Others*. Cambridge, MA: Harvard University Press.

Campbell, John. 1994. "A Simple View of Color." In John Haldane and Crispin Wright (eds.), *Reality, Representation, and Projection*. Oxford: Clarendon Press.

Caneva, Giulia. 2010. *Il codice botanico di Augusto: Roma, Ara Pacis: Parlare al popolo attraverso le immagini della natura*. Rome: Gangemi.

Carastro, Cléo. 2009. "La notion de *khrōs* chez Homère: Éléments pour une anthropologie de la couleur en Grèce ancienne." In Cléo Carastro (ed.), *L'Antiquité en couleurs: Catégories, pratiques, représentations*. Grenoble: Jérôme Millon.

Cardon, Dominique. 2007. *Natural Dyes: Sources, Tradition, Technology and Science*. London: Archetype.

Cardon, Dominique. 2010. "Natural Dyes, Our Global Heritage of Colors." In Textile Society of America, *12th Biennial Symposium*, Lincoln, Nebraska, October 6–9, 2010. Available online: http://digitalcommons.unl.edu/tsaconf/12 (accessed May 21, 2020).

Cardon, Dominique, Witold Nowik, Hero Granger-Taylor, Renata Marcinowska, Katarzine Kusyk, and Marek Trojanowicz. 2011. "Who Could Wear True Purple in Roman Egypt? Technical and Social Considerations on Some New Identifications of Purple from Marine Mollusks in Archaeological Textiles." In Carmen Alfaro Giner, Jean-Pierre Brun, Philippe Borgard, and Raffaella Pierobon Benoit (eds.), *Textiles y tintes en la ciudad antigua … Actas del III Symposium Internacional sobre Textiles y Tintes del Mediterráneo en el Mundo Antiguo, Nápoles, 13 al 15 de noviembre, 2008*. Valencia: Universitat de València; Naples: Centre Jean Bérard.

Carroll, Maureen, and John Peter Wild, eds. 2012. *Dressing the Dead in Classical Antiquity*. Stroud: Amberley.

Castagnoli, Luca. 2013. "Democritus and Epicurus on Sensible Qualities in Plutarch's *Against Colotes 3–9*." *Aitia*, 3: 2–24.

Caston, Victor. 2005. "The Spirit and the Letter: Aristotle on Perception." In R. Salles (ed.), *Metaphysics, Soul, and Ethics in Ancient Thought*. Oxford: Oxford University Press.

Caston, Victor. 2018. "Aristotle on the Reality of Colors and Other Perceptible Qualities." *Res Philosophica*, 95: 35–68.

Catullus. 1988. *Catullus; Tibullus; Pervigilium Veneris*. Translated by Francis Warre Cornish; revised by G.P. Goold. 2nd edn. Cambridge, MA: Harvard University Press.

Causey, Faya. 2011. *Amber and the Ancient World*. Los Angeles: Getty Publications.

Chapin, Anne P. 2014. "Aegean Painting in the Bronze Age." In Jerome Jordan Pollitt (ed.), *The Cambridge History of Painting in the Classical World*. New York: Cambridge University Press.

Chapman, John. 2002. "Colourful Prehistories: The Problem with the Berlin and Kay Color Paradigm." In Andrew Jones and Gavin MacGregor (eds.), *Colouring the Past: The Significance of Color in Archaeological Research*. Oxford: Berg.

Christesen, Paul, and Donald G. Kyle, eds. 2014. *A Companion to Sport and Spectacle in Greek and Roman Antiquity*. Chichester: Wiley Blackwell.

Christol, Alain. 2002. "Les couleurs de la mer." In Laurence Villard (ed.), *Couleurs et vision dans l'antiquité classique*. Mont-Saint-Aignan: Publications de l'Université de Rouen.

Cicero. 1948–53. *The Verrine Orations*. Translated by L.H.G. Greenwood. Rev. edn. 2 vols. Cambridge, MA: Harvard University Press; London: Heinemann.

Cicero. 1984. *Pro Sestio; In Vatinium*. Translated by R. Gardner. Cambridge, MA: Harvard University Press; London: Heinemann.

Cicero. 1989. *Tusculan Disputations*. Translated by J.E. King. Rev. edn. Cambridge, MA: Harvard University Press.

Cicero. 2009. *Philippics 1–6*. Edited and translated by D.R. Shackleton Bailey. Rev. edn. Cambridge, MA: Harvard University Press.

Clarke, Giles. 1979. *The Roman Cemetery at Lankhills, Winchester*. Oxford: Clarendon Press.

Clarke, Jacqueline R. 2001. "Colours in Conflict: Catullus' Use of Colour Imagery in Catullus 63." *Classical Quarterly*, 51: 163–77.

Clarke, Jacqueline R. 2003. *Imagery of Colour and Shining in Catullus, Propertius, and Horace*. New York: Lang.

Clarke, Michael. 2004. "The Semantics of Colour in the Early Greek Word-Hoard." In Liza Cleland and Karen Stears (eds.), *Colour in the Ancient Mediterranean World*. Oxford: John and Erica Hedges.

Clausewitz, Carl von. 1976. *On War*. Edited and translated by Michael Howard and Peter Paret. Princeton, NJ: Princeton University Press.

Clay, Jenny Strauss. 2006. *The Politics of Olympus: Form and Meaning in the Major Homeric Hymns*. London: Duckworth.

Cleland, Liza. 2004a. "Introduction." In Liza Cleland, Karen Stears, and G. Davies (eds.), *Colour in the Ancient Mediterranean World*. Oxford: John and Erica Hedges.

Cleland, Liza. 2004b. "The Semiosis of Description: Some Reflections on Fabric and Colour in the Brauron Inventories." In Liza Cleland, Mary Harlow, and Lloyd Llewellyn-Jones (eds.), *The Clothed Body in the Ancient World*. Oxford: Oxbow.

Cleland, Liza. 2005. *The Brauron Clothing Catalogues: Text, Analysis, Glossary and Translation*. Oxford: British Archaeological Reports.

Cleland, Liza, and Karen Stears, eds. 2004. *Colour in the Ancient Mediterranean World*. Oxford: John and Erica Hedges.

Cleland, Liza, M. Harlow, and L. Llewellyn-Jones, eds. 2005. *The Clothed Body in the Ancient World*. Oxford: Oxbow Books.

Cleland, Liza, Glenys Davies, and Lloyd Llewellyn-Jones. 2007. *Greek and Roman Dress from A-Z*. London and New York: Routledge.

Clementi, Catia, Valeria Ciocan, Manuela Vagnini, Brenda Doherty, Marisa Laurenzi Tabasso, Cinzia Conti, Brunetto Giovanni Brunetti, and Costanza Miliani. 2011."Non-Invasive and Micro-Destructive Investigation of the *Domus Aurea* Wall Painting Decorations." *Analytical and Bioanalytical Chemistry*, 401: 1815–26.

Clinton, Kevin. 1992. *Myth and Cult: The Iconography of the Eleusinian Mysteries*. Stockholm: Svenska Institutet i Athen.

The Codex of Justinian. 2016. Translated by Fred H. Blume, and edited by Bruce W. Frier. 3 vols. Cambridge: Cambridge University Press.

Cohen, Ada. 1997. *The Alexander Mosaic: Stories of Victory and Defeat*. Cambridge: Cambridge University Press.

Cohen, Beth. 2001. "Ethnic Identity in Democratic Athens and the Visual Vocabulary of Male Costume." In Irad Malkin (ed.), *Ancient Perceptions of Greek Ethnicity*. Washington, DC: Center for Hellenic Studies.

Cohen, Beth. 2006. "Coral-Red Gloss: Potters, Painters and Painter-Potters." In Beth Cohen (ed.), *The Colours of Clay: Special Techniques in Athenian Vases*. Los Angeles: Getty Publications.

Coles, Revel. 1980. "P. Harr. 73 and 160 Revised." *Zeitschrift für Papyrologie und Epigraphik*, 37: 229–39.

Coles, Revel, ed. 1987. *The Oxyrhynchus Papyri*, vol. 54. London: Egypt Exploration Society.

Collareta, Marco. 2008. "From Color to Black and White and Back Again: The Middle Ages and Early Modern Times." In Roberta Panzanelli (ed.), *The Color of Life: Polychromy in Sculpture from Antiquity to the Present*. Los Angeles: J. Paul Getty Museum.

Conklin, Harold C. 1955. "Hanunóo Color Categories." *Southwestern Journal of Anthropology*, 11: 339–44.

Conklin, Harold C. 1986. "Hanunóo Color Categories." *Journal of Anthropological Research*, 42: 441–6.

Constantinidis, D., and Lilian Karali. 2011. "A Proposed Survey of East Mediterranean Murex Heaps from the Bronze Age to Roman Times: A GIS Analysis of Possible Trade Networks." In Carmen Alfaro Giner, Jean-Pierre Brun, Philippe Borgard, and Raffaella Pierobon Benoit (eds.), *Textiles y tintes en la ciudad antigua … Actas del III Symposium Internacional sobre Textiles y Tintes del Mediterráneo en el Mundo Antiguo, Nápoles, 13 al 15 de noviembre, 2008*. Valencia: Universitat de València; Naples: Centre Jean Bérard.

Cooney, Gabriel. 2002. "So Many Shades of Rock: Color Symbolism and Irish Stone Axeheads." In Andrew Jones and Gavin Macgregor (eds.), *Colouring the Past: The Significance of Color in Archaeological Research*. Oxford: Berg.

Corbett, Greville G., and Ian R.L. Davies. 1995. "Linguistic and Behavioural Measures for Ranking Basic Colour Terms." *Studies in Language*, 19: 301–57.

Corpus Inscriptionum Latinarum (CIL), vol. 9. 1883. Edited by Theodor Mommsen. Berlin: Reimer.

Corpus Inscriptionum Latinarum (CIL), vol. 4. 1952–70. Edited by Matteo Della Corte. Berlin: De Gruyter.

Corso, Antonio. 2007. *The Art of Praxiteles II: The Mature Years*. Rome: L'Erma di Bretschneider.

Cosyns, Peter. 2015. "Beyond the Channel! That's Quite a Different Matter. A Comparison of Roman Black Glass from Britannia, Gallia Belgica and Germania Inferior." In Ian Freestone, Justine Bayley, and Caroline Jackson (eds.), *Glass of the Roman World*. Oxford: Oxbow Books.

Crawford, Michael H., and Joyce M. Reynolds. 1979. "The Aezani Copy of the Prices Edict." *Zeitschrift für Papyrologie und Epigraphik*, 34: 163–210.

Cristofani, Mauro. 1990. *La grande Roma dei Tarquini: Roma, Palazzo delle Esposizioni, 12 giugno–30 settembre 1990*. Rome: Bretschneider.

Csapo, Eric, and William J. Slater. 1995. *The Context of Ancient Drama*. Ann Arbor: University of Michigan Press.

Cunningham, Allan. 1886. "Homer's Sense of Colour." *Nature*, 34: 1–2.

Dandreau, Alain. 1999. "La peinture murale minoenne, I: La palette du peintre égéen et égyptien à l'Age du Bronze: Nouvelles données analytiques." *Bulletin de Correspondance Hellénique*, 123(1): 1–41.

Davidson, John. 2005. "Theatrical Production." In Justina Gregory (ed.), *A Companion to Greek Tragedy*. Malden, MA: Blackwell.

Davies, W. Vivian. 2001. *Color and Painting in Ancient Egypt*. London: British Museum Press.

Deacy, Susan, and Alexandra Villing. 2004. "Athena Blues? Colour and Divinity in Ancient Greece." In Liza Cleland and Karen Stears (eds.), *Colour in the Ancient Mediterranean World*. Oxford: John and Erica Hedges.

Del Bufalo, Dario. 2012. *Porphyry: Red Imperial Porphyry, Power and Religion*. Turin: Allemandi.

Delbrueck, Richard. 1932. *Antike Porphyrwerke*. Berlin: Walter de Gruyter.

Descamps-Lequime, Sophie. 2015. "The Color of Bronze: Polychromy and the Aesthetics of Bronze Surfaces." In Jens M. Daehner and Kenneth Lapatin, (eds.), *Power and Pathos: Bronze Sculpture of the Hellenistic World*. Los Angeles: J. Paul Getty Museum.

Descamps-Lequime, Sophie, ed. 2007. *Peinture et couleur dans le monde Grec antique*. Paris: Musée du Louvre.

Destrée, Pierre, and Penelope Murray, eds. 2015. *A Companion to Ancient Aesthetics*. Malden, MA: Wiley.

Deutscher, Guy. 2010. *Through the Language Glass: Why the World Looks Different in Other Languages*. London: Arrow Books.

Diels, Hermann, ed. 1879. *Doxographi Graeci*. Berlin: Reimer.

Diels, Hermann, and Walter Kranz, eds. 1951. *Die Fragmente der Vorsocratiker*. 3 vols. Berlin: Weidmannsche Verlagbuchhandlung.

Diocletian. 1974. *Edictum Diocletiani et Collegarum de pretiis rerum venalium*. Edited by Marta Giacchero. 2 vols. Genoa: Istituto di storia antica e scienze ausiliarie.

Diocletian. 2016. "An English Translation of the Edict on Maximum Prices, Also Known as the Price Edict of Diocletian." Translated by Antony Kropff. Version 2.1. Available online: https://www.academia.edu/23644199/New_English_translation_of_the_Price_Edict_of_Diocletianus (accessed April 15, 2019).

Diodorus Siculus. 1939. *The Library of History*, vol. 3. Translated by C.H. Oldfather. Cambridge, MA: Harvard University Press; London: Heinemann.

Diodorus Siculus. 1963. *The Library of History*, vol. 8. Edited and translated by
 C. Bradford Welles. Cambridge, MA: Harvard University Press; London: Heinemann.
Diogenes Laertius. 1925. *Lives of Eminent Philosophers*. Edited and translated by
 R.D. Hicks. 2 vols. Cambridge, MA: Harvard University Press; London: Heinemann.
Dionysius of Halicarnassus. 1939. *Roman Antiquities*, vol. 2. Translated by Earnest
 Cary. Cambridge, MA: Harvard University Press; London: Heinemann.
Dioscorides. 2005. *Pedanius Dioscorides of Anazarbus: De materia medica*. Translated
 by Lily Y. Beck. Hildesheim: Olms–Weidmann.
Dreyfus, Renée. 2017. "Rediscovering Color: Polychrome Art from Ancient Egypt and
 the Near East." In Vinzenz Brinkmann, Renée Dreyfus, and Ulrike Koch-Brinkmann
 (eds.), *Gods in Color: Polychromy in the Ancient World*. San Francisco: Fine Arts
 Museums of San Francisco.
Droß-Krüpe, Kerstin, and Annette Paetz gen. Schieck. 2014. "Unravelling the
 Tangled Threads of Ancient Embroidery: A Compilation of Written Sources and
 Archaeologically Preserved Textiles." In Mary Harlow and Mary-Louise Nosch
 (eds.), *Greek and Roman Textiles and Dress: An Interdisciplinary Anthology*.
 Oxford: Oxbow Books.
Dubin, Lois Sherr. 2009. *The Worldwide History of Beads*. London: Thames and Hudson.
Dubois-Pelerin, Éva. 2008. *Le luxe privé à Rome et en Italie au Ier siècle après J.-C.*
 Naples: Centre Jean Berard.
Duckworth, Chloë N. 2012. "Imitation, Artificiality and Creation: The Color
 and Perception of The Earliest Glass in New Kingdom Egypt." *Cambridge
 Archaeological Journal*, 22(3): 309–27.
Dunbabin, Katherine M.D. 1999. *Mosaics of the Greek and Roman World*. Cambridge:
 Cambridge Univeristy Press.
Dunbabin, Katherine M.D. 2016. *Theater and Spectacle in the Art of the Roman
 Empire*. Ithaca, NY: Cornell University Press.
Dürrbach, Félix, Pierre Roussel, Marcel Launey, André Plassart, and Jacques Coupry,
 eds. 1926–72. *Inscriptions de Délos*. 7 vols. Paris: Champion and De Boccard.
Eastaugh, Nicholas, Valentine Walsh, Tracey Chaplin, and Ruth Siddall. 2008. *Pigment
 Compendium: A Dictionary and Optical Microscopy of Historic Pigments*. London:
 Routledge.
Eaverly, Mary Ann. 2013. *Tan Men, Pale Women: Color and Gender in Archaic Greece
 and Egypt, A Comparative Approach*. Ann Arbor: University of Michigan Press.
Eckardt, Hella. 2014. *Objects and Identities: Roman Britain and the North-West
 Provinces*. Oxford: Oxford University Press.
Eco, Umberto. 1985. "How Culture Conditions the Colours We See." In Marshall
 Blonksy (ed.), *On Signs*. Oxford: Blackwell.
Edgeworth, Robert J. 1979. "Does 'Purpureus' Mean 'Bright'?" *Glotta*, 57: 281–91.
Edgeworth, Robert J. 1983. "Terms for 'Brown' in Ancient Greek." *Glotta*, 61: 31–40.
Edgeworth, Robert J. 1985. "Luteus: Pink or Yellow?" *Glotta*, 63: 212–20.
Edgeworth, Robert J. 1992. *The Colors of the Aeneid*. New York: Peter Lang.
Edwards, Howell G.M., Denis W. Farwell, and Silvia Rozenberg. 1999. "Raman
 Spectroscopic Study of Red Pigment and Fresco Fragments from King Herod's
 Palace at Jericho." *Journal of Raman Spectroscopy*, 30(5): 361–6.
Eiseman, Lee, and Keith Recker. 2011. *Pantone: The 20th Century in Color*. San
 Francisco: Chronicle Books.
Ekroth, Gunnel. 2014. "Animal Sacrifice in Antiquity." In Gordon L. Campbell (ed.),
 The Oxford Handbook of Animals in Classical Thought and Life. Oxford: Oxford
 University Press.

Ellis, Simon P. 1997. "Late Antique Dining: Architecture, Furnishings and Behaviour." In Ray Laurence and Andrew Wallace-Hadrill (eds.), *Domestic Space in the Roman World: Pompeii and Beyond*. Portsmouth, RI: Journal of Roman Archaeology.

Empedocles. 2001. *The Poem of Empedocles*. Translated by Brad Inwood. Toronto: University of Toronto Press.

Enegren, Hedvig Landenius, and Francesco Meo, eds. 2017. *Treasures from the Sea: Sea Silk and Shellfish Purple Dye in Antiquity*. Oxford: Oxbow.

Espérandieu, Émile. 1913. *Recueil général des bas-reliefs de la Gaule romaine*, vol. 5. Paris: Imprimerie nationale.

Euripides. 1994. *Cyclops; Alcestis; Medea*. Translated by David Kovacs. New edn. Cambridge, MA: Harvard University Press.

Euripides. 2002. *Helen; Phoenician Women; Orestes*. Translated by David Kovacs. Rev. edn. Cambridge, MA: Harvard University Press.

Euripides. 2005. *Children of Heracles; Hippolytus; Andromache; Hecuba*. Translated by David Kovacs. Rev. edn. Cambridge, MA: Harvard University Press.

Everson, Stephen. 1997. *Aristotle on Perception*. Oxford: Oxford University Press.

Fang, Jui-Lien, and Gerry McDonnell. 2011. "The Color of Copper Alloys." *Historical Metallurgy*, 45(1): 52–61.

Fant, J. Clayton. 1999. "Augustus and the City of Marble." In Max Schvoerer (ed.), *Archéomatériaux: marbres et autres roches: ASMOSIA IV, actes de la IVème Conférence Internationale de l'Association pour l'Étude des Marbres et Autres Roches Utilisés dans le Passé, Bordeaux-Talence, 9–13 Octobre 1995*. Bordeaux: Centre de Recherche Appliquée à 'Archéologie.

Feeney, Denis C. 1992. "'Shall I compare thee … ?': Catullus 68b and the Limits of Analogy." In Tony Woodman and Jonathan Powell (eds.), *Author and Audience in Latin Literature*. Cambridge: Cambridge University Press.

Ferrand, J., Stephanie Rossano, Ph. Rollet, Thierry Allard, Patrick Cordier, G. Catillon, Ginette Auxiette, François Farges, and Sylvain Pont. 2014. "On the Origin of the Green Color of Archaeological Bone Artefacts of the Gallo-Roman Period." *Archaeometry*, 56(6): 1024–40.

Ferrence, Susan, and Gordon Bendersky. 2004. "Therapy with Saffron and the Goddess at Thera." *Perspectives in Biology and Medicine*, 47(2): 199–226.

Festus, Sextus Pompeius. 1913. *De verborum significatu quae supersunt cum Pauli epitome*. Edited by Wallace M. Lindsay. Leipzig: Teubner.

Filippi, Fedora, ed. 2005. *I colori del fasto: Palazzo Altemps; la domus del Gianicolo e i suoi marmi Roma, Museo Nazionale Romano in Palazzo Altemps, 17 Dicembre 2005–18 Aprile 2006*. Milan: Electa.

Fine, Kit. 1996. "The Problem of Mixture." In Frank A. Lewis and Robert Bolton (eds.), *Form, Matter, and Mixture in Aristotle*. Oxford: Blackwell.

Flohr, Miko. 2007. "*Nec quicquam ingenuum habere potest officina*? Spatial Contexts of Urban Production at Pompeii, AD 79." *Bulletin Antieke Beschaving*, 82: 129–48.

Flohr, Miko. 2013a. "The Textile Economy of Pompeii." *Journal of Roman Archaeology*, 26: 53–78.

Flohr, Miko. 2013b. *The World of the* Fullo: *Work, Economy, and Society in Roman Italy*. Oxford: Oxford University Press.

Florus. 1984. *Epitome of Roman History*. Translated by E.S. Forster. Cambridge, MA: Harvard University Press.

Foerster, Gideon. 1995. *Masada V: The Yigael Yadin Excavations, 1963–1965: Final Reports, Art and Architecture*. Jerusalem: Israel Exploration Society.

Foley, Helene P., ed. 1994. *The Homeric* Hymn to Demeter: *Translation, Commentary, and Interpretive Essays.* Princeton, NJ: Princeton University Press.

Forbes, R.J. 1955. *Studies in Ancient Technology*, vol. 3. Leiden: Brill.

Forbes, R.J. 1956. *Studies in Ancient Technology*, vol. 4. Leiden: Brill.

Forbes, R.J. 1966. *Studies in Ancient Technology*, vol. 5. 2nd edn. Leiden: Brill.

Fordyce, C.J., ed. 1961. *Catullus: A Commentary.* Oxford: Clarendon Press.

Formigli, Edilberto, ed. 2013. *Colore e luce nella statuaria antica in bronzo.* Rome: Bretschneider.

Fountoulakis, Andreas. 2004. "The Colours of Desire and Death: Colour Terms in Bion's *Epitaph on Adonis.*" In Liza Cleland, Karen Stears, and Glenys Davies (eds.), *Colour in the Ancient Mediterranean World.* Oxford: John and Erica Hedges.

Fournet, Jean-Luc. 2004. "Deux textes relatifs à des couleurs." In Hermann Harrauer and Rosario Pintaudi (eds.), *Gedenkschrift Ulrike Horak (P. Horak).* 2 vols. Florence: Gonnelli.

Fragmenta historicorum graecorum (FGH). 1841–84. Edited by Karl Otfried Müller, Theodor Müller, M. Letronne, and Charles Victor Langlois. 5 vols. Paris: Ambrosio Firmin Didot.

Franks, Hallie M. 2012. *Hunters, Heroes, Kings: The Frieze of Tomb II at Vergina.* Princeton, NJ: American School of Classical Studies at Athens.

Freedberg, David. 1989. *The Power of Images: Studies in the History and Theory of Response.* Chicago: Chicago University Press.

Fremersdorf, Fritz, and Edeltraud Polónyi-Fremersdorf. 1984. *Die farblosen Gläser der Frühzeit in Köln, 2 und 3 Jahrhundert.* Bonn: Rudolf Habelt and Archäologische Gesellschaft Köln.

Freyer-Schauenberg, Brigitte. 2002 "Die Statue des Trajan auf Samos." *Mitteilungen des Deutschen Archäologischen Instituts: Athenische Abteilung*, 117: 257–99.

Fruyt, Michèle. 2006. "La lexicalisation et la conceptualisation de la couleur dans les textes techniques et scientifiques latins." In Claude Thomasset (ed.), *L'écriture du texte scientifique: des origines de la langue française au xviiie siècle.* Paris: Presses de l'Université Paris-Sorbonne.

Furley, David. 1993. "Democritus and Epicurus on Sensible Qualities." In Jacques Brunschwig and Martha C. Nussbaum (eds.), *Passions and Perceptions.* Cambridge: Cambridge University Press.

Gabelmann, Hanns. 1977. "Di ritterliche Trabea." *Jahrbuch des Deutschen Archäologischen Instituts*, 92: 322–74.

Gaetani, Maria Carolina, Ulderico Santamaria, and Claudio Seccaroni. 2004. "The Use of Egyptian Blue and Lapis Lazuli in the Middle Ages: The Wall Paintings of the San Saba Church in Rome." *Studies in Conservation*, 49(1): 13–22.

Gage, John. 1993. *Colour and Culture: Practice and Meaning from Antiquity to Abstraction.* London: Thames and Hudson.

Gage, John. 1999. *Color and Meaning: Art, Science, and Symbolism.* London: Thames and Hudson; Berkeley: University of California Press.

Gaifman, Milette. 2008. "Visualized Rituals and Dedicatory Inscriptions on Votive Offerings to the Nymphs." *Opuscula*, 1: 85–103.

Gans, Ulrich-Walter. 1994. "Hellenistische Architekturteile aus Hartgestein in Alexandria." *Archäologischer Anzeiger*, 3: 433–53.

Ganson, Todd. 1999. "Democritus Against Reducing Sensible Qualities." *Ancient Philosophy*, 19: 201–15.

Ganson, Todd. 2004. "Third-Century Peripatetics on Vision." In William W. Fortenbaugh and Stephen A. White (eds.), *Lyco of Troas and Hieronymus of Rhodes*. New Brunswick, NJ: Transaction.

Gaspa, Salvatore, Cécile Michel, and Marie-Louise Nosch, eds. 2017. *Textile Terminologies from the Orient to the Mediterranean and Europe, 1000 BC to 1000 AD*. Lincoln, NE: Zea Books.

Gell, Alfred. 1998. *Art and Agency*. Oxford: Oxford University Press.

Gellius, Aulus. 1927. *Attic Nights*, vol. 1. Translated by John Rolfe. Cambridge, MA: Harvard University Press; London: Heinemann.

Gellius, Aulus. 1968. *Noctes Atticae*. Edited by Peter K. Marshall. Oxford: Oxford University Press.

Georgiou, Giorgos. 2009. "Three Stone Sarcophagi from a Cypro-Classical Tomb at Kition." *Cahiers d'Études Chypriotes*, 39: 118–24.

Gernet, Louis. 1957. "Dénominations et perceptions des couleurs chez les grecs." In Ignace Meyerson (ed.), *Problèmes de la couleur*. Paris: S.E.V.P.E.N.

Gert, Joshua. 2006. "A Realistic Colour Realism." *Australasian Journal of Philosophy*, 84(4): 565–89.

Giacometti, Giovanni. 1998. "Il colore della porpora e la meccanica quantistica." In Oddone Longo (ed.), *La Porpora: Realtà e immaginario di un colore simbolico*. Venice: Instituto Veneto di Scienze, Lettere, ed Arti.

Gillis, Carole. 1999. "The Economic Value and Color Symbolism of Tin." In Suzanne M.M. Young and A. Mark Pollard (eds.), *Metals in Antiquity*. Oxford: Archaeopress.

Giumlia-Mair, Alessandra R. 1995. "The Appearance of Black Patinated Copper-Gold Alloys in the Mediterranean Area in the Second Millennium B.C.: Material Characterisation and Problem of Origin." In Giulio Mortiani and Jeremy P. Northover (eds.), *Prehistoric Gold in Europe*. Dordrecht: Kluwer.

Giumlia-Mair, Alessandra R. 2018. "Polychromy on Greek and Roman Metals: Texts and Analyses." In Heidemarie Eilbracht, Orsolya Heinrich-Tamáska, Barbara Niemeyer, Ina Reiche, and Hans-Ulrich Voss (eds.), *Über den Glanz des Goldes und die Polychromie: technische Vielfalt und kulturelle Bedeutung vor- und frühgeschichtlicher Metallarbeiten*. Bonn: Habelt.

Gladstone, William Ewart. 1858. "Homer's Perceptions and Use of Colour." In *Studies on Homer and the Homeric Age*, vol. 3. Oxford: Oxford University Press.

Gladstone, William Ewart. 1877. "The Colour-Sense." *Nineteenth Century: A Monthly Review*, 2: 366–88.

Glare, P.G.W., ed. 1982. *Oxford Latin Dictionary*. Oxford: Oxford University Press.

Gold, Barbara K., and John F. Donahue, eds. 2005. *Roman Dining*. Baltimore: Johns Hopkins University Press.

Goldbeck, Fabian, and Johannes Wienand, eds. 2017. *Der römische Triumph in Prinzipat und Spätantike*. Berlin: De Gruyter.

Goldman, Rachael B. 2013. *Color-Terms in Social and Cultural Context in Ancient Rome*. Piscataway, NJ: Gorgias Press.

González, José Miguel. 2013. *The Epic Rhapsode and His Craft: Homeric Performance in a Diachronic Perspective*. Washington, DC: Center for Hellenic Studies.

Gordon, Richard. 1999. "Imagining Greek and Roman Magic." In Valerie Irene Jane Flint (ed.), *Witchcraft and Magic in Europe: Ancient Greece and Rome*. London: Athlone Press.

Gostenčnik, Kordula. 2013. "Textile Production and Trade in Roman Noricum." In Margarita Gleba and Judit Pásztókai-Szeöke (eds.), *Work and Identity: The Agents of Textile Production and Exchange in the Roman Period*. Oxford: Oxbow.

Gottschalk, H.B. 1964. "The *De Coloribus* and its Author." *Hermes*, 92(1): 59–85.

Grand-Clément, Adeline. 2009. "Les marbres antiques retrouvent des couleurs: Apport des recherches récentes et débats en cours." *Anabases*, 10: 243–50.

Grand-Clément, Adeline. 2010. "Les yeux d'Athéna: Le rôle des couleurs dans la construction de l'identité divine." *Archiv für Religionsgeschichte*, 12: 7–22.

Grand-Clément, Adeline. 2011. *La fabrique des couleurs: Histoire du paysage sensible des Grecs anciens (VIIIᵉ–début du Vᵉ s. av. n. è)*. Paris: De Boccard.

Grand-Clément, Adeline. 2012. "Poikilia: Pour une anthropologie de la bigarrure." In Pascal Payen and Evelyne Scheid-Tissinier (eds.), *Anthropologie de l'Antiquité: Anciens objets, nouvelles approches*. Turnhout: Brepols.

Grand-Clément, Adeline. 2015. "Poikilia." In Pierre Destrée and Penelope Murray (eds.), *A Companion to Ancient Aesthetics*. Malden, MA: Wiley-Blackwell.

Grand-Clément, Adeline. 2016. "Gold and Purple: Brilliance, Materiality and Agency of Color in Ancient Greece." In Rachael B. Goldman (ed.), *Essays in Global Color History: Interpreting the Ancient Spectrum*. Piscataway, NJ: Gorgias Press.

Grand-Clément, Adeline. 2017. "Des couleurs et des sens: Percevoir la présence divine." In Gabriella Pironti and Corinne Bonnet (eds.), *Les dieux d'Homère: Polythéisme et poésie en Grèce ancienne*. Liège: Presses Universitaires de Liège.

Graser, Elsa R. 1940. "Edict of Diocletian on Maximum Prices." In Tenney Frank (ed.), *An Economic Survey of Ancient Rome*, vol. 5. Baltimore: Johns Hopkins University Press.

Gregarek, Heike. 1999. "Untersuchungen zur kaiserzeitlichen Idealplastik aus Buntmarmor." *Kölner Jahrbuch*, 32: 33–284.

Griffith, Mark. 2010. "Satyr Play and Tragedy, Face to Face." In Oliver Taplin and Rosie Wyles (eds.), *The Pronomos Vase and its Context*. Oxford: Oxford University Press.

Gros, Pierre. 1976. *Aurea Templa: Recherches sur l'architecture religieuse de Rome à l'époque d'Auguste*. Rome: École Française de Rome.

Grose, David F. 1991. "Early Imperial Roman Cast Glass: The Translucent Colored and Colourless Fine Wares." In Martine Newby and Kenneth Scott Painter (eds.), *Roman Glass: Two Centuries of Art and Invention*. London: Society of Antiquaries of London.

Guidobaldi, Federico. 2000. "La lussuosa aula presso Porta Marina a Ostia: La decorazione in *opus sectile* dell'aula." In Serena Ensoli and Eugenio La Rocca (eds.), *Aurea Roma: dalla città pagana alla città cristiana: Mostra, Roma, Palazzo delle Esposizioni, 22 dicembre 2000–20 aprile 2001*. Rome: Bretschneider.

Guidobaldi, Federico. 2003. "Sectilia pavimenta e incrustationes: I rivestimenti polichromi pavimentali e parietali in marmo o materiali litici e litoidi dell'antichità romana." In Annamaria Giusti (ed.), *Eternità e nobilità di materia: Itinerario artistico fra le pietre policrome*. Florence: Polistampa.

Guidobaldi, Maria Paola, Angelo Esposito, Domenico Camardo, and Mario Notomista. 2015. "La presenza di vetri alle finestre di edifici pubblici e privati nell'antica Ercolano." In Luciana Mandruzzato and Marina Uboldi (eds.), *Il vetro in Italia centrale dall'antichità al contemporaneo, XVII Giornate Nazionali di Studio sul Vetro, Massa Martana e Perugia, Maggio 11–12, 2013*. Milan: Centro Culturale Mediolanense.

Hacker, Peter M.S. 1987. *Appearance and Reality: A Philosophical Investigation into Perception and Perceptual Qualities*. Oxford: Blackwell.

Hahm, David. 1978. "Early Hellenistic Theories of Vision and the Perception of Color." In Peter K. Machamer and Robert G. Turnbull (eds.), *Studies in Perception*. Columbus: Ohio State University Press.

Hallett, Christopher H. 2018. "Terracotta, Antiquarianism, and the 'Archaic Revival' of Early Augustan Rome." In Catherine M. Draycott, Rubina Raja, Katherine Welch, and William T. Wootton (eds.), *Visual Histories of the Classical World: Essays in Honour of R.R.R. Smith*. Turnhout: Brepols.

Halleux, Robert, ed. 1981. *Les alchimistes grecs, Tome 1: Papyrus de Leyde, Papyrus de Stockholm, fragments de recette*. Paris: Belles Lettres.

Harlizius-Klück, Ellen, and Giovanni Fanfani. 2016. "(B)orders in Ancient Weaving and Archaic Poetry." In Giovanni Fanfani, Mary Harlow, and Marie-Louise Nosch (eds.), *Spinning Fates and the Song of the Loom: The Use of Textiles, Clothing and Cloth Production as Metaphor, Symbol and Narrative Device in Greek and Latin Literature*. Oxford: Oxbow.

Harlow, Mary, and Marie-Louise Nosch. 2014a. "Weaving the Threads: Methodologies in Textile and Dress Research for the Greek and Roman World—The State of the Art and the Case for Cross-Disciplinarity." In Mary Harlow and Marie-Louise Nosch (eds.), *Greek and Roman Textiles and Dress: An Interdisciplinary Anthology*. Oxford: Oxbow.

Harlow, Mary, and Marie-Louise Nosch, eds. 2014b. *Greek and Roman Textiles and Dress: An Interdisciplinary Anthology*. Oxford: Oxbow.

Harrison, Evelyn B. 1988. "Theseum East Frieze: Color and Attachments." *Hesperia*, 57: 339–49.

Harrison, Evelyn B. 1996. "Pheidias." In Olga Palagia and J.J. Pollitt (eds.), *Personal Styles in Greek Sculpture*. Cambridge: Cambridge University Press.

Hassler, Uta, ed. 2014. *Maltechnik & Farbmittel der Semperzeit*. Munich: Hirmer.

Havelock, Christine M. 1995. *The Aphrodite of Knidos and her Successors: A Historical Review of the Female Nude in Greek Art*. Ann Arbor: University of Michigan Press.

Haynes, Melissa. 2013. "Framing a View of the Unviewable: Architecture, Aphrodite, and Erotic Looking at the Lucianic 'Erôtes'." *Helios*, 40(1–2): 71–95.

Hays, David G., Enid Margolis, Raoul Naroll, and Dale Revere Perkins. 1972. "Color Term Salience." *American Anthropologist*, 74: 1107–21.

Heilmeyer, Wolf-Dieter. 1975. "Apollodorus von Damaskus, der Architekt des Pantheon." *Jahrbuch des Deutschen Archäologischen Instituts*, 90: 316–47.

Hellmann, Marie-Christine. 1992. *Recherches sur le vocabulaire de l'architecture Grecque, d'après les inscriptions de Délos*. Athens: École Française d'Athènes.

Hellmann, Marie-Christine. 2002. *L'architecture Grecque: 1, Les principes de la construction*. Paris: Picard.

Henkel, Friedrich. 1913. *Die römischen Fingerringe der Rheinlande und der benachbarten Gebiete: mit Unterstützung der Römisch-Germanischen Kommission der Kaiserlich Archäologischen Instituts*. 2 vols. Berlin: Georg Riemer.

Hennemeyer, Arnd. 2011. "Zur Lichtwirkung am Zeustempel in Olympia." In Ulrike Wulf-Rheidt and Peter Schneider (eds.), *Licht-Konzepte in der vormodernen Architektur, Diskussionen zur Archäologischen Bauforschung (DiskAB) 10*. Regensburg: Schnell and Steiner.

Hennemeyer, Arnd. 2017. "Antike Architekturpolychromie im 19. Jahrhundert: Mit wissenschaftlicher Methode und künstlerischer Einfühlung vom Fragment zum Gesamtbild." In Uta Hassler (ed.), *Langfristperspektiven archäologischer Stätten: Wissensgeschichte und forschungsgeleitete Konservierung*. Munich: Hirmer.

Hering, Ewald. 1964. *Outlines of a Theory of the Light Sense*. Cambridge, MA: Harvard University Press.

Herodian. 1969–70. *History of the Empire*. Translated by C.R. Whittaker. 2 vols. London: Heinemann; Cambridge, MA: Harvard University Press.

Herodotus. 1920–5. *The Persian Wars*. Translated by A.D. Godley. 4 vols. Cambridge, MA: Harvard University Press; London: Heinemann.

Herrmann, Georgina. 1968. "Lapis Lazuli: The Early Phases of its Trade." *Iraq*, 30: 21–67.

Hesiod. 2018. *Theogony; Works and Days; Testimonia*. Translated by Glenn W. Most. Rev. edn. Cambridge, MA: Harvard University Press.

Heskell, Julia. 1994. "Cicero as Evidence for Attitudes to Dress in the Late Republic." In Judith L. Sebesta and Larissa Bonfante (eds.), *The World of Roman Costume*. Madison: University of Wisconsin Press.

Hittorff, Jacques Ignace. 1851. *Restitution du temple d'Empédocle à Sélinonte, ou l'architecture polychrome chez les Grecs*. Paris: Didot Fréres.

Hoecherl, Marlies. 2015. *Controlling Colours: Function and Meaning of Color in the British Iron Age*. Oxford: Archaeopress.

Hoepfner, Wolfram. 2002. "Farbe in der griechischen Architektur." In Michalis A. Tiverios and Despoina S. Tsiaphaki (eds.), *Color in Ancient Greece: The Role of Color in Ancient Greek Art and Architecture (700–31 B.C.): Proceedings of the Conference Held in Thessaloniki, 12th–16th April, 2000*. Thessaloniki: Aristoteleio Panepistimio Thessalonikeis.

Holloway, R. Ross. 2008. "The Painting of Ancient Sculpture." *American Journal of Archaeology*, 112: 347–51.

Homer. 1995. *Odyssey*. Translated by Augustus Taber Murray and George Dimock. 2nd rev. edn. 2 vols. Cambridge, MA: Harvard University Press.

Homer. 1999. *Iliad*. Translated by Augustus Taber Murray and William F. Wyatt. 2nd rev. edn. 2 vols. Cambridge, MA: Harvard University Press.

Homer. 2003. *Homeric Hymns; Homeric Apocrypha; Lives of Homer*. Edited and translated by Martin L. West. Cambridge, MA: Harvard University Press.

Horace. 2004. *Odes and Epodes*. Edited and translated by Niall Rudd. Cambridge, MA: Harvard University Press.

Horizon. 2011. [TV Programme] 2011–12, episode 1. "Do You See What I See." BBC TWO, August 8.

Hudson, Nicholas F. 2010. "Changing Places: The Archaeology of the Roman *Convivium*." *American Journal of Archaeology*, 114(4): 663–95.

Hughes, Lisa. 2007. "'Dyeing' in Ancient Italy? Evidence for the Purpurarii." In Carole Gillis and Marie-Louise B. Nosch (eds.), *Ancient Textiles: Production, Craft and Society*. Oxford: Oxbow.

Huntingford, George Wynn Brereton, ed. and trans. 1980. *The Periplus of the Erythraean Sea*. London: Hakluyt Society.

Hurwit, Jeffrey M. 2014. "The Lost Art: Early Greek Wall and Panel Painting." In J.J. Pollitt, *The Cambridge History of Painting in the Classical World*. Cambridge: Cambridge University Press.

Ierodiakonou, Katerina. 2005a. "Empedocles on Colour and Colour Vision." *Oxford Studies in Ancient Philosophy*, 29: 1–37.

Ierodiakonou, Katerina. 2005b. "Plato's Theory of Colours in the *Timaeus*." *Rhizai*, 2(2): 219–33.

Ierodiakonou, Katerina. 2009. "Basic and Mixed Colours in Empedocles and Plato." In Cléo Carastro (ed.), *L'Antiquité en couleurs: Catégories, pratiques, représentations*. Grenoble: Jérôme Millon.

Ierodiakonou, Katerina. 2015. "Hellenistic Philosophers on the Phenomenon of Changing Colours." In Brooke Holmes and Klaus-Dietrich Fischer (eds.), *The Frontiers of Ancient Science*. Berlin: De Gruyter.

Ierodiakonou, Katerina. 2018. "Aristotle and Alexander of Aphrodisias on Colour." In B. Bydén and F. Radovic (eds.), *Cross Cultural Dialogues: The Parva Naturalia in Greek, Arabic and Latin Aristotelianism*. Dordrecht: Springer.

Immerwahr, Sara Anderson. 1990. *Aegean Painting in the Bronze Age*. University Park: Pennsylvania State University Press.

Irwin, Eleanor. 1974. *Colour Terms in Greek Poetry*. Toronto: Hakkert.

Jacobson, David M., and Michael Weitzman. 1992. "What was Corinthian Bronze?" *American Journal of Archaeology*, 96: 237–47.

James, Catherine. 1996. *The Jewellery of Roman Britain: Celtic and Classical Traditions*. London: University College London Press.

James, Liz. 1996. *Light and Colour in Byzantine Art*. Oxford: Clarendon Press.

Jeammet, Violaine, ed. 2010. *Tanagras: Figurines for Life and Eternity: The Musée du Louvre's Collection of Greek Figurines*. Valencia: Fundación Bancaja.

Jenkins, Ian. 2001. *Cleaning and Controversy: The Parthenon Sculptures 1811–1939*. London: British Museum Publications.

Jenkins, Ian. 2006. *Greek Architecture and Its Sculpture in the British Museum*. London: British Museum Press.

Jenkins, Ian, and Andrew Middleton. 1997. "The Polychromy of the Mausoleum." In Ian Jenkins and Geoffrey B. Waywell (eds.), *Sculptors and Sculpture of Caria and the Dodecanese*. London: British Museum Press.

Jensen, William B., ed. 2008. *The Leyden and Stockholm Papyri: Greco-Egyptian Chemical Documents from the Early 4th Century AD*. Translated by Earle Radcliffe Caley. Cincinnati, OH: Oesper Collections in the History of Chemistry.

Jockey, Philippe. 2015. *Le mythe de la Grèce blanche: Histoire d'un rêve occidental*. Paris: Belin.

Jockey, Philippe, ed. 2018. *Les arts de la couleur en Grèce ancienne ... et ailleurs: Approches interdisciplinaires*. Athens: École Française d'Athènes.

Johansen, Thomas. 1997. *Aristotle on the Sense-Organs*. Cambridge: Cambridge University Press.

Johns, Catherine. 1996. *The Jewellery of Roman Britain: Celtic and Classical Traditions*. London: University College London Press.

Johns, Catherine, and Timothy W. Potter. 1983. *The Thetford Treasure: Roman Jewellery and Silver*. London: Trustees of the British Museum.

Jones, Andrew. 2004. "Matter and Memory: Colour, Remembrance and the Neolithic/ Bronze Age Transition." In Elizabeth DeMarrais, Chris Gosden, and Colin Renfrew (eds.), *Rethinking Materiality: The Engagement of Mind with the Material World*. Cambridge: McDonald Institute for Archaeological Research.

Jones, Andrew, and Gavin MacGregor, eds. 2002. *Colouring the Past: The Significance of Colour in Archaeological Research*. Oxford: Berg.

Jones, Michael, and Susanna McFadden, eds. 2015. *Art of Empire: The Roman Frescoes and Imperial Cult Chamber in Luxor Temple*. New Haven, CT: Yale University Press.

Jones, Nathaniel B. 2019. *Painting, Ethics, and Aesthetics in Rome*. Cambridge: Cambridge University Press.

Juan-Tresserras, Jordi. 2000. "El uso de plantas para el lavado y teñido de tejidos en época romana: Análisis de residuos de la *fullonica* y la *tinctoria* de Barcino." *Complutum*, 11: 245–52.

Juvenal. 2004. *Juvenal and Persius*. Translated by Susanna Morton Braund. New edn. London: Heinemann; Cambridge, MA: Harvard University Press.

Kaczmaraczyk, Alexander, and Robert E.M. Hedges. 1983. *Ancient Egyptian Faience: An Analytical Survey of Egyptian Faience from Predynastic to Roman Times*. Warminster: Aris and Phillips.

Kakoulli, Ioanna. 1997. "Roman Wall Paintings in Cyprus: A Scientific Investigation of Their Technology." In Hamdallah Béarat (ed.), *Roman Wall Painting: Materials, Techniques, Analysis and Conservation: Proceedings of the International Workshop, Fribourg, 7–9 March 1996*. Freiburg: Institute of Mineralogy and Petrography.

Kakoulli, Ioanna. 2009. "Egyptian Blue in Greek Painting between 2500 and 50 BC." In Andrew J. Shortland, Ian C. Freestone and Thilo Rehren (eds.), *From Mine to Microscope: Advances in the Study of Ancient Technology*. Oxford: Oxbow.

Kalaitzaki, A., Asimina Vafiadou, A. Frony, David Reese, A. Drivaliari, and Ioannis Liritzis. 2017. "PO-PU-RE: Workshops, Use and Archaeometric Analysis in Pre-Roman Central Eastern Mediterranean." *Mediterranean Archaeology and Archaeometry*, 17(1): 103–30.

Kalderon, Mark. 2015. *Form Without Matter: Empedocles and Aristotle on Color Perception*. Oxford: Oxford University Press.

Kane, Susan. 2006. "Bronze Plaques from the Archaic Favissa at Cyrene." In Emanuela Fabbricotti and Oliva Menozzi (eds.), *Cirenaica: studi, scavi e scoperte, parte I: Nuovi dati da città e territorio, Atti del X Convegno di Archeologia Cirenaica Chieti 24–26 Novembre 2003*. Oxford: Hedges.

Kanold, Inge B., and Rolf Haubrichs. 2008. "Tyrian Purple Dyeing: An Experimental Approach with Fresh *Murex Trunculus*." In Carmen Alfaro Giner and Lilian Karali (eds.), *Vestidos, textiles y tintes: Estudios sobre la producción de bienes de consumo en la Antigüedad: Actas del II Symposium Internacional sobre Textiles y Tintes del Mediterráno en el Mundo Antiguo (Atenas, 24 al 26 de noviembre, 2005)*. Valencia: Universitat de València.

Kantarelou, Vasiliki, Michail Axiotis, and Andreas Germanos Karydas. 2016. "New Investigations into the Statue of Phrasikleia II: A Systematic Investigation of Pigment Traces on Phrasikleia Statue by Means of Scanning Micro-XRF Analyses." *Jahrbuch des Deutschen Archäologischen Instituts*, 131: 51–91.

Karali, Lilian, and Fragkiska Megaloudi. 2008. "Purple Dyes in the Environment and the History of the Aegean: A Short Review." In Carmen Alfaro Giner and Lilian Karali (eds.), *Purpureae vestes II: Vestidos, textiles y tintes, estudios sobre la producción de bienes de consumo en la Antigüedad*. Valencia: Universitat de València.

Katsaros, Thomas, and Yannis Bassiakos. 2002. "Color in Hellenistic Painting." In Michalis A. Tiverios and Despoina S. Tsiaphakis (eds.), *Color in Ancient Greece: The Role of Color in Ancient Greek Art and Architecture (700–31 B.C), Proceedings of the Conference Held in Thessaloniki, 12th–16th April, 2000*. Thessaloniki: Aristoteleio Panepistimio Thessalonikis.

Katsaros, Thomas, and Theodore Ganetsos. 2012. "Raman Characterization of Gemstones from the Collection of the Byzantine and Christian Museum." *Archaeology*, 1(2): 7–14.

Katsaros, Thomas, and Constantinos Vasiliadis. 2019. "Polychromy in Greek Sculpture." In Olga Palagia (ed.), *Handbook of Greek Sculpture*. Berlin: De Gruyter.

Katsaros, Thomas, Ioannis Liritzis, and Nikolaos Laskaris. 2010. "Identification of Theophrastus' Pigments *egyptios yanos* and *psimythion* from Archaeological Excavations: A Case Study." *ArcheoSciences*, 34: 69–79.

Kay, Paul. 1999. "The Emergence of Basic Color Lexicons Hypothesis: A Comment on 'The Vocabulary of Color with Particular Reference to Ancient Greek and Classical Latin,' by John Lyons." In Alexander Borg (ed.), *The Language of Color in the Mediterranean*. Stockholm: Almqvist and Wiksell.

Kay, Paul, and Chad K. McDaniel. 1978. "The Linguistic Significance of the Meanings of Basic Color Terms." *Language*, 54: 610–46.

Kay, Paul, Brent Berlin, Luisa Maffi, and William Merrifield. 1997. "Color Naming Across Languages." In Clyde L. Hardin and Luisa Maffi (eds.), *Color Categories in Thought and Language*. Cambridge: Cambridge University Press.

Kay, Paul, Brent Berlin, Luisa Maffi, William R. Merrifield, and Richard Cook. 2009. *The World Color Survey*. Stanford, CA: Center for the Study of Language and Information (CSLI).

Kiilerich, Bente. 2014. "The *Opus Sectile* from Porta Marina at Ostia and the Aesthetics of Interior Decoration." In Ine Jacobs (ed.), *Production and Prosperity in the Theodosian Period*. Leuven: Peeters.

Kiilerich, Bente. 2016. "Subtlety and Simulation in Late Antique *Opus Sectile*." In Paola Antonella Andreuccetti and Deborah Bindani (eds.), *Il colore nel Medioevo: arte, simbolo, tecnica: tra materiali constitutive e colori aggiunti: mosaici, intarsi e plastica lapidea, Atti delle Giornate di Studi Lucca 24–26 Ottobre 2013*. Lucca: Istituto Storico Lucchese.

Kirk, Geoffrey Stephen, John Earle Raven, and Malcolm Schofield. 1983. *The Presocratic Philosophers: A Critical History with a Selection of Texts*. 2nd edn. Cambridge: Cambridge University Press.

Kober, Alice Elizabeth. 1932. *The Use of Color Terms in the Greek Poets, Including all the Poets from Homer to 146 B.C. Except the Epigrammatists*. Geneva, NY: Humphrey.

Koch, Herbert. 1912. *Dachterrakotten aus Campanien mit Ausschluss von Pompei*. Berlin: Reimer.

Koch, Herbert. 1955. *Studien zum Theseustempel in Athen*. Berlin: Akademie-Verlag.

Koch, Nadia J. 1996. *De Picturae Initiis: Die Anfänge der griechischen Malerei im 7. Jahrhundert v. Chr.* Munich: Biering and Brinkmann.

Koch-Brinkmann, Ulrike, Heinrich Piening, and Vinzenz Brinkmann. 2014. "Girls and Goddesses: On the Costumes of Archaic Female Statues." In Jan Stubbe Østergaard and Anne Marie Nielsen (eds.), *Transformations: Classical Sculpture in Colour*. Copenhagen: Ny Carlsberg Glyptotek.

Kock, Theodor, ed. 1880–8. *Comicorum atticorum fragmenta*. 3 vols. Leipzig: Teubner.

Koenigs, Wolf. 2008. "Die Erscheinung des Bauwerks: Aspekte klassischer und hellenistischer Oberflächen." In İnci Delemen (ed.), *Euergetes: Festschrift für Dr. Haluk Abbasoğlu*. Antalya: Suna and İnan Kıraç Research Institute on Mediterranean Civilizations.

Koenigs, Wolf. 2015. *Der Athenatempel von Priene*. Wiesbaden: Reichert.

Kolendo, Jerzy. 1986. "Il *tinctor tenuarius*—tintore in un' iscrizione di Verona."
 Archeologia (Warsaw), 37: 31–40.
Koren, Zvi C. 2005. "The First Optimal All-Murex All-Natural Purple Dyeing in
 the Eastern Mediterranean in a Millennium and a Half." *Dyes in History and
 Archaeology*, 20: 136–49.
Koren, Zvi C. 2013. "New Chemical Insights into the Ancient Molluskan Purple
 Dyeing Process." In Ruth Ann Armitage and James H. Burton (eds.), *Archaeological
 Chemistry VIII*. Washington, DC: American Chemical Society.
Korka, Elena. 2013 "Η γραπτή πώρινη σαρκοφάγος Φανερωμένης Χιλιομοδίου
 Κορινθίας: Προκαταρκτική παρουσίαση" (A Painted Poros Sarcophagus from
 Faneromeni Chiliomodiou in Corinthia: A Preliminary Presentation). In
 Konstantinos Kissas and Wolf-Dietrich Niemeier (eds.), *The Corinthia and the
 Northeast Peloponnese: Topography and History from Prehistoric Times until the
 End of Antiquity*. Munich: Hirmer.
Kottaridi, Angéliki. 2006. "Couleur et sens: L'emploi de la couleur dans la tombe de
 la reine Eurydice." In Anne-Maris Guimier-Sorbets and Miltiades B. Hatzopoulos
 (eds.), *Rois, cités, necropolis: Institutions, rites et monuments en Macédoine*. Athens:
 Centre de Recherches de l'Antiquité Grecque et Romaine.
Koutsakou, Andriani. 2013. "The Words *Poikilos* and *Krotokos* in Connection with
 Clothing and the Search for the Sources of the Ancient Greek Dress." *Thetis*, 20:
 53–77.
Kreuzner, Christina. 2013. "Alkanna Tinctoria (L.) Tausch as a Purple Dye in the
 Recipes of *Papyrus Holmiensis* and *Papyrus Leidensis X*." *e-PreservationScience*, 10:
 123–30. Available online: http://www.morana-rtd.com/e-preservationscience/2013/
 Kreuzner-16-01-2013.pdf (accessed May 22, 2020).
Kristol, Andres M. 1978. *Color: Les langues romanes devant le phénomène de la couleur*.
 Berne: Francke.
Kristol, Andres M. 1980. "Color Systems in Southern Italy: A Case of Regression."
 Language, 56: 137–45.
La Follette, Laetitia. 1994. "The Costume of the Roman Bride." In Judith Lynn Sebesta
 and Larissa Bonfante (eds.), *The World of Roman Costume*. Madison: University of
 Wisconsin Press.
Lahusen, Götz, and Edilberto Formigli. 2001. *Römische Bildnisse aus Bronze: Kunst
 und Technik*. Munich: Hirmer.
Lao, Eugenia. 2011. "Luxury and the Creation of a Good Consumer." In Roy K. Gibson
 and Ruth Morello (eds.), *Pliny the Elder: Themes and Contexts*. Leiden: Brill.
Lapatin, Kenneth. 2001. *Chryselephantine Statuary in the Ancient Mediterranean
 World*. Oxford: Oxford University Press.
Lapatin, Kenneth. 2015a. "Luxury Arts." In Barbara E. Borg (ed.), *A Companion to
 Roman Art*. Chichester: Wiley.
Lapatin, Kenneth. 2015b. *Luxus: The Sumptuous Arts of Greece and Rome*. Los
 Angeles: J. Paul Getty Museum.
Lapidge, Michael. 1989. "Stoic Cosmology and Roman Literature, First to Third
 centuries A.D." *Aufsteig und Niedergang der römischen Welt*, II. 36(3): 1379–429.
Larsson Lovén, Lena. 1998. "Male and Female Professions in the Textile Production
 of Roman Italy." In Lise Bender Jørgensen and Christina Rinaldo (eds.), *Textiles in
 European Archaeology: Report from the 6th NESAT Symposium, 7–11th May 1996
 in Borås*. Göteborg: Department of Archaeology, Göteborg University.

Lazzaretti, Alessandra. 2014. "Verres, Cicero and Other Collectors in Late Republican Rome." In Maia Wellington Gahtan and Donatella Pegazzano (eds.), *Museum Archetypes and Collecting in the Ancient World*. Leiden: Brill.

Lazzarini, Lorenzo. 1982. "The Discovery of Egyptian Blue in a Roman Fresco of the Mediaeval Period (Ninth Century AD)." *Studies in Conservation*, 27: 84–6.

Lazzarini, Lorenzo, and Marco Verità. 2015. "First Evidence for 1st Century AD Production of Egyptian Blue Frit in Roman Italy." *Journal of Archaeological Science*, 53: 578–85.

Lee, Lorna, and Stephen Quirke. 2000. "Painting Materials." In Paul T. Nicholson and Ian Shaw (eds.), *Ancient Egyptian Materials and Technology*. Cambridge: Cambridge University Press.

Lee, Mi-Kyoung. 2005. *Epistemology after Protagoras*. Oxford: Oxford University Press.

Lee, Mireille M. 2015. *Body, Dress, and Identity in Ancient Greece*. Cambridge: Cambridge University Press.

Leggett, William F. 1944. *Ancient and Medieval Dyes*. New York: Chemical Publishing.

Lenzi, Sarah Elizabeth. 2016. *La policromia dei monochromata: La ricerca del colore su dipinti su lastre di marmo di età romana*. Florence: Florence University Press.

Lepinski, Sarah. 2016. "Roman Interior Design." In Georgia L. Irby (ed.), *A Companion to Science, Technology, and Medicine in Ancient Greece and Rome*. Chichester: Wiley Blackwell.

Lewis, Charlton T., and Charles Short. 1879. *A Latin Dictionary Founded on Andrews' Edition of Freund's Latin Dictionary*. Oxford: Clarendon Press.

Lewis, Sian, and Lloyd Llewellyn-Jones. 2018. *The Culture of Animals in Antiquity: A Sourcebook with Commentaries*. London: Routledge.

Linders, Tullia. 1972. *Studies in the Treasure Records of Artemis Brauronia Found in Athens*. Lund: Åström.

Liverani, Paolo. 2003. "Die Polychromie des Augustus von Prima Porta, vorläufiger Bericht." In Gerhard Zimmer (ed.), *Neue Forschungen zur hellenistischen Plastik: Kolloquium zum 70. Geburtstag von Georg Daltrop*. Wolnzach: Kaster.

Liverani, Paolo. 2004. "L'Augusto di Prima Porta." In Paolo Liverani (ed.), *I colori del bianco: Mille anni di colore nella scultura antica*. Rome: De Luca.

Liverani, Paolo. 2009. "Osservazioni sulla policromia e la doratura della scultura in età tardoantica." In Paola Antonella Andreuccetti and Iacopo Lazzareschi Cervelli (eds.), *Il colore nel Medioevo, arte, simbolo, tecnica: Pietra e colore, conoscenza, conservazione e restauro della policromia; Atti delle giornate di studi, Lucca 22.–24.11.2007*. Lucca: Istituto Storico Lucchese.

Liverani, Paolo. 2018. "Reflections on the Colour Coding in Roman Art." In Philippe Jockey (ed.), *Les arts de la couleur en Grèce ancienne … et ailleures: Approches interdisciplinaires*. Athens: École Française d'Athènes.

Liverani, Paolo, and Ulderico Santamaria, eds. 2014. *Diversamente bianco: La policromia della scultura romana*. Rome: Quasar.

Liverani, Paolo, Hansgeorg Bankel, and Anna Gramiccia, eds. 2004. *I colori del bianco: Policromia nella scultura antica*. Rome: De Luca.

Livy. 1919. *History of Rome*, vol. 1. Translated by B.O. Foster. Cambridge, MA: Harvard University Press; London: Heinemann.

Livy. 1926. *History of Rome*, vol. 4. Translated by B.O. Foster. Cambridge, MA: Harvard University Press; London: Heinemann.

Livy. 1949. *History of Rome*, vol. 8. Translated by F.G. Moore. Cambridge, MA: Harvard University Press; London: Heinemann.

Livy. 2017. *History of Rome*, vol. 9. Edited and translated by John C. Yardley. Cambridge, MA: Harvard University Press.

Livy. 2018. *History of Rome*, vol. 10. Edited by John Briscoe and John Yardley; translated by John Yardley. Cambridge, MA: Harvard University Press.

Llewellyn-Jones, Lloyd. 2002. "A Woman's View? Dress, Eroticism, and the Ideal Female Body in Athenian Art." In Lloyd Llewellyn-Jones (ed.), *Women's Dress in the Ancient Greek World*. Swansea: Classical Press of Wales.

Llewellyn-Jones, Lloyd. 2003. *Aphrodite's Tortoise: The Veiled Woman of Ancient Greece*. Swansea: Classical Press of Wales.

Lloyd, Geoffrey Ernest Richard. 1966. *Polarity and Analogy, Two Types of Argumentation in Early Greek Thought*. Cambridge: Cambridge University Press.

Long, Anthony, and David Sedley. 1987. *The Hellenistic Philosophers*. 2 vols. Cambridge: Cambridge University Press.

Longo, Oddone. 1998a. "La zoologia delle porpore nell'antichità Greco-Romana." In Oddone Longo (ed.), *La Porpora: Realtà e immaginario di un colore simbolico*. Venice: Instituto Veneto di Scienze, Lettere, ed Arti.

Longo, Oddone, ed. 1998b. *La Porpora: Realtà e immaginario di un colore simbolico*. Venice: Instituto Veneto di Scienze, Lettere, ed Arti.

Lorenz, Hendrik. 2007. "The Assimilation of Sense to Sense-Object in Aristotle." *Oxford Studies in Ancient Philosophy*, 33: 179–220.

Loria, Kevin. 2015. "No One Could Describe the Color 'Blue' until Modern Times." *Business Insider*, February 28. Available online: https://www.businessinsider.com/what-is-blue-and-how-do-we-see-color-2015-2?IR=T (accessed May 20, 2020).

Lucan. 1928. *The Civil War*. Translated by J.D. Duff. Cambridge, MA: Harvard University Press; London: Heinemann.

Lucian. 1967a. *Lucian*, vol. 8. Translated by M.D. McLeod. Cambridge, MA: Harvard University Press; London: Heinemann.

Lucian. 1967b. *Soloecista, Lucius or The Ass, Amores, Halcyon, Demosthenes, Podagra, Ocypus, Cyniscus, Philopatris, Charidemus, Nero*. Translated by M.D. McLeod. Cambridge, MA: Harvard University Press; London: Heinemann.

Lucretius. 1992. *De rerum natura*. Translated by W.H.D. Rouse; revised by Martin Ferguson Smith. Corrected 2nd edn. Cambridge, MA: Harvard University Press.

Lucy, John A. 1992. *Language Diversity and Thought: A Reformulation of the Linguistic Relativity Hypothesis*. Cambridge: Cambridge University Press.

Lucy, John A., and Richard A. Shweder. 1979. "Whorf and his Critics: Linguistic and Nonlinguistic Influences on Color Memory." *American Anthropologist*, 81: 581–615.

Lyons, John. 1999. "The Vocabulary of Color with Particular Reference to Ancient Greek and Classical Latin." In Alexander Borg (ed.), *The Language of Color in the Mediterranean*. Stockholm: Almqvist and Wiksell.

Lysias. 1930. *Lysias*. Translated by W.R.M. Lamb. Cambridge, MA: Harvard University Press; London: Heinemann.

MacGregor, Arthur. 1985. *Bone, Antler, Ivory and Horn: The Technology of Skeletal Materials since the Roman Period*. London: Croom Helm.

MacLachlan, Bonnie. 1993. *The Age of Grace: Charis in Early Greek Poetry*. Princeton, NJ: Princeton University Press.

MacLaury, Robert E. 1997. *Color and Cognition in Mesoamerica: Constructing Categories as Vantages*. Austin: University of Texas Press.

MacLaury, Robert E. 1999. "Basic Color Terms: Twenty-Five Years After." In Alexander Borg (ed.), *The Language of Color in the Mediterranean*. Stockholm: Almqvist and Wiksell.

Macrobius. 2011. *Saturnalia*, Books 1–2. Edited and translated by Robert A. Kaster. Cambridge, MA: Harvard University Press.

Maffi, Luisa. 2007. "Foreword." In Robert E. MacLaury, Galina V. Paramei, and Don Dedrick (eds.), *Anthropology of Color*. Amsterdam: John Benjamins.

Magnus, Hugo. 1877. *Die Geschichtliche Entwickelung des Farbensinnes*. Leipzig: von Veit.

Maier, Franz Georg. 1979. "The Paphian Shrine of Aphrodite and Crete." In Republic of Cyprus, Department of Antiquities (ed.), *Acts of the International Archaeological Symposium 'The Relations Between Cyprus and Crete, ca.2000–500 BC, Nicosia, 16th April–22nd April 1978*. Nicosia: Department of Antiquities.

Mallwitz, Alfred, and Wolfgang Schiering. 1964. *Die Werkstatt des Pheidias in Olympia*. Berlin: De Gruyter.

Mandel, Ursula. 2010. "On the Qualities of the 'Colour' White in Antiquity." In Vinzenz Brinkmann, Oliver Primavesi, and Max Hollein (eds.), *Circumlitio: The Polychromy of Antique and Medieval Sculpture*. Munich: Hirmer.

Manfrini, Ivonne. 2009. "Entre refus et nécessité de la couleur: La sculpture grecque antique." In Cléo Carastro (ed.), *L'Antiquité en couleurs: Catégories, pratiques, représentations*. Grenoble: Jérôme Millon.

Mansfield, John M. 1985. "The Robe of Athena and the Panathenaic Peplos." PhD thesis, University of California, Berkeley.

Manzelli, Valentina. 1994. *La policromia nella statuaria greca arcaica*. Rome: L'Erma di Bretschneider.

Marcaida, Iker, Maite Maguregui, Silvia Fdez-Ortiz de Vallejuelo, Héctor Morillas, Nagore Prieto-Taboada, Marco Veneranda, Kepa Castro, and Juan Manuel Madariaga. 2017. "In Situ X-ray Fluorescence-Based Method to Differentiate Among Red Ochre Pigments and Yellow Ochre Pigments Thermally Transformed to Red Pigments of Wall Paintings from Pompeii." *Analytical and Bioanalytical Chemistry*, 409(15): 3853–60.

Marconi, Clemente. 2011. "The Birth of an Image: The Painting of a Statue of Herakles and Theories of Representation in Ancient Greek Culture." *RES: Anthropology and Aesthetics*, 59/60: 145–67.

Marconi, Clemente. 2012. "Le attività dell'Institute of Fine Arts—NYU sull' Acropoli di Selinunte (2006–2010)." In Carmine Ampolo (ed.), *Sicilia Occidentale: Studi, Rassegne, Ricerche*. Pisa: Scuola Normale Superiore di Pisa.

Marsengill, Katherine. 2018. "Panel Paintings and Early Christian Icons." In Robin M. Jensen and Mark D. Ellison (eds.), *The Routledge Handbook of Early Christian Art*. London: Routledge.

Marshall, Christopher W. 1999. "Some Fifth-Century Masking Conventions." *Greece & Rome*, 46: 188–202.

Martelli, Matteo. 2014. "Alchemical Textiles: Colourful Garments, Recipes and Dyeing Techniques in Graeco-Roman Egypt." In Mary Harlow and Marie-Louise Nosch (eds.), *Greek and Roman Textiles and Dress: An Interdisciplinary Anthology*. Oxford: Oxbow.

Martial. 1993. *Epigrams*. Translated by D.R. Shackleton Bailey. 2 vols. Cambridge, MA: Harvard University Press.

Marzano, Annalisa. 2013. *Harvesting the Sea: The Exploitation of Marine Resources in the Roman Mediterranean*. Oxford: Oxford University Press.

Mastrorosa, Ida Gilda. 2015. "Antiques and Sumptuary Trends in Ancient Rome: A Look Around the Dining Halls of the Late Republic and Early Empire." In Maia Wellington Gahtan and Donatella Pegazzano (eds.), *Museum Archetypes and Collecting in the Ancient World*. Leiden: Brill.

Mattern, Torsten. 1999. "'Vielheit und Einheit': Zu Erscheinungsbild und Wirkung römischer Tempelarchitektur." *Bonner Jahrbücher*, 199: 1–30.

Matthews, Roger, and John Curtis, eds. 2012. *Proceedings of the 7th International Congress of the Archaeology of the Ancient Near East*, vol. 2, *Ancient and Modern Issues in Cultural Heritage, Colour & Light in Architecture, Art & Material Culture*. Wiesbaden: Harrassowitz.

Maund, Barry. 2019. "Color." In Edward N. Zalta (ed.), *The Stanford Encyclopedia of Philosophy*. Available online: https://plato.stanford.edu/archives/spr2019/entries/color/ (accessed May 22, 2020).

Maxwell-Stuart, Peter G. 1970. "The Black Cloaks of the Ephebes." *Proceedings of the Cambridge Philological Society*, 196(16): 113–16.

Maxwell-Stuart, Peter G. 1981. *Studies in Greek Colour Terminology*. 2 vols. Leiden: Brill.

Mazois, François, and François C. Gau. 1838. *Les ruines de Pompei*, vol. 4. Paris: Didot.

McCracken, Grant David. 1990. *Culture and Consumption: New Approaches to the Symbolic Character of Consumer Goods and Activities*. Bloomington: Indiana University Press.

McFadden, Susanna. 2015. "Picturing Power in Late Roman Egypt: The Imperial Cult, Imperial Portraits, and a Visual Panegyric for Diocletian." In Michael Jones and Susanna McFadden (eds.), *Art of Empire: The Roman Frescoes and Imperial Cult Chamber in Luxor Temple*. New Haven, CT: Yale University Press.

McGinn, Colin. 1996. "Another Look at Color." *Journal of Philosophy*, 93(11): 537–55.

McKenzie, Judith. 2007. *The Architecture of Alexandria and Egypt: c. 300 B.C. to A.D. 700*. New Haven, CT: Yale University Press.

Meiers, Fabienne. 2013. "*Ars purpuraria*: Neue methodische Ansätze bei der Anwendung von Küpenverfahren in der Purpurfärberei." *Experimentelle Archäologie in Europa*, 12: 43–58.

Meister, Jan B. 2017. "Tracht, Insignien und Performanz des Triumphators zwischen später Republik und früher Kaiserzeit." In Fabian Goldbeck and Johannes Wienand (eds.), *Der römische Triumph in Prinzipat und Spätantike*. Berlin: De Gruyter.

Meritt Shoe, Lucy T. 1996. "Athenian Ionic Capitals from the Athenian Agora." *Hesperia*, 65: 121–74.

Mertens, Joan R. 2006. "Attic White Ground: Pottery and Painter." In Beth Cohen (ed.), *The Colours of Clay: Special Techniques in Athenian Vases*. Los Angeles: J. Paul Getty Museum.

Merker, Gloria S. 1967. "The Rainbow Mosaic at Pergamon and Aristotelian Colour Theory." *American Journal of Archaeology*, 71: 81–2.

Mervis, Carolyn B., Jack Catlin, and Eleanor H. Rosch. 1975. "Development of the Structure of Color Categories." *Developmental Psychology*, 11: 54–60.

Mielsch, Harald. 1975. *Römische Stuckreliefs*. Heidelberg: Kerle.

Miles, Margaret M. 2016. "The Interiors of Greek Temples." In Margaret M. Miles (ed.), *A Companion to Greek Architecture*. Chichester: Wiley Blackwell.

Miller, Margaret. 1989. "The *Ependytes* in Classical Athens." *Hesperia*, 58(3): 313–29.

Miller, Margaret. 1997. *Athens and Persia in the Fifth Century B.C.: A Study in Cultural Receptivity*. Cambridge: Cambridge University Press.

Miller, Margaret. 2006. "Orientalism and Ornamentalism: Athenian Reactions to Achaemenid Persia." *Arts: the Proceedings of the Sydney University Arts Association*, 28: 117–46.

Miller, Margaret. 2006/2007. "Persians in the Greek Imagination." *Meditarch*, 19/20: 109–23.

Mills, Harianne. 1984. "Greek Clothing Regulations: Sacred and Profane." *Zeitschrift für Papyrologie und Epigraphie*, 55: 245–55.

Moeller, Walter O. 1973. "*Infectores* and *Offectores* at Pompeii." *Latomus*, 32(2): 368–9.

Moeller, Walter O. 1976. *The Wool Trade of Ancient Pompeii*. Leiden: Brill.

Monro, David Binning, and Thomas William Allen, eds. 1963. *Homer, Volumes I–IV*. Oxford: Oxford University Press.

Moore, Timothy J. 2012. *Roman Theatre*. Cambridge: Cambridge University Press.

Moorey, Peter Roger Stuart. 1991. *Ancient Mesopotamian Materials and Industries: The Archaeological Evidence*. Oxford: Clarendon Press.

Moormann, Eric M. 1988. *La pittura parietale romana come fonte di conoscenza per la scultura antica*. Assen: Van Gorcum.

Moreno, Paolo. 2001. *Apelles: The Alexander Mosaic*. Milan: Skira.

Mourelatos, Alexander. 2005. "Intrinsic and Relational Properties of Atoms in the Democritean Ontology." In R. Salles (ed.), *Metaphysics, Soul, and Ethics in Ancient Thought*. Oxford: Oxford University Press.

Mulliez, Maud. 2014. *Le luxe de l'imitation: Le trompe l'oeil de la fin de la République romaine, mémoire des artisans de la couleur*. Naples: Centre Jean Bérard.

Muskett, Georgina. 2004. "Colour Coding and the Representation of Costumes in Mycenaean Wall Painting." In Liza Cleland and Karen Stears (eds.), *Colour in the Ancient Mediterranean World*. Oxford: John and Erica Hedges.

Nagel, Alexander. 2013. "Color and Gilding in Achaemenid Architecture and Sculpture." In D. Potts (ed.), *Oxford Handbook of Ancient Iran*. New York: Oxford University Press.

Neer, Richard. 2010. *The Emergence of the Classical Style in Greek Sculpture*. Chicago: University of Chicago Press.

Neils, Jennifer. 2016. "Color and Carving: Architectural Decoration in Mainland Greece." In Margaret M. Miles (ed.), *A Companion to Greek Architecture*. Chichester: Blackwell.

New American Bible Revised Edition. 2005. Charlotte, NC: Saint Benedict Press.

Nicola, Marco, Chiara Mastrippolito, and Admir Masic. 2016. "Iron Oxide-Based Pigments and Their Use in History." In Damien Faivre (ed.), *Iron Oxides: From Nature to Applications*. Weinheim: Wiley-VCH.

Niemeier, Wolf-Dietrich, Barbara Niemeier, and Ann Brysbaert. 2012. "The Olpe Chigi and New Evidence for Early Archaic Greek Wallpainting from the Oracle Sanctuary of Apollon at Abai (Kalapodi)." In A. Benincasa and E. Mugione (eds.), *L'Olpe Chigi: Storia di un agalma: Atti del Convegno Internazionale (Salerno, 3–4 giugno 2010)*. Salerno: Pandemos.

Nonius. 1903. *De compendiosa doctrina libros XX*. Edited by Wallace M. Lindsay. 3 vols. Leipzig: Teubner.

Normann, Alexander von. 1996. *Architekturtoreutik in der Antike*. Munich: Tuduv.

Nosch, Marie Louise Bech. 2004. "Red Coloured Textiles in the Linear B Inscriptions." In Liza Cleland and Karen Stears (eds.), *Colour in the Ancient Mediterranean World*. Oxford: John and Erica Hedges.

Oakley, John Howard. 2004. *Picturing Death in Classical Athens: The Evidence of the White Lekythoi*. Cambridge: Cambridge University Press.

Oddo, Maria Emanuela. 2018. "The Tomb of the Diver: Annotated Bibliography." In Gabriel Zuchtriegel (ed.), *The Invisible Image: The Tomb of the Diver, on the Fiftieth Anniversary of its Discovery*. Naples: Arte'M.

Oddy, Andrew. 1993. "Gilding of Metals in the Old World." In Susan La Niece
 and Paul Craddock (eds.), *Metal Plating and Patination: Cultural, Technical and
 Historical Developments*. Oxford: Butterworth-Heinemann.
Ogden, Daniel. 2002. "Controlling Women's Dress: Gynaikonomoi." In Lloyd
 Llewellyn-Jones (ed.), *Women's Dress in the Ancient Greek World*. London:
 Duckworth; Swansea: Classical Press of Wales.
Ogden, Jack, and Dyfri Williams. 1994. *Greek Gold Jewellery of the Classical World*.
 London: British Museum Press.
Ohnesorg, Aenne. 2011. "Der Naxische Lichtdom: Das Phänomen lichtdurchlässiger
 inselionischer Marmordächer." In Ulrike Wulf-Rheidt and Peter Schneider (eds.),
 *Licht-Konzepte in der vormodernen Architektur, Diskussionen zur Archäologischen
 Bauforschung (DiskAB) 10*. Regensburg: Schnell and Steiner.
O'Keefe, Tim. 1997. "The Ontological Status of Sensible Qualities for Democritus and
 Epicurus." *Ancient Philosophy*, 17: 119–34.
Olson, Kelly. 2008. *Dress and the Roman Woman: Self-Presentation and Society*.
 London: Routledge.
Olson, Kelly. 2017. *Masculinity and Dress in Roman Antiquity*. Abingdon: Routledge,
 Taylor and Francis.
Oppenheim, L. 1949. "The Golden Garments of the Gods." *Journal of Near Eastern
 Studies*, 8: 172–93.
Osborne, Harold. 1968. "Colour Concepts of the Ancient Greeks." *British Journal of
 Aesthetics*, 8: 269–83.
Osborne, Roy. 2004. *Color Influencing Form: A Color Coursebook*. London: Universal
 Publishers.
Østergaard, Jan Stubbe. 2010. "The Polychromy of Antique Sculpture: A Challenge to
 Western Ideals?" In Vinzenz Brinkmann, Oliver Primavesi, and Max Hollein (eds.),
 Circumlitio: The Polychromy of Antique and Mediaeval Sculpture. Munich: Hirmer.
Østergaard, Jan Stubbe. 2015. "Identical Roman Copies? Diversification through
 Color." In Salvatore Settis with Anna Anguissola and Davide Gasparotto (eds.),
 Serial/Portable Classica: The Multiplying Art in Greece and Rome. Milan:
 Fondazione Prada.
Østergaard, Jan Stubbe. 2017. "Caligula in the Ny Carlsberg Glyptotek, Copenhagen."
 In Vinzenz Brinkmann, Renée Dreyfus, and Ulrike-Koch Brinkmann (eds.), *Gods in
 Color: Polychromy in the Ancient World*. San Francisco: Fine Arts Museums of
 San Francisco.
Østergaard, Jan Stubbe. 2019. "Polychromy, Sculptural, Greek and Roman." In Tim
 Whitmarsh (ed.), *Oxford Classical Dictionary*. 5th edn. Oxford: Oxford University
 Press. http://doi.org/10.1093/acrefore/9780199381135.013.8118
Østergaard, Jan Stubbe, and Anne Marie Nielsen, eds. 2014. *Transformations: Classical
 Sculpture in Colour*. Copenhagen: Ny Carlsberg Glyptotek.
Ovid. 1977. *Heroides; Amores*. Translated by Grant Showerman, revised by G.P. Goold.
 2nd edn. Cambridge, MA: Harvard University Press; London: Heinemann.
Ovid. 1977–84. *Metamorphoses*. Translated by Frank Justus Miller. 3rd edn.
 (vol. 1), 2nd edn. (vols. 2 and 4). Cambridge, MA: Harvard University Press;
 London: Heinemann.
Ovid. 1979. *The Art of Love and Other Poems*. Translated by J.H. Mozley, revised by
 G.P. Goold. 2nd edn. Cambridge, MA: Harvard University Press; London: Heinemann.
Ovid. 1989. *Fasti*. Translated by James G. Frazer. 2nd edn. Cambridge, MA: Harvard
 University Press.

Oxford English Dictionary Online. 2019. 2nd edn. Oxford: Oxford University Press. Available online: https://www.oed.com (accessed May 22, 2020).

Palagia, Olga, ed. 2006. *Greek Sculpture: Function, Materials and Techniques in the Archaic and Classical Periods*. Cambridge: Cambridge University Press.

Pallecchi Pasquino, Gianna Giachi, Maria Perla Colombini, Francesca Modugno, and Erika Ribechini. 2009. "The Painting of the Etruscan Tomba della Quadriga Infernale (4th century BCE), in Sarteano (Siena, Italy): Technical Features." *Journal of Archaeological Science*, 36: 2635–42.

Pasnau, Robert. 2007. "Democritus and Secondary Qualities." *Archiv für Geschichte der Philosophie*, 89: 99–121.

Passeri, Irma, Anne Gunnison, and Erin Mysak. 2017. "The Examination of Flesh Tones on an Ancient Painted Shield from Dura Europos." In Yvonne Schmuhl and Esther P. Wipfler (eds.), *Inkarnat und Signifikanz: Das menschliche Abbild in der Tafelmalerei von 200 bis 1250 im Mittelmeerraum*. Munich: Zentralinstitut für Kunstgeschichte.

Pausanias. 1965–9. *Description of Greece*. Translated by W.H.S. Jones and Henry Arderne Ormerod. 5 vols. Cambridge, MA: Harvard University Press; London: Heinemann.

Pellino, Giuseppe 2006. *Rilievi architettonici fittili d'età imperiale dalla Campania*. Rome: Bretschneider.

Perdikatsis, Vassili. 1998. "Analysis of Greek Bronze Age Wall Painting Pigments." In Sylvie Colinart and Michel Menu (eds.), *La couleur dans la peinture et l'émaillage de l'Egypte ancienne*. Bari: Edipuglia.

Pesando, Fabrizio. 2010. "La domus pompeiana in età sannitica: Nuove acquisizioni dalla Regio VI." In Martin Bentz and Christoph Reusser (eds.), *Etruskisch-italische und römisch-republikanische Häuser*. Wiesbaden: Reichert.

Petrides, Antonis K. 2014. *Menander, New Comedy and the Visual*. Cambridge: Cambridge University Press.

Petridou, Georgia. 2015. *Divine Epiphany in Greek Literature and Culture*. Oxford: Oxford University Press.

Philostratus. 2005. *The Life of Apollonius of Tyana*. Edited and translated by Christopher P. Jones. 2 vols. Cambridge, MA: Harvard University Press.

Phleps, Hermann. 1930. *Farbige Architektur bei den Römern und im Mittelalter*. Berlin: E. Wasmuth Aktiengesellschaft.

Pindar. 2012a. *Nemean Odes; Isthmian Odes; Fragments*. Edited and translated by William H. Race. Rev. edn. Cambridge, MA: Harvard University Press.

Pindar. 2012b. *Olympian Odes; Pythian Odes*. Edited and translated by William H. Race. Rev. edn. Cambridge, MA: Harvard University Press.

Plantzos, Dimitris. 1999. *Hellenistic Engraved Gems*. Oxford: Clarendon Press.

Plantzos, Dimitris. 2018. *The Art of Painting in Ancient Greece*. Athens: Kapon.

Platnauer, Maurice. 1921. "Greek Colour-Perception." *Classical Quarterly*, 15: 153–62.

Plato. 1926. *Laws*. Edited and translated by R.G. Bury. 2 vols. Cambridge, MA: Harvard University Press; London: Heinemann.

Plato. 1932. *Lysis; Symposium; Gorgias*. Translated by W.R.M. Lamb. Corrected edn. London: Cambridge, MA: Harvard University Press; London: Heinemann.

Plato. 1976. *Meno*. Translated by G.M.A. Grube. Indianapolis, IN: Hackett.

Plato. 1990. *The Theaetetus of Plato*. Translated by M.J. Levett, revised by Myles Burnyeat. Indianapolis, IN: Hackett.

Plato. 2000. *Timaeus*. Translated by Donald J. Zeyl. Indianapolis, IN: Hackett.

Plato. 2013. *Republic*, vol. 1. Edited and translated by C.J. Emlyn-Jones and William Preddy. Cambridge, MA: Harvard University Press.

Platt, Verity. 2011. *Facing the Gods: Epiphany and Representation in Graeco-Roman Art, Literature and Religion*. Cambridge: Cambridge University Press.

Platt, Verity. 2014. "Likeness and Likelihood in Greek Art." In Victoria Wohl (ed.), *Probabilities, Hypotheticals, and Counterfactuals in Ancient Greek Thought*. Cambridge: Cambridge University Press.

Platt, Verity. 2016a. "The Matter of Classical Art History." *Daedalus*, 145(2): 5–14.

Platt, Verity. 2016b. "Sight and the Gods: On the Desire to See Naked Nymphs." In Michael Squire (ed.), *Sight and the Ancient Senses*. London: Routledge.

Plautus. 2011. *Plautus*, vol. 2, *Casina; The Casket Comedy; Curculio; Epidicus; The Two Menaechmuses*. Translated by Wolfgang de Melo. Cambridge, MA: Harvard University Press.

Pliny the Elder. 1942. *Natural History*, vol. 2. Translated by H. Rackham. Cambridge, MA: Harvard University Press; London: Heinemann.

Pliny the Elder. 1950. *Natural History*, vol. 5. Translated by H. Rackham. London: Heinemann; Cambridge, MA: Harvard University Press.

Pliny the Elder. 1952. *Natural History*, vol. 9. Translated by H. Rackham. London: Heinemann; Cambridge, MA: Harvard University Press.

Pliny the Elder. 1962. *Natural History*, vol. 10. Translated by D.E. Eichholz. London: Heinemann; Cambridge, MA: Harvard University Press.

Pliny the Elder. 1963. *Natural History*, vol. 8. Translated by W.H.S. Jones. Cambridge, MA: Harvard University Press; London: Heinemann.

Pliny the Elder. 1968. *Natural History*, vol. 4. Translated by H. Rackham. Rev. edn. Cambridge, MA: Harvard University Press; London: Heinemann.

Pliny the Elder. 1969. *Natural History*, vol. 6. Translated by W.H.S. Jones. Rev. edn. Cambridge, MA: Harvard University Press; London: Heinemann.

Pliny the Elder. 1983. *Natural History*, vol. 3. Translated by H. Rackham. 2nd edn. Cambridge, MA: Harvard University Press; London: Heinemann.

Pliny the Younger. 1969. *Letters and Panegyricus*, vol. 2. Translated by Betty Radice. Cambridge, MA: Harvard University Press; London: Heinemann.

Plutarch. 1914a. *Lives*, vol.1, *Theseus and Romulus; Lycurgus and Numa; Solon and Publicola*. Translated by Bernadotte Perrin Cambridge, MA: Harvard University Press; London: Heinemann.

Plutarch. 1914b. *Lives*, vol. 2, *Themistocles and Camillus; Aristides and Cato Major; Cimon and Lucullus*. Translated by Bernadotte Perrin. Cambridge, MA: Harvard University Press; London: Heinemann.

Plutarch. 1919. *Lives*, vol. 7, *Demosthenes and Cicero; Alexander and Caesar*. Translated by Bernadotte Perrin. Cambridge, MA: Harvard University Press; London: Heinemann.

Plutarch. 1959. *Moralia*, vol. 7. Translated by Phillip H. De Lacy and Benedict Einarson. Cambridge, MA: Harvard University Press; London: Heinemann.

Plutarch. 1967. *Moralia*, vol. 14. Translated by Benedict Einarson and Phillip H. de Lacy. Cambridge, MA: Harvard University Press; London: Heinemann.

Poe, Joe Park. 1996. "The Supposed Conventional Meanings of Dramatic Masks: A Re-Examination of Pollux 4.133–54." *Philologus*, 140: 306–28.

Polinger Foster, Karen. 2008. "Minoan Faience Revisited." In Caroline M. Jackson and Emma C. Wagner (eds.), *Vitreous Materials in the Late Bronze Age Aegean*. Oxford: Oxbow Books.

Pollitt, J.J. 1986. *Art in the Hellenistic Age*. Cambridge: Cambridge University Press.

Pollitt, J.J., ed. 2014. *The Cambridge History of Painting in the Classical World*. Cambridge: Cambridge University Press.

Pollux, Julius. 1900–1937. *Pollucis Onomasticon*. Edited by Eric Bethe. 3 vols. Leipzig: Teubner.

Polybius. 2011. *The Histories*, vol. 3. Translated by W.R. Paton, revised by F.W. Walbank and C. Habicht. Rev. edn. Cambridge, MA: Harvard University Press.

Pontrandolfo, Angela, and Agnès Rouveret. 1992. *Le tombe dipinte di Paestum*. Modena: Panini.

Posamentir, Richard, and Holger Wienholz. 2012. "Gebäude mit *litterae aureae* in den kleinasiatischen Provinzen, die Basilika von Berytus und der Jupitertempel von Baalbek." *Istanbuler Mitteilungen*, 62: 161–98.

Praschniker, Camillo, and Max Theueur. 1979. *Das Mausoleum von Belevi*. Vienna: Österreichisches Archäologisches Institut.

Prater, Andreas. 2002. "The Rediscovery of Colour in Greek Architecture and Sculpture." In Michalēs Tiverios and D.S. Tsiaphakē (eds.), *Color in Ancient Greece: The Role of Color in Ancient Greek Art and Architecture (700–31 B.C.)*. Thessaloniki: Aristotle University of Thessaloniki, and Hidryma Meleton Lamprake.

Prater, Andreas. 2004. "Streit um Farbe: Die Wiederentdeckung der Polychromie in der griechischen Architektur und Plastik im 18. und 19. Jahrhundert." In Vinzenz Brinkmann and Raimund Wünsche (eds.), *Bunte Götter. Die Farbigkeit antiker Skulptur: Eine Ausstellung der Staatlichen Antikensammlungen und Glyptothek München*. Munich: Hirmer.

Presicce, Claudio Parisi. 2012. "Costantino e i suoi figli: Il nuovo volto dei potenti." In Paolo Biscottini and Gemma Sena Chiesa (eds.), *Costantino 313 d.C.* Milan: Mondadori Electa.

Price, Jennifer, and Sally Cottam. 1998. *Romano-British Glass Vessels: A Handbook*. York: Council for British Archaeology.

Prioux, Évelyne. 2014. "The Poetic Depictions of Ancient Dactyliothecae." In Maia Wellington Gahtan and Donatella Pegazzano (eds.), *Museum Archetypes and Collecting in the Ancient World*. Leiden: Brill.

Propertius. 1999. *Elegies*. Edited and translated by G.P. Goold. Rev. edn. Cambridge, MA: Harvard University Press.

Puttock, Sonia. 2002. *Ritual Significance of Personal Ornaments in Roman Britain*. BAR British Series 327. Oxford: Archaeopress.

Radiolab. 2012. [Radio Programme] "Colors." National Public Radio, May 21.

Radman-Livaja, Ivan. 2013a. "Craftspeople, Merchants or Clients? The Evidence of Personal Names on the Commercial Lead Tags from Siscia." In Margarita Gleba and Judit Pásztókai-Szeöke (eds.), *Making Textiles in Pre-Roman and Roman Times: People, Places, Identities*. Oxford: Oxbow.

Radman-Livaja, Ivan. 2013b. "Two Lead Tags from Strbinci (Certissia?)." *Arheološki radovi i rasprave*, 17: 165–80.

Radman-Livaja, Ivan. 2018. "Prices and Costs in the Textile Industry in the Light of the Lead Tags from Siscia." In Andrew Wilson and Alan Bowman (eds.), *Trade, Commerce, and the State in the Roman World*. Oxford: Oxford University Press.

Rainer, Leslie, Kiernan Graves, Shin Maekawa, Mark Gittins, and Francesca Piqué. 2017. *Conservation of the Architectural Surfaces in the Tablinum of the House of the Bicentenary, Herculaneum, Phase I: Examination, Investigations, and Condition Assessment*. Los Angeles: The Getty Conservation Institute.

Rayet, Olivier, and Albert Thomas. 1877–80. *Milet et le Golfe Latmique*. Paris: Baudry.

Regier, Terry, and Paul Kay. 2009. "Language, Thought, and Color: Whorf was Half Right." *Trends in Cognitive Sciences*, 13(10): 439–46.

Reinhold, Meyer. 1970. *History of Purple as a Status Symbol in Antiquity*. Brussels: Latomus.

Rendall, Gerald H., trans. 1931. *Tertullian: Apology; De Spectaculis. Minucius Felix: Octavius*. London: Heinemann.

Rescigno, Carlo. 2010. "Metope dipinte con centauromachia da un tempio Cumano di epoca Sannitica: Osservazioni preliminare." In Irene Bragantini (ed.), *Atti del X Congresso Internazionale dell'AIPMA (Association Internationale pour la Peinture Murale Antique), Napoli, 17–21 Settembre 2007*. Naples: Università degli studi di Napoli.

Rhomiopoulou, Katerina, and Barbara Schmidt-Dounas with Hariklia Brecoulaki. 2010. *Das Palmettengrab in Lefkadia*. Mainz: von Zabern.

Richardson, Nicholas J. 1974. *The Homeric Hymn to Demeter*. Oxford: Oxford University Press.

Ridgway, Brunilde S. 1990. "Metal Attachments in Greek Marble Sculpture." In Marion True and Jerry Podany (eds.), *Marble: Art Historical and Scientific Perspectives on Ancient Sculpture*. Malibu: Getty Publications.

Ridgway, Brunilde S. 1999. *Prayers in Stone: Greek Architectural Sculpture ca. 600–100 BC*. Berkeley: University of California Press.

Ridgway, Brunilde S. 2004. *Second Chance: Greek Sculptural Studies Revisited*. London: Pindar Press.

Riedl, Nicole, and Friederike Funke. 2013. "Die römische Außenmalerei und ihre Restaurierungsgeschichte." In Nicole Riedl (ed.), *Weltkulturerbe Konstantinsbasilika Trier: Wandmalerei in freier Bewitterung als konservatorische Herausforderung*. Munich: ICOMOS.

Riley, Charles. 1996. *Color Codes: Modern Theories of Color in Philosophy, Painting and Architecture, Literature, Music and Psychology*. Hanover: UPNE.

Roberson, Debi, Ian Davies, and Jules Davidoff. 2000. "Color Categories are not Universal: Replications and New Evidence from a Stone-Age Culture." *Journal of Experimental Psychology: General*, 129: 369–98.

Roberts, Paul. 2008. *Mummy Portraits from Roman Egypt*. London: British Museum Press.

Rondot, Vincent. 2013. *Derniers visages des dieux d'Egypte: Iconographies, panthéons et cultes dans le Fayoum hellénisé des II^e–III^e siècles de notre ère*. Paris: Louvre éditions.

Rosch, Eleanor Heider. 1972. "Universals in Color Naming and Memory." *Journal of Experimental Psychology: General*, 93: 10–20.

Rosch, Eleanor Heider. 1973. "Natural Categories." *Cognitive Psychology*, 4: 328–50.

Ronchaud, Louis de. 1886. *Au Parthénon: La décoration intérieur de la cella*. Paris: Leroux.

Rose, Charles Brian. 2017. "Fieldwork at Phrygian Gordion, 2013–2015." *American Journal of Archaeology*, 121: 135–78.

Rosenmeyer, Thomas G. 1989. *Senecan Drama and Stoic Cosmology*. Berkeley: University of California Press.

Rosini, Orietta. 2010. "I colori dell'Ara Pacis: Storia di un esperimento." *Archeomatica*, 3: 20–5.

Rothe, Ursula. 2020. *The Toga and Roman Identity*. London: Bloomsbury.

Rouveret, Agnès. 2015. "Painting and Private Art Collections in Rome." In Pierre
 Destrée and Penelope Murray (eds.), *A Companion to Ancient Aesthetics*. Malden,
 MA: Wiley.
Rouveret, Agnès, Sandrine Dubel, and Valérie Naas. 2006. *Couleurs et matières dans
 l'Antiquité: textes, techniques et pratiques*. Paris: Editions Rue d'Ulm.
Rowe, Christopher. 1972. "Conceptions of Colour and Colour Symbolism in the
 Ancient World." *Eranos*, 41: 327–64.
Rowe, Christopher. 1977. "Conceptions of Colour and Colour-Symbolism in the
 Ancient World." In Adolf Portmann (ed.), *Color Symbolism, Six Excerpts from the
 Eranos Yearbook 1972*. Zurich: Spring Publications.
Rowland, Ingrid D., and Thomas Noble Howe. 1999. "Commentary." In Vitruvius,
 Ten Books on Architecture, translated by Ingrid D. Rowland. Cambridge:
 Cambridge University Press.
Rudolph, Kelli. 2011. "Democritus' Perspectival Theory of Vision." *Journal of Hellenic
 Studies*, 131: 67–83.
Rutherford-Dyer, Robert. 1983. "Homer's Wine-Dark Sea." *Greece and Rome*, 30(2):
 125–8.
Rütti, Beat. 1991. "Early Enamelled Glass." In Martine Newby and Kenneth Scott
 Painter (eds.), *Roman Glass: Two Centuries of Art and Invention*. London: Society
 of Antiquaries of London.
Salvant, J., J. Williams, M. Ganio, F. Casadio, C. Daher, K. Sutherland, L. Monico,
 F. Vanmeert, S. De Meyer, K. Janssens, C. Cartwright, and M. Walton. 2018.
 "A Roman Egyptian Painting Workshop: Technical Investigation of the Portraits
 from Tebtunis, Egypt." *Archaeometry*, 60(4): 815–33. https://doi.org/10.1111/
 arcm.12351.
Sambursky, Samuel. 1959. *Physics of the Stoics*. London: Routledge.
Sampson, Geoffrey. 2013. "Gladstone as Linguist." *Journal of Literary Semantics*,
 42: 1–29.
Sand, Luise, and Yvonne Schmuhl. 2017. "Der Tondo des Septimius Severus, der Julia
 Domna, des Caracalla und des Geta." In Yvonne Schmuhl and Esther P. Wipfler
 (eds.), *Inkarnat und Signifikanz: Das menschliche Abbild in der Tafelmalerei von 200
 bis 1250 im Mittelmeerraum*. Munich: Zentralinstitut für Kunstgeschichte.
Sappho and Alcaeus. 1982. *Greek Lyric I. Sappho and Alcaeus*. Edited and translated by
 David A. Campbell. Cambridge, MA: Harvard University Press.
Sassi, Maria M. 1994. "Una percezione imperfetta? I Greci e la definizione dei colori."
 l'immagine riflessa, 2: 281–302.
Sassi, Maria M. 2009. "Entre corps et lumière: Réflexions antiques sur la nature de
 la couleur." In Cléo Carastro (ed.), *L'Antiquité en couleurs: Catégories, pratiques,
 représentations*. Grenoble: Jérôme Millon.
Sassi, Maria M. 2015. "Perceiving Colors." In Pierre Destrée and Penelope Murray
 (eds.), *A Companion to Ancient Aesthetics*. Oxford: Wiley.
Saunders, Barbara. 2000. "Revisiting 'Basic Color Terms'." *Journal of the Royal
 Anthropological Institute*, 6: 81–99.
Saunders, Barbara, and Jaap van Brakel. 1997. "Are there Nontrivial Constraints on
 Colour Categorization?" *Behavioral and Brain Sciences*, 20: 167–228.
Savalli, Angela, Paola Pesaresi, and Lorenzo Lazzarini. 2014. "Casa del Rilievo di
 Telefo and Opus Sectile at Herculaneum." In Patrizio Pensabene and Eleonora
 Gasparini (eds.), *Interdisciplinary Studies on Ancient Stone 10: Proceedings of the
 Tenth International Conference of ASMOSIA*. Rome: Bretschneider.

Savay-Guerraz, Hugues, and Kathy Sas. 2002. "Les couleurs du cirque." In Kathy
 Sas and Hugo Thoen (eds.), *Brillance et prestige: la joaillerie romaine en Europe
 occidentale*. Leuven: Peeters.

Scahill, David. 2009. "The Origins of the Corinthian Capital." In Peter Schultz (ed.),
 *Structure, Image, and Ornament: Architectural Sculpture in the Greek World,
 Proceedings of an International Conference Held at the American School of Classical
 Studies, 27–28 November 2004*. Oxford: Oxbow.

Schädler, Ulrich. 2007. "The Doctor's Grave: New Light on the History of Ancient
 Board Games." In Philip Crummy (ed.), *Stanway: An Elite Burial at Camulodunum*.
 London: Society for the Promotion of Roman Studies.

Schäfer, J. 1977. "Zur kunstegeschichtlichen Interpretation altägäischer Wandmalerei."
 Jahrbuch des Deutschen Archäologischen Instituts, 92: 1–23.

Schäfer, Thomas. 2013. "Marmo e bronzo: sui materiali di lusso nella plastica greca di
 età tardo-arcaica." In Edilberto Formigli (ed.), *Colore e luce nella statuaria antica in
 bronzo*. Rome: Bretschneider.

Schenkel, Wolfgang. 2007. "Color Terms in Ancient Egyptian and Coptic." In Robert
 E. MacLaury, Galina V. Paramei, and Don Dedrick (eds.), *Anthropology of Color:
 Interdisciplinary Multilevel Modeling*. Amsterdam: John Benjamins.

Schenkel, Wolfgang. 2019. "Colours as Viewed by the Ancient Egyptians and the
 Explanation of this View as Seen by Academics Studying Colour." In Shiyanthi
 Thavapalan and David A. Warburton (eds.), *The Value of Colour: Material and
 Economic Aspects in the Ancient World*. Berlin: Topoi.

Schmaltz, Bernhard. 2016. "Neue Untersuchungen an der Statue der Phrasikleia I:
 Es ist nicht alles Gold, was glänzt …" *Jahrbuch des Deutschen Archäologischen
 Instituts*, 131: 31–50.

Schmaltz, Bernhard. 2018. "The Acropolis Kore 682 from Athens: An Approach
 to the Reconstruction of a Greek Late Archaic Sculpture of a Girl." In Philippe
 Jockey (ed.), *Les arts de la couleur en Grèce ancienne … et ailleures*. Athens: École
 Française d'Athènes.

Schmitz, Christine. 1993. *Die kosmische Dimension in den Tragödien Senecas*. Berlin:
 De Gruyter.

Schöntag, Roger, and Barbara Schäfer-Prieß. 2007. "Color Term Research of Hugo
 Magnus." In Robert E. MacLaury, Galina V. Paramei, and Don Dedrick (eds.),
 Anthropology of Color. Amsterdam: John Benjamins.

Schultz, Wolfgang. 1904. *Das Farbenempfindungssystem der Hellenen*. Leipzig: Barth.

Schwandner, Ernst-Ludwig. 1985. *Der ältere Porostempel der Aphaia auf Aegina*.
 Berlin: De Gruyter.

Scott, George D. 1995. "A Study of the Lycurgus Cup." *Journal of Glass Studies*, 37:
 51–64.

Scullion, Scott. 1994. *Three Studies in Athenian Dramaturgy*. Stuttgart: Teubner.

Scullion, Scott. 2002. "'Nothing to Do with Dionysus: Tragedy Misconceived as
 Ritual." *Classical Quarterly*, 52: 102–37.

Sear, Frank B. 1977. *Roman Wall and Vault Mosaics*. Heidelberg: Kerle.

Sebesta, Judith Lynn. 1994. "Tunica Ralla, Tunica Spissa: The Colors and Textiles of
 Roman Costume." In Judith Lynn Sebesta and Larissa Bonfante (eds.), *The World of
 Roman Costume*. Madison: University of Wisconsin Press.

Sebesta, Judith Lynn. 1997. "Women's Costume and Feminine Civic Morality in
 Augustan Rome." *Gender and History*, 9(3): 529–41.

Sebesta, Judith Lynn. 2005. "The Toga Praetexta of Roman Children and Praetextate Garments." In Liza Cleland, M. Harlow, and L. Llewellyn-Jones (eds.), *The Clothed Body in the Ancient World*. Oxford: Oxbow Books.

Sedley, David. 1988. "Epicurean Anti-Reductionism." In Jonathan Barnes and Mario Mignucci (eds.), *Matter and Metaphysics*. Naples: Bibliopolis.

Sedley, David. 1992. "Empedocles' Theory of Vision and Theophrastus' *De Sensibus*." In William W. Fortenbaugh and Dimitri Gutas (eds.), *Theophrastus: His Psychological, Doxographical and Scientific Writings*. New Brunswick, NJ: Transaction.

Sekunda, Nicholas. 2009. "Laconian Shoes with Roman Senatorial Laces." *British School at Athens Studies*, 16: 253–9.

Semper, Gottfried. 1860. *Die textile Kunst für sich betrachtet und in Beziehung zur Baukunst, Bd. 1: Der Stil in den technischen und tektonischen Künsten oder praktische Ästhetik*. Frankfurt: Verlag für Kunst und Wissenschaft.

Seneca the Elder. 1974. *Declamations*. Translated by Michael Winterbottom. 2 vols. Cambridge, MA: Harvard University Press; London: Heinemann.

Seneca the Younger. 1917. *Ad Lucilium epistulae morales*, vol. 1. Translated by Richard M. Gummere. Cambridge, MA: Harvard University Press; London: Heinemann.

Seneca the Younger. 1928. *Moral Essays*, vol. 1. Translated by John W. Basore. Cambridge, MA: Harvard University Press; London: Heinemann.

Seneca the Younger. 1932. *Moral Essays*, vol. 2. Translated by John W. Basore. Cambridge, MA: Harvard University Press; London: Heinemann.

Seneca the Younger. 2018. *Oedipus; Agamemnon; Thyestes; Hercules on Oeta; Octavia*. Edited and translated by John G. Fitch. Rev. edn. Cambridge, MA: Harvard University Press.

Sevinç, Nurten, Reyhand Körpe, Musa Tombul, Charles Brian Rose, Donna Strahan, Henrike Kiesewetter, and John Walldrot. 2001. "A New Painted Graeco-Persian Sarcophagus from Çan." *Studia Trioca*, 11: 383–420.

Shapiro, A. 1980. "Jason's Cloak." *Transactions of the American Philological Association*, 110: 263–86.

Shelton, Jo-Ann. 1975. "Problems of Time in Seneca's *Hercules Furens* and *Thyestes*." *California Studies in Classical Antiquity*, 8: 257–69.

Siotti, Eliana. 2017. *La policromia sui sarcofago romano: Catalogo e risultati scientifici*. Rome: Bretschneider.

Skovmøller, Amalie. 2014. "Where Marble Meets Colour: Surface Texturing of Hair, Skin and Dress on Roman Marble Portraits as Support for Painted Polychromy." In Mary Harlow and Marie-Louise Nosch (eds.), *Greek and Roman Textiles and Dress: An Interdisciplinary Anthology*. Oxford: Oxbow.

Skovmøller, Amelie, and Rikke H. Therkildsen. 2015. "The Polychromy of Roman Polished Portraits." In Patrizio Pensabene and Elenora Gasparini (eds.), *Interdisciplinary Studies on Ancient Stone*. Rome: Bretschneider.

Sophocles. 1997. *Ajax; Electra; Oedipus Tyrannus*. Edited and translated by Hugh Lloyd-Jones. Corrected edn. Cambridge, MA: Harvard University Press.

Sophocles. 2011. *Ajax*. Edited by Patrick J. Finglass. Cambridge: Cambridge University Press.

Sorabji, Richard. 1972. "Aristotle, Mathematics, and Colour: Intermediate Colours as Mixtures of Black and White." *Classical Quarterly*, 22: 293–308.

Sorabji, Richard. 1991. "From Aristotle to Brentano: The Development of the Concept of Intentionality." *Oxford Studies in Ancient Philosophy* (suppl.): 227–59.

Sorabji, Richard. 1992. "Intentionality and Physiological Processes: Aristotle's Theory of Sense-Perception." In Martha Nussbaum and Amelie Oksenberg Rorty (eds.), *Essays on Aristotle's* De anima. Oxford: Oxford University Press.

Sorabji, Richard. 2001. "Aristotle on Sensory Processes and Intentionality." In Dominik Perler (ed.), *Ancient and Medieval Theories of Intentionality*. Leiden: Brill.

Sotiropoulou, Sophia, and Ioannis Karapanagiotis. 2006. "Conchylian Purple Investigation in Prehistoric Wall Paintings of the Aegean Area." In Laurent Meijer, Nicole Guyard, Leandros Skaltsounis, and Gerhard Eisenbrand (eds.), *Indirubin, the Red Shade of Indigo*. Roscoff: Editions "Life in Progress."

Spantidaki, Stella. 2014. "Embellishment Techniques of Classical Greek Textiles." In Mary Harlow and Marie-Louise Nosch (eds.), *Greek and Roman Textiles and Dress: An Interdisciplinary Anthology*. Oxford: Oxbow.

Spantidaki, Stella. 2017. "Textile Production in Iron Age Greece: The Case of the Amorgina Textiles." In Margarita Gleba and Romina Laurito (eds.), *Contextualising Textile Production in Italy in the 1st Millennium BCE*. Rome: Gangemi.

Sperl, Dina. 1990. "Glas und Licht in Architektur und Kunst." In Wolf-Dieter Heilmeyer and Wolfram Hoepfner (eds.), *Licht und Architektur*. Tübingen: Wasmuth Verlag.

Spier, Jeffrey. 2007. *Late Antique and Early Christian Gems*. Wiesbaden: Reichert.

Stager, Jennifer. 2016. "The Materiality of Color in Ancient Mediterranean Art." In Rachel B. Goldman (ed.), *Essays in Global Color History: Interpreting the Ancient Spectrum*. Piscataway, NJ: Gorgias Press.

Stager, Jennifer. Forthcoming. *Rethinking Color: Bodies, Materials, and Vision in Ancient Mediterranean Art and its Afterlives*.

Stanzl, Günther. 2015. "Das Ptolemaion von Limyra." In Jacques Des Courtils (ed.), *L'architecture monumentale grecque au IIIe siècle a.C.* Bordeaux: Ausonius.

Stead, Ian Mathieson. 1967. "A La Tène III Burial at Welwyn Garden City." *Archaeologia*, 101: 1–62.

Stephenson, John. 2016. "Dining as Spectacle in Late Roman Houses." *Bulletin of the Institute of Classical Studies of the University of London*, 59(1): 54–71.

Stern, Eva Marianne. 1985. "Die Kapitelle der Nordhalle des Erechtheion." *Mitteilungen des Deutschen Archäologischen Instituts, Athenische Abteilung*, 100: 405–26.

Stern, Eva Marianne. 1995. *Roman Mold-Blown Glass*. Toledo: Bretschneider, and Toledo Museum of Art.

Stern, Eva Marianne. 1997. "Glass and Rock Crystal: A Multifaceted Relationship." *Journal of Roman Archaeology*, 10: 192–206.

Steures, Désiré. 2002. "Late Roman Thirst: How Dark Colored Drinking Sets from Trier Were Used." *Bulletin Antieke Beschaving*, 77: 175–9.

Stewart, Andrew. 1993. *Faces of Power: Alexander's Image and Hellenistic Politics*. Berkeley: University of California Press.

Stewart, Susan. 2007. *Cosmetics and Perfumes in the Roman World*. Stroud: Tempus.

Stirling, Lea M. 2008. "Pagan Statuettes in Late Antique Corinth: Sculpture from the Panagia Domus." *Hesperia*, 77: 89–161.

Stone, Shelly. 1994. "The Toga: From National to Ceremonial Costume." In Judith L. Sebesta and Larissa Bonfante (eds.), *The World of Roman Costume*. Madison: University of Wisconsin Press.

Strabo. 1866–77. *Strabonis Geographica*. Edited by A. Meineke. 3 vols. Leipzig: Teubner.

Stratiki, Kerasia. 2004. "*Melas* in Greek Hero Cults." In Liza Cleland and Karen Stears with Glenys Davies (eds.), *Colour in the Ancient Mediterranean World*. Oxford: John and Erica Hedges.

Struycken, P. 2003. "Colour Mixtures According to Democritus and Plato." *Mnemosyne*, 56: 273–305.

Stulz, Heinke. 1990. *Die Farbe Purpur im frühen Griechentum: Beobachtet in der Literatur und in der bildenden Kunst*. Stuttgart: Teubner.

Suetonius. 1997. *Lives of the Caesars*, vol. 2, *The Lives of Illustrious Men*. Translated by John C. Rolfe. 2nd edn. Cambridge, MA: Harvard University Press.

Suetonius. 1998. *Lives of the Caesars*, vol. 1. Translated by John C. Rolfe. 2nd edn. Cambridge, MA: Harvard University Press.

Summitt, James Bruce. 2000. "Greek Architectural Polychromy from the Seventh to Second Centuries BC: History and Significance." PhD thesis, University of Michigan.

Suter, Ann. 2002. *The Narcissus and the Pomegranate: An Archaeology of the Homeric Hymn to Demeter*. Ann Arbor: University of Michigan Press.

Svoboda, Marie, and Caroline Cartwright, eds. 2020. *Mummy Portraits of Roman Egypt: Emerging Research from the APPEAR Project*. Los Angeles: J. Paul Getty Museum.

Swift, Ellen. 2003. "Late Roman Bead Necklaces and Bracelets." *Journal of Roman Archaeology*, 16: 336–49.

Swift, Ellen. 2009. *Style and Function in Roman Decoration: Living with Objects and Interiors*. Farnham: Ashgate.

Swift, Ellen. 2017. *Roman Artefacts and Society: Design, Behaviour and Experience*. Oxford: Oxford University Press.

Symonds, Robin. 1992. *Rhenish Wares: Fine Dark Colored Pottery from Gaul and Germany*. Oxford: Oxford University Committee for Archaeology.

Tait, William John. 1982. *Tutankhamun's Tomb Series VII: Game Boxes and Accessories from the Tomb of Tutankhamun*. Oxford: Griffith Institute.

Taylor, C.C.W. 1999. *The Atomists: Leucippus and Democritus*. Toronto: University of Toronto Press.

Taylor, John H. 2001. "Patterns of Colouring on Ancient Egyptian Coffins from the New Kingdom to the Twenty-Sixth Dynasty: An Overview." In W. Vivian Davies (ed.), *Color and Painting in Ancient Egypt*. London: British Museum Press.

Terence. 2001. *Phormio; The Mother-in-Law; The Brothers*. Edited and translated by John Barsby. Cambridge, MA: Harvard University Press.

Theodorakopoulos, Elena. 2007. "Poem 68: Love and Death, and the Gifts of Venus and the Muses." In Marilyn B. Skinner (ed.), *A Companion to Catullus*. Malden, MA: Blackwell.

The Theodosian Code and Novels, and the Sirmondian Constitutions. 1952. Translated by Clyde Pharr in collaboration with Theresa Sherrer Davidson, and Mary Brown Pharr. Princeton, NJ: Princeton University Press.

Theophrastus. 1879. *De sensu et sensibilibus*. In Hermann Diels (ed.), *Doxographi Graeci*. Berlin: Reimer.

Theophrastus. 1956. *On Stones*. Edited and translated by Earle R. Caley and John F.C. Richards. Columbus: Ohio State University.

Thimme, Jurgen, ed. 1977. *Art and Culture of the Cyclades in the Third Millennium B.C.* Chicago: University of Chicago Press.

Thomas, Bridget M. 2002. "Constraints and Contradictions: Whiteness and Femininity in Ancient Greece." In Lloyd Llewellyn-Jones (ed.), *Women's Dress in the Ancient Greek World*. London: Duckworth; Swansea: Classical Press of Wales.

Technart 2019. n.d. "This Was Technart 2019." Available online: https://www.uantwerpen.be/en/conferences/technart-2019/ (accessed May 20, 2020).

Thucydides. 1919. *History of the Peloponnesian War*. Edited and translated by C.F. Smith. 4 vols. Cambridge, MA: Harvard University Press; London: Heinemann.

Tiverios, Michales A., and Desponia S. Tsiafakis, eds. 2002. *Color in Ancient Greece: The Role of Color in Ancient Greek Art and Architecture (700–31 BC): Proceedings of the Conference Held in Thessaloniki, 12–16 April, 2000*. Thessaloniki: Aristotle University of Thessaloniki, Lambrakis Research Foundation.

Tracking Colour. n.d. Available online: http://trackingcolour.com (accessed May 20, 2020).

Trillmich, Walter. 2014. "Aureae Litterae." *Madrider Mitteilungen*, 54: 326–47.

Tuominen, Miira. 2014. "On Activity and Passivity in Perception: Aristotle, Philoponus, and Pseudo-Simplicius." In José Filipe Silva and Mikko Yrjonsuuri (eds.), *Active Perception in the History of Philosophy*. Leiden: Brill.

Ungaro, Lucrezia. 2004. "Il rivestimento dipinto dell' 'Aula del Colosso' nel Foro di Augusto." In Paolo Liverani, Hansgeorg Bankel, and Anna Gramiccia (eds.), *I colori del bianco: Policromia nella scultura antica*. Rome: De Luca.

Valerius Flaccus, Gaius. 1936. *Argonautica*. Translated by J.H. Mozley. Rev. edn. Cambridge, MA: Harvard University Press; London: Heinemann.

Valerius Maximus. 2000. *Memorable Doings and Sayings*, vol. 1. Translated by D.R. Shackleton Bailey. Cambridge, MA: Harvard University Press.

Valeva, Julia. 2015. "The Decoration of Thracian Chamber Tombs." In Julia Valeva, Emil Nankov, and Denver Graninger (eds.), *A Companion to Ancient Thrace*. Chichester: Wiley. https://doi.org/10.1002/9781118878248.ch13.

Varro. 1935. *Marcus Porcius Cato: On Agriculture; Marcus Terentius Varro: On Agriculture*. Translated by William Davis Hooper; revised by Harrison Boyd Ash. Rev. edn. Cambridge, MA: Harvard University Press; London: Heinemann.

Varro. 1951. *On the Latin Language*. Translated by Roland G. Kent. Rev. edn. 2 vols. Cambridge, MA: Harvard University Press; London: Heinemann.

Veblen, Thorstien. [1899] 2017. *The Theory of the Leisure Class*. London: Routledge. https://doi.org/10.4324/9781315135373.

Velleius Paterculus. 1924. *Compendium of Roman History; Res gestae divi Augusti*. Translated by Frederick W. Shipley. Cambridge, MA: Harvard University Press; London: Heinemann.

Vernant, Jean-Pierre. 1991. *Mortals and Immortals*. Edited and translated by Froma Zeitlin. Princeton, NJ: Princeton University Press.

Verri, Giovanni, Thorsten Opper, and Lorenzo Lazzarini. 2014. "'In picturae modum variata circumlitio'?: The Reconstruction of the Polychromy of a Roman Ideal Female Head (Treu Head)." In Paolo Liverani and Ulderico Santamaria (eds.), *Diversamente bianco: La policromio della scultura romana*. Rome: Quasar.

Versnel, H.S. 1970. *Triumphus: An Inquiry into the Origin, Development, and Meaning of the Roman Triumph*. Leiden: Brill.

Vickers, Michael. 1996. "Rock Crystal: The Key to Cut Glass and Diatreta in Persia and Rome." *Journal of Roman Archaeology*, 9: 48–65.

Vidal-Naquet, Pierre. 1980. *Le chasseur noir*. Paris: Maspero.

Vikan, Gary. 1990. "Art and Marriage in Early Byzantium." *Dumbarton Oaks Papers*, 44: 144–63.

Virgil. 1999. *Eclogues; Georgics; Aeneid Books I–VI*. Translated by H. Rushton Fairclough, edited by G.P. Goold. Rev. edn. Cambridge, MA: Harvard University Press.

Virgil. 2000. *Aeneid Books VII–XII; Appendix Vergiliana*. Translated by H. Ruston Fairclough, edited by G.P. Goold. Rev. edn. Cambridge, MA: Harvard University Press.

Vitruvius. 1998. *On Architecture*. Edited and translated by Frank Granger. 2 vols. Cambridge, MA: Harvard University Press.

Vlassopoulou, Christina. 2010. "New Investigations into the Polychromy of the Parthenon." In Vinzenz Brinkmann, Oliver Primavesi, and Max Hollein (eds.), *Circumlitio: The Polychromy of Antique and Mediaeval Sculpture; Conference Proceedings, 10–12 December 2008, Liebieghaus-Skulpturensammlung*. Frankfurt: Hirmer.

Volk, Katherina. 2006. "Cosmic Disruptions in Seneca's *Thyestes*: Two Ways of Looking at an Eclipse." In Katharina Volk and Gareth D. Williams (eds.), *Seeing Seneca Whole: Perspectives on Philosophy, Poetry and Politics*. Boston: Brill.

Von Graeve, Volkmar. 1970. *Der Alexandersarkophag und seine Werkstatt*. Berlin: Mann.

Wace, A.J.B. 1948. "Weaving or Embroidery?" *American Journal of Archaeology*, 52(1): 51–5.

Wagner-Hasel, Beate. 2002. "The Graces and Colour Weaving." In Lloyd Llewellyn-Jones (ed.), *Women's Dress in the Ancient Greek World*. London: Duckworth; Swansea: Classical Press of Wales.

Walker, Susan, and Morris Bierbrier. 1997. *Ancient Faces: Mummy Portraits from Roman Egypt: [Part IV of A Catalogue of Roman Portraits in the British Museum]*. London: British Museum Press.

Wallace, Florence Elizabeth. 1927. *Color in Homer and in Ancient Art: Preliminary Studies*. Northampton, MA: Smith College.

Walter-Karydi, Elena. 1986. "Prinzipien der archaischen Farbgebung." In Karin Braun (ed.), *Studien zur klassischen Archäologie, Festschrift Friedrich Hiller*. Saarbrücken: Saarbrücker Druck.

Walter-Karydi, Elena. 1998. *The Greek House: The Rise of Noble Houses in Late Classical Times*. Athens: Archaeological Society at Athens.

Walter-Karydi, Elena. 2018. "The Emergence of Polychromy in Ancient Greek Art in the 7th Century BC." In Philippe Jockey (ed.), *Les arts de la couleur en Grèce ancienne … et ailleurs: Approches interdisciplinaires*. Athens. École Française d'Athènes.

Warburton, David A. 2004. "The Terminology of Ancient Egyptian Colours in Context." In Liza Cleland and Karen Stears (eds.), *Color in the Ancient Mediterranean World*. Oxford: Archaeopress.

Warburton, David A. 2008. "The Theoretical Implications of Ancient Egyptian Colour Vocabulary for Anthropological and Cognitive Theory." *Lingua Aegyptia*, 16: 213–59.

Watkins, Michael. 2005. "Seeing Red: The Metaphysics of Colours Without the Physics." *Australasian Journal of Philosophy*, 83(1): 33–52.

Webster, Thomas Bertram Lonsdale. 1956. *Greek Theatre Production*. London: Methuen.

Webster, Thomas Bertram Lonsdale. 1967. *Monuments Illustrating Tragedy and Satyr Play*. 2nd edn. London: University of London Institute of Classical Studies.

Webster, Thomas Bertram Lonsdale. 1978. *Monuments Illustrating Old and Middle Comedy*. Revised by John Richard Green. 3rd edn. London: University of London Institute of Classical Studies.

Webster, Thomas Bertram Lonsdale. 1995. *Monuments Illustrating New Comedy*. Revised by John Richard Green and Axel Seeberg. 3rd edn. London: University of London Institute of Classical Studies.

Wees, Hans van. 2005. "Trailing Tunics and Sheepskin Coats: Dress and Status in Early Greece." In Liza Cleland, Mary Harlow, and Lloyd Lewellyn-Jones (eds.), *The Clothed Body in the Ancient World*. Oxford: Oxbow Books.

Wees, Hans van. 2017. "Luxury, Austerity and Equality in Sparta." In Anton Powell (ed.), *A Companion to Sparta*. Hoboken, NJ: Wiley.

Wees, Hans van. 2018. "Luxury, Austerity and Equality in Archaic Greece." In Werner Riess (ed.), *Colloquia Attica Neuere Forschungen zur Archaik, zum athenischen Recht und zur Magie*. Stuttgart: Franz Steiner.

Wehgartner, Irma. 2002. "Color on Classical Vases." In Michales A. Tiverios and Desponia S. Tsiafakis (eds.), *Color in Ancient Greece: The Role of Color in Ancient Greek Art and Architecture 700–31 B.C.* Thessaloniki: Aristotle University of Thessaloniki, Lambrakis Research Foundation.

Wendland, Paul, ed. 1901. *Alexandri Aphrodisiensis in librum de sensu commentarium*. Berlin: Reimer.

Wescott, Roger W. 1970. "Bini Color Terms." *American Anthropologist*, 12: 349–60.

West, Martin L., ed. and trans. 2003. *Homeric Hymns, Homeric Apocrypha, Lives of Homer*. Cambridge, MA: Harvard University Press.

Wharton, David. 2016. "Abstract and Embodied Colors in Pliny the Elder's *Natural History*." In William Michael Short (ed.), *Embodiment in Latin Semantics*. Amsterdam: John Benjamins.

Wharton, David. Forthcoming. "Prestige, Color, and Color Language." In Katerina Ierodiakonou (ed.), *Psychologie de la couleur dans le monde gréco romain—Colour Psychology in the Graeco-Roman World*. Vandœuvres: Fondation Hardt.

Whitehouse, David. 1991. "Cameo Glass." In Martine Newby and Kenneth Scott Painter (eds.), *Roman Glass: Two Centuries of Art and Invention*. London: Society of Antiquaries of London.

Whitehouse, David. 2001. *Roman Glass in the Corning Museum of Glass*, vol. 2. Corning, NY: Corning Museum of Glass.

Whitehouse, David. 2003. *Roman Glass in the Corning Museum of Glass*, vol. 3. Corning, NY: Corning Museum of Glass.

Whorf, Benjamin Lee. 1956. "Linguistics as an Exact Science." In Benjamin Lee Whorf and John B. Carroll, *Language, Thought, and Reality: Selected Writings*. Cambridge: Massachusetts Institute of Technology Press.

Wierzbicka, Anna. 1990. "The Meaning of Color Terms: Semantics, Culture, and Cognition." *Cognitive Linguistics*, 1: 99–150.

Wierzbicka, Anna. 2005. "There are no 'Color Universals' but there are Universals of Visual Semantics." *Anthropological Linguistics*, 47: 217–44.

Wierzbicka, Anna. 2008. "Why there are no 'Colour Universals' in Language and Thought." *Journal of the Royal Anthropological Institute*, 14: 407–25.

Wilcken, Ulrich. 1936. *Die Bremer Papyri*. Berlin: Akademie der Wissenschaften.

Wiles, David. 1991. *The Masks of Menander: Sign and Meaning in Greek and Roman Performance*. Cambridge: Cambridge University Press.

Williams, Dyfri, and Jack Ogden. 1994. *Greek Gold: Jewelry of the Classical World*. New York: Harry Abrams.

Wilson, Andrew I. 2004. "Archaeological Evidence for Textile Production and Dyeing in Roman North Africa." In Carmen Alfaro Giner, John Peter Wild, and Benjamí Costa Ribas (eds.), *Purpureae vestes: Actas del I symposium internacional sobre textiles y tintes del mediterráneo en época romana (Ibiza, 8 al 10 de noviembre, 2002)*. València: Consell Insular d'Eivissa i Formentera; Universitat de València.

Winter, Irene J. 1981. "Royal Rhetoric and the Development of Historical Narrative in Neo-Assyrian Reliefs." *Studies in Visual Communication*, 7: 2–38.

Winter, Nancy A. 2002. "The Use of Color on Archaic Architectural Terracottas and Figurines." In Michaelis A. Tiverios and Desponia S. Tsiafakis (eds.), *Color in Ancient Greece: The Role of Color in Ancient Greek Art and Architecture 700–31 B.C.* Thessaloniki: Aristotle University of Thessaloniki.

Winter, Nancy A. 2009. *Symbols of Wealth and Power: Architectural Terracotta Decoration in Etruria and Central Italy, 640–510 B.C.* Ann Arbor: University of Michigan Press.

Wirth, Fritz. 1931. "Wanddekorationen ersten Stils in Athen." *Athenische Mitteilungen*, 56: 33–58.

Woodward, Ann, and John Hunter. 2015. *Ritual in Early Bronze Age Grave Goods: An Examination of Ritual and Dress Equipment from Chalcolithic and Early Bronze Age Graves in England*. Oxford: Oxbow Books.

Woolley, Charles Leonard. 1934. *Ur Excavations*, vol. 2, *The Royal Cemetery*. London: British Museum; Philadelphia: Museum of the University of Pennsylvania.

Wrenhaven, Kelly L. 2011. "Greek Representations of the Slave Body: A Conflict of Ideas?" In Richard Alston, Edith Hall, and Justine McConnell (eds.), *Reading Ancient Slavery*. London: Bristol Classical Press.

Wright, David H. 1993. *The Vatican Vergil, a Masterpiece of Late Antique Art*. Berkeley: University of California Press.

Wunderlich, Eva. 1925. *Die Bedeutung der roten Farbe im Kultus der Griechen und Römer: Erläutert mit Berücksichtigung entsprechender Bräuche bei anderen Völkern*. Berlin: De Gruyter.

Wyles, Rosie. 2011. *Costume in Greek Tragedy*. London: Bristol Classical Press.

Xenophon. 1925. *Hiero; Agesilaus; Constitution of the Lacedaemonians; Ways and Means; Cavalry Commander; Art of Horsemanship; On Hunting; Constitution of the Athenians*. Edited and translated by E.C. Marchant, and revised by G.W. Bowersock. Cambridge, MA: Harvard University Press; London: Heinemann.

Xenophon. 1998. *Anabasis*. Edited and translated by Carleton M. Brownson. Cambridge, MA: Harvard University Press.

Xenophon. 2013. *Memorabilia; Oeconomicus; Symposium; Apology*. Translated by E.C. Marchant and O.J. Todd. Rev. edn. Cambridge, MA: Harvard University Press.

Young, Diana. 2006. "The Colours of Things." In Chris Tilley, Webb Keane, Susanne Küchler, Mike Rowlands, and Patricia Spyer (eds.), *Handbook of Material Culture*. London: Sage.

Zambon, Alessia. 2012. "Les premiers voyageurs et la dorure du Parthénon: Mise au point sur une controverse ancienne." *Revue Archéologique*, 53: 41–61.

Ziderman, Irving. 1987. "The First Identification of Authentic Tekelet." *Bulletin of the American Schools of Oriental Research*, 265: 25–33.

Ziderman, Irving. 2004. "Purple Dyeing in the Mediterranean World." In Liza Cleland and Karen Stears with Glenys Davies (eds.), *Colour in the Ancient Mediterranean World*. Oxford: John and Erica Hedges.

Zink, Stephan. 2014. "Polychromy in Roman Architecture: Colors, Materials, and Techniques." In Jan Stubbe Østergaard and Anne Marie Nielsen (eds.), *Transformations: Classical Sculpture in Colour*. Copenhagen: Ny Carlsberg Glyptotek.

Zink, Stephan. 2019. "Polychromy, Architectural, Greek and Roman." In Sander Goldberg (ed.), *Oxford Classical Dictionary*. New York: Oxford University Press. Available online: https://oxfordre.com/classics/view/10.1093/acrefore/9780199381135.001.0001/acrefore-9780199381135-e-8184 (accessed May 21, 2020).

Zink, Stephan. Forthcoming. "Polychrome Reconstructions of Roman Architecture: Evidence, Ideal, and Ideology." In Dorian Borbonus and Elisha Dumser (eds.), *Building the Classical World:* Bauforschung *as a Contemporary Approach*. New York: Oxford University Press.

Zink, Stephan, and Heinrich Piening. 2009. "*Haec Aurea Templa*: The Palatine Temple of Apollo and Its Polychromy." *Journal of Roman Archaeology*, 22: 109–22.

Zink, Stephan, Moritz Taschner, Ina Reiche, Matthias Alfeld Cristina Aibéo, Ellen Egel, Katharina Müller, Anne Ristau, Birgit Neuhaus, and Wolfgang Massmann. 2019. "Tracing the Colours of Hermogenes' Temple of Artemis: Architectural Surface Analysis in the Antikensammlung Berlin." In Brigitte Bourgeois (ed.), *Les couleurs de l'Antique, Actes de la 8e table ronde sur la polychromie de la sculpture et de l'architecture antique, Technè* 48: 14–26.

Zisis, V.G. 1955. "Cotton, Linen and Hempen Textiles from the 5th Century BC." *Praktikates Akademias Athenon*, 29: 590–2.

Zorach, Rebecca, and Michael W. Phillips. 2016. *Gold: Nature and Culture*. Chicago: University of Chicago Press.

CONTRIBUTORS

Mark Abbe is Associate Professor in the Lamar Dodd School of Art at the University of Georgia, USA.

Karen Bassi is Professor of Literature and Classics at the University of California at Santa Cruz, USA.

Hilary Becker is Assistant Professor in the Department of Classical and Near Eastern Studies at Binghamton University, State University of New York, USA.

Katerina Ierodiakonou is Associate Professor of Ancient Philosophy in the Department of Philosophy of the University of Geneva, Switzerland, and the Department of Philosophy and History of Science of the University of Athens, Greece.

Lloyd Llewellyn-Jones is Professor of Ancient History, Lead in Equality and Diversity in the School of History, Archaeology, and Religion at Cardiff University, UK.

Katherine McDonald is Senior Lecturer of Classics and Ancient History at the University of Exeter, UK.

Kelly Olson is Professor of Classics in the Department of Classical Studies at Western University, Canada.

Verity Platt is Professor of Classics in the Department of Classics at Cornell University, USA.

Ellen Swift is Professor of Roman Archaeology in the School of European Culture and Languages at the University of Kent, UK.

David Wharton is Associate Professor of Classical Studies in the Department of Classical Studies at the University of North Carolina at Greensboro, USA.

Stephan Zink is Research Fellow at the German Archaeological Institute in Berlin, Germany.

INDEX